W9-AQW-887

THE ARTIST'S EYES

VISION AND THE HISTORY OF ART

Abrams, New York

THE ARTIST'S EYES

VISION AND THE HISTORY OF ART

GLEN COVE PUBLIC LIBRARY
4 GLEN COVE AVENUE
GLEN COVE. NEW YORK 11542-2885

MICHAEL F. MARMOR and JAMES G. RAVIN

3 1571 00277 7640

CONTENTS

ACKNOWLEDGMENTS

FROM THE AUTHORS:

Needless to say, this book could not have been realized without great support, effort, and skill from the professionals at Abrams. Eric Himmel, Abrams' editor in chief, recognized the value of this book. Our editor, Susan Homer, worked on every phase of the project with insight, precision, and a surprising understanding of ophthalmology. Kara Strubel is responsible for the elegant design within constraints of a lot of words and images. Our copyeditor, Elizabeth Smith, and Abrams' managing editor, Andrea Colvin, also deserve special mention. Ann Handler at Art Resource, Maria Marguia-Harding at Bridgeman Art Library, and Cristin O'Keefe Aptowicz at Artists Rights Society tracked down critical images and permissions. We must also mention our colleague in the small world of ophthalmology and art, Philippe Lanthony, whose knowledge, writing, and friendship have been much appreciated over the years. Contributions from Robert Weale and Philippe Lanthony in our original book (*The Eye of the Artist*) have not been used because of reorganization, but many of their insights remain.

FROM MICHAEL F. MARMOR:

Special thanks are owed to many people whose support was critical to me in preparing this book. First and foremost to my wife, Jane, who may now reclaim our house from piles of books and notes in multiple rooms. Her patience and critical eye have been invaluable. My son, David, provided computer-graphic expertise for the disease simulations, and other complex diagrams. My daughter, Andrea, provided encouragement throughout. Judy Roberts typed and organized endless drafts with skill and good humor. As the project was being developed, Catharine Carlin, editor for ophthalmology and neuroscience at for Oxford University Press, gave encouragement and valuable suggestions. Mildred Marmur provided sophisticated and critical knowledge of the book trade. Writer Andrew Potok and his wife, Lois, introduced me to Eric Himmel.

Many individuals contributed information and materials. An earlier version of the Euphronios chapter was written with Jody Maxmin. The initial version of the Matisse chapter was written by Anne Kemble during a research elective with me. Artists Bridget Riley, Jens Johannsen, and Peter Silten graciously shared both ideas and art, and Jens has kindly allowed description of his color deficiency and inclusion of his observations about color. S. B. Kennedy, a leading scholar on the work of Paul Henry, provided expertise and images. Elizabeth Murray provided critical photographs. MaryAnn Wijtman of the Visual Arts Service at Stanford assisted with image adjustments. Colin Stinson, Mariko Chang, and others at the Cantor Arts Center at Stanford University helped with material from their collection.

FROM JAMES G. RAVIN:

Special thanks are due to Nancy, Amy, Tracy, Victoria, and Ellen Ravin for their encouragement and assistance. Christie Kenyon coauthored an earlier version of our thoughts about Edgar Degas. Nancy Anderson was a coauthor on a previous paper about Charles Meryon. Tracy Ravin has been a coauthor on publications about Francisco de Goya. Peter Odell coauthored an earlier paper about Chuck Close. We thank Chuck Close for allowing us to divulge aspects of his medical history. The staff of the Toledo Museum of Art has been particularly helpful, including Patricia Whitesides, the registrar, and the librarians under the direction of Anne Morris.

ABOUT THE AUTHORS

MICHAEL F. MARMOR was trained at Harvard College and Harvard Medical School, and is a leading expert in retinal disease and retinal physiology. His parents were art collectors, and his interest in the relationship of vision to art is both personal and academic. He is professor and past chair of ophthalmology at the Stanford University School of Medicine, and a faculty member in the Center for Biomedical Ethics and the undergraduate Program in Human Biology. Dr. Marmor has written more than 250 scientific papers; he is also the author of two previous books concerning vision, eye disease, and art, and has taught widely on these topics. He has assisted with art exhibitions at the Cantor Center for the Visual Arts (Stanford) and the Musée Marmottan Monet in Paris.

JAMES G. RAVIN's fascination with the creativity of artists dates from his childhood lessons in studio art. An art history major at the University of Michigan, Dr. Ravin has studied the effects of illness on artists since he attended the University of Michigan Medical School. His investigations have been published in the *Journal of the American Medical Association*, and have been featured on CNN, the *Today Show*, and other national media. Dr. Ravin's special interest is in nineteenth-century European painting. Dr. Ravin is a clinical associate professor at the University of Toledo College of Medicine and has published more than 60 scientific articles and several book chapters.

INTRODUCTION

Art, in the context of painting and drawing, is fundamentally a visual medium, for both artist and viewer. A few artists have made works that are meant to be experienced in darkness or by touch, but in general, when we display art in our homes, travel to a cultural or religious site, or visit a museum, we expect to *see* art. At the same time, it is obvious that while visual content may be a necessary component of most art, it is certainly not sufficient to define it. The definition of art depends on much more, including whether or why art differs from design, photography, religion, propaganda, or doodling, and how art has meant different things in different ages and to different people (whether artists or viewers). Our purpose in this book is to focus attention on *vision*—which lies at the core of the visual arts no matter how they are defined—and to look at the eye as the structure in which the process of vision originates and the structure that can most directly confound vision in the presence of disease. We present this information within the frameworks of both art history and medical history.

This book is based upon our earlier work, *The Eye of the Artist*,[1] but includes new and updated material, a broader range of artists, and new organization to clarify the roles of both visual processes and eye diseases in art. We are indebted to many who have written books on related aspects of vision, eye disease, and art, including Patrick Trevor-Roper,[2] Arthur Linksz,[3] Philippe Lanthony,[4] Margaret Livingstone,[5] and Semir Zeki.[6] But our approach to the eye, for its role in vision as well as disease, is our own.

When we say that art is a visual medium, the term *visual* refers to the complex of eye and brain that receives and interprets light and images. Artists don't paint with invisible ultraviolet or infrared pigments, or draw faces that can only be seen with gamma rays. Art is seen by visible light, which by definition is that portion of electromagnetic radiation to which retinal nerve cells can respond. The mechanisms by which the eye and brain recognize and process light are a foundation for how we see. For example, the physical properties and circuitry of nerve cells within the retina account for why we see colors during the day but cannot distinguish them by dim moonlight; why the inside of a tunnel appears black as we approach it on a sunny day, while things inside become visible as soon as we enter; and why we can read the finest of print, and yet be fooled by an optical illusion. These are facts of the physics and physiology of life, and are not options for us—or any artist—to modify or avoid. Artists see the

world physically, as we all do, although they may be more perceptive than most of us in interpreting the complexity of vision to enhance the impact of their work.

When diseases of the eye alter visual input, one no longer has a normal view of the world—or of art. This can be devastating for an artist, although the impact will vary with the style of work and the degree to which his or her art is dependent on fine detail, shadow, color, or even illusion. Eye disease may affect any portion of the eye, including the external tissues, the cornea, the lens, the retina, and the optic nerve to the brain. Depending on the nature of the disease and the tissues involved, it can require the use of corrective lenses, blur vision, alter color perception, create sensitivity to light and glare, and/or impair the perception of depth.

We will review characteristics of vision and eye disease that are relevant to the production and appreciation of art, and which represent a physical foundation for art. In that sense, these are the tools of the trade. We will also explain why some popular theories about artist's ocular problems are probably not true. We will highlight a number of well-known artists, but discuss many others as examples. We hope that the medically experienced reader will forgive us for including some basic material and definitions for readers who lack such background. Conversely, we hope that the non-medical reader will find our medical excursions intriguing. It is important to emphasize that information about how the eye works and about eye diseases of artists does not and cannot explain art. However, to ignore it is to deny the factual constraints that all artists face in producing their work, and that all viewers must face in interpreting it. Insight into the visual aspects of art is not a threat to artistry or to art history. It is rather a means of appreciating better how artistry takes place, and where the analysis of works of art can begin.

NOTES

1. Marmor and Ravin, *The Eye of the Artist* (1997).
2. Trevor-Roper, *The World Through Blunted Sight* (1970).
3. Linksz, *An Ophthalmologist Looks at Art* (1980).
4. Lanthony, *Les Yeux des Peintres* (1999); Lanthony, *An Eye for Painting* (2006).
5. Livingstone, *Vision and Art: The Biology of Seeing* (2002).
6. Zeki, *Inner Vision: An Exploration of Art and the Brain* (1999).

WHY GLASSES ARE NEEDED

STRUCTURE AND OPTICS OF THE EYE

The eye is like a camera insofar as it has a set of lenses in the front (the cornea and the lens) that focus images upon a light-sensitive film (the retina) in the back (see fig. 1.1). In the idealized eye, images from far away are perfectly in focus when the focusing muscles that adjust the lens are relaxed. Through a process called accommodation, these muscles change the shape of the lens to increase its focusing power and allow us to see objects up close. In actuality, the human lens is only an instrument for fine-tuning vision; the major focusing, or refractive, element of the eye is the external surface of the cornea. The cornea is more powerful than the lens within the eye because the power of any lens, whether in the eye or made of glass, relates not only to its shape but also to its optical density (i.e., its ability to slow down and bend light) relative to the surrounding medium. Because there is a large difference between the densities of water and air, the cornea, which is mainly water (like most of the body), is a powerful focusing element. Since the lens of the eye is inside and surrounded by watery fluid of a similar density, it is much less effective. In a young person, the cornea accounts for roughly three-quarters of the eye's refractive power, and the lens for the last quarter. The importance of the air-lens interface is especially obvious under water. We can't see well under water because the density of the water neutralizes most of the cornea's power, and spectacles are useless because glass and plastic have densities similar to water. Fish compensate for this loss of corneal power by having exceptionally powerful lenses (much rounder than ours) within their eyes.

Although the idealized (emmetropic) eye that is fully relaxed is focused perfectly on objects at infinity, many of us have eyes that are not ideal and thus have what is called a refractive error. A myopic (nearsighted) eye is too long relative to its lens system, so that faraway images come to a focus in front of the retina and appear blurred (see fig 1.2). Objects very close can be seen clearly because the rays of light diverging from them move the point of focus farther back onto the retina. Myopia is easily corrected with spectacles or contact lenses that have a concave shape.

A hyperopic (farsighted) eye is too short for its lens system, so that faraway objects come to a focus behind the retina (see fig. 1.2). A hyperopic individual must not only focus, or accom-

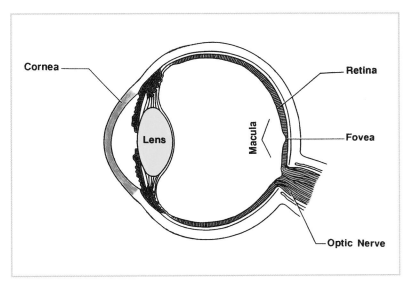

Cornea — Retina — Lens — Macula — Fovea — Optic Nerve

1.1

modate, to see faraway objects, but also must focus additionally in order to read. Hyperopia is corrected with convex lenses.

Some eyes have a degree of astigmatism, which means that the surface of the eye is slightly barrel-shaped, rather than spherical. In other words, images are focused more strongly in one direction than in another. This error, which is independent of any underlying myopia or hyperopia, can be corrected either with glasses that are ground to compensate for the asymmetry or with hard contact lenses that have a spherical outer surface. Most soft contact lenses that mold to the surface of the eye do not correct astigmatism.

An optical problem that eventually affects all of us is presbyopia, or the loss of accommodation that comes with aging (see chapter 23). As we get older, the lens becomes less elastic, and we gradually lose the ability to focus over the whole range, from infinity to near (see fig. 1.3). By the age of fifty, most people who see clearly at a distance are no longer able to read comfortably with the same correction, and so convex lenses are prescribed for reading (on top of whatever is worn for distance). It is important to understand that presbyopia is only a problem of *range*

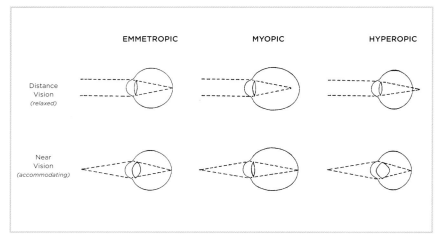

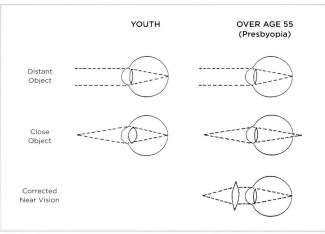

of focus and it is not ordinarily accompanied by any change in preexisting myopia or hyperopia. Older individuals do not usually change their distance correction (i.e., they do not become farsighted); they simply cannot focus over a range as broad as they could when they were younger.

REFRACTIVE ERRORS AND ART

How do refractive errors affect artists? These problems must have been critical in ancient times, when glasses were not available to correct poor vision. It is doubtful that nearsighted individuals painted landscapes in ancient Rome or Egypt, or even in Byzantine times. Portraiture would not have been much easier unless the myopia was quite mild. Similarly, it is doubtful that severe hyperopes entered service in the fine-jewelry trade. Furthermore, presbyopia must have been a major problem for artists in ancient times who survived beyond fifty years of age, at which point they could no longer do close work. The ancients were aware of magnification through curved water bottles, but

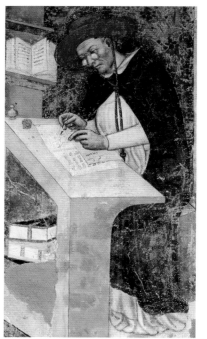

Fig. 1.2 Optics of the human eye. In an ideal (emmetropic) eye that is fully relaxed, objects at infinity are perfectly focused on the retina. A nearsighted (myopic) eye is too long when fully relaxed, while a farsighted (hyperopic) eye is too short. Thus, a myopic individual will need less (and a hyperopic individual more) accommodation than normal to focus on close objects. (The differences in eye size, and in lens thickness with accommodation, have been exaggerated in these diagrams.)

Fig. 1.3 Loss of accommodation with age (presbyopia) in an emmetropic eye. Distance vision is unchanged, but after the age of fifty, the lens is no longer able to change its shape sufficiently to accommodate for near objects. A convex reading lens compensates for the lost accommodation. (The magnitude of the lens changes are exaggerated in this diagram.)

Fig. 1.4 Tommaso da Modena, *Hugues de Provence at his Desk*, from the *Cycle of Forty Illustrious Members of the Dominican Order* in the Chapterhouse, 1342. Fresco. This is one of the earliest artistic depictions of reading glasses.

there is no evidence that practical reading lenses were used in daily life. There is evidence, however, that presbyopia may have modified the artistic career of one of the most famous vase painters in ancient Greece, as discussed in chapter 4.

Spectacles for reading were being manufactured in Italy by the end of the thirteenth century (see fig. 1.4), although hand magnifiers may well have been used in European and other cultures for many years before that. Monocles and spectacles with concave lenses for myopia were being sold in the mid-fifteenth century, although it is not known exactly when this technology was invented.[1] Glasses used by Pope Leo X (1475–1521), one of the Medici, have been measured to be -12 diopters, a rather high degree of myopia (see fig. 1.5). The implication for art is that, by the fourteenth or fifteenth century, artists were no longer slaves to either their inborn states of refraction or to presbyopia. Spectacles were not well made in those days, and astigmatic corrections would not be available for several centuries; however, a person of moderate means was no longer forced to remain blind to distance (if myopic), and could, beyond the age of fifty, continue to read (see fig. 1.6) and draw or paint.

Since corrective lenses were widely sold, it is hard to accurately judge whether or not near- or farsightedness had any impact on artistic production from the Renaissance onward. We often do not know which artists needed glasses—and of equal importance, we do not know which artists actually wore their glasses to paint. We are unaware of any artist for whom myopia or hyperopia is *documented* to have been a factor, though writers have speculated that the fuzzy appearance of the world with uncorrected myopic eyes may have influenced the Impressionists as they explored new ways of painting. This issue is discussed in the next chapter.

Astigmatic errors pose a different set of challenges to the artist and to the analysis of its potential effects on art. Many of us who wear glasses have a small amount of astigmatic correction. Without glasses, objects are more blurred in one direction or another. In our modern era, glasses that correct this abnormality are available, so astigmatism need not be an issue for artists, as argued above for myopia and hyperopia. However, a few centuries ago, when astigmatic glasses were not available, an astigmatic painter could do nothing about the fact that he or she received blurred images upon the retina. Could this asymmetrical optical blur have led to distorted scenes or portraits? It is not likely since blur is not really distortion. Furthermore, most painters in those eras aimed to duplicate on canvas what they saw in the world. In order to appear the same to the artist, the

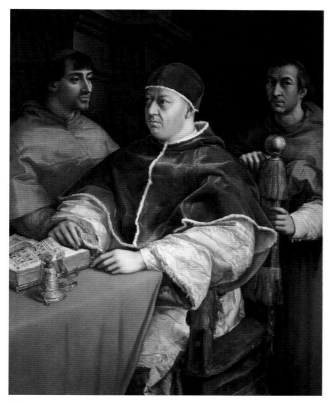

1.5

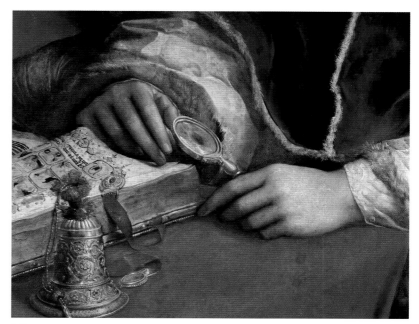

1.5 (detail)

Fig. 1.5 Raphael (Raffaello Sannzio), *Pope Leo X Medici*, 1517. Oil on wood, 61 ¼ x 47 in. (155.5 x 119.5 cm). Pope Leo X is holding a biconcave monocle (see detail) to correct his myopia, as spectacle frames in his time were still too awkward for continual use.

Fig. 1.6 Marinus Claesz van Reymerswaele, *The Tax Collectors*, 1549. Oil on wood, 34 x 27 ½ in. (86 x 70 cm). This painting, which was much copied, shows a style of lenses widely available in the fifteenth and sixteenth centuries.

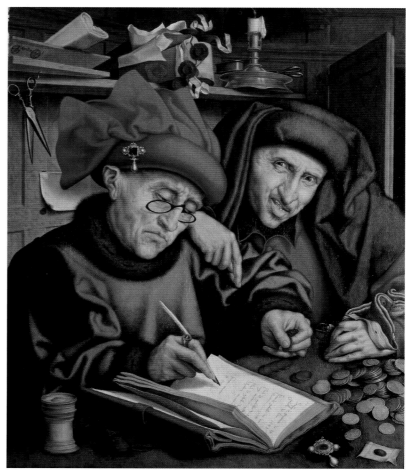

1.6

depicted scene would have had to *match* the real scene, no matter what the optical distortion (see fig. 3.6).

Despite this logic, a number of scholars have speculated that astigmatism was a factor in the art of painters such as Lucas Cranach, the Elder; Hans Holbein, the Younger; and El Greco. Holbein, for example, painted a renowned, exceedingly wide portrait of Henry VIII (see fig. 1.7), who looks thinner through a properly oriented astigmatic lens. But of course, by many reports, Henry VIII *was* exceedingly corpulent, and other Holbein portraits depict figures quite normal in physiology (see fig. 1.8). El Greco painted highly naturalistic paintings early in his career, so was not forced into the elongations that characterize his later work. However, unlike an astigmatic distortion, his elongations are both horizontal—notice his portrayal of hands—and vertical (see fig. 3.2). His art is discussed more fully in chapter 3. Interpreting a need for glasses from artistic elongation becomes farfetched with Amedeo Modigliani's portraits and nudes, which are elongated in different directions (see fig. 1.9), or with the sticklike sculptures of Alberto Giacometti. These artists' works are examples of why we are hesitant to diagnose eye disease from art. It is a speculative exercise at best, and one rarely knows the intentions of the artist, who may have had good reason for taking the liberties with realism that he or she did. One is on

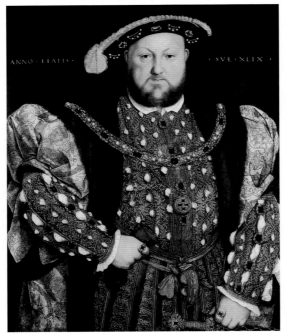

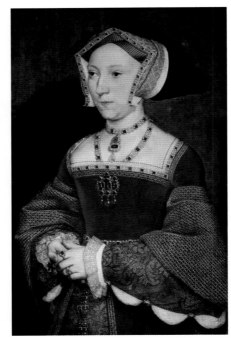

Fig. 1.7 Hans Holbein, the Younger, *Portrait of Henry VIII*, 1540. Oil on panel, 35 x 29 1/3 in. (88.5 x 74.5 cm). Though this striking portrait of a massive man has led to speculation about possible astigmatism in the artist, Henry VIII is known to have been obese.

Fig. 1.8 Hans Holbein, the Younger, *Jane Seymour*, 1536. Oil on panel, 25 3/4 x 16 in. (65.4 x 40.7 cm). This portrait, done about the same time as Holbein's *Portrait of Henry VIII*, depicts normal physiognomy. Thus, Holbein is unlikely to have suffered from astigmatism.

Fig. 1.9 Amedeo Modigliani, *Portrait of a Polish Woman*, 1919. Oil on canvas, 39 1/2 x 25 1/2 in (81.3 x 59.7 cm). This portrait shows elongation in vertical (neck), diagonal (head), and horizontal (hands) directions. This multidirectional distortion would not occur from astigmatism, which has a fixed axis.

1.7

1.8

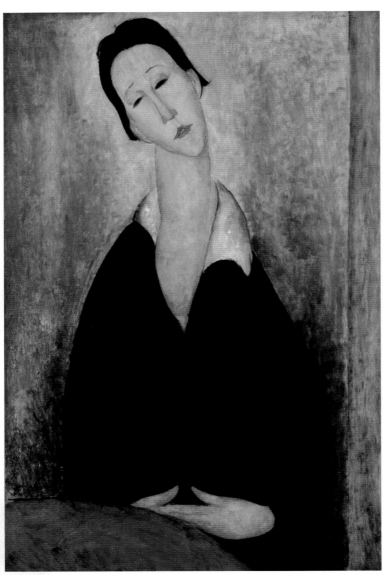

1.9

firm ground in terms of analyzing visual or medical effects on art only when a disease is known to have been present.

Presbyopia is different from myopia, hyperopia, and astigmatism in that it is not a result of ocular shape, but represents a failure in the accommodation (focusing) system with age. Moreover, unlike the other refractive problems, we know that all elderly artists were presbyopic (because *everyone* is after age fifty). We may not know whether they could see better at a distance or up close, but we do know that without glasses they could not do both. However, like all of the other refractive problems, presbyopia was largely a nonissue for art by the beginning of the Renaissance, when reading glasses were widely, and inexpensively, available.

NOTES
1. Ilardi, *Renaissance Vision from Spectacles to Telescopes* (2007).

THE MYTH OF IMPRESSIONISM AND MYOPIA

Impressionism was a powerful movement in art that emerged in the late nineteenth century when a group of French artists put on a series of exhibitions that challenged the conventions of painting promulgated by the official French Salons, organized by the Académie des Beaux-Arts and the Société des Artistes Français (see fig. 2.1). These upstarts, who included Édouard Manet, Claude Monet, Pierre-Auguste Renoir, Paul Cézanne, Edgar Degas, Camille Pissarro, and others, rejected the need for naturalistic realism, and for grand subjects from mythology and history, and focused instead on creating an "impression" of the environment or scene as it was at a moment in time. The overriding characteristic of the style is an innovative use of color, as a defining quality of the painting—sometimes even more so than the subject.[1] But there was no mandate to avoid precision, and indeed the early Impressionists showed a wide range of naturalistic detail in their styles and among their subjects. Some critics of the time decried the loss of detail, and the work of Monet—arguably the most famous and archetypical of the group—is often characterized by imprecise objects and the application of large dabs of paint. This quality has led to the popular speculation that Impressionism may have derived from myopia in its practitioners, who could not see well and used their myopic vision as a tool.

We must emphasize at the outset that Impressionism was a serious, and much debated, movement in art. The term surfaced at least a decade prior to the exhibition that displayed Monet's iconic *Impression: Sunrise, Le Havre* (see fig. 8.17), and the ideas associated with it incited heated arguments among painters, art critics, and collectors (whose attraction to this "new" style was a major factor in solidifying a place for Impressionism and its artists in the competitive market). The movement is far too complex, diverse, and far-reaching to be reduced to a simple need for glasses. However, one might ask justifiably if myopia was a common affliction among the Impressionists, and if a conscious blurring of vision (or failure to correct vision) might have been an influence or tool in the realization of some Impressionistic works.

Of course some of the Impressionists may have been myopic, but by the nineteenth century, glasses of reasonably good quality were easily available to anyone who needed or wanted them. The question, therefore, is not merely if the artists were myopic but whether they chose to use corrective lenses. It is not widely known that the use of optical devices to blur scenes and tone down color is a much older concept than Impressionism. Claude Lorrain (1600–1682) was a seventeenth-century landscape painter who was much admired in the eighteenth and nineteenth centuries for his soft and picturesque landscapes (see fig. 2.2). Artists, and people desiring an idealized view of the world, began to use specially colored mirrors called "Claude glasses" to give landscape vistas a muted and hazy aura similar to the ones Lorrain painted.[2] These devices, as well as colored filters, were accessible through the end of the nineteenth century, and afforded anyone interested the opportunity to experience atmospheric effects and the impact of softer colors. Yet these effects were not the goal of the Impressionists who sought to embrace and emphasize—rather than minimize—the effects of colors in the landscape. The "blur" of Impressionist paintings is largely incidental, rather than central, to that goal.

Claude Monet (1840–1926) was not known to be myopic, insofar as he did not routinely wear glasses, and there is no mention of nearsightedness in any of his correspondence. However, when he was examined by the ophthalmologist Richard Liebreich, MD, in 1913, after his cataracts were diagnosed (see chapter 30), he was prescribed a pair of -1.75 diopter glasses for distance vision. (This correction is not a very high one, and the need for it may in large part have been due to the growing cataracts, which often enhance myopia.) There are photographs of Monet wearing glasses after his cataract surgery, when his vision would have been extremely poor without correction. However, available photographs of the artist in younger days—both posed and candid—show him without glasses. If he had myopia, it would have been mild, as he could obviously still negotiate the world with ease. Furthermore his early paintings offer evidence that he could see distant details accurately. Monet's *Quai du Louvre, Paris* (see fig. 2.3) shows a wide view of the Seine done in 1866 and 1867 that depicts quite precisely the details of buildings across the river. Monet might have enjoyed a slightly blurred view of the world for certain purposes, but he most certainly had the capability of seeing well when he chose to do so. A widely publicized anecdote[3] states that when Monet was offered spectacles, he rejected them by saying, "Good God, I see like Bouguereau," an established painter of the Salon (see fig. 2.1) and an artist roundly disdained by the Impressionists.

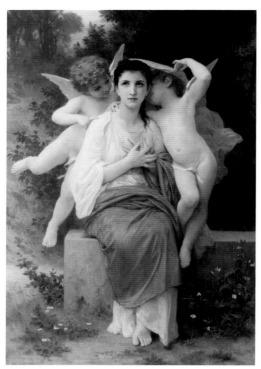

2.1

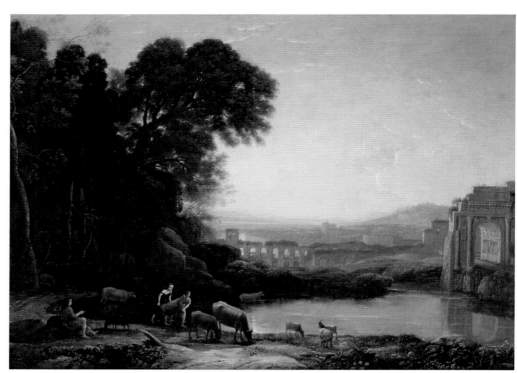

2.2

Paul Cézanne (1839–1906) is similarly reported to have been myopic,[4] and to have rejected glasses when he said, "Take those vulgar things away." He certainly had no difficulty seeing distant details when he chose to portray them in landscape scenes (see fig. 2.4), and his later abstract style was a conscious choice that he used selectively (see chapter 24).

Edgar Degas' (1834–1917) visual situation was more complex, since he had a known retinal problem (see chapters 35 and 38) that blurred his vision progressively for non-optical reasons. While he is described as myopic in several sources,[5] there are few photographs of him wearing glasses. Pairs of his glasses that have been measured probably date from the late 1870s and beyond and show mild myopia (equivalent to -0.50 to -1.50 diopters). This level of myopia would not compromise general activity to any great degree, but glasses may have been prescribed in an effort to compensate for retinal problems, which were already symptomatic in 1870. Degas may have tolerated a mild blur in life in preference to the nuisance of spectacles, but he probably received limited benefit from such correction once his vision became blurred from the retinal disease.

Furthermore, Degas believed that artists are involved in the act of seeing, and may choose to use or to modify visual information. In the context of discussion with friends about the painter Eugène Carrière, who was rumored (probably incorrectly) to have an eye problem, Degas said, "I am convinced that these differences in vision are of no importance. One sees as one wishes to see. It's false; and it is that falsity that constitutes art."[6] As with our previous examples, Degas painted quite precisely in his youth (see fig. 2.5).

Pierre-Auguste Renoir (1841–1919) created a vast number of beautiful paintings that do not require the viewer to search for any deep or hidden meaning. When his friend, the art dealer Ambroise Vollard, asked him about Impressionist theory, Renoir brushed the question aside, saying, "For my part, I have always tried to paint human beings just as I would beautiful fruit."[7] Some critics have suggested that visual abnormalities may have

affected his artistic ability and production, but his main medical issues were systemic rather than ocular. His early works, although Impressionistic, were largely representational (see fig. 2.6).

In December 1888, Renoir was afflicted with a serious bout of rheumatoid arthritis, an illness that was to cause him much grief in the years to come. In addition to the arthritis, he also complained of problems with his ears, teeth, and eyes, although there is no record of how his eyes were bothering him. His vision apparently remained keen. Rheumatoid arthritis caused the artist to have massive deformities of many joints and reduced his ability to use his hands. Many photographs of him taken during his last decades of life clearly show the arthritic changes. Motion pictures of Renoir at work exist, and even if we take into account the jerky movements of early cinematography, he appears to jab at the canvas rather than painting with a smooth motion. The arthritis certainly reduced his manual dexterity. He lost the ability to make fine motions with his fingertips and tended to move the brush with his forearm and arm, which caused a broader and less detailed depiction of forms. One biographer has stated that the progression of the arthritis had an important impact on the evolution of his style: "Because of his illness, Renoir was never able to regain the heights of genius, diversity and innovation apparent in his greatest paintings of 1872 through 1883."[8]

It has been suggested that Renoir was nearsighted, but the meager basis for this claim is mainly that when Renoir was in his sixties, he liked to look closely at details without wearing glasses.[9] Seeing objects up close without any glasses comes easily for a nearsighted individual at any age, while an individual with normal vision typically begins to have difficulty seeing near objects in his or her forties.

A biography of Renoir warns readers to be careful in evaluating memoirs written long after the fact since they depend on distant memory: "After the artist's death, many of his friends and his son Jean wrote colorful, anecdotal accounts of his life and art."[10] Jean wrote that his father's eyesight remained keen

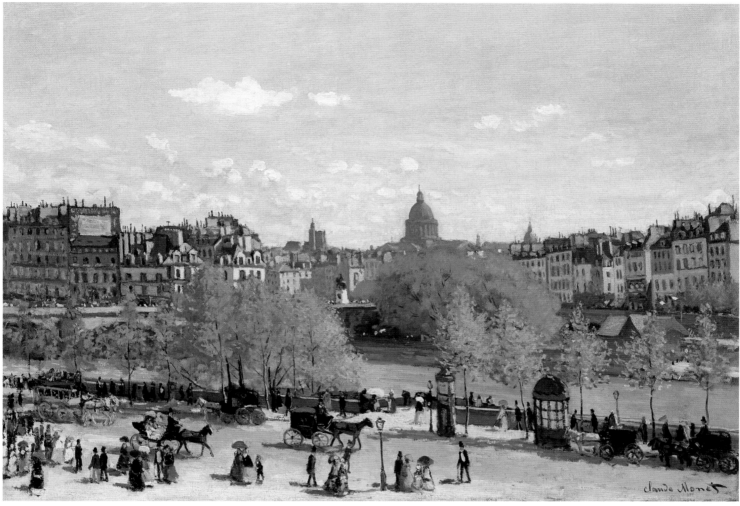

2.3

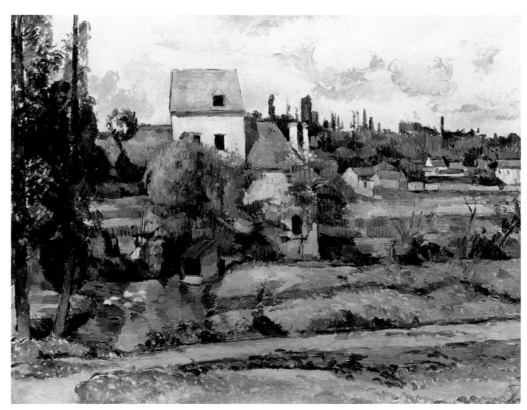

Fig. 2.1 William-Adolphe Bouguereau, *The Heart's Awakening*, 1892. Oil on canvas, 63 x 43 ¾ in. (160 x 111 cm). Bouguereau was very popular in his day, and his pictures exemplify the stylized subject matter appreciated by the Salon.

Fig. 2.2. Claude Lorrain, *Morning*, 17th century. Oil on canvas, 39 x 57 in. (99 x 144.7 cm). Many of Lorrain's paintings depict a misty haze with a limited range of color.

Fig. 2.3 Claude Monet, *Quai du Louvre, Paris*, 1866–67. Oil on canvas, 25 ½ x 36 ½ in. (65 x 93 cm). Monet's early paintings are quite representational and precisely drawn, as this river scene reveals.

Fig. 2.4 Paul Cézanne, *Moulin de la Couleuvre at Pontoise*, 1881. Oil on canvas, 29 x 36 in. (73.5 x 91.5 cm). Cézanne did not reproduce scenes in as much detail as Monet, but he clearly appreciated faraway roofs and chimneys.

2.4

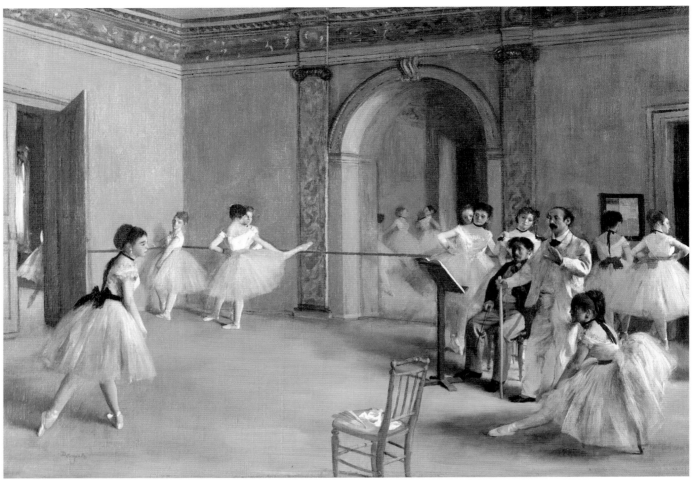

2.5

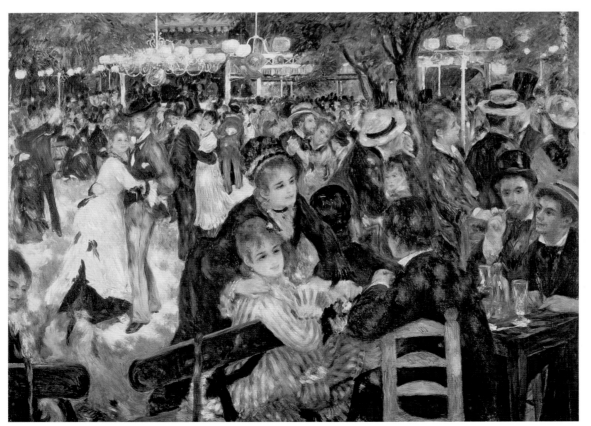

Fig. 2.5 Edgar Degas, *The Dance Foyer at the Opera on the Rue Le Peletier*, 1872. Oil on canvas, 12 ½ x 18 in. (32 x 46 cm). Degas generally painted indoors, unlike most of the other Impressionists. His early paintings show precise reproduction of details, such as the wall moldings in this ballet scene.

Fig. 2.6 Pierre-August Renoir, *Ball at the Moulin de la Galette*, 1876. Oil on canvas, 51 ½ x 69 in. (131 x 175 cm). This early Impressionist work portrays details, such as the lighting fixtures, quite precisely.

2.6

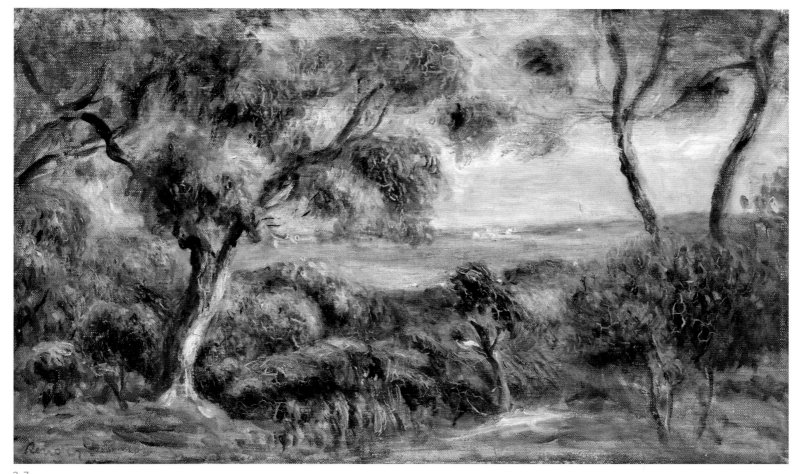

2.7

Fig. 2.7 Pierre-August Renoir, *The Sea at Cagnes*, c. 1910. Oil on canvas, 11 ¹/₄ x 18 ¹/₂ in. (28.5 x 46.5 cm). This late harbor view shows faraway sights.

up to his death and that "I can still see him applying a point of white, no larger than a pinhead, to his canvas to indicate a reflection in the eye of a model . . . We had to use a magnifying glass to make out the details of the perfect likeness. He sometimes wore glasses for reading, but he did so chiefly to save his eyes. When he was in a hurry or whenever he mislaid his glasses, he managed quite well without them. Whenever the weather permitted, we liked to sit on the terrace in the evening and watch the fishermen at Cros-de-Cagnes sailing back to port (see fig. 2.7). My father was always the first to spot a boat."[11]

The Renoir family archive was sold in 2005. This large collection included a pair of the artist's reading glasses in its case, along with letters, photographs, and even his Legion of Honor medal.[12] Renoir's need for reading glasses is consistent with his son Jean's statement. The reasonable conclusion is to discount the anecdote about Renoir's alleged nearsightedness (myopia) and to accept the account of his age-related need for glasses (presbyopia). Renoir's form of Impressionism is best described as a conscious stylistic choice and not an ocular problem.

It is tempting, as ophthalmologists, to seek (and therefore to find) clues to ocular abnormality in many works of art. However, this exercise is a hazardous one since artists choose style, clarity, color, and many other characteristics of their work for diverse aesthetic and cultural reasons. It would be intriguing to know more about the need for glasses among the Impressionists, but this information would not alter the fact that the Impressionist movement was a grand revolution in Western art, of intellectual as well as aesthetic importance. It was not a result of myopia.

NOTES

1. Schapiro, *Impressionism: Reflections and Perceptions* (1997), p. 210.
2. Maillet, *The Claude Glass: Use and Meaning of the Black Mirror in Western Art* (2004).
3. Trevor-Roper, *The World Through Blunted Sight* (1988), p. 38.
4. Ibid., p. 37.
5. Kendall, "Degas and the Contingency of Vision" (1988).
6. Ibid.
7. Vollard, *Renoir: An Intimate Record* (1930), pp. 114 and 116.
8. White, *Renoir: His Life, Art, and Letters* (1984), p. 191.
9. Trevor-Roper, *The World Through Blunted Sight* (1970), p. 38.
10. White, *Renoir: His Life, Art, and Letters* (1984), p. 7.
11. Renoir, *Renoir, My Father* (1962), p. 264.
12. *Art Newspaper* (2007).

3

Fig. 3.1 El Greco, *St. Martin and the Beggar*, 1597–99. Oil on canvas, 76 x 40 ½ in. (193 x 103 cm). This painting is typical of El Greco's work.

Fig. 3.2 El Greco, *St. Jerome as a Scholar*, c. 1610. Oil on canvas, 42 ½ x 35 ½ in. (108 x 89 cm). Note the elongation of the hands horizontally, while the face is elongated vertically.

Fig 3.3 El Greco, *Healing of the Blind Man*, c. 1570. Oil on panel, 26 x 33 in. (65.5 x 84 cm). This early work lacks distortion.

EL GRECO

When El Greco (1541–1614) emerged as an important artist in sixteenth-century Spain, his paintings were recognized as powerful and innovative. His emotionally expressive canvases stunned observers, who were faced with a style quite different from standard modes of representation. He replaced traditional forms, particularly the stiff figures and muted colors of staid religious art, with unusual anatomy and bright colors (see figs. 3.1 and 3.2).

El Greco is considered the first great Spanish painter, and he is one of the few old masters whose popularity remains universal. Nicknamed El Greco, or "the Greek," when he moved away from his Greek homeland, his given name at birth was Doménikos Theotokópoulos. He was born on the island of Crete into a wealthy and socially prominent family, studied in Italy, and spent the last half of his life in Spain. Little is known about his early years on Crete, but there he was trained in the traditional Byzantine style of icon painting, and the mystical, elongated figures typical of icons were to become an important feature of his mature style. At about age twenty-seven he moved to Venice, where he spent three years. Venice controlled Crete at the time and was home to thousands of Greeks. The city was at the peak of its glory and the artistic center of Italy. Titian, Tintoretto, and Paolo Veronese all were painting actively, and El Greco learned from each of them. He was attracted to Titian's studio since it was the most prestigious, but Titian had a reputation for working his students hard and teaching them little, so it is not likely that El Greco stayed there for long. He must have found the bright colors, dramatic light, and movement in Venetian art of the time appealing, for they became features of his own art.

In 1570 El Greco moved to Rome, where he saw the paintings of Raphael and Michelangelo. The nudes of Michelangelo's *Last Judgment* in the Sistine Chapel offended some people, who advised that the work be repainted. Reportedly, El Greco boasted that he could redo the painting well—and with proper decorum. He also said that "Michelangelo was a good man, but he did not know how to paint."[1] Nevertheless he had great respect for Michelangelo's ability to draw. El Greco also saw the paintings of Parmigianino, a virtuoso in the Mannerist style, whose works are characterized by graceful, elongated figures and ambiguous space. These same features later characterized El Greco's work.

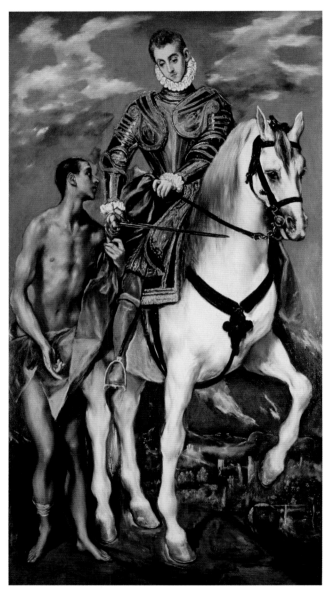

3.1

When and why El Greco left Italy for Spain is not known. The plague of 1575 or the epidemic of the following year (which killed Titian) may have been factors. In Rome he was at the center of intellectual circles, and he made contacts that most likely helped when he moved to Spain. Probably his unusual style was not attracting commissions in Italy, so he decided to try elsewhere. He certainly was aware that Spain was the most powerful country on earth and that its ruler, Philip II, was seek-

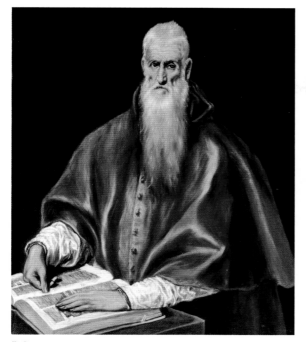

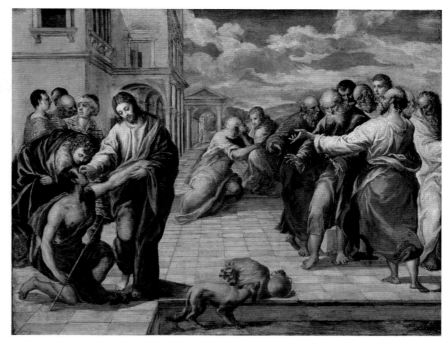

3.2 3.3

ing artists to decorate the new palace and monastery, El Escorial. In any case, by 1577 El Greco was living in Spain. Although he was to become a popular artist, he painted only one work for the king. Philip rejected the painting and offered no further royal commissions. However, the ecclesiastical authorities, proponents of the era's Counter-Reformation, appreciated El Greco's spiritual approach and commissioned him to create works for them. They found the artist's distorted figures to be highly expressive and compatible with their austere theology. The many copies of El Greco's work done during the seventeenth century further attest to his popularity.

After he moved to Spain, El Greco's work matured. His highly personal and visionary style included elongated and isolated figures, which, nearly floating, exist in a strange type of space (see fig. 3.4). This form of representation enhances the celestial quality of the scenes depicted. The lighting is an eerie, ghostlike white, and evokes a strong emotional response. This original style was controversial from its inception. Though El Greco did not satisfy King Philip II, who preferred more conventional (and mediocre) artists, he gained much fame in Toledo, the center of the Counter-Reformation. He was not concerned with popular taste, and he even became involved in litigation concerning religious interpretations of his paintings and the fees he demanded.

El Greco's paintings have long been popular in Spain, but he did not acquire an international reputation until the twentieth century. Interest was first rekindled in France during the 1840s, when his work was exhibited in the Louvre. Eugène Delacroix, Jean-François Millet, and Edgar Degas owned his paintings; Paul Cézanne and John Singer Sargent copied them. Americans became more aware of his work after the first book in English devoted to his art was published in the early twentieth century. Not every critic found his art appealing, however. One author, writing in *Art News*, described his paintings as a "jumble of carelessly thrown together, badly drawn figures not worth fifty dollars."[2] Today most viewers admire the dramatic lighting, brilliant colors, and movement of his figures.

El Greco's style was so original that it shocked many observers. Although all surviving records indicate that he was perfectly sane, early in the twentieth century some physicians from the Iberian Peninsula suggested that he might have been demented. One read into the artist's personal history signs of "inadaptation, extravagance, eccentricity, megalomania and a penchant for lawsuits," and he saw in the paintings "faces of hanged men, idiotic figures, figures without heads and hydrocephalic heads."[3] Another physician suggested that El Greco had "the mind of a degenerate."[4] Some famous authors have touched on aspects of El Greco's mental anguish and speculative homosexuality, including Ernest Hemingway in *Death in the Afternoon* and W. Somerset Maugham in *Don Fernando: Or, Variations on Some Spanish Themes*.

ASTIGMATISM?

A German ophthalmologist writing in 1911 was the first to suggest that El Greco's distortions were due to a specific eye defect: astigmatism. Soon a Spanish ophthalmologist wrote a series of articles stating that crossed eyes and astigmatism explained the apparent figural anomalies in El Greco's paintings, including the distorted anatomy.[5] Other physicians and historians took positions on both sides of what became a long debate.

El Greco is not the only artist diagnosed with an eye defect because of his distorted figures. Hans Holbein, the Younger; Lucas Cranach, the Elder; Sandro Botticelli; Titian; Amedeo Modigliani; and Sargent have also been placed in this category. Interestingly, Sargent expressed his views on this controversy. In 1915 the Duke of Alba sent him a booklet written by the Madrid ophthalmologist who was a strong advocate of the theory that El Greco was astigmatic, and Sargent wrote him back: "Many thanks for sending the pamphlet on El Greco's astigmatism—it has interested me very much although I am not absolutely convinced. Being very astigmatic myself I am very familiar with the phenomena that result from that peculiarity of eyesight, and it seems to me very unlikely that an artist should be influenced by

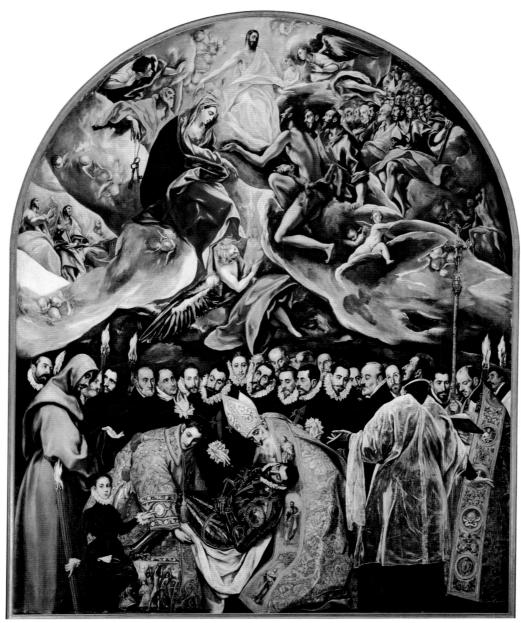

3.4

Fig. 3.4 El Greco, *The Burial of Count Orgaz, from a Legend of 1323*, 1586–88. Oil on canvas, 189 x 141 ¼ in. (480 x 360 cm). The distortion is greater for heavenly figures than for mortals.

them in the matter of form and not at all in the matter of colour where they are much more noticeable."[6]

Astigmatism is an ocular abnormality in which light rays emitted from a single point are not focused on a point on the retina but rather spread out of focus along an axis. It has been argued that astigmatism may be evidenced in an artist's work because some artists sometimes have distorted objects in one direction primarily, and abnormal elongation (e.g., of El Greco's standing figures) can be "corrected" by looking at them through an astigmatic (cylindrical) lens. However, the optical effect of astigmatism within the eye is simply to blur the retinal image along one axis. This does not specifically elongate or shorten the image. The effect of the ocular abnormality is quite different than the effect of looking through an external astigmatic lens (which creates an elongated focused image).

Historically, the response to the question of what caused El Greco to elongate his figures has always been that it was a sty-

listic choice. El Greco lived during the Mannerist period, which began in the middle of the sixteenth century and is characterized by the use of strong colors, elongated anatomy, and unrealistic lighting and perspective. El Greco was thought to have been influenced both by Byzantine icons and the distortions of Mannerist painting.

There are also logical arguments against astigmatism as a factor in El Greco's art:[7]

1. If astigmatism does account for the elongated forms, the elongation should occur in only one direction. However, both horizontal and vertical distortions can be found in El Greco's work. While most of his figures are stretched vertically, their fingers are often stretched horizontally (see fig. 3.2). If astigmatism were the cause of the vertical elongation, then the horizontal fingers would have been depicted as short and stubby.

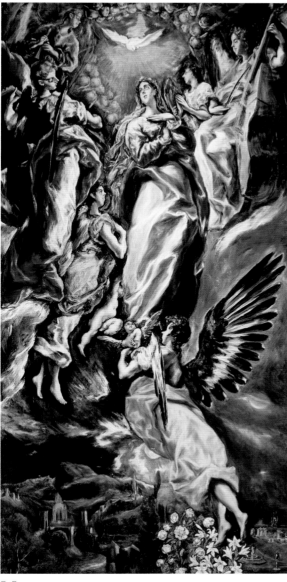

3.5

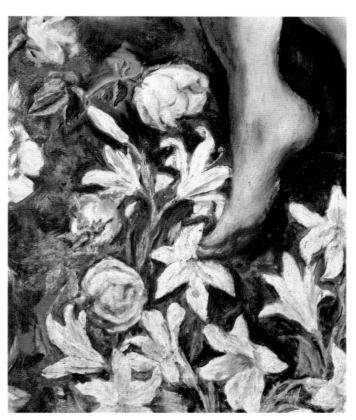

Fig. 3.5 El Greco, *The Assumption of the Virgin*, 1607–13. Oil on canvas, 136 ½ x 68 ½ in. (347 x 174 cm). The flowers in this painting are painted realistically (see detail) while the heavenly figures are strikingly elongated, perhaps in part to create the illusion that we are looking up at them. The prominent wings of an angel are also drawn without any obvious distortion.

3.5 (detail)

2. Many people have a mild astigmatic error on top of their underlying refractive state (myopia, emmetropia, or hyperopia) and as a general rule, the astigmatism changes relatively little over time. However, El Greco's early paintings were quite conventional and realistic (see fig. 3.3). It would have been highly unlikely for him to have progressed to such drastic elongations because of changes in vision, and if he had a progressive condition, his artistic distortions should have worsened progressively.

3. In the celebrated painting *The Burial of the Count of Orgaz, from a Legend of 1323* (see fig. 3.4), the figures in the lower part of the canvas have proportions that are relatively normal, while the figures in the upper region are much more distorted; an ocular abnormality could not be the cause of such inconsistency. El Greco may have wanted to dramatize the size of figures in heaven above as opposed to those still on the earth below. Furthermore, there are other paintings that show distorted figures in combination with undistorted natural images, such as the flowers in his late *The Assumption of the Virgin* (see fig. 3.5).

4. As noted earlier, the visual effects of astigmatism are quite different than the effects of an external astigmatic lens. An astigmatic defect blurs shapes in one direction (as opposed to distorting them). If El Greco truly had a significant astigmatic error, he would have complained of blurry vision, and this would have affected his painting more than any distortions.

5. If an artist attempts to paint an object realistically, the object and its painted image should correspond exactly no matter what distortions are taking place. Otherwise, when the artist compares the two, he or she will notice a discrepancy (see fig. 3.6).

While point 5 seems obvious, it has generated much discussion (despite the provisos in point 4). For example, subjects with normal vision were made into "artificial El Grecos" when they were asked to look at a square through a cylindrical lens and telescope system that stretched their view horizontally by 30 percent.[8] When attempting to draw the square from memory, they drew it vertically elongated, but when they were asked to

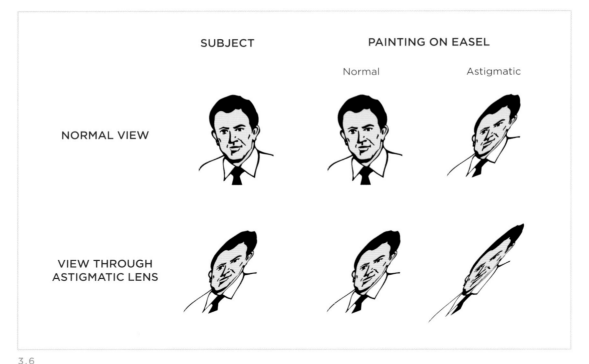

SUBJECT

PAINTING ON EASEL

Normal

Astigmatic

NORMAL VIEW

VIEW THROUGH
ASTIGMATIC LENS

Fig 3.6 Astigmatic self-correction. A person with astigmatism actually sees blur rather than elongation, but distortion (as seen through a lens) would not, in any event, explain elongation in art. This diagram shows images as they might be seen through an astigmatic lens. A painting on the easel must look normal if the distorted view is to appear identical. If the figure on the easel is distorted, the view through the lens will be doubly distorted.

3.6

simply render a square, the proportions they drew were accurate; freehand portraits done "from memory" showed an "El Greco effect," but those done "from life" did not. At this point, the author of the study concluded that El Greco may have painted images from life accurately yet distorted the figures because he painted them from memory. However, to simulate El Greco's supposed astigmatism more realistically, one subject wore the "El Greco telescope" over one eye, and over the course of two days, was asked to draw squares. She adapted to the optically induced distortion after two days. The author concluded that even had El Greco suffered from astigmatism, he would have been adapted to it.

CHANGES IN DETAILS AND COLOR

Over the course of El Greco's long career, he repeated themes, and his mature style is characterized not only by distortion, but also by a relative loss of detail. In addition, it has been suggested that he used more reds and browns in later works. This shift is difficult to demonstrate consistently, however, since he made canvases with a variety of tonalities throughout his career, and color judgments are complicated by the uncertain effects of time on varnish and pigment. Similar changes in detail and color may be found to varying degrees in the paintings of other elderly artists from different countries and eras, including Titian, John Constable, Rembrandt van Rijn, Pierre-Auguste Renoir,[9] and Georges Rouault.[10] But the same arguments can be raised that these changes may simply have been stylistic choices rather than the results of ocular disorders, such as cataracts (see chapters 23–25).

The intention of the artist, especially what is often called "artistic license," is always a factor in any retrospective analysis. There are other complicating issues as well. For instance, El Greco employed assistants, including his son, so that one might expect undesirable distortions or colors to be corrected. Or, if an artist did not finish a painting, it might have been left more sketchlike than he or she intended it to be. Also, the painting's overall tone may be more brown if the artist used an earth tone for the underpainting and did not, for whatever reason, add the top layers.

In his mature works, El Greco consciously aimed to portray a form of idealized beauty and used colors both to create aesthetic effects and to depict the world as he saw it. Scholars now view El Greco primarily as a painter of the Counter-Reformation, of which Toledo was the center. The content of El Greco's paintings appealed to the ecclesiastical authorities of that movement and time; and his style, in all its vivid colors and dramatic depiction of the human body, remains very appealing today.

NOTES

1. Davies, *El Greco* (2003), p. 66.
2. Montebello, Director's note to "El Greco," *Metropolitan Museum of Art Bulletin* (1981), p. 1. Author of quote unidentified.
3. Lopera, *El Greco: Identity and Transformation* (1999), p. 33.
4. Ibid., p. 33.
5. Ibid.
6. Charteris, *John Sargent* (1927), pp. 195–196.
7. Trevor-Roper, "Influence of Eye Disease on Pictorial Art" (1959); Ravin and Hodge, "El Greco: Astigmatism or Calculated Distortion" (1967); Linksz, *An Ophthalmologist Looks at Art* (1980), pp. 103–104.
8. Anstis, "Was El Greco Astigmatic?" (2002).
9. Ravin, "Geriatrics and Painting" (1968).
10. Charman and Evans, "Possible Effects of Changes in Lens Pigmentation on Colour Balance in an Artist's Work" (1976).

EUPHRONIOS: A PRESBYOPIC POTTER IN ANCIENT ATHENS

Art historian Jody Maxmin has emphasized that keen insight into the human condition, and a gift for communicating that insight, are among the enduring attributes of ancient Greek culture.[1] In the dialogues of Plato and the lucid historical narratives of Thucydides, clarity of expression based on careful observation and analysis were components of a particularly Hellenic way of looking at the world. In the visual arts, not surprisingly, Greek sculptors and painters were guided by similar interests and tendencies.

By the end of the sixth century BCE, on the eve of the great world war with Persia, sharp scrutiny and representation of reality prevailed in Greek art. Nowhere is this more apparent than in the marble statues of men and women dedicated to Athena

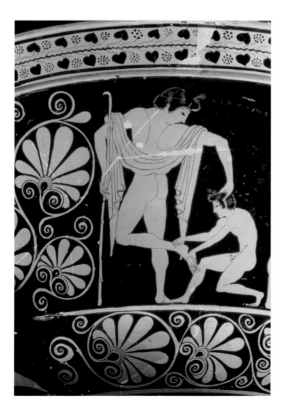

4.1

on the Acropolis in Athens, statues that reveal both anatomical accuracy and, in their brooding facial features, the carvers' capacity to capture something of the emotional tenor of the times.[2] Not to be outdone by their contemporaries working in stone, the painters of red-figure vases seem to have been just as interested in the precise depiction of the human body—in action and inaction—in all its complex beauty. They also conveyed, where appropriate, solemn and sometimes emotionally charged themes, in keeping with the somber mood of the day. Preeminent among these talented, ambitious painters was the Athenian master Euphronios (see fig. 4.1).[3]

Born around the year 540 BCE, Euphronios began his career as a painter (c. 520–500) soon after the invention of red-figure painting, around 530 BCE. Prior to this time, black-figure painting (see fig. 4.2) was predominant. In black-figure painting, black silhouettes were painted onto the orange surface of the vase, then details were etched into the paint with a sharp tool and further enlivened with red and white color.[4]

However, artists began to experiment with color reversal and soon came upon the more painterly and naturalistic possibilities of red-figure painting (see fig. 4.3). In this technique, black outlines were painted around the contours of now "skin-colored" figures, and internal details were applied with a brush dipped in black that, when diluted, produced an appealing honey color; the background was then blackened in. Once this new technique was mastered by the painters and embraced by their clientele, and once it was shown to be a trend with staying power, the craft was taken to the next level by eager young men like Euphronios. An Athenian red-figure *hydria*, or "water pot," from around 470 BCE (see fig. 4.3) shows a young man decorating a vase, which allows us to imagine how Euphronios might have looked at work. He and his contemporaries began to explore the relatively rich opportunities offered by red-figure painting, such as modulations and subtleties of brushstroke, which the less flexible etching tool of black-figure painting would not allow. These details include raised relief lines for sharp contours, paler diluted lines to define rippling, subcutaneous musculature, and even the bold use of impasto—possibilities which the inventors of red-figure painting, preoccupied with the challenges of devising and popularizing their new technique, had not thought or sought to investigate.

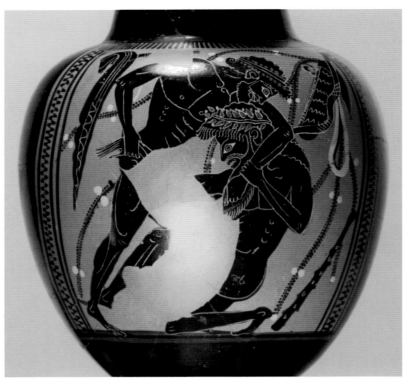

4.2

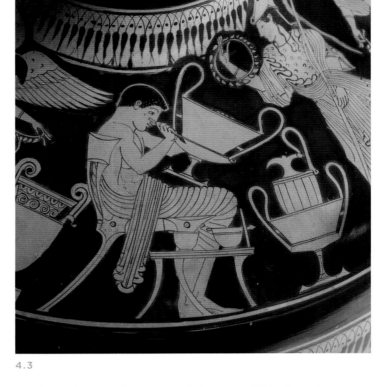

4.3

Nowhere is Euphronios's ability to integrate these powers of observation, imagination, and manual dexterity more pronounced or subtle than on his famous krater, a vase for mixing water and wine, that was for many years displayed in the Metropolitan Museum of Art in New York (see fig. 4.4). This masterpiece has now been returned to Rome as a part of a major repatriation of ancient art that was believed to have been stolen from archeological sites in Italy and smuggled out of the country. The primary side of the krater captures a solemn, melancholy moment from the sixteenth book of Homer's *Iliad*: Sleep and Death, the winged twin brothers, bend down to lift the lifeless body of Zeus's son Sarpedon, whose fresh blood is running in rivulets from puncture wounds to the thigh, abdomen, and chest. Flanking the brothers is a pair of soldiers, sentinels with shield and spear, providing further closure to an already poignant study of life and death, and age and youth, in elegiac opposition.

The artist's powers of observation—both at a distance and at extremely close range—are evident in the large, muscular bodies of the men, whose contours are as crisply defined. Having painted in the outlines for all the figures, the painter would then have pulled his chair close to the workbench, assembled his finest brushes, and set to work on the exquisite details which make the figures, living and dead, so poignantly real. The greatest concentration of such details occurs on the figure of Death, whose eyelashes, tiny dotted scales on wings and corslet, and finely pleated undergarment draw our eyes to his side of the picture, where even more minutely painted lashes, teeth, and wavy hair are found on Sarpedon. Fingernails and toenails, the demarcation of ulnae and malleoli of corpse and caretakers, the creases along Sarpedon's right index finger—all would have required the tiniest of brushes and the sharpest of eyes.

One of the mysterious aspects of the career of this elite artist is his abrupt abandonment of the profession of painting. After Euphronios finished the Sarpedon krater, which is dated to around 510 BCE ,[5] he continued for another decade to paint vases and drinking cups made for him by collaborating potters. Then, around 500 BCE, he put down his brush forever. None of his late vases are as ambitious or dazzling as the Sarpedon krater, though none give evidence of a wavering hand or burntout soul. Did he leave his workshop to join his fellow Athenians in the campaigns that began in 499, leading up to the Persian invasion of Marathon in 490, or did he die? These possibilities are ruled out by evidence of his persistent presence in Athens for the duration of the Persian Wars and beyond, but as a *potter* for other red-figure painters. His signature, followed by the verb *epoiesen* (generally thought to mean "potted" though some have argued that the word denotes ownership of the workshop)[6] appears throughout the war years (499–479 BCE) on vases decorated and signed by other painters. He lived long enough (at least beyond the age of sixty) to serve as a potter for the Pistoxenos Painter. A cup in Berlin, dated to 470 BCE and attributed to the Pistoxenos Painter, bears the latest extant signature "Euphronios epoiesen."[7]

What would have prompted such a vocational shift, from consummate painter to either potter or entrepreneur? Sir John Beazley, a world authority on Greek decorated pottery, considered the possibility of bad eyesight, among other possibilities, as early as 1944: "We cannot know what led Euphronios to turn from decorating vases to shaping them. A mishap; change in eyesight—there were no spectacles to correct such changes; the legitimate desire for a still better living. He may actually have preferred shaping vases to decorating them." [8] Remembering that Euphronios was born around 540 BCE and would

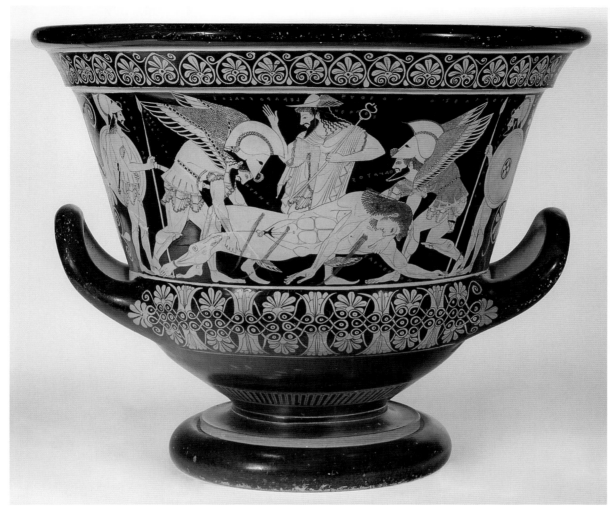

4.4

Fig. 4.2 Leagros Group, Athenian black-figure oinochoe, or "wine pourer," showing Herakles versus Antaios, c. 530 BCE. In black-figure pottery, details were etched into black silhouettes, rather than painted.

Fig. 4.3 Leningrad Painter, hydria (kalpis), Attic red-figure pottery, 470–460 BCE. 12 ½ x 5 in. (32.2 x 13 cm). Some scholars believe that this vase is metal rather than clay. Regardless, the image shows a young craftsman applying his fine touches at close range.

Fig. 4.4 Euphronios. Athenian red-figure krater, c. 515 BCE. Also signed by Euxitheos as potter. Euphronios's most famous krater, it depicts Sleep and Death lifting the body of Sarpedon. Precise brushwork shows armor links and even the eyelashes on Death (see detail).

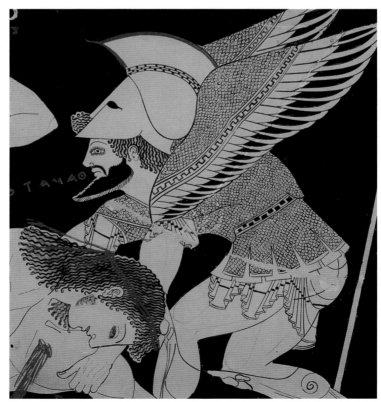

4.4 (detail)

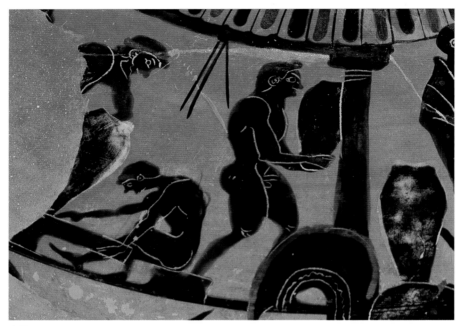

4.5

Fig. 4.5 Leagros Group, Athenian black-figure hydria. c. 520 BCE. **This image shows potters at work.**

have been approximately forty years old when he quit painting, the problem may simply have been presbyopia. A small child can practically see the tip of the nose, but between the ages of forty-five and fifty, an adult who sees clearly at a distance (either naturally or wearing spectacles) will begin to have trouble with reading and other close work (see chapters 1 and 23). A myopic individual may not need reading glasses, of course, but at the price of poor vision (without glasses) at a distance. However, a hyperopic individual will begin to have difficulty with near work at an even younger age. Euphronios may have been mildly hyperopic.

It is puzzling, given the intellectual sophistication and technical ingenuity of the ancient Greeks, that no optical aids for presbyopia were available. It is even unclear to what extent the Greeks recognized presbyopia as a medical ailment, since it is not mentioned in the extant medical texts. The phenomenon was known, of course; Oribasius (a Greek physician from the fourth century CE) wrote that "the vision of old people is opposite to that of myopes: The first do not see clearly what is close, but see well at a distance."[9] However, the cure he recommended was far from optical and far from likely to help: a fortifying ointment of pomegranate juice and honey for printmakers, painters, and goldsmiths. The ancient Greek language had no word specifically to describe the disorder. "Presbys" and "presbytes" refer to an old man, an elder, or an ambassador, but "presbyopia" appears to be a modern word, coined within the past few centuries out of analogy with myopia and related terms.

Julius Hirschberg states definitively in the first volume of his eleven-volume *History of Ophthalmology* that "spectacles were completely unknown in ancient Greece and Rome,"[10] although it was recognized that a hollow glass sphere filled with water could magnify objects. Seneca (4 BCE–65 CE), the Roman philosopher and tutor of Nero, observed that "letters, however tiny and obscure, are seen larger and clearer when viewed through a glass ball filled with water."[11] Such spheres may have been used sporadically by elderly Greeks, but no description of their

regular use as a cure or device for presbyopia has been discovered. The Greek scholar John Boardman was also convinced that Greek artisans did their fine work with the naked eye. In his discussion of ancient Greek makers of gems and finger rings, Boardman notes that "although the magnifying effect of crystal or glass in lens form may well have been observed at an early date, it is highly improbable that it was exploited by artists. No deliberately fashioned lenses have been found and it is unlikely that Pliny would have failed to mention their use."[12]

If Euphronios was presbyopic, and intended to remain actively engaged in his chosen profession, he would have been forced to modify his activity to avoid close work. As a potter for other painters, he could have functioned effectively without having to depend on extreme proximity to the clay, as required for the meticulous painting of vases and cups. The shaping of vases on a potter's wheel, the building of walls and refining of contours, depends more on subtlety of palm and fingertips than on coordination of brush, hand, and eye (see fig. 4.5). Indeed, it was for these reasons that artists such as Degas (see chapters 35 and 38) and O'Keeffe (see chapter 37) turned to sculpture and pottery when their vision failed. And if *epoiesen* meant that Euphronios owned and operated the workshop, the inability to focus inside of two feet never impeded anyone from supervising and deriving financial profit from the sweat and toil of others. Either as potter or businessman, Euphronios could have continued his ceramic career as a presbyope.

It may be relevant that Euphronios dedicated an offering to Athena on the Athenian Acropolis some twenty years later (just after 480 BCE).[13] An inscribed pillar monument there bears the name of Euphronios as *kerameus*, or "potter," and specifies the recipient as Athena *Hygieia*. This designation is important for it identifies Athena in her capacity as overseer of health and healing, one of her many responsibilities in the sixth and fifth centuries BCE, and well before the establishment in 420 BCE of a sanctuary of Asklepios on the south slope of the Acropolis. The inscription almost certainly identifies the red-figure painter-

turned-potter (not some hitherto unknown potter of the same name) appealing to Athena for a cure of an unspecified malady or mishap. Whether his supplication to her was prompted by ophthalmological problems, such as presbyopia, glaucoma, cataracts, or some other disorder, we cannot determine.

It may be significant that approximately 40 percent of the votive body parts placed by later pilgrims in the shrine of Asklepios are models of eyes. It may be that Asklepios's fame as an eye specialist was inherited from his predecessor, Athena, whose ophthalmological fame extends as far back as the Trojan War (twelfth century BCE), in which Homer describes her having removed mist from the eyes of Diomedes. With respect to Euphronios, we cannot know for sure whether deteriorating eyesight or some other concern prompted his appeal to Athena, nor can we tell if Athena answered it with a cure or patiently presided over time's capacity to heal. We do know that he could continue to work as a potter, as suggested by his signature on the aforementioned drinking cup decorated by the Pistoxenos Painter.

Euphronios did not have the good fortune to spend his entire career painting, but other Greek vase painters enjoyed long careers. The Amasis Painter, the black-figure impresario, maintained his keen eye and jeweler's touch, decorating large and small vases alike, from c. 560 until 525 BCE. Art historian Dietrich von Bothmer speculated, as a result, that he was myopic and thus able to see well at close range even in his older years.[14] Perhaps it was nearsightedness that spurred the young Amasis Painter to concentrate on decorating vases rather than on art forms more dependent on distant observation. Or perhaps his myopia was in part a result of years of intense close work during his youth and apprenticeship. There is evidence that extensive near work and reading may be one factor contributing to the development of myopia in modern society—a problem that physicians are hoping to resolve. In ancient Greece, paradoxically, the disease may also have been the cure for long-lived vase painters and others whose livelihood depended on detailed close work.

Euphronios serves as a reminder that many ancient people whose work obliged them to operate at close range—jewelers, coin makers, gem cutters, vase painters, dentists, and scribes—would, at middle age, have faced blurring of objects that they had been accustomed to seeing clearly. Unless they were tenacious and resourceful enough to find new employment that did not require the sharp near-acuity of their younger years, such persons and their families would have suffered, even starved. Homer, himself blind, was a paragon of such adaptability, and when he called his hero Odysseus *polytropos*, an epithet implying versatile, ingenious, crafty, or turning in many ways, he could as well have been describing Euphronios—painter, potter, and presbyope.

NOTES

1. Maxmin, "Euphronios Epoiesen: Portrait of the Artist as a Presbyopic Potter" (1974); Maxmin and Marmor, "Euphronios: A Presbyope in Ancient Athens?" (1997).

2. Richter, *Kouroi: Archaic Greek Youths* (1970), figs. 564–571; *Korai: Archaic Greek Maidens* (1968), figs. 411–419; Payne and Young, *Archaic Marble Sculpture from the Athenian Acropolis* (1950), plates 70, 71, 75–78, 83–88, and 109–115.

3. Guiliani et al. *Euphronios: pittore ad Atene nel VI secolo a. C.* (1991); Cygielman, *Euphronios: atti del seminario internazionale distudi* (1992); Denoyelle, *Euphronios peintre* (1992); Wehgartner, *Euphronios und seine Zeit* (1992).

4. Noble, *Techniques of Painted Attic Pottery* (1988).

5. von Bothmer, chart in Guiliani, *Euphronios: pittore ad Atene nel VI secolo a. C.*, (1991) p. 268.

6. Cook, "Epoiesen on Greek Vases" (1971); Robertson, "Epoiesen on Greek Vases: Other Considerations" (1972); Eisman, "A Further Note on Epoiesen Signatures" (1974).

7. Beazley, *Attic Red-Figure Vase-Painters* (1963), pp. 859–860; Guiliani et al, *Euphronios pittore ad Atene nel IV secolo a. C.* (1991), pp. 226–229.

8. Beazley, "Potter and Painter in Ancient Athens" (1944). In Kurtz, *Greek Vases: Lectures by J. D. Beazley* (1989), pp. 39–59.

9. J. Hirschberg, *The History of Ophthalmology* (1982), pp. 108 and 159.

10. Ibid., p. 159.

11. Seneca, *Naturales Quaestiones* (1971).

12. Boardman, *Greek Gems and Finger Rings* (1972), p. 382.

13. Maxmin, "Euphronios Epoiesen: Portrait of the Artist as a Presbyopic Potter" (1974), pp. 178–80; Maxmin and Marmor, "Euphronios: A Presbyope in Ancient Athens?" (1997).

14. von Bothmer, *The Amasis Painter and His World* (1985), p. 43.

THE THINKING EYE: CODING VISION

The "film" in the ocular "camera" is a tissue called the retina. However, the retina is not merely a light-sensitive layer. It is an outgrowth and functioning part of the brain; and in a very real sense, we think within our eyes. As the human embryo develops, two buds emerge from the primitive brain to become retinas in each eye. Each retina contains several layers of nerve cells that begin to organize and code visual information before it is sent to the brain. How this process occurs is critical to how we see, which ultimately has more to do with outlines and contrast than with resolution (e.g., the ability to see small print). Ocular and cerebral components of vision are linked, of course, and higher brain processing is also relevant to the work of artists.[1] But as artists work in a visual medium, they are uniquely dependent upon the initial visual input and transference of accurate imagery—the jobs of the eye!

The most specialized cells in the retina are the photoreceptors. Photoreceptors have the unique ability to transform light energy into neural signals. It was the evolution of these cells that made vision possible in primitive animals and that eventually led to our own complex vertebrate eyes. In humans, there are two types of photoreceptors, cones and rods, which serve day and night vision respectively. Cones are distributed throughout the retina but are concentrated in a central region called the macula. They reach a high density in a small zone called the fovea, where they account for good visual acuity as long as there is plenty of light. The cones also are sensitive to color. The rods are sensitive to dim light, but they cannot differentiate colors or fine details. While the highest concentration of rods in the retina is just outside the macula, there are none at its very center, which is the reason you may spot a dim star out of the corner of your eye, only to find that it disappears when you look right at it. On a moonlit walk it is easy to see shapes and movement, but in that dim light, the world is devoid of colors and one cannot read. In other words, our ocular cameras come automatically equipped with two types of film: a fine grain color film with low ASA rating (needing sunlight or other good lighting), and a coarse grain black-and-white film with high ASA rating (sensitive in dim light).

This analogy between eye and camera fails when we look deeper into the retina and at the visual connections beyond. The film in a camera (or sensor in a digital camera) simply records an

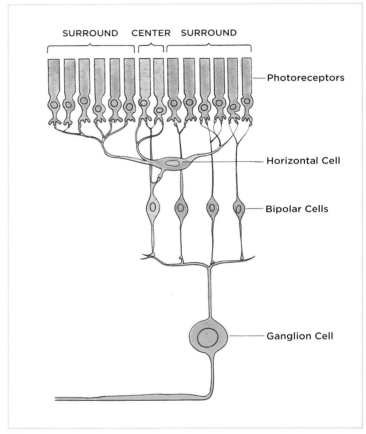

SURROUND CENTER SURROUND

— Photoreceptors

— Horizontal Cell

— Bipolar Cells

— Ganglion Cell

5.1

Fig. 5.1 Simplified diagram of nerve cell layers in the human retina (modified from Hubel[2]). Visual information must pass through at least two cellular junctions (synapses) before reaching the ganglion cells that form the optic nerve. There are many more photoreceptors than ganglion cells. Sensitivity to contrast comes from the horizontal cells that spread laterally beyond the core of the photoreceptors, which stimulate the bipolar cell directly. This horizontal cell input is inhibitory (i.e., opposite to excitatory input from the central photoreceptors). Thus, the center of the receptive field for each bipolar and ganglion cell receives excitatory input from overlying photoreceptors, while the larger inhibitory surround represents input from horizontal cells.

image, dot by dot, as the molecules of pigment or the photosensors are affected by light. The retina, however, contains neural circuits that analyze visual information before it ever leaves the eye (see fig. 5.1). The photoreceptor cells record the image much like film does, but there are roughly 125 million photoreceptors in the eye (of which six million are cones for day vision and the rest are rods), and only one million fibers in the optic nerve to carry the information to the brain. Thus, there is no way that every image imprinted on the photoreceptors can be transferred

directly, dot by dot, into the brain; some sort of simplification is required. The nerve cell layers in the retina—primarily the bipolar cells and horizontal cells, as shown in figure 5.1—organize and code the visual image. Then only the most essential details are conveyed to the brain by the ganglion cells. Cracking this code was one of the great achievements of twentieth-century physiology, and it has allowed us to understand many of the quirks—weaknesses as well as strengths—of human vision.

Signals from the retina are transmitted via the optic nerve to a way station in the core of the brain called the geniculate body, and then to the primary visual cortex at the back of the brain. The extraordinary experiments of David Hubel and Torsten Wiesel, which earned them the Nobel Prize in 1981, showed how visual cortex cells recognize and sort out specific types of visual information.[2] For example, an individual cortical cell may be sensitive only to the edges of an object oriented at a specific angle, and moving in a specific direction, within a small region in space. From the input of thousands of such cells sampling each region in our fields of view, the brain outlines and ultimately fills in the shape of everything we see. However, all these mechanisms are derived from the initial coding of light, dark, and edges within the retina.[3]

VISION IS RELATIVE: CONTRAST

The key to the visual code of the retina is contrast. To simplify and codify images, the retina registers comparisons rather than absolutes. In other words, the retina will analyze the edge between object A and object B with exquisite sensitivity, to see which is lighter, but it won't register the actual brightness of either. At first glance this property of vision may seem to result in a lot of wasted information, but it is in fact remarkably effective and efficient. We can recognize faces, shapes, movement, and color or brightness gradations with minimal cues, and we don't squander neural signals on confirming that the center of a red sweater is just as red as the edge. Furthermore, coding by contrast allows us to read or recognize the same faces and objects indoors and outdoors, in light or in shadow, because the relative brightness of objects remains relatively constant even though the amount of light energy reaching our eyes may be thousands of times greater in sunlight than it is indoors.

The mechanisms for contrast sensitivity are hardwired into the retina, as shown in figure 5.1. The bipolar cells, which bridge the photoreceptors and the ganglion cells, receive input not only from the photoreceptors directly in front of them but also from the horizontal cells, which have long, thin extensions that contact a much larger halo of photoreceptors. Horizontal cell synapses have a contrary or inhibitory effect on the signal from the photoreceptors. Thus each bipolar cell receives a core of direct and positive input from a central group of photoreceptors, and simultaneously receives a surrounding doughnut of negative input from the horizontal cells (from contact with photoreceptors outside the central core). This center-surround organization of the cell's visual input is transmitted to the ganglion cells and then to the brain. The effects of stimulating the center and the surround roughly balance each other out, so that diffuse bright light, which illuminates both the excitatory center and the inhibitory surround, is not a good stimulus for any of these cells (see fig. 5.2). However, an image with an edge will be a powerful stimulus cell since the edge can stimulate the center

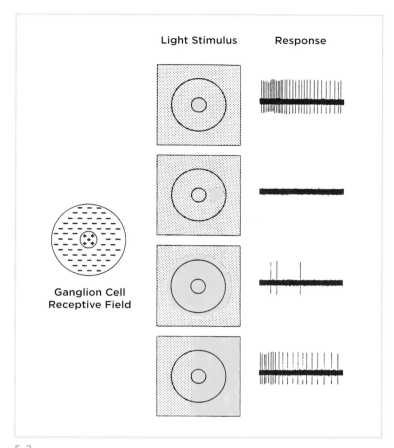

5.2

Fig. 5.2 Ganglion cell receptive fields, showing center-surround organization (modified from Blakemore[4]). Light falling in the center (top example) excites a vigorous response from the cell, while light in the surround (second example) suppresses its activity. Diffuse light over the entire receptive field (third example) is only a weak stimulus because center and surround balance each other. However, an edge between light and dark (bottom example) can be a powerful stimulus, because only part of the surround is activated when the center is stimulated.

strongly while only partially activating the surround (leaving a net positive effect). Because of this neural circuitry, our retinas are exquisitely sensitive to contrasts between light and dark, but are relatively insensitive to the absolute brightness or dimness of the world around us. An example of this phenomenon is shown in figure 5.3, a photograph of a crossword puzzle that is partly in shadow. More light is reflected off the black areas that are sunlit than off the white areas that are in shadow, yet we have no trouble perceiving a zone of sun and a zone of shadow, and perceiving details within them that are differentiated by local contrast.

These hardwired properties of vision are effective for most purposes, but also lead to optical illusions. For example, when you look at the two central gray circles in figure 5.4, it appears that one is much lighter than the other. However, connecting the central gray zones (see fig. 5.5) reveals that they are identical. Why does this phenomenon occur? Our retinal circuits are poorly equipped for judging the absolute brightness of each gray center by itself. But they are powerfully stimulated by the contrast, which tells our brain that the one gray core is "dark" (because it is surrounded by lighter gray) or the other gray core is "light" (because it is surrounded by darker gray).

5.3

Fig. 5.3 Crossword puzzle with a shadow across it. The actual brightness of the squares that are circled is identical, but we have no trouble seeing one as black and the other as white because each is surrounded locally by squares that contrast with it.

Fig. 5.4 A contrast illusion. The central circles appear to differ in brightness, but are actually identical. The light background makes the gray appear dark by contrast, while the dark background makes the same gray appear light.

An extension of this concept is the interesting phenomenon of Mach bands (see chapter 6), which influence how we see edges and brightness, and play a role in many types of art.[4] A Mach band is the illusion that at a sharp junction between light and dark, images appear a little brighter on the light side and a little darker on the dark side. As a consequence the gray rectangles in figure 5.6 appear to be graded or fluted, although each one is actually an even shade of gray. Conversely, if one creates a junction that accentuates lightness and darkness, viewers will have the illusion that everything to one side is lighter than on the other side (see fig. 5.7). These effects have been recognized by artists throughout history. In Asian brush painting they are used to accentuate lightness (sky) or darkness (mountains) by manipulation of the boundaries between the two, as in *Peach Blossom Spring* by Shichang Wang (see fig. 5.8). In modern art they may be used consciously to create complex and sometimes illusory patterns that enhance the visual effects of a design, such as Matt Kahn's *Sound Stage* (see fig. 5.9).

SETTING THE GRAY SCALE: ADAPTATION

When we adjust, or adapt, to dim light (such as partial moonlight), our rod photoreceptor cells must *chemically* synthesize a maximum amount of the light-sensitive pigment rhodopsin. This process can take twenty minutes or more. Since most of our lives are spent in better illumination, however, it would be disabling if we had to wait that long every time we turned a light on or off. The cone photoreceptors, which give us daytime vision and color vision, can make neural rather than chemical adaptations within seconds to compensate for changes in ambient brightness. The mechanism for this adaptation is relevant to art. At any given time, a cone cell can only discriminate light levels or stimuli within roughly a hundredfold range of brightness—more will be dazzling, and less will just appear black (see fig. 5.10). But the cones automatically slide this range up or down to match the ambient lighting (i.e., the encompassing environmental

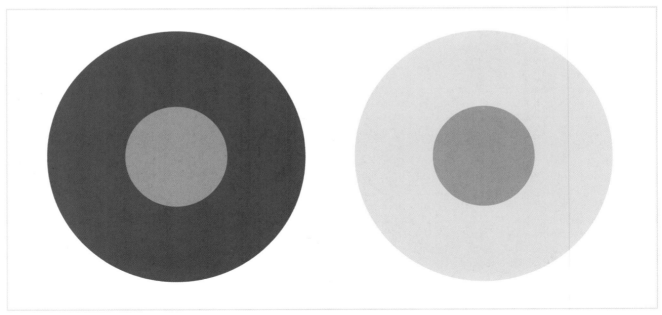

5.4

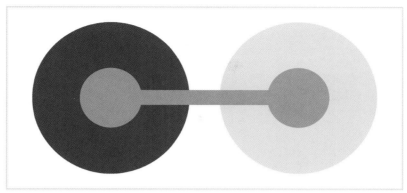

5.5

Fig. 5.5 The same contrast illusion. Here, the central gray zones connected to show that they are identical.

Fig. 5.6 Mach bands. The regions of light and dark that are seen adjacent to each junction are illusory, and they are perceived because of contrast between the different bands of gray. Although each gray band may appear to be shaded from dark to light, it is actually colored evenly. Mask the junctions to prove this to yourself.

Fig. 5.7 Illusory brightness difference on a spinning disk produced by Mach bands between two evenly shaded regions (known as the Craik–O'Brien effect). The stationary disk (left) shows a wedge pattern that one might think would produce (simply) a band of light and dark between two equally gray zones. In the photograph of the spinning disk (right), however, the outer circle appears darker because of the Mach band: The eye recognizes the light-dark contrast, but not the gradual recovery, so that everything on one side of the junction is seen as light and on the other side as dark.

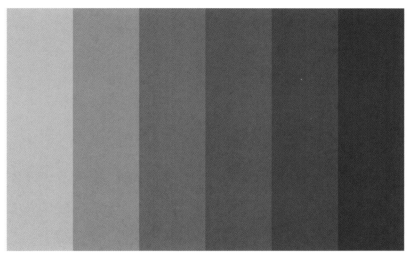

5.6

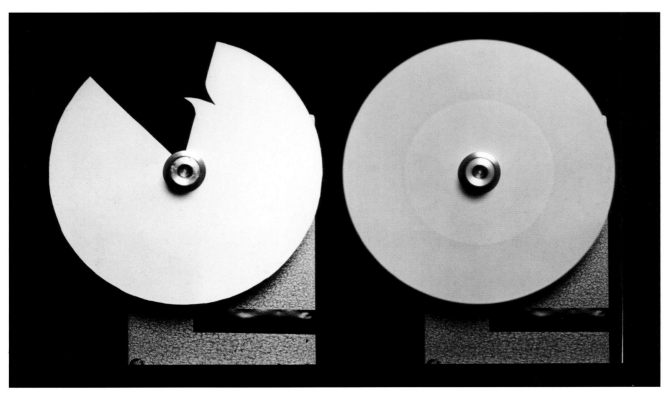

5.7

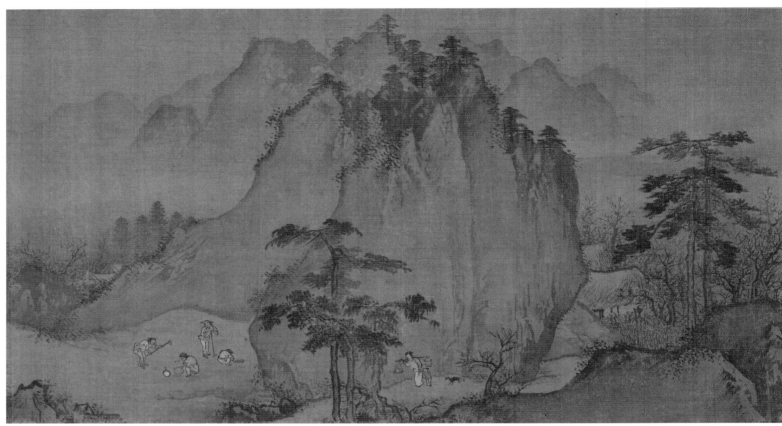

Fig. 5.8 Shichang Wang, *Peach Blossom Spring*, 1531. Handscroll, ink on silk, 9 ⁵/₈ x 75 in. (24.4 x 190.5 cm). The mountains are outlined with Mach bands, which make them appear dark. However, the center of the mountains in the foreground is no darker than the sky.

5.8

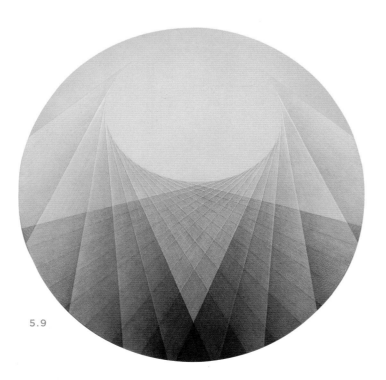

5.9

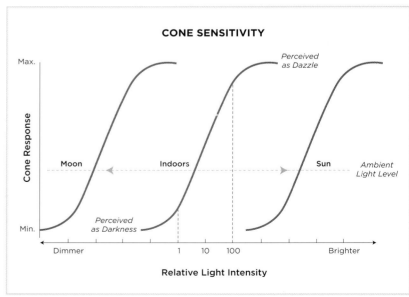

5.10

Fig. 5.9 Matt Kahn, *Sound Stage*, 1983. Acrylic on canvas, diameter 45 in. (114.3 cm). Subtle patterns create Mach bands and interlocking zones of lightness or darkness; some of the illusory edges are enhanced by added light or dark lines.

Fig. 5.10 Cone sensitivity. The S-shaped curves show the range of retinal cone sensitivity to light and the manner in which it adapts (adjusts) to different levels of ambient (environmental) illumination. Cones are responsive to light over roughly a hundredfold range of intensity above and below the ambient level. In other words, too much light above the environmental level becomes white glare, and light much below ambient level is lost in blackness. We adjust to new lighting by sliding this sensitivity curve up or down, giving a new set of definitions for dazzle and darkness. Note how darkness at one ambient light level may be dazzling at another.

Fig. 5.11 Jeffrey Smart, *Cahill Expressway*, 1962. Oil on plywood, 32 x 44 in. (81.2 x 111.7 cm). The tunnel interior appears black since the indoor lighting level is much less than the ambient brightness.

Fig. 5.12 William Keith, *Mount Shasta*, late 19th century. Oil on canvas, 24 1/8 x 30 1/8 in. (59.7 x 74.9 cm). This painting shows sunlit and dark areas. We perceive an outdoor scene even though true sunlight is many thousands of times brighter than indoor light reflecting off a canvas or book. This perception is possible because the brightness difference in the painting between white clouds and shaded foliage is nearly a hundredfold, which is close to the maximal sensitivity range (gray scale) of our cone photoreceptors (as shown in figure 5.9).

5.11

5.12

5.13

lighting) and reset their gray scale of sensitivity.[5] For example, you can enjoy the scenery while driving on a bright sunny day, but the interior of a tunnel seems pitch black because its interior lighting is below the dark end of the cone range of sensitivity, as shown in *Cahill Expressway* by Jeffrey Smart (see fig. 5.11). Yet within a short time after entering a tunnel, your retina adjusts to the new level of brightness, and you see the road quite well. When you emerge, the bright sunlight is off the top end of the sensitivity curve for indoor illumination, and you are dazzled for a few seconds until adjusting once again.

It is this mechanism of cone adjustment that makes it possible to illustrate indoor and outdoor scenes, in both art and photography, and to create an aura of dawn, noon, or dusk in a realistic fashion. No matter what the lighting, outdoors or indoors, we only recognize that hundredfold difference in light energy between white and black, and this range is divided into the same number of discernible grays. No artist or photographer can match on canvas the billionfold change in brightness between noon sun and starlight, but they *can* show a hundredfold change in brightness with white and black paints or with photographic printing. Since it spans the range of cone sensitivity, the illusion of a sunlit day or a candlelit restaurant can be produced effectively on canvas, as in William Keith's *Mount Shasta* or Vincent van Gogh's *The Potato Eaters* (see figs. 5.12 and 5.13), or in photographs. The implications for art are more fully considered in chapter 7.

Understanding the retinal code gives insight into the way that contrast and adaptation determine vision, and the way that artists are able to mimic it. The power of edges, contrast, and

Fig. 5.13 Vincent van Gogh, *The Potato Eaters*, 1885. Oil on canvas, 32 1/2 x 45 in. (82 x 114 cm). This is a dimly lit indoor scene, but like figure 5.11, it spans nearly a hundredfold spread between the light from the gas lamp or the white cups, and the darkly shadowed clothing. This spread effectively mimics our adaptation to a dim indoor environment (which we recognize by content rather than absolute level of illumination).

brightness—the artist's tools of the trade—is evident in art from cave paintings to modern times. Yet we would caution that while visual science may help us to understand certain effects in art, it can never fully explain art. The fact that some art may be judged to be beautiful, expressive, or valuable is a cultural determination and not a scientific one, and dependent on a variety of historical, political, economic, experiential, and personal factors, not to mention the indefinable qualities of artistic license and skill.

NOTES

1. Livingstone, *Vision and Art: The Biology of Seeing* (2002); Zeki, *A Vision of the Brain* (1993).
2. Hubel, *Eye, Brain and Vision* (1988).
3. Ratliff, "Contour and Contrast" (1972).
4. Blakemore, "The Baffled Brain" (1973).
5. Valeton and van Norren, "Light Adaptation of Primate Cones: An Analysis Based on Extracellular Data" (1983).

6.1

MACH BANDS:
THE ARTIST'S "EDGE"

The Czech scientist Ernst Mach (1838–1916) was a Renaissance man. Physicist, psychologist, and philosopher, he made contributions in a variety of disciplines that influenced the course of modern scientific thinking.[1] He championed positivism in science, which demanded vigorous experimental proof for concepts and theories, even those as broad as time and space.

Early in his career Mach was intrigued by perception, and he studied the curious bands of lightness or darkness that appeared on shadows and at the borders of regions that differed in brightness (see fig. 6.1). These phenomena, now called Mach bands, were not new; they had been observed by other psychologists before him and used by artists for millennia. However, Mach had the insight to recognize that the enhancement of contrast at a border is not simply a matter of psychological interpretation but, in fact, is derived from physiologic processes within the retina. He was ahead of his time, since the anatomic and physiologic evidence for specific inhibitory and excitatory neural convergence within the retina would not appear for the

Fig. 6.1 Shadows of scissor blades with Mach bands. The sharp shadow edges show an apparent dark border with a lighter zone just outside—but these are perceptual rather than real.

Fig. 6.2 Illusion of darkness and lightness produced by the presence of Mach bands. The central region appears lighter because of Mach bands on either side. Masking the junctions will show that all three regions are the same.

6.2

6.3

6.4

better part of a century. Nowadays, Mach may be known best for his definition of air speed as a function of the local speed of sound. Nevertheless, while Mach 1 may be faster than most of us will travel, Mach bands appear throughout our daily lives and are important features of both the production and appreciation of art.

Mach bands are present wherever different levels of brightness meet at a sharp boundary, as they do in figure 6.1. They reflect the neural connections in the retina and brain that make us more sensitive to differences in brightness than to just light or dark, as discussed in chapter 5 (and shown in figs. 5.4 and 5.6). These cues at borders are so powerful in guiding perception that the presence of a Mach band can create a sense of lightness or darkness on either side that doesn't actually exist (see figs. 6.2 and 5.7).[2]

Both perceived Mach bands (see fig. 6.1) and illusory phenomena produced as a result of Mach bands (see fig. 6.2) have been used—at times intentionally and at times unconsciously—throughout the history of art. They can even be seen in prehistoric cave paintings, such as those from Font-de-Gaume in France. Refined examples of Mach bands appear in wall paintings from Pompeii and Herculaneum, done between the second century BCE and the time of Vesuvius's eruption in 79 CE (see fig. 6.3). Mach band effects also appear in the architectural trompe l'oeil perspective paintings that adorned the walls of many ancient Roman villas, enhancing the sense of depth.

Mach band effects are an important component of ancient and traditional Asian painting as well, particularly brush paint-

6.5

6.6

Fig. 6.3 "Still life with eggs, game and bronze dishes," 1st century CE. Roman fresco from the House of Julia Felix in Pompeii. The birds and towels cast complex shadows with Mach band effects that have been enhanced in places by the artist.

Fig. 6.4 Ma Yüan, *Viewing Plum Blossoms by Moonlight (Cai mei tu)*. Fan mounted as an album leaf, ink and color on silk, 9 7/8 x 10 1/2 in. (25.1 x 26.7 cm). In Asian brush painting, Mach bands are often used to create an illusion of lightness or darkness (as in figure 6.2). For example, the mountain in this thirteenth-century image appears darker relative to the sky, but its interior actually has the same lightness as the sky.

Fig. 6.5 Robert Campin and assistant, *The Annunciation Triptych*, detail of the central panel of the so-called Merode altarpiece, c. 1425. Oil on wood, 25 1/4 x 24 7/8 in. (64.1 x 63.2 cm). Note the Mach bands in the multiple shadows of the pot and towels.

Fig. 6.6 Leonardo da Vinci, *Drapery Study for a Seated Figure*, c. 1475–80. Oil on canvas, 10.4 x 10 in. (26.6 x 23.3 cm). Leonardo accentuates the illuminated and shadowed edges of the drapery (on the left and right of the figure respectively) by darkening or lightening the wall behind.

ing in which lightness and darkness are portrayed by shading rather than solid colors. In a brush painting by the twelfth-century landscape painter Ma Yüan (see fig. 6.4), strong Mach bands make the rock of the mountains appear dark, although in fact only the edges are darker than the surrounding sky. The use of these effects can be traced back to at least the T'ang Dynasty in China (618–907 CE), and may have been used even earlier, although original artworks have not been preserved. Whereas the Greek and Roman artists mostly portrayed shadows (or zones of shading) that create illusory Mach band phenomena at the edges, the Asian artists created Mach band edge effects

in order to generate the illusion of lightness or darkness across space (see also fig. 5.8). They may have lacked Mach's insight into retinal circuitry, but they clearly recognized the illusory power of contrast.

Mach bands largely disappeared from Western art during the Dark Ages, when perspective and shadows were abandoned in favor of iconography. But they reappeared during the Renaissance. As in Greek and Roman art, they were used mostly at the edges of objects and shadows, and they reflected the artists' recognition of these perceptual phenomena. The use of Mach bands to create illusory areas of light and dark, as in Asian brush painting, was not prominent in Western art until the twentieth century. Nevertheless, remarkable examples of shadow effects appear in the precise paintings of the Flemish Master of Flémalle, Robert Campin, who was active from 1406 to 1444. He was obviously fascinated by shadows and painted them with exquisite precision, often showing the double or triple shadows that may occur from multiple sources of light. Note the similarity of the shadow effects in *The Annunciation Triptych* (see fig. 6.5) to those of the Roman wall painting in figure 6.3 and the shadows of the scissor blades in figure 6.1. In some places there is a dark line at a junction of shadows, indicating that Campin not only recognized the perception of Mach bands but even tried to enhance it.

Leonardo da Vinci (1452–1519) described Mach bands clearly in his writings: "The border of a vertical rod will appear very dark against a white field, and against a dark background it will appear brighter than any part of the rod, even though the light striking the latter is equally bright all along."[3] Some of da

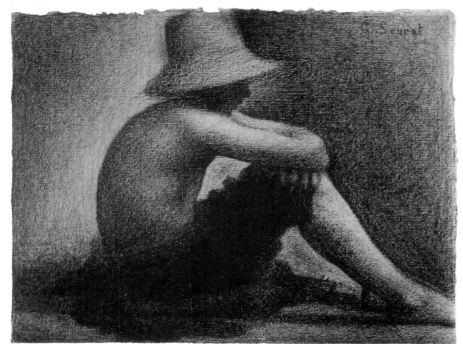

6.7

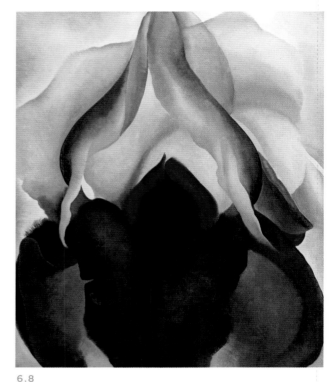

6.8

Vinci's drawings show experimentation with heightened border contrast (see fig. 6.6).

The lightening or darkening of borders to enhance contrast is a device that has been used consciously by many painters since da Vinci's time. The Neo-Impressionists were particularly fascinated by this phenomenon, and Mach bands are unusually prominent in the works of Georges Seurat, Paul Signac, and others of this school.[4] Note in Georges Seurat's (1859–1891) sketch of a seated boy (see fig. 6.7) how the background is lighter behind the boy's back and right calf, but darker in front of his right arm and leg. The wall has become an irrational mixture of light and dark that bears no relationship to actual illumination or shadows. Here Mach bands have run amok and threaten to interfere with, rather than enhance, the picture. This extreme use of border contrasts by Seurat is not accidental, however, and he employed similar effects in many of his drawings and in well-known oils, such as *The Bathers at Asnières*—for which figure 6.7 is a study—and *Les Poseuses*. Perhaps the most striking example is one of his last major oils, *Le Cirque* (*The Circus*) (see fig. 11.2), in which many of the figures and objects are shaded to appear light or dark because of edge effects. In part, he was trying to follow the dictates of scientists and art theorists who emphasized the importance of contrast in making objects distinct and luminous. This principle can be traced back to da Vinci's writings, and while we have no record that Seurat read his writings, we know that he studied David Sutter's "Les phénomènes de la vision" and Charles Blanc's *Grammaire des arts du dessin*, both of which echo the Renaissance artist's ideas about contrast. Blanc wrote, "Leonardo da Vinci says we should place a light background in contrast to a shadow and a dark background to a mass of light, and it is a general principle, a precept not to be attacked."[5]

In the twentieth century artists also began to use Mach bands to create visual effects and the perception of light or dark fields as they had been used in Asian painting. Notable examples are Georgia O'Keeffe (1887–1986) and Arthur Dove (1880–1946).

These two American artists shared an ability to see abstract forms in nature and to focus attention on the colors and shapes of a scene, independent of its figurative content. Both worked in the first half of the twentieth century and benefited from the patronage and friendship of photographer and art dealer Alfred Stieglitz. Dove maintained his relationship with Stieglitz until 1946 when both men died; O'Keeffe married Stieglitz in 1924 and continued to paint for another forty years after his death. Stieglitz was one of the few dealers to recognize Dove's talent early in the century, and his patronage literally kept Dove alive during the Depression (along with purchases and gifts from the Washington collector Duncan Phillips). Although one can find similarity in the artistic approaches of O'Keeffe and Dove, it is interesting to note that they used Mach bands in different ways: O'Keeffe produced Mach effects at borders to enhance the

6.9

Fig. 6.7 Georges Seurat, *Seated Boy with Straw Hat* (study for *Bathers at Asnières*), 1883–84. Black conté crayon on Michallet paper, 9 1/2 x 12 1/4 in. (24.1 x 33.1 cm). Seurat follows Leonardo's precept, to make the background contrast with the subject. As a result, the background has no consistent brightness.

Fig. 6.8 Georgia O'Keeffe, *Black Iris*, 1926. Oil on canvas, 36 x 29 7/8 in. (91.4 x 75.9 cm). Mach band effects contribute to the apparent lightness and darkness of different petals in this painting.

Fig. 6.9 Arthur G. Dove, *Sun*, 1943. Wax emulsion on canvas, 24 x 32 in. (61.0 x 81.4 cm). Dove created graded bands of shading and color, and enhanced the Mach band effect at some of the boundaries.

Fig. 6.10 Lyonel Feininger, *Ships*, 1917. Oil on canvas, 28 x 33 1/2 in. (71 x 85.5 cm). Both perceptual and illusory Mach band effects contribute to the power of this painting.

Fig. 6.11 Victor Vasarely, *Torony III*, 1988. Lithograph, 40 x 36 in. (101.6 x 91.4 cm). The precise gradations of color and brightness cause strong Mach band sensations between adjacent squares. The image also depicts an impossible figure (see chapter 19).

6.10

apparent lightness or darkness of regions such as a flower petal or a range of mountains (see fig. 6.8). In contrast, Dove painted adjacent or concentric bands of gradually increasing brightness to create Mach band effects (see fig. 6.9). He called these gradations "power bands" and was fascinated by their effect, although there is no known evidence that he ever analyzed them from a physiologic vantage point.

Lyonel Feininger (1871–1956) was another artist who used Mach bands in his work. He fragmented scenes into geometric zones of color, light, and dark, at times juxtaposing these zones to generate Mach band effects, and at other times enhancing the contrast at junctions by darkening or lightening one or both of the edges. *Ships* (see fig. 6.10) reflects his use of both techniques and demonstrates how they contribute to the shimmering and ethereal impact of the painting.

Modern optical artists, not surprisingly, have also been fascinated by Mach bands. Mach band effects have been used by Matt Kahn (see fig. 5.9) and by Victor Vasarely (1908–1997) (see fig. 6.11), both of whom produced images dominated by a progression of colors and brightnesses. Critics have debated whether such paintings represent art or simply decoration, and whether the Mach bands in Kahn's or Vasarely's pictures are artistic genius or merely visual games. We would argue that physiologic understanding of Mach band illusions is irrelevant to whether an artist uses them or not. No one would say that scientific discoveries about the nature of light diminish the fact that Monet painted in color. Kahn, Vasarely, and indeed also Campin, da Vinci, Seurat, and countless others, have painted or generated Mach bands because these phenomena are a component of normal visual experience, as are color, shadow, texture, and movement. The measure of a painting is whether visual tools have been used effectively to challenge and engage the viewer, and not which techniques have been used. Recognizing

6.11

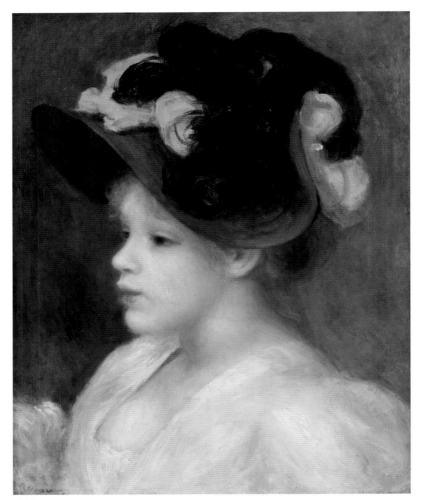

6.12

Fig. 6.12 Pierre-Auguste Renoir, *Young Girl in a Pink-and-Black Hat*, c. 1890s. Oil on canvas, 16 x 12 ¾ in. (40.6 x 32.4 cm). Renoir blurred the border of the girl's face (mouth and chin especially) to create a soft impression. The hat is outlined with sharper borders.

how Mach bands are a feature of a work of art neither denigrates nor elevates the status of that artwork; it simply allows the viewer to appreciate better what the artist perceived or was trying to achieve.

It should also be noted that some artists have accomplished their artistic goals by avoiding or obliterating Mach bands and sharp border contrast altogether. One of the salient characteristics of Pierre-Auguste Renoir's (1841–1919) work is the softness of his female faces and figures, which is rather like the misty cinematography of old movies. How did Renoir create this effect? Careful inspection of his canvases (see fig. 6.12) reveals that he diffused the sharp border around faces or nude figures with a relatively broad line of paint that has a brightness and color between that of the flesh and the surrounding background. In other words, he created a graded intermediate zone between the skin and its surround, thereby eliminating Mach bands, diminishing the range of contrast, and blurring the sense of form. This technique also contributes to the softness of figures in the work of other painters, such as Correggio, an Italian Renaissance artist who influenced Baroque and Rococo painters.

Ernst Mach did not invent the phenomenon of Mach bands, since the capacity to see them resides within us all; nor was he the first to observe them, since artists have depicted them for millennia. However, he had the insight to recognize that they derive from the eye itself, from the retinal processing that crafts our sensitivity to contrast. The phenomena of Mach bands may have been used by artists for ages, but it is the legacy of Mach that we can understand why.

NOTES

1. Ratliff, *Mach Bands: Quantitative Studies on Neural Networks in the Retina* (1965); Cohen and Seeger, *Ernst Mach: Physicist and Philosopher* (1970).

2. Burr, "Implications of the Craik-O'Brien Illusion for Brightness Perception" (1987).

3. Weale, "Discoverers of Mach-Bands" (1979).

4. Ratliff, *Paul Signac and Color in Neo-Impressionism* (1992).

5. Homer, *Seurat and the Science of Painting* (1964).

Artists face a formidable challenge in portraying scenes with many different types of lighting, especially as paintings are typically viewed indoors and can rarely match the brightness of the real world. This problem is not limited to representational artists, since any artist who seeks effects that depend upon sensations of lightness or darkness will face a similar issue. As noted in chapter 5, sunlight is many thousands of times brighter than indoor light, but the whitest paint that an artist can use to illustrate snow on a sunny day will always have less brightness than the lighting in a gallery. Conversely, the lighter portions of a nighttime painting, seen in a gallery, may well be brighter than the actual scene. In essence, even the most precise representational artists must rely on the principles and illusions of contrast to bring viewers into their pictorial world, whether they do so consciously or unconsciously.

We have discussed the importance of edge effects in chapter 6. Their use in art has been instinctive since ancient times, and was formalized by Leonardo da Vinci and others who added sophisticated elements, such as shadows and Mach bands. However, creating an entire scene as night or day, or isolating part of a canvas to represent a region of unique lighting, poses a different challenge since there may be no convenient edge to generate the contrast. Instead, the artist must manipulate shading and background levels to parallel the gray scale, as well as the ratios of light to dark, that would be perceived by an eye adapted to the conditions being illustrated. With appropriate gradations, a viewer can perceive dark-to-light transitions similar to those that characterize a sunny day or an indoor scene, and, which, within the context of a painting, solidify the illusion.

THE LIGHTED WORLD

The realism of a well-lit scene will depend upon an artist's skill in matching the gradations of lighting and contrast that are found in the real world. While no painting can match outdoor brightness, the painter can duplicate the *ratio* of brightness experienced by the viewer between sky (or sunlit regions) and shadows. William Keith's *Mount Shasta* (see fig. 5.12) is a good example, in which the brightness in the sky is nearly one hundred times that of the scenery in the shadows, a difference that spans much of the sensitivity range of our cone cells. *Women at the Garden at Ville d'Avray*, by Claude Monet, is another (see fig. 7.1). Because this garden scene depicts an appropriate spread of brightness for a sunny day, from sunlit dresses to shadowed foliage, it is a convincing representation. With indoor scenes, there must also be brightness ratios that are realistic for the portrayed lighting. In *The Potato Eaters*, by Vincent Van Gogh (see fig. 5.13), a single lamp illuminates the people close to it. *Portraits in an Office (New Orleans)*, often called *The Cotton Exchange, New Orleans*, by Edgar Degas (see fig. 7.2), shows a different type of indoor scene, one in which the room is diffusely illuminated so that everyone can be seen well, and the gray scale goes from white cotton shirts to dark suits. Both scenes appear realistic within their contexts and for eyes that would be adapted to the levels of indoor lighting that are depicted.

The importance of adaptation to different levels of lighting extends to color perception as well. The "resetting" of our gray scale, whether we are indoors or outdoors, lets us maintain the color ratios that allow us to see a normal spectrum. Without such adaptation, all colors would wash out to white when we are outdoors or be too dark to distinguish indoors. Because our eyes adjust to the brightness, the relative redness, greenness, or blueness of the world can also be maintained, and so we can sit on a patio and enjoy the sight of flowers in the garden or a beautifully colored dress, even as the sun goes down and the patio lights come on.

THE UNLIGHTED WORLD

The portrayal of night is a complex endeavor. Areas of evening lighting from lamps, moon, or stars, can effectively set a scene, especially if brightness-darkness ratios are appropriately maintained. However, lighting that is extremely dim follows different principles because cone cells in the retina do not function below moonlight levels. Rods take over, and rod cells neither see color (they contain only one visual pigment, rhodopsin) nor see clearly (there are no rods in the center of the macula). In other words, dim moonlight only allows blurry and colorless vision. Artists generally portray it in gray with no areas of conspicuous brightness, and they get into trouble when they add color or portray distant objects with unrealistic clarity.

Starry Night (Nuit Étoilée) by Jean Francois Millet (1814–1875) and *View of Dresden in the Moonlight* by Johan Christian Dahl (1788–1857) are two nocturnal scenes, depicting conditions that would be too dim for much, if any, cone function (see figs. 7.3 and 7.4). Millet's painting is quite realistic: He shows no colors and little detail, and objects at a distance are uniformly hazy (which corresponds to a rod visual acuity of roughly 20/200). However, many paintings of night scenes, such as Dahl's view of Dresden, show precise and distant details that would not be seen in the dim light. Dahl depicts a crisp skyline across the entire painting and even flags and rigging near the bridge that would be hazy or invisible. Bright full moonlight does allow some weak cone vision, but not far outside the direct beam.

Of course, physiologic descriptions of night vision do not address either aesthetics or artistic intention. An artist may have good reason to take liberties with the accuracy of light and dark perceptions to generate the impression, rather than the reality, of a night scene, or to allow recognition of important details. For example, we can presume that Dahl wanted us to recognize the glory of the Dresden skyline, even if his rendering is not physiologically accurate. There is no right or wrong in art, but a sophisticated viewer can seek to understand whether or how an artist has expanded upon nature.

THE COMPLEX SCENE

There are cautions and caveats with respect to paintings that have complex lighting, just as there are for scenes that are solely light or dark. The realism of a painting that shows multiple areas of extreme lighting will depend upon the accuracy of the portrayal of areas relative to the brightness that would surround the putative viewer and set his or her level of sensitivity.

Fig. 7.1 Claude Monet, *Women at the Garden at Ville d'Avray*, 1867. Oil on canvas, 10 x 8 in. (25.5 x 20.5 cm). This early painting by Monet portrays a realistic range of brightness, from the sunlit dresses to the shadows.

Fig. 7.2 Edgar Degas, *Portraits in an Office (New Orleans)*, 1873. Oil on canvas, 28 ½ x 36 in. (73 x 92 cm). This painting, often called *The Cotton Exchange, New Orleans*, portrays an office that is diffusely but realistically lit. There is an appropriate range of brightness, from the white shirts to the dark suits.

Lady Writing a Letter with Her Maid by Johannes Vermeer (1632–1675), depicts nearly the full range of cone sensitivity (a hundredfold spread of brightness) between the sunlit window and the shadowed corners (see fig. 7.5). There are marvelous details, such as the washed-out folds of the woman's shirt in the sunlit glare and the dramatic shadowing of both women. These details convey the effects of real-world lighting and enliven the painting. *The Intruder: A Lady at Her Toilette Surprised by her Lover (A Cavalier Talking to a Lady)*, by Pieter de Hooch (1629–1684) also shows bright light from a window, but the figures are barely shadowed and the floor is a remarkably homogenous expanse with little variation of lighting (see fig. 7.6). This is a lovely painting, and yet it lacks the brilliance of the Vermeer, in part because it does not fully utilize the range of brightness that would be found in such a scene.

If an artist fails to adjust the lighting in all parts of a painting to match the viewer's level of adaptation, the painting will portray a set of independent scenes that could not be experienced simultaneously. For example, it would be unrealistic to show a bright outdoor scene that includes visible details within a dimly lit tunnel, such as Jeffrey Smart's *Cahill Expressway* (see fig. 5.11). Rembrandt van Rijn (1606–1669) recognized this dilemma in his famous portrait *Philosopher in Meditation* (see fig. 7.7). If, as viewers, we are adapted to the bright light coming in the window—as is the philosopher in the painting—the shadows would appear almost black in the depths of the room, as indeed they do. To enable us to see the man behind the staircase, Rembrandt has added a fire yet keeps the brightest intensities within its glow well below those from the window. The temptation in such situations would be for the artist to paint two independent scenes, each with a full range of contrast between light and dark, rather

Fig. 7.3 Jean François Millet, *Starry Night (Nuit Étoilée)*, c. 1851. Oil on canvas, 25 ¾ x 32 in. (65.4 x 81.3 cm). This is a realistic portrayal of what we can (or cannot) see on a dark night.

Fig. 7.4 Johan Christian Dahl, *View of Dresden in the Moonlight*, 1839. Oil on canvas, 31 x 51 in. (78 x 130 cm). The details of the bridge and skyline in this painting are beautiful but unrealistic in the dim light.

7.3

7.4

than a continuous or realistic spectrum of brightness. This is the case with Albrecht Altdorfer's (1480–1538) painting *Agony in the Garden of Olives* (see fig. 7.8), which depicts a naturalistic scene in which the figures are illuminated quite unnaturally. He had a dilemma in trying to portray a moment when a reddish sunset is mixed with cold white moonlight seen peeking through the trees.[1] Color issues aside, however, the time shown must be one of minimal light since men are already carrying torches. Yet the figures in the foreground are fully lit despite no identifiable light source (the sun and moon are behind them). It was clearly more important to Altdorfer that viewers recognize the story from the Gospel than worry about lighting. It can be instructive to see how different artists have chosen to handle such visual challenges in their art. Once again, there is no right or wrong, depending on the artist's goals, but by understanding vision we can recognize the artist's choices and factor that information into our analysis of the work.

SHADOWS

Shadows result from the blockage of light from a directional source and are an integral part of many—if not most—scenes in the real world. Whether light comes from a point source (such as a lamp), or a diffuse source in one location (such as the sky), it will be blocked by objects in its path, which generates shadows. Although a natural part of this world, shadows have an intriguing history in the evolution of art. Shadows were painted carefully, even to the point of documenting Mach bands, in ancient Rome (see fig. 6.3). However, they (along with linear perspective) essentially disappeared from art in the Middle Ages (see

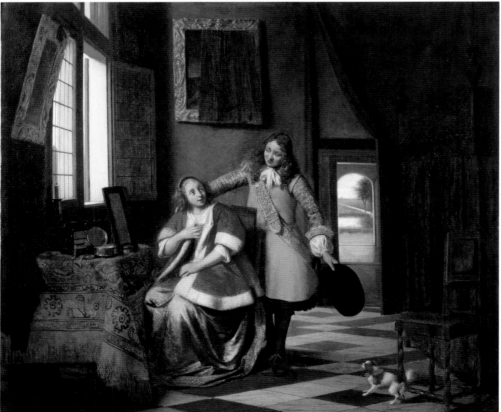

Fig. 7.5 Johannes Vermeer, *Lady Writing a Letter with Her Maid*, c. 1670–71. Oil on canvas, 28 ¹/₂ x 23 ¹/₂ in. (72.2 x 59.7 cm). Note the brilliant gradations of lighting, from the sunlit blouse to the shadowed tablecloth.

Fig. 7.6 Pieter de Hooch, *The Intruder: A Lady at Her Toilette Surprised by Her Lover (A Cavalier Talking to a Lady)*, c. 1655. Oil on canvas, 21 ¹/₂ x 25 in. (54.5 x 63 cm). The lighting of the figures and room is relatively homogeneous and thus less evocative of a real scene.

Fig. 7.7 Rembrandt van Rijn, *Philosopher in Meditation*, 1632. Oil on panel, 11 x 13 in. (28 x 34 cm). Sunlight fades from the window to the deep interior, where a fire provides only dim illumination.

Fig. 7.8 Albrecht Altdorfer, *Agony in the Garden of Olives*, from the Saint Sebastian altar, 1518. Oil on wood, 50 ¹/₂ x 37 in. (128.5 x 94 cm). There is no lighting source to account for the frontal illumination of the foreground figures.

chapter 18). Byzantine art focuses largely on religious topics, with the purpose of teaching and spreading the Gospel rather than portraying a realistic world. Indeed, the saints and heavenly figures were purposefully set apart from reality. Shadows and linear perspective are also rarely used in Islamic art, or in Chinese and Japanese art, presumably because these art forms are codified and stylized rather than realistic (see figs. 18.2–18.4).

Toward the Renaissance, shadows returned with a vengeance, and were painted with great care and detail, as in Robert Campin's *The Annunciation Triptych* (see fig. 6.5), completed circa 1425. Sometimes when an outdoor painting was made over many days and at different times of day, an artist would forget to adjust the shadows for a constant position of the sun. The painting would then show a "sundial effect," where different shadows point in different directions. Occasionally an artist as great as Monet seems to have added shadows later without looking carefully at the painted subjects: In his 1868–69 painting *The Magpie* (see fig. 7.9), the shadows of the trees don't match the trunks, and the shadow of the bird is backwards!

Impressionism emphasized another curious feature of shadows: color. Traditional shadows were portrayed as gray, but actually, in bright sunlight shadows often take on a bluish color. The explanation for this occurrence is a mixture of physics and visual coding. Whenever an object is lit by two sources from different directions and of different colors, the cast shadows will have color because they are illuminated by the source that is *not* being blocked. In bright sunlight on a snowy day, for example, a fence will block yellow-white sunlight and cast a bluish shadow that is lit only by the bluish light from the sky, as in Monet's *The Magpie*. This blueness is further enhanced by color contrast, since the shadow has more blue than the surrounding white snow (which is illuminated by yellowish sunlight). Recognition of this phenomenon is not new. Da Vinci wrote, of a white object partly in the sun: "The part not facing the sun stays in the shadow and partakes (*only*) of the color of the air."[2] Many artists depicted this phenomenon to one degree or another, but it was the Impressionists who made it famous (or, to some critics, infamous) by their extensive and intensive use of it.

ART IN THE GALLERY

A final topic to analyze is the effect of gallery illumination. Some have argued that a work of art should be viewed under the conditions in which it was finished, to make it appear most realistic. This issue is not a simple one to resolve—in part because artists work in complex ways, and an outdoor landscape that is started in the field might be finished in a dark gas-lit studio. Did the artist use colors and brightness that made sense in the studio or take the canvas outside to check the colors? Furthermore, artists surely don't paint night scenes in darkened rooms or want their finished works to be viewed with the lights out. We wouldn't see anything! If we knew for certain which Rembrandt painting was finished by candlelight, or by sunlight through the window, we might try to adjust the gallery illumination—but in practice, attempts to correct for these distinctions are fraught with the potential for more error than gain.

While lighting differences will unquestionably alter colors in a painting, the effects are sometimes less than one might imagine because to make distinctions, the eye and brain work more by color contrasts than by absolute colors. While the viewer can

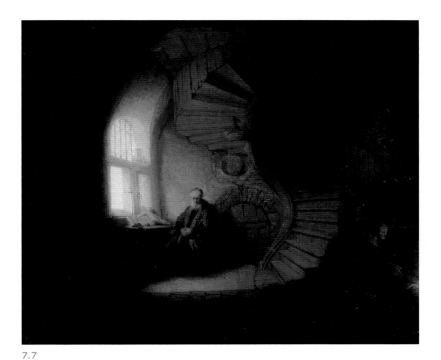

7.7

7.8

7.9

recognize that yellow candlelight renders whites slightly murky and weakens yellow-white distinctions, he or she has no trouble recognizing a full-color spectrum in candlelight. However, these issues can indeed be important for scenes in which subtle color levels or distinctions are central to the artist's purpose. Color tonality (and gallery lighting) may be critical for some Impressionist works that aim to mimic subtle lighting and shadows—or some Renaissance works that strive to match the aura of white moonlight or a yellow oil lamp. Sadly, we rarely know the lighting in which artists have finished their paintings, which would determine the best lighting for viewing.

Another concern with respect to gallery lighting is over-illumination, which can detract from a painting in several ways. Brilliant spotlights will wash out subtle colors, just as if one tried to read an art book on the beach. And poorly designed lighting can reflect off a canvas, creating highlights of reflection or glare that block out portions of the art. Most egregious, although subtle, is the effect of white walls! Thanks to the power of contrast (see chapters 5 and 6), a white wall tends to make everything upon it seem relatively dark. This problem occurs for two reasons: There is not only a direct illusory effect of the light-colored boundary (see fig. 5.4), but also the white walls in a gallery set the background illumination to which cone cells adapt. In the absence of spotlights, all of the art will appear dark relative to the greater brightness of the walls (an example, if less extreme, of the tunnel phenomenon on a sunny day). To counter this effect when next viewing art in a gallery, try cupping your hands to look at the art through a "tube" that shuts out the surrounding wall: Paintings and their colors will magically brighten.

Fig. 7.9 Claude Monet, *The Magpie*, 1868–69. Oil on canvas, 35 x 51 in. (89 x 130 cm). The shadows in this painting are bluish in color, which is a real phenomenon. Curiously, the shadows of the bird and trees do not correspond accurately to their objects.

Fig. 8.1 Additive and subtractive color mixtures. Mixing light is additive, since turning on a new light adds energy. The combination of red and green is brighter than either alone and is perceived as yellow. Mixing paint is subtractive, since paint appears to have one color only because it absorbs other wavelengths. Mixing red and green paints causes the absorption of more colors, and yields a dark and murky brown.

Fig. 8.2 Spectral sensitivity of the three types of human cone photoreceptors. The visible spectrum of electromagnetic energy (i.e., light) ranges from about 400 nanometers (blue) to 700 nanometers (red). Individual cones are most sensitive to blue, green, or red light.

NOTES

1. Weale, "A Matter of Illumination" (2002).
2. Da Vinci, *Leonardo on Art and the Artist* (2002), p. 111.

LIGHT PIGMENT

8.1

Color is a powerful sensation that brings variety and emotion to our world. Yet it is a late adaptation in evolutionary terms, and in many ways, as will become clearer below, it is a secondary sensation that is superimposed onto the more primitive, and perhaps primary, perceptions of form, depth, and movement, all of which rely solely on brightness or luminance. From an artist's vantage point, colors pose a special challenge, since the physics and physiology of light must be acknowledged, but within the context of practical skills, such as paint mixing and lighting.

It is important to recognize the distinction between pigment and light (see fig. 8.1). Painters lay pigments on canvas, but it is light that enters our eyes. Pigments are a subtractive medium in that they absorb most wavelengths of light, and their "color" represents only those wavelengths that are reflected. Thus, red paint absorbs everything but red. Light is additive because it represents energy. How does this difference affect color mixing? If you mix paints, you *absorb* more wavelengths and end up with a darker mixture, and the primary colors are red, yellow, and blue. However, if you mix light, you end up with a brighter mixture,

and the primary colors are red, green, and blue. Thus, a mixture of red and green light yields the brighter sensation of yellow.

Artists speak of three color properties: hue, saturation, and value. *Hue* is the dominant wavelength of light, i.e., its physical color in the spectrum. *Saturation* defines the strength of a color relative to white. Thus, a pure red prismatic color is fully saturated, whereas one mixed with white appears weaker (i.e., as pink). *Value* is the absolute brightness (or luminance or energy) of a color, and is equivalent to its brightness in a black-and-white—or colorless—world.

We see colors because the cone photoreceptors in the retina (the cells that can cope with daylight levels of illumination) have evolved into three types, each with a distinctive photopigment that captures light. Each cone type is sensitive to a different range of the color spectrum (red, green, or blue, as shown in figure 8.2). When looking at a colored object, our cone photoreceptors sample the relative amounts of red, green, and blue light, and the proportions of each define the color. All subprimate mammals have just two cone types, sensitive to blue light and long-wavelength light, which makes them red-green color-blind (see chapter 5). In the late stages of evolution, the long-wavelength cones mutated in some primates, which enabled these species (and eventually humans) to distinguish red and green, as well as a full spectrum of color.

The three types of cone photoreceptors account for the initial recognition of color by the retina but not for ultimate conscious perception. The retina must code the initial input information (just as it does black-and-white information) so that it can be conveyed to the brain through a limited number of optic-nerve fibers. The fundamental code is the same: The retinal cells are wired to recognize contrast. In the case of colors, the cells respond most vigorously to contrasts between red and green (the two "new" cone types), or contrasts between blue and yellow (the two "old" cone types, yellow being a combination of red and green). The balance between these two contrasts allows recognition of the full spectrum. We do not really judge redness well by absolute wavelength; e.g., in a room lit up by red light, here everything seems "white," and the distinctiveness of a red object is lost. Ultimately, we judge redness by how much it differs from greenness in the background. It is conceivable (although not proven) that this process may influence common subjective sensations. For

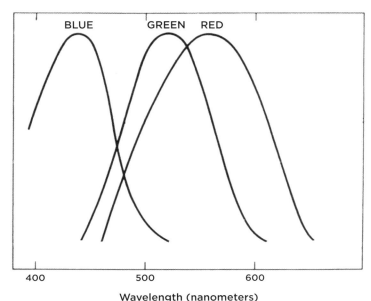

BLUE GREEN RED

400 500 600

Wavelength (nanometers)

8.2

8.3 a

8.3 b

8.4

Fig. 8.3 Richard Anuszkiewicz, *Plus Reversed*, 1960. Oil on canvas, 74 ⁵/₈ x 58 ¹/₄ in, (189.6 x 148 cm). Art © Richard Anuszkiewicz/Licensed by VAGA, New York, NY. (a) The red and green colors in this painting are relatively complementary, and thus they contrast vibrantly. (b) They are also relatively equiluminant (in terms of brightness) as evident in black and white. The lack of brightness contrast makes the pattern unstable.

Fig. 8.4 Complementary afterimages. Fix your gaze on the dot between the four colored rectangles for thirty seconds without moving. Then look at the dot on the white background and you will observe rectangles of complementary colors (green versus red, yellow versus blue).

example, red and green are colors that are juxtaposed in the visual process, and when contrasted, they often appear vibrant or even disturbing, while other combinations, such as red and yellow, are more apt to seem harmonious. These dynamic sensations have been exploited by many artists, including Pointillists, such as Georges Seurat (see chapter 11), and Op artists, such as Richard Anuszkiewicz, as in his *Plus Reversed* from 1960 (see fig. 8.3a).

We emphasized earlier the exquisite sensitivity of the eye to brightness differences. Similarly, the eye is exquisitely sensitive to color differences. In fact, the brain uses the relative constancy of color relationships to maintain recognition of the colors in faces, clothes, and other patterns, even when the color of the background lighting varies (such as during a sunset or in candlelight). The intrinsic role of contrast in color perception is easy to demonstrate to yourself (see fig. 8.4): When you stare for a period of time at a strongly colored object, your eyes become adapted (and thus relatively less sensitive) to that color; if you then look at a white page, you will see an afterimage of the object, in the complementary color (e.g., blue for yellow). Similarly, an object *next* to an area of one color will appear to take on some of that color's complementary hue. This feature of perception can lead to illusions, as in figure 8.5, where an *X* pattern of one color appears bluish or pinkish, depending on the color of the background.

A further complexity of color perception is the fact that our ability to distinguish discrete from mixed spots of color depends in part upon the size of the object being viewed. This is the case because each bipolar cell or ganglion cell in the retina perceives a finite (albeit small) part of the world, called its receptive field. If adjacent dots of color are tiny enough, they will fall entirely within the color-sensitive receptive fields, and the eye cannot discriminate between them. It is this feature of perception that allows us to see smooth halftone pictures in a magazine or colors

Fig. 8.5 Joseph Albers, *Study in Reversed Grounds*, 1963. This plate shows an illusion of simultaneous contrast. The *X* pattern surrounded by pink appears blue, while the *X* pattern surrounded by blue-green appears pink. Nevertheless, where the *X* patterns join at the bottom, you can see that their colors are identical. Cover this junction to strengthen the illusion.

8.5

on a television screen. Both kinds of images are composed of very tiny dots having only three or four fixed colors; as the dots are too small to resolve (we normally do not discern them), the colors blend according to physical laws for the mixing of colored pigment or light.

How these physical laws apply will depend on whether the spots of color are independent of one another or mixed together. The situation for colored light is straightforward: If a television screen is showing pixels of only one color, and a second color is added, there will be a greater amount of light energy coming off the screen, resulting in the perception of a new color, one that is intermediate between the two. The situation for painting and printing is more complicated: If a printed page or a Pointillist painting has dots of one color on it, and dots of a second color are interspersed (*not* mixed or overlapped), the dots reflect light that will mix according to the rules for mixing light. On the other hand, if the dots on the page or canvas overlap so that the pigments are mixed, they will collectively absorb more wavelengths according to the rules of mixing paint. In reality, Pointillist paintings, as well as printed books and magazines, consist of both situations, because some dots of paint or ink are discrete and reflect colors additively, while others are overlapped so that there is a subtractive mixing of pigments. These color effects are further complicated by the facts that most pigment does not reflect pure spectral colors and reflected light lacks the intensity of a light source.

As may be surmised, perception of color in an image made up of dots will change when the dot size is large enough for retinal cells to both recognize individual dots and the contrast between them. Furthermore, the receptive fields of the retinal cells that process black-and-white visual acuity are very small (so that we have maximal resolution for tiny objects and fine print), while the color-sensitive receptive fields are somewhat larger. An implication of this feature of perception is that colored dots

of the "right" size can be big enough to be recognized as dots but small enough to blend as colors; this has influenced the work of many painters, including Georges Seurat, Roy Lichtenstein, Bridget Riley, and Chuck Close, and is relevant to styles of art ranging from Pointillism to Op and Pop Art.

Pointillism alters the rules of mixing paint, since discrete dots behave as light rather than as pigment. This fact can raise some unexpected problems, since juxtaposing complementary colors will result in white or gray. For example, mixing blue and yellow paint normally results in green, but with discrete dots of color, the outcome is rather grayish, such as in Seurat's *Le Cirque* (*The Circus*), shown in figure 11.2. In many of Georges Seurat's Pointillist paintings, he juxtaposed dots of relatively complementary colors, creating areas that are curiously colorless when viewed from far away (see chapter 11). In *Harbour at Port-en-Bessin at High Tide* (see fig. 8.6), for example, the sails, houses, distant cliffs, and rock piers appear gray from far away, although Seurat did not use gray paint. He used a mixture of blue and orange dots. Seurat was certainly aware of this effect, as he titled several other paintings done with this technique *Evening* or *Gray Weather*. For the foliage and water, Seurat maintained a green-and-blue tone by allowing only a small number of pinkish dots to intervene. To minimize these issues, some of the Neo-Impressionists, such as Paul Signac, preferred a technique known as Divisionism, in which larger spots of color that do not fully merge at ordinary viewing distances are used to produce a more vibrant appearance.

The distinction between Pointillism, as Seurat practiced it, and the Divisionism practiced by Signac, Henri-Edmond Cross, Henri Matisse, and others, is in fact more complex than the mere difference in dot size. With the artist's use of alternating color patterns made up of intermediate-size dots, the viewer will perceive color *assimilation* rather than contrast, a phenomenon

Fig. 8.6 Georges Seurat, *Harbour at Port-en-Bessin at High Tide*, 1888. Oil on canvas, 26 ½ x 32 ¼ in. (67 x 82 cm). Note how the blue-red mélange of dots on sails, cliffs, piers, and buildings tends to "gray out" if the image is held far away.

Fig. 8.7 Paul Signac, *Entrance to the Grand Canal, Venice*, 1905. Oil on canvas, 28 ⅜ x 36 ¼ in. (73.5 x 92.1 cm). Signac's dots of color are large enough to appear vibrant (rather than blend as do the smaller dots in Pointillist works). There are also hints of the von Bezold effect, as shown in figure 8.8. Compare with figure 8.6 and the other paintings by Seurat illustrated in chapter 11.

8.6

8.7

8.8 a

8.8 b

Fig. 8.8 The von Bezold effect. **(a)** Red lines assimilate lightness or darkness from the adjacent white or black lines. **(b)** Red squares assimilate the color of surrounding yellow or blue squares, to appear somewhat orange or purple. These effects occur only when patterns have a particular size and regularity.

Fig. 8.9 Parallel pathways within the visual system for fine acuity, depth and motion, and color perception. The sensation of color, which is a newer evolutionary development, is superimposed on a more fundamental recognition of objects, depth, and motion by luminance (black-and-white) contrast.

Fig. 8.10 Raoul Dufy, *Boardwalk in Nice*, c. 1924. Gouache on paper, 15 x 18 in. (38 x 46 cm). This painting makes sense despite the fact that the blocks of color barely approximate the outlines of buildings, trees, and other components of the scene.

first described by the German rug maker Wilhelm von Bezold, and shown in figure 8.8. In figure 8.8a, lines of white or black make the intervening red seem lighter or darker (i.e., they are assimilated, whereas one might expect red to appear darker next to white). In figure 8.8b, red squares appear slightly orange among the yellow squares and slightly violet among the blue ones. The neural basis for the von Bezold phenomenon has not been determined. This assimilation of colors can be seen in some Divisionist works, such as Signac's *Entrance to the Grand Canal, Venice* (see fig. 8.7), in which the yellows interspersed with the white background have a light tone, while those among the dark poles and gondolas appear darker.

THE BRAIN AND PARALLEL SYSTEMS OF PERCEPTION

The mechanisms described so far serve to get images into the visual system, but there is a large step between imprinting a shape upon the visual pigments of the retina and consciously recognizing what that object may be. The visual system represents a series of way stations through the retina, brainstem, and brain, at each of which information is further categorized and refined. However, components of visual information, such as resolution and form, color, and depth and movement, are kept in relatively independent pathways as they travel through the visual system from the eye to the primary visual cortex of the brain[2] (see fig. 8.9). Each square millimeter of visual cortex corresponds to a specific small area of the world, its receptive field, and most of the cells therein respond only to brightness in order to evaluate the presence of edges and movement. But each square millimeter also contains a distinct "blob" of cells that determines the color of that receptive field. Ultimately visual awareness is a combination of hundreds or thousands of luminance-sensitive cells responding primarily to edges and contrasts to define form and depth, with a color map superimposed. Our conscious perception integrates all of these aspects of vision so that we recognize and interpret characteristics such as texture, facial expression, and complex movements.

This parallel processing, as it relates to art, has been discussed at length by neurobiologist Margaret Livingstone,[3] and a somewhat extreme example is shown in Raoul Dufy's (1877–1953) *Boardwalk in Nice* (see fig. 8.10). This beach scene with buildings and palm trees is deceptive because it is not immediately obvious that the colors spread well beyond the outlines of the

PARALLEL VISUAL PATHWAYS

	Small ganglion cells		Large ganglion cells
	↓		↓
	Cortex layer 4Cβ		Cortex layer 4Cα
	↙	↘	↓
	VISUAL ACUITY FORM	**COLOR**	**MOVEMENT DEPTH**
Light requirement	High	High	Low
Resolution	Small	Medium	Large
Contrast sensitivity	Low	Low	High
Response speed	Slow	Slow	Fast

8.9

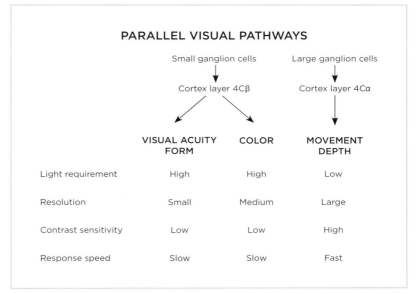

8.10

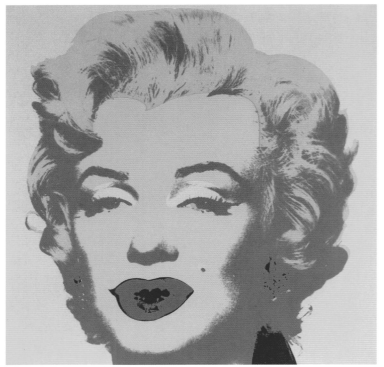

8.11 a

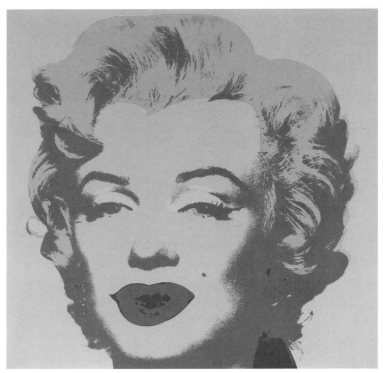

8.11 b

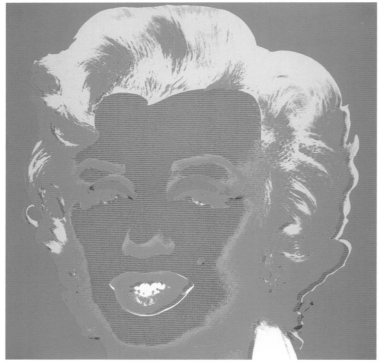

8.12 a

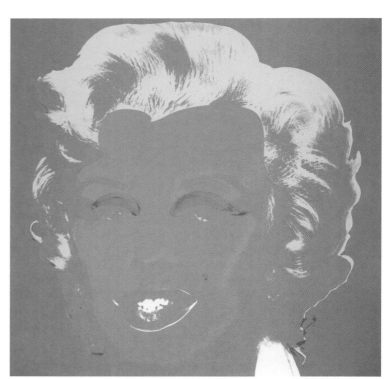

8.12 b

Fig. 8.11 Andy Warhol, Untitled from the portfolio Marilyn, 1967. Serigraph, printed in color, 36 x 36 in. (91.5 x 91.5 cm). **(a)** Despite the wild Fauvist colors, Marilyn's face is easily recognizable and has a sense of depth. **(b)** A black-and-white image shows that ordinary luminance relationships are preserved among facial structures.

Fig. 8.12 Andy Warhol, Untitled from the portfolio Marilyn, 1967. Serigraph, printed in color, 36 x 36 in. (91.5 x 91.5 cm). **(a)** In this version, Marilyn's face is both hard to recognize and without depth. **(b)** The black-and-white image shows that facial structures are hard to discern because there is little luminance difference among the colors.

8.13 a

8.13 b

8.14 a

8.14 b

Fig. 8.13 André Derain, *London Bridge*, 1906. Oil on canvas, 26 x 39 in. (66 x 99 cm). **(a)** This scene makes sense despite unusual colors. **(b)** The reason is evident in black and white, which show that brightness values correspond to those of a naturally colored scene.

Fig. 8.14 André Derain, *Bridge Over the Riou*, 1906. Oil on canvas, 32 ¹/₂ x 40 in. (82.5 x 101.6 cm). **(a)** This scene is harder to decipher than *London Bridge*. **(b)** The luminance image shows that color values vary among different parts of the buildings and trees, which makes the view confusing.

trees, figure, and other objects within the painting. Why isn't this "sloppiness" bothersome? Because our color perception system is not geared to the recognition of sharp outlines. As long as we have a clear discrimination of the outlined shapes from our form and resolution pathways, we accept a general awareness of color in the vicinity, and our first conscious impression may be that of a normally colored image. Many other artists have made use of this perceptual phenomenon, including Henri Matisse, Pablo Picasso, Paul Cézanne, Ben Shahn, and the American Modernist Abraham Walkowitz, whose career was eventually stopped by glaucoma (see fig. 23.7 and chapter 31).

The segregation of components of vision begins within the retina. We have already noted that rods and cones divide the tasks of night vision and day vision respectively, and that the cones initiate the process of discriminating colors. By the time this information reaches the ganglion cells, the last set of retinal neurons, the cells have become further specialized. Some smaller ganglion cells carry only information about color, while others carry brightness-coded information about fine spatial discriminations and resolution; larger ganglion cells are concerned primarily with brightness-coded motion recognition, depth perception, and spatial orientation. Thus, the color information has already been segregated from the more basic (evolutionarily older) mechanisms of perception, which are effectively color-blind. The bottom line is that we need luminance (brightness) differences to optimally recognize shapes, faces, depth, and movement. This feature of vision has many implications for art.[4]

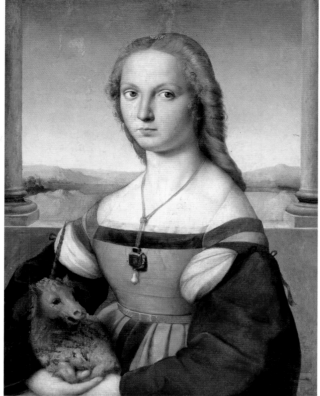

8.15a

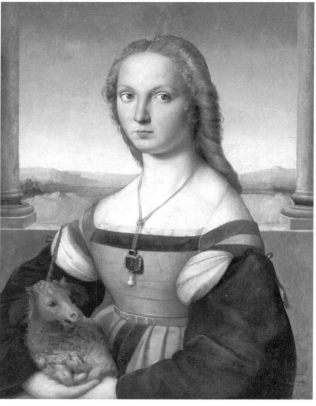

8.15b

8.16

EQUILUMINANCE AND ART

Because luminance contrast is necessary to see the edges and shapes that allow recognition of letters, faces, objects, and depth, painters must create images that provide such contrast. Colors can be superimposed upon a scene but are not sufficient on their own to demarcate the world. Two objects that are equally bright to the human eye are called *equiluminant*, regardless of their color. A dark red color and a light green color, having different brightness or value, will effectively demarcate an object or allow us to read red letters printed upon a green background. However, if the brightness or value of these same colors is adjusted so that they are equiluminant, the objects or the print will become difficult to recognize. Thus we easily see the reds and greens in Anuszkiewicz's *Plus Reversed* (see fig. 8.3), but the shapes and pattern of the colors are curiously unstable since the colors are relatively equiluminant (and hard to distinguish in black and white). Andy Warhol's (1928–1987) *Marilyn Monroe* series provides another striking example. Despite garish and unusual colors in many prints from the series, when the colors have appropriate luminance contrast, Marilyn's face stands out and almost appears three-dimensional (see fig. 8.11). But even strong reds and greens leave the face flat and curiously hard to identify when the colors have similar luminance (see fig. 8.12). This difference helps us to understand certain effects of Fauvist paintings, where seemingly bright and "inappropriate" colors are used. For example, figures 8.13 and 8.14 show paintings done by André Derain (1880–1954) in 1906: In *London Bridge*, components of the painting have relatively standard brightness relationships, so that the strong colors enhance and give unique spirit to an otherwise ordinary scene. *Bridge Over the Riou* is much harder to

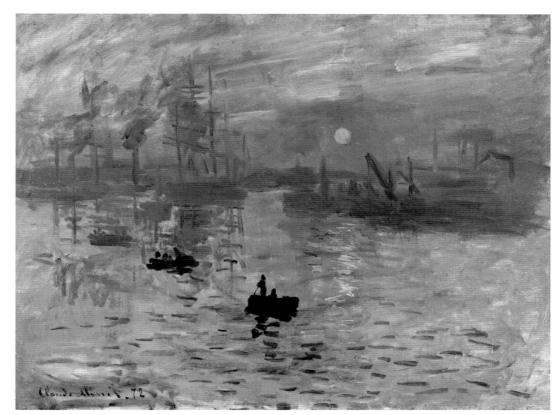

Fig. 8.15 Raphael, *A Lady with a Unicorn*, c. 1505–06. Oil on wood (transferred to canvas), 27 x 21 in. (67.7 x 53.2 cm). **(a)** The rendering of the lady is almost photographic. **(b)** She also appears normal in black and white because the colors have natural luminance relationships.

Fig. 8.16 Claude Monet, *Cathedral at Rouen, Evening*, 1893–94. Oil on canvas, 39 1/3 x 25 1/2 in. (100 x 65 cm). The blue and orange tones are close in luminance, which makes door portals and windows difficult to see and lacking in depth.

Fig. 8.17 Claude Monet, *Impression: Sunrise, Le Havre*, 1872. Oil on canvas, 18 7/8 x 24 13/16 in. (48 x 63 cm). The luminance of the sun and reddish sky are almost identical to that of the clouds and water, which gives the colors a mystical glow.

8.17

appreciate as a natural scene because (intentionally or unintentionally) the luminance values are curiously inconsistent among different parts of the trees and buildings. Another example of unusual Fauvist colors, which make sense in terms of luminance, is Matisse's *La Gitane* (*Gypsy*) (see fig. 12.3).

To summarize, color alone will not function effectively to represent objects (or depth), unless it also provides realistic luminance contrast. Most representational artists recognize this fact instinctively, and their color choice complements the light and dark aspects of their paintings accordingly, such as in Raphael's Renaissance painting *A Lady with a Unicorn* (see fig. 8.15). Conversely, relatively equiluminant colors may be used consciously to obscure detail or alter the sense of distance and depth, as Monet does in certain views of the facade of the Rouen cathedral (see fig. 8.16), or Matisse does in paintings where he seeks to make color the predominant stimulus, such as *Gate of the Casbah* (see fig. 12.4). As Livingstone has pointed out, this effect may account for the special glow of the sun in Monet's iconic painting *Impression: Sunrise, Le Havre* (see fig. 8.17) since there is little difference in luminance between the red sun and the gray predawn sky.

COLOR NAMES

Colors and color names carry psychological or emotional implications for many people, but these connotations reside in the brain rather than the eye. You can measure a wavelength of light that will stimulate the retina, but the name that anyone attaches to that color is arbitrary. Even if we agree that 650 nanometers is red, the dividing line between red and orange will be a matter of personal judgment. Different cultures and individuals assign different names (and more or fewer of them) to different parts of the spectrum. Similarly, the psychological or emotional effect of colors is arbitrary and without any proven scientific basis. Red may represent heat, fear, or danger, but also may generate sensations of love, friendship, and sweetness. Studies on the psychological implications of color effects are useful for the advertising industry and can be important for art historical analysis insofar as cultural implications of color have influenced the color choices of artists throughout the centuries. For example, blue is traditionally associated with the Madonna, a practice that began in the eleventh or twelfth centuries for complex reasons, including the cost of blue paint, which was in those days made from ground-up lapis lazuli.[5] Our treatment of color in this book is concerned with its physiological effects.

NOTES

1. Ratliff, *Paul Signac and Color in Neo-Impressionism* (1992).
2. Livingstone and Hubel, "Segregation of Form, Color, Movement, and Depth: Anatomy, Physiology, and Perception" (1988); Zeki, *A Vision of the Brain* (1993).
3. Livingstone, "Art, Illusion and the Visual System" (1988).
4. Livingstone, *Vision and Art: The Biology of Seeing* (2002).
5. Pastoureau, *Blue: The History of a Color* (2001).

A CIRCLE OF COLOR: TURNER, NEWTON, AND GOETHE

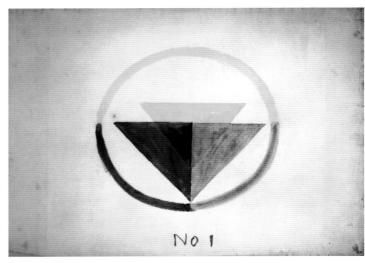

9.1

The nature of color has intrigued scientists, philosophers, and artists throughout history. Modern science has elucidated the physical nature of light and reconciled the quantum and wave natures of electromagnetic radiation. However, the mechanisms by which physical stimuli are translated into the subjective perception of color are still subjects of study and debate. Contemporary art schools teach about light and color, but there is no universally accepted way to define colors, since different criteria apply for physics, photography, printing, pigments, and perception. Furthermore, within the context of art, the physiological effects of using and juxtaposing colors are difficult to separate from their cultural and psychological impact. This situation is not so different from the one two hundred years ago, when J. M. W. Turner (1775–1851) was a young artist, evaluating the science and theory of the day and formulating his ideas about color and style.

Isaac Newton (1643–1727) was famous by Turner's time, more than one hundred years after Newton's seminal discovery that a prism breaks white light into a full spectrum of colors. Newton had interpreted this observation to indicate that white light is a mixture of all the spectral colors, and he argued that light was, therefore, corpuscular in nature, a concept that could not be fully verified until the advent of quantum mechanics. This belief was counterintuitive to those who accepted the Aristotelian belief that color was not a property of light, but rather a feature of visible objects:[1] They reasoned that since color is not visible without light, it must be a feature of each object and appear only upon interaction with light (which itself has no color). This logic was hard to shake, even in the face of Newton's experiments, and debate raged for nearly two centuries.[2] During this period, Newton's supporters praised him lavishly and made him a national hero. Many popular accounts of his work (similar to modern-day books explaining the theory of relativity) were published, including *Newtonianism for Ladies* in 1737. Voltaire popularized Newton in France in 1738 with *Éléments de la philosophie de Newton*. Alexander Pope glorified Newton in a famous couplet: "Nature, and Nature's Laws lay hid in Night. / God said, 'Let Newton be!' and All was Light." On the other hand, reputable scientists of the time such as Christiaan Huygens and Robert Hooke criticized Newton's theory for its failure to explain the wavelike properties of light. Eighteenth-century Irish philosopher Bishop Berkeley took offense at Newton's science as a threat to theology. And the English poet Samuel Taylor Coleridge feared that Newton's scientific rigor corrupted the imagination: "I believe the Souls of 500 Sir Isaac Newtons would go to the making up of a Shakespere [sic] or a Milton."[3]

Johann Wolfgang von Goethe (1749–1832) was among those who had trouble accepting Newton's concept that white light was divisible into colors. Goethe is most famous as a poet and playwright, and as author of *Faust*, one of the great literary masterpieces of all time. But in his time, Goethe, a true Renaissance man, was also famous as a philosopher and scientist. He wrote a highly regarded book on botany, was the first to recognize a bony feature of the skull, and both named and founded the scientific discipline of morphology.[4] He was interested in phenomena of perception and carried out many careful observational experiments about colors and how they are perceived. In 1810 he published a book called *Zur Farbenlehre* (*Theory of Colours*),[5] which incorporated his scientific observations and philosophy about the perception of color with a rather pointed, and at times polemical, refutation of Newton's corpuscular theory of light. Goethe's work has been largely disregarded in modern times, since Newton's physical observations about light have proven to be accurate. However, Goethe's book was well received and widely read in its own time, particularly by those who still questioned Newton, and by artists and philosophers who were more interested in the sensory aspects of color than the physical ones. No less a figure than Beethoven said, "Can you lend me *Theory of Colours* for a few weeks? It is an important work. His last things are insipid."[6]

Turner came of age amid these scientific developments and controversies. He could not help but be aware of Newton's work, although there is no evidence that he specifically read or contemplated Newton's reports on color. We do know that Turner lectured for many years about color (as well as other aspects of art) when he served as professor of perspective at the Royal Academy, and that he referred his students in one lecture to a Newtonian account of the formation of colors.[7] We also know that he owned a copy of the English translation of Goethe's *Theory of Colours*, which was published in 1840.[8] He read it carefully and made extensive marginal notes, and these give some

insight as to how he interpreted the great playwright's musings about color theory and color perception.[9]

Turner trained as an architect in his youth, but his extraordinary skill in drawing soon became apparent, and he was admitted to the Royal Academy. Within a few years his pictures were on display, and by his mid-twenties he was elected to full membership. In 1807 he was appointed professor of perspective, a post that he held for many years. He diligently prepared a course of lectures and even planned a book (which was never written) to teach his approach to art, although his contemporaries describe him as a remarkably obscure speaker.[10] One wrote, " . . . you could hardly hear anything Turner said, he rambled on in a very indistinct way which was most difficult to follow . . . But though the subject matter of his lectures was neither listened to nor understood, they were well attended as he used to display beautiful drawings of imaginary buildings with fine effects of light and shade." Another wrote, "Turner's lectures on perspective, from his naturally enigmatical and ambiguous style of delivery, were almost unintelligible. Half of each lecture was addressed to the attendant behind him, who was constantly busied, under his muttered directions, in selecting from a huge portfolio drawings and diagrams to illustrate his teaching. Many of these were truly beautiful, speaking intelligibly enough to the eye if his language did not to the ear."

Although Turner took his lectures seriously and prepared detailed notes, he didn't deliver his first lectures until 1811 (four years after he was appointed professor of perspective) and he lectured only sporadically thereafter. That he may have had some unconscious ambivalence about teaching is illustrated by a series of incidents that occurred before his 1814 lectures.[11] The first lecture on January 3 was cancelled because he left his demonstration portfolio in a hackney coach on the way to the Royal Academy. He advertised in the *Morning Chronicle* for

their return, and the finder advertised as well (although with a dim view of their worth): "PORTFOLIO FOUND . . . containing some drawings on the Science of Perspective . . . Should no application be made within fourteen days they will be disposed of as waste paper, being considered of little value." Turner's lecture was then rescheduled for eight o'clock in the evening on January 10, but he did not appear at the scheduled time. When he finally arrived at nine o'clock, "in searching his pocket he ascertained that he had lost his lecture! . . . he had left the lecture in the hackney coach which had conveyed him." For the record,

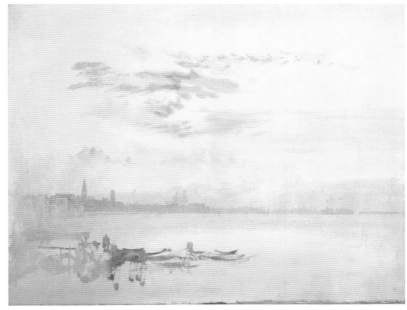

9.2

Fig. 9.1 Joseph Mallord William Turner, *Colour Circle No.1, Lecture Diagram*, c. 1822–28. Pencil and watercolor on paper, 22 x 30 in. (55.6 x 76.2 cm). Note the predominance of primary pigment colors (red, yellow, and blue) in Turner's diagram and how their confluence is dark.

Fig 9.2 Joseph Mallord William Turner, *Venice Looking East Towards San Pietro di Castello—Early Morning*, from Como and Venice sketchbook [Finberg LXXXI], 1819. Watercolor on paper, 8 ³/₄ x 11 ¹/₄ in. (22.3 x 28.7 cm). This Impressionistic view is dominated, as are many of Turner's works, by yellow light against blue water, with red adding a sense of drama.

Fig. 9.3 Joseph Mallord William Turner, *The "Fighting Temeraire" Tugged to Her Last Berth to be Broken Up*, before 1839. Oil on canvas, 35 ³/₄ x 48 in. (90.8 x 121.9 cm). There is a predominance of the primary colors, with much of the painting's power coming from the treatment of light against shade.

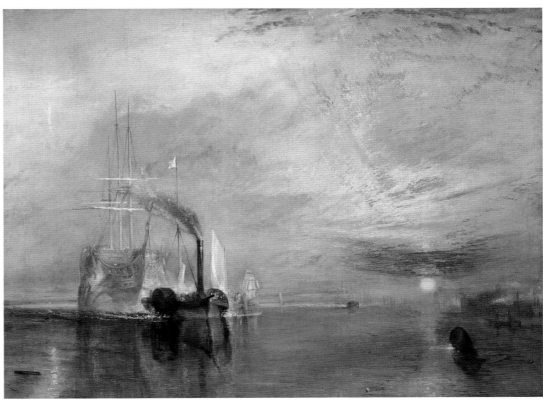

9.3

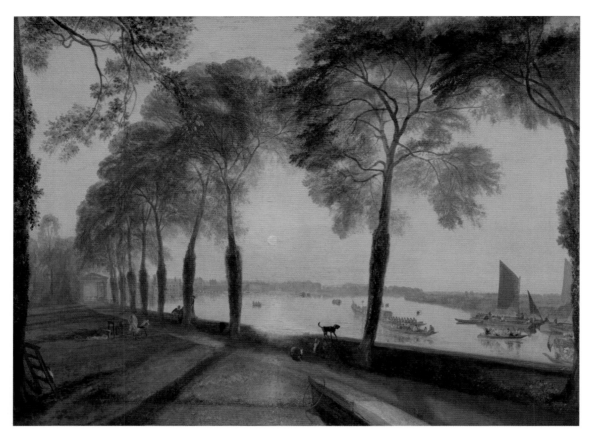

Fig. 9.4 Joseph Mallord William Turner, *Mortlake Terrace*, 1827. Oil on canvas, 36 1/4 x 48 1/8 in. (92.1 x 122.2 cm). This twilight scene is dominated by yellow from the setting sun.

he did finally deliver the lecture—but then four years later, he again left his papers on a coach.

Turner's lecture notes reveal that he viewed color as subsidiary to light and dark, which were to him the most powerful elements of painting. The color circles he made to show in his lectures (see fig. 9.1) are based strongly on the primary pigment colors of red, yellow, and blue, which dominated Turner's work in both watercolor and oil throughout his career (see figs. 9.2 and 9.3). He wrote in his lecture notes,[12] "suppose the yellow triangle light, red and blue shade" to emphasize that the dichotomy of light and dark dominates the colors. But then he gave meaning to the colors: "Hence we have gray morning, the yellow mid-day and crimson evening." Furthermore, "Green [is] the weakest of the direct rays," while "the strongest ray as to power, [is] red." Indeed, throughout Turner's work there is a juxtaposition of yellow symbolizing light, blue indicating calmness and cold, and red as a throbbing power that selectively intercedes. Greens are used sparingly, if at all. Light and dark are usually the dominant forces, whether as a brilliant sun over the water, or as the darkening gloom of a storm. Turner was perhaps prescient, as were many artists, in recognizing the importance of light/dark contrast independent of color for many aspects of vision (see chapters 5 and 7)—but of course he had no scientific understanding of why.

Turner's powerful but selective use of colors did not go unnoticed by the critics of his time.[13] One wrote in 1827 of Turner's painting *Mortlake Terrace* (see fig. 9.4): "That the Lord Mayor's barge, which was introduced only for the sake of the colour, should look yellow in its gingerbread decorations, is natural; and that the Aldermen's wives should look yellow from sea-sickness is also natural. But that the trees should look yellow, that the

Moffatt family themselves and all their friends and connections; dogs, grass plots and white stone copings of red brick walls should all be afflicted with the jaundice, is too much to be endured." Another critic speculated sarcastically in 1831 as to whether it might be "disease (opthalmia [sic] or calenture [violent tropical fever and delirium]) which leads him into the most marvellous absurdities and audacities of colour that painter ever ventured on." In 1872 respected ophthalmologist Richard Liebreich, MD, argued quite seriously that Turner's use of reddish and yellow tones increased as he aged and might therefore be a result of developing cataract.[14]

However, Turner's predisposition to yellow, as the color of light and day, began early in his career and long before one could possibly postulate eye disease. At age twenty-three, his work was considered "too much to the brown" by a colleague;[15] he was only thirty-one when a well-known collector Sir George Beaumont commented that "his colouring has become jaundiced."[16] Furthermore, even in Turner's late paintings, one finds representational details that could not have been done by an individual with significantly impaired sight. Yellow has fascinated many other artists, such as van Gogh (see chapter 10), and we need not stretch medical probability to explain this artistic choice by Turner. With respect to the hazy images in Turner's works, the issues are similar to those inherent to Impressionism (see chapter 2): Turner clearly could paint precise and representational works when he wished, and he included great detail in some later works as we have noted; yet many of his pictures revel in the hazy light of dawn or mist. Furthermore, spectacles were readily available in his day, and there is no reason to think that he would not have availed himself of good vision had he needed them. Some of his reading glasses have been preserved, and they

have powers of +3.00 and +4.00 diopters, which indicate that he used spectacles when necessary but also that he was neither myopic nor severely farsighted.[17]

About the time that Turner was appointed a professor at the Royal Academy, Goethe was working on his book *Theory of Colours*, which linked color to his philosophical approach to the arts. Whether by mistake or through pride, he chose to attack Newton as the source of error in color theory, and he did not mince words: "A great mathematician was possessed with an entirely false notion on the physical origin of colors; yet, owing to his great authority as a geometer, the mistakes which he committed as an experimentalist long became sanctioned in the eyes of a world ever fettered in prejudices."[18] He refused to accept Newton's concept that white light incorporated all colors, but rather adhered to the Aristotelian view that color derived "from the primordial phenomenon of light and darkness, as affected or acted upon by semitransparent mediums."[19]

Goethe recognized, however, that the eye sees only light and color and not objects themselves: "The eye sees no form, inasmuch as light, shade, and color together constitute that which to our vision distinguishes object from object."[20] Whereas Plato (see chapter 17) argued that painted images could never express the true nature of an object, Goethe wrote that from "light, shade, and color, we construct the visible world, and thus, at the same time make painting possible, an art which has the power of producing on a flat surface a much more perfect visible world than the actual one can be."[21]

Perhaps it was this philosophical concern—that reality derives from visual input—which led Goethe to distrust devices that distort the world, including optical aids and spectacles. He did not like visitors to wear glasses in his presence.[22] And while he could accept glasses on an old acquaintance with significant myopia, he became furious at people who wore glasses as a fad, or to a first meeting with him when they should have known better. Goethe himself was not myopic, and did occasionally use an opera glass to see far away. In his novel *Wilhelm Meister*, the title character muses about the morality of optical technology, saying, "It is not the occasional use of telescope, microscope or glasses by the highly cultivated individual that is felt to be dangerous here, but rather the wholesale, indiscriminate surrender to a fad that interposes a distorting lens between the world and that most important sense, the sense of sight."[23]

For all of its physical misinformation, Goethe's book on color is still a remarkable and careful document with respect to his psychophysical observations of how colors appear under specific experimental circumstances, and how they interact in our perceptual experience. Goethe was a good scientist in terms of documenting and recording the conditions of his observations, and his descriptions of visual phenomena, such as afterimages, color contrast, and shadows are extraordinary. Toward the end of his life he apparently came to regret his intemperate comments against Newton and was prepared to leave some of them out of a new edition of his book.[24] Nevertheless, his book had considerable influence, perhaps in part because it was easier to read than the more mathematical material written by physicists. He was a soul mate to Turner in his belief that light and dark were fundamentally more important than color. He wrote that "colors may be disposed rightly in themselves, but that a work may still appear motley, if they are falsely arranged in relation to light and shade."[25] Goethe was clearly aware that when objects and background are equiluminant, it is difficult to perceive shape and/or a sense of depth (issues that are discussed in terms of modern knowledge in chapter 8). And he emphasized the fundamental antagonism of blue and yellow:[26]

PLUS	MINUS
Blue	Yellow
Negation	Action
Shadow	Light
Darkness	Brightness
Weakness	Force
Coldness	Warmth
Distance	Proximity
Attraction	Repulsion
Affinity with alkalis	Affinity with acids

It should be pointed out that while colors have a physical definition in terms of wavelength of light, color names are purely arbitrary and subjective, as are judgments about implications of color, such as "warmth" or "weakness." Red can mean danger, love, or both—and such interpretations are in the realm of psychology and culture rather than science.

Turner added the words "light and shade" next to this list,[27] and in 1843 he exhibited a pair of pictures that is of particular interest because Goethe is mentioned in one of the titles. The first painting, *Shade and Darkness—The Evening of the Deluge* (see fig. 9.5), is dominated by cool blues and grays that elicit a sense of darkness and foreboding. The second, entitled *Light and Color (Goethe's Theory)—The Morning after the Deluge* (see fig. 9.6), is dominated by brilliant yellow and light with a frame of powerful red. It appears likely that the color and theme of these paintings derive from Goethe's list, although scholars have argued whether Turner was praising Goethe or criticizing him in these demonstrations.[28] While Turner accepted the dichotomy of light and shade, he differed from Goethe in believing that shadows and shade are a part of the spectrum of light and color, rather than an absence of them.

Today we have the luxury to look back, with the perspective of one hundred fifty years, on the interaction of three great minds: Newton, Goethe, and Turner. Newton's corpuscular theory of light has since been modified by wave theory and quantum mechanics, but his brilliance in recognizing that white light is a composite of different wavelengths (i.e., different colors and different energies) remains a scientific landmark. Goethe's refusal to accept Newton's concept of light branded his own book as "non-science," although it contains many rigorous and useful observations about color perception. There is renewed appreciation for his skill as an observer, and renewed awe at his ability to understand so well both the scientific and ethereal aspects of human nature. Turner, caught between these philosophical giants, seemed interested in science but skeptical of its value in art. He could accept Newton's physics and view color as a part of light, while also appreciating the emotional impact of light versus darkness in his artistic work.

9.5

9.6

There are lessons in these musings. Artists have used scientific information variably in their work. Turner and Seurat read about theories of color but either misinterpreted them or relied on theories that are no longer valid. Yet their art is exceptional. More modern artists, such as M. C. Escher and Bridget Riley, have relied on scientific images as inspiration and sources for pictures that are equally compelling. On the other hand, the work of many great artists is not informed by science. To understand the nature of light and the nature of vision is to understand one part of the world, and it may explain why certain colors, contrasts, or shadows have special visual impact upon us. But this knowledge does not ensure the sensitivity and innovation that makes an artist great. Turner and Seurat made choices in the construction of their paintings that were clearly affected by their interpretation of the science of the day; ultimately, however, the refinement and form of their paintings was determined by artistic rather than scientific judgment. We may not wish to go as far as Goethe and say that art is more perfect than the visible world, but we can surmise that it is a more perfect world because of art!

NOTES

1. Lindberg, *Theories of Vision from Al-Kindi to Kepler* (1976).
2. Cantor, "Anti-Newton" (1988).
3. Coleridge to Thomas Poole, 23 March 1801, *The Collected Letters of Samuel Taylor Coleridge* (1956), p. 709.
4. Magnus, *Goethe as a Scientist* (1949).
5. Goethe, *Theory of Colours* (1970 reprint of 1840 edition).
6. Kohler and Herr, *Ludwig van Beethoven's Konversationhefte* (1972), p. 348. Translated on the cover of Goethe's *Theory of Colours*.
7. Gage, *Color in Turner* (1969), p. 110.
8. Magnus, *Goethe as a Scientist* (1949).
9. Gage, Turner's annotated books: "Goethe's Theory of Colours" (1984).
10. Whitley, *Art in England* 1800–1820 (1928), pp. 179–180.
11. Ibid., pp. 221–223.
12. Gage, *Color in Turner* (1969), p. 210.
13. Whitley, *Art in England* 1821–1834 (1928), pp. 132 and 213.
14. Liebreich, "Turner and Mulready—On the Effect of Certain Faults of Vision on Painting, with Especial Reference to Their Works" (1872).
15. Whitley, *Art in England* 1821–1834 (1928), pp. 132 and 213.
16. Cave (ed.), *The Diary of Joseph Farington, vol. III* (1979), p. 1075 (Oct. 24, 1798); Cave (ed.), *The Diary of Joseph Farington, vol. VII* (1982), p. 2735 (Apr. 26, 1806).
17. Trevor-Roper, *The World Through Blunted Sight* (1988).
18. Goethe, *Theory of Colours* (1970 reprint of 1840 edition), section 726, p. 287.
19. Ibid., section 247, p. 102.
20. Ibid., introduction, lii-liii.
21. Ibid., section 726, p. 287.
22. Strauss, "Why Did Goethe Hate Glasses?" (1981).
23. Goethe, *Theory of Colours* (1970 reprint of 1840 edition), section 247, p. 102.
24. Gage, *Color and Culture* (1993), p. 202.
25. Goethe, *Theory of Colours* (1970 reprint of 1840 edition), section 898, p. 344.
26. Ibid., section 696, p. 276.
27. Magnus, *Goethe as a Scientist* (1949).
28. Gage, *Color in Turner* (1969), pp. 173–188; Gage, *Color and Culture* (1993), pp. 201–204.

Fig. 9.5 Joseph Mallord William Turner, *Shade and Darkness—The Evening of the Deluge*, exhibited 1843. Oil on canvas, 31 x 30 ³⁄₄ in. (78.7 x 78.1 cm). Goethe's theory linked shadows with blue and coldness. However, scholars have debated whether Turner painted this canvas and its companion (see fig. 9.6) to document and praise Goethe's dichotomies, or to take exception to them.

Fig. 9.6 Joseph Mallord William Turner, *Light and Colour (Goethe's Theory)— The Morning after the Deluge*, exhibited 1843. Oil on canvas, 31 x 31 in. (78.7 x 78.7 cm). Goethe linked yellow with light and warmth. This work was painted as a companion to figure 9.5.

THE YELLOW VISION OF VAN GOGH

Vincent van Gogh (1853–1890) painted in a distinctive style, often characterized by a striking use of yellow that some speculate may not have been by artistic choice. His life, full of tragedy, has captured the public's interest. His works have sold at record prices in the current markets, though he struggled to sell them during his lifetime and succeeded only rarely. His medical problems have led to a long list of possible diagnoses. A strong case has been made for psychiatric entities, with manic-depressive (bipolar) illness frequently mentioned to explain the episode of his ear and ultimate suicide.[1] Epilepsy was entertained as a diagnosis on his admission to the hospital in Arles and the asylum at St. Rémy during the last two years of his life.[2] Infectious diseases and toxins have also been considered as diagnoses or adjunctive factors. Recently, acute intermittent porphyria, a hereditary metabolic disease, has been proposed as an all-inclusive diagnosis.[3] This disorder can have a range of neurological manifestations, including pain and mental disturbance, and is believed to account for the madness of King George III of England.[4] Van Gogh's family history is suggestive of a hereditary disease; both his brother Theo and sister Wilhelmina had related symptoms and insanity. However, there is no direct evidence of acute intermittent porphyria in van Gogh, and his personality disturbance was persistent and prominent over many years.

VAN GOGH'S EYESIGHT

Considering the artist's unusual approach to art, some critics have wondered if his eyesight was normal. Furthermore, some of his putative physical disorders, such as toxic exposures and acute intermittent porphyria, can affect vision. The only medical data are the results of a vision examination by his last personal physician, the well-known Paul-Ferdinand Gachet, MD.[5] Van Gogh's vision was tested by Gachet in May 1890 at the doctor's country home in Auvers. Prior to this meeting, the artist's younger brother, Theo, had brought Gachet up to date about Vincent's health status. The examination was an informal one (and in no sense complete) to avoid creating anxiety on van Gogh's part. Gachet was a physician for one of the French railroad companies and was called on at times to test the vision of workers. He had a visual acuity chart on the wall, next to a painting by Camille Pissarro. The chart piqued van Gogh's curiosity, and he reportedly asked Gachet about it. The doctor tested the artist's vision and found it excellent. He needed no glasses for reading or for distance. When tested with the color-vision materials used for the railroad personnel, the results were, again, perfectly normal. This is the extent of the data available on the testing of van Gogh's eyes.

HALOES OF COLOR

Colored haloes around sources of light are found in several of van Gogh's most famous paintings, including 1889's *Starry Night* and *The Night Café* (*Le Café de nuit*) (see fig. 10.1). Certainly van Gogh was not the first artist to paint curvilinear forms of color around light sources. This technique has been employed previously, for symbolic reasons in religious paintings and to create a sense of atmosphere in landscapes. Nevertheless, this visual phenomenon has given rise to speculation that van Gogh may have suffered from a form of glaucoma, a disease that can cause colored haloes to appear around lights.[6] Colored haloes are caused by diffraction of light, the breaking up of white light into its component parts, the color spectrum. Anyone who wears glasses or contacts for distant vision has probably noticed that if the lenses are filmy, in the presence of fog or at night, color haloes can surround streetlights or automobile headlights. But van Gogh did not wear glasses. The cornea itself can diffract light if it becomes abnormally swollen (edematous), and angle closure glaucoma is one of the few diseases capable of causing such swelling intermittently. In this form of glaucoma, a marked elevation of intraocular pressure overcomes the cornea's ability to pump out fluid. However, there is no evidence from van Gogh's lifetime that he ever suffered from glaucoma. In his letters, there is no mention of the characteristic symptoms of this disease: eye pain, nausea, and sudden loss of vision. Furthermore, acute angle closure glaucoma is rarely found in patients under age forty, and van Gogh died at age thirty-seven. In short, there are many reasons to discount this diagnosis, and glaucoma is hardly necessary to explain an artistic device used by so many artists over the ages.

10.1

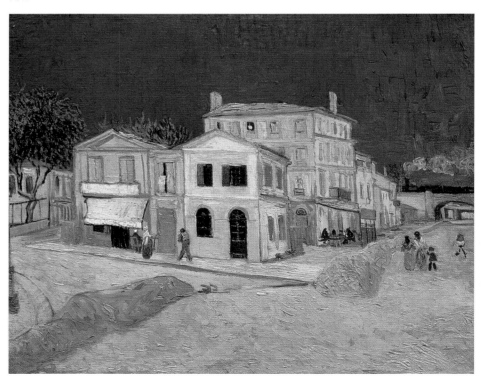

10.2

Fig. 10.1 Vincent van Gogh, *The Night Café (Le Café de nuit)*, 1888. Oil on canvas, 28 ½ x 36 ¼ in. (72.4 x 92.1 cm). This scene has yellow tonality, but it is appropriate to the lighting from lamps. Note the haloes about the lights.

Fig. 10.2 Vincent van Gogh, *The Yellow House*, 1888. Oil on canvas, 28 ½ x 36 in. (72 x 91.5 cm). The yellow house contrasts with an intense blue sky.

Fig. 10.3 Vincent van Gogh, *Portrait of Dr. Gachet*, 1890. Oil on canvas, 23 ½ x 22 in. (67 x 56 cm). Dr. Gachet holds a sprig of foxglove, the source of digitalis.

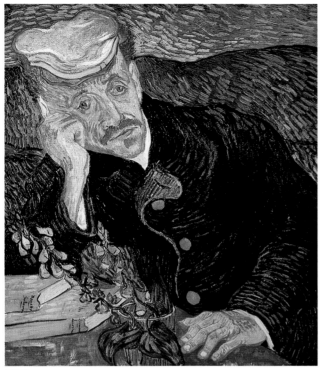

10.3

THE QUESTION OF XANTHOPSIA OR "YELLOW VISION"

A yellow coloration dominates many of van Gogh's paintings[7] and is particularly evident in his late works. Examples of works with a marked yellow cast include *The Night Café* (*Le Café de nuit*) (see fig. 10.1), his paintings of wheat fields, and the painting of the house at Arles simply entitled *The Yellow House* (see fig. 10.2). A yellowishness characterizes the flesh in many of van Gogh's self-portraits, particularly the late ones, even though he is not known to have been jaundiced.

DIGITALIS

After van Gogh cut off part of his left ear in late December 1888, he was admitted to the hospital in Arles. There, he was under the care of Felix Rey, MD, a twenty-three-year-old intern who had graduated from the prestigious University of Montpellier medical school, an ancient school known for its excellent psychiatry program. Rey believed that van Gogh was suffering from a form of epilepsy; Rey was perhaps influenced by a doctoral thesis on epilepsy written by a classmate.[8]

Treatment of seizure disorders at that time often included the use of digitalis, a medication for which there was a large body of pharmacologic knowledge. Although its main use was in cardiology, it was also prescribed for many other purposes. Dr. Gachet, Vincent's last physician, was well aware of this drug and of the importance of proper dosage.

Van Gogh painted portraits of only two of his many physicians, Drs. Rey and Gachet. He painted Rey one time and Gachet twice. The extremely famous portrait of Gachet, auctioned by Christie's in 1990, was at that time the most expensive painting ever to have been sold at a public auction. (It went to a Japanese businessman for $82.5 million and has since disap-

peared from public view.) In the foreground of this painting (see fig. 10.3), there is a sprig of purple foxglove, the plant from which digitalis is derived. Van Gogh had wanted to include something in the painting that would indicate the subject was a physician, and Gachet had suggested the foxglove, symbolic of his interest in diseases of the heart.[9] Although there is no evidence that Vincent was ever treated with digitalis for the diagnosis of a seizure disorder, or for any other diagnosis, the question has frequently arisen because "yellow vision" can be a symptom of digitalis toxicity.

Gachet has been accused of mismanaging van Gogh's care by giving him an excessive dose of digitalis.[10] However, there are several reasons for believing that Gachet could not have possibly treated him with a dose sufficient to cause ocular side effects. First, Gachet was well aware of the potential for problems with this medication. He even wrote that digitalis could be deadly. In his unpublished treatise on military ophthalmia (i.e., ocular inflammation), Gachet stated: "We understand the physiologic effects of this plant well enough today to be afraid of its dangers, and strongly advise against its use, since it can produce syncope by slowing the heartbeat and it can cause paralysis of that organ."[11] Van Gogh would not likely have survived the toxic levels of digitalis necessary to cause xanthopsia, had it been used over an extended period of time.

Second, although digitalis was a medication on the homeopathic medical formulary at the time Gachet was practicing medicine, he would never have given this drug in a dose sufficiently high to cause toxicity. The founder of homeopathy, Samuel Hahnemann, developed a formulary, which lists seventy-three indications for treatment with digitalis, including melancholic thoughts, hypochondria, mental illness, headache, nausea, vomiting, pain in the eyes, swelling of the eyelids, tearing, and inflammation of the eyes.[12] However, homeopathic doses are so extremely low, just minute fractions of allopathic doses, that toxicity is not possible. Although educated in traditional allopathic medicine, Gachet followed homeopathic formulas when it came to therapy. Camille Pissarro had recommended to Theo van Gogh that Gachet, who had treated Pissarro's mother, be engaged as van Gogh's physician. Pissarro knew not only that Gachet would treat the artist sympathetically but also that the doctor was an advocate of homeopathy.

Third, Gachet was not convinced that van Gogh suffered from a seizure disorder, the working diagnosis made when Vincent was admitted to the hospital in Arles and during his confinement at the asylum in St. Rémy. Gachet's son described the scenario in May 1890 when Vincent arrived in Auvers. Prior to that time, although Gachet was familiar with van Gogh's work (he had seen van Gogh's paintings at the exhibitions of the Independents in 1888, 1890, and 1899), the two had never met. Yet from his conversations with Theo, Gachet was optimistic that he could be of help. As soon as he met the artist face-to-face, however, he realized that the medications under consideration would not be effective, and that the diagnosis must be changed from "*crises nerveuses épileptoïdes*" to "*maladie mentale circulaire.*"[13] This latter diagnosis represents an earlier wording for what is known today as manic-depressive (bipolar) illness, a disorder first described in the middle of the nineteenth century[14] by Jean Pierre Falret, MD (1794–1870), a French psychiatrist who worked at the Salpêtrière in Paris. Falret noted the mood swings separated by periods of perfect lucidity, the states of excitation

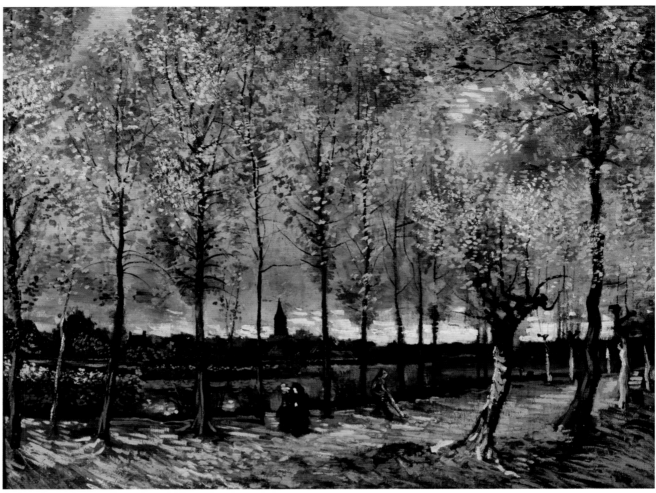

10.4

and depression, the hallucinations, the hereditary aspects of the disease, and the need to use specific medications for its treatment.[15] Gachet studied at the Salpêtrière as an extern on Falret's service in 1855. In 1858 he published his thesis for the medical degree on the subject of melancholy,[16] and he retained an intense interest in mental illness throughout his medical career.

SANTONIN

It has been suggested, without any direct evidence, that van Gogh may have taken santonin, another medication that can acutely cause xanthopsia or yellow vision.[17] Available as an antimicrobial agent against gastrointestinal worms since the beginning of the nineteenth century, santonin was often recommended during van Gogh's lifetime as a preventive medication and utilized for rather imprecise indications. Van Gogh was interested in health questions and owned a copy of Dr. François-Vincent Raspail's popular *Manuel annuaire de la Santé*,[18] which he portrayed in his painting *Still Life: Drawing Board, Pipe, Onions, Sealing-Wax* of 1889. Raspail recommended the use of santonin for gastrointestinal disorders, and van Gogh did have some digestive problems. Others have speculated that van Gogh may have suffered from pica (abnormal craving) for chemicals such as camphor, thujone, and turpentine.[19] This pica could have induced him to take santonin. He did use large doses of camphor to fight off insomnia. He frequently drank absinthe, which contains thujone

as an active ingredient. The artist Paul Signac reported that van Gogh wanted to drink a large volume of turpentine while he was with him.[20] One can only speculate on whether occasional binges with santonin or other substances may have given van Gogh isolated xanthopic experiences. However, as with digitalis, he could not have attained toxic levels for extended periods of time without grave medical risk.

NONMEDICAL FACTORS

Do van Gogh's canvases support a diagnosis of xanthopsia? If so, a significant number of paintings should show a dominance of yellow tints with *no* white, blue, or violet.[21] Some canvases come close to meeting this description, the most interesting being *The Night Café* (*Le Café de nuit*) (see fig. 10.1). Nevertheless, such examples are rare, but do extend back to Holland, where as a young painter, van Gogh had already exhibited a love of the color yellow. Early works featuring strong yellow include *The Potato Eaters* (see fig. 5.13) and *Lane with Poplars, Nuenen* (see fig. 10.4). What is more striking is that the yellow is most often balanced by an abundance of blues and sometimes whites as well. *The Yellow House* and *Wheatfield with Cypresses* (see figs. 10. 2 and 10.5) are typical of many paintings in which strong blues and whites offset the yellow.

These examples emphasize that great caution should be taken in judging the eyesight of artists from their works. Medi-

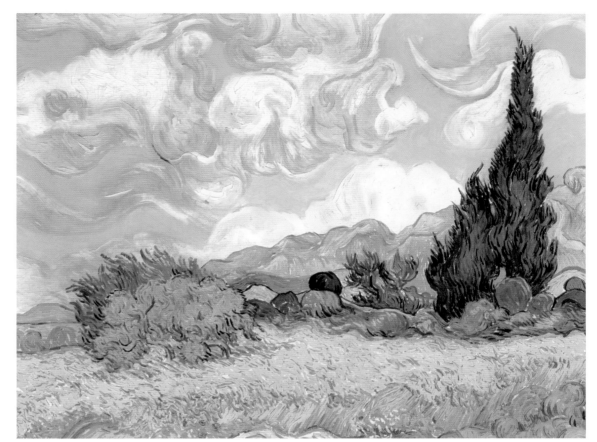

Fig. 10.4 Vincent van Gogh, *Lane with Poplars, Nuenen*, 1985. Oil on canvas, 30 ½ x 38 ½ in. (78 x 98 cm). This early painting from Holland has an overriding yellow tonality.

Fig. 10.5 Vincent van Gogh, *Wheatfield with Cypresses*, 1889. Oil on canvas, 28 ½ x 35 ¾ in. (72.1 x 90.9 cm). In this painting, yellow is associated with both blue and white.

Fig. 10.6 Vincent van Gogh, *Self-Portrait Dedicated to Paul Gauguin*, 1888. Oil on canvas, 24 x 19 ¹¹/₁₆ in. (61 x 50 cm). Van Gogh experimented with the color of his own eyes in self-portraits. In this example, the irises are yellow-brown, while the whites of the eyes are greenish.

10.5

cal historiography has too often been eager to fit unusual diseases to symptoms, perhaps as an outgrowth of a medical education system which trains young doctors to think more of possibilities (lest a diagnosis be missed) than probabilities.[22] Van Gogh is certainly not the first artist whose predominant use of yellow has been attributed to an ocular problem. Others include Guido Reni, Luca Signorelli, Antonio Verrio, El Greco, Titian, and J. M. W. Turner (see chapter 9), although the evidence is marginal that ocular disease (such as a yellowish cataract) was responsible in any of these cases. There are only a few artists, such as Claude Monet (see chapter 30), whose shift in color usage and color vision has been firmly documented as being a result of disease.

There are ample nonmedical explanations for van Gogh's use of color. First, he had an intellectual fascination with color throughout his career, and his letters are filled with discourses about the importance of color and its use. He was constantly experimenting with different tonalities. Like many artists (see chapters 9 and 11), van Gogh studied the color science of his day and tried at times to follow it. In August 1884 he purchased Charles Blanc's *Grammaire des arts du dessin: architecture, sculpture, peinture*, which proposed a basic color triangle, in which red, blue, and yellow are located at the points and opposite the intervening shades of green, orange, and violet respectively.[23] The legacy of Blanc is clear in a letter van Gogh wrote in 1886 and 1887 describing a series of flower paintings: "I have made a series of color studies . . . seeking oppositions of blue with orange, red and green, yellow and violet . . . trying to render intense color and not a grey harmony."[24] Such contrasts appear through his work.

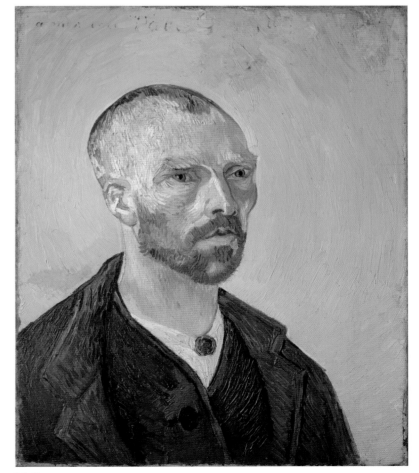

10.6

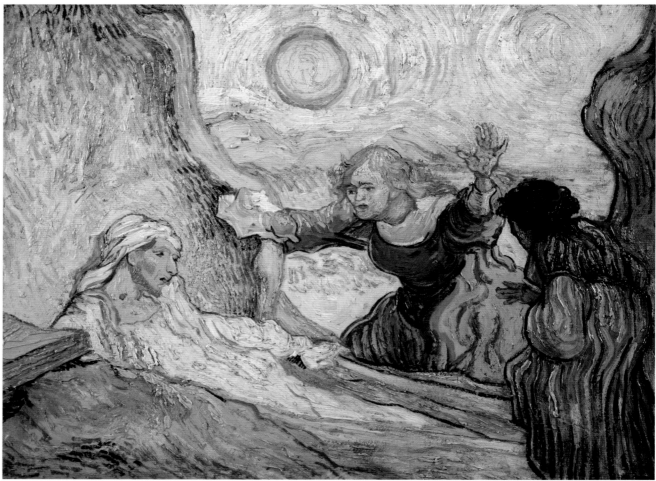

10.7

Fig. 10.7 Vincent van Gogh, *The Raising of Lazarus (after Rembrandt)*, 1890. Oil on paper, canvas, 19 ½ x 25 ½ in. (50 x 65 cm). This painting has an overwhelming and curious use of yellow. But van Gogh describes an intellectual and artistic rationale for his choice of colors.

Second, as much as van Gogh emphasized contrast (and striking examples are found in many of his canvases), he also experimented liberally with color harmonies and impressionistic effects of colors. He described his thought processes in Holland, early in his career, in contemplating autumn in Nuenen in November 1885, and argued that an artist's choice of colors can drive a viewer's perception, independent of nature's choice of colors: "Suppose I have to paint an autumn landscape, trees with yellow leaves. All right—when I conceive it as a symphony in yellow, what does it matter if the fundamental color of yellow is the same as that of the leaves or not?"[25] The painting *Lane with Poplars, Nuenen* (see fig. 10.4) might pass for a xanthopic canvas, with its yellow tonality and gray-green sky, except that small patches of blue and white in the sky show that the yellowish color choices were intentional.

Third, facets of van Gogh's work, such as his self-portraits, demonstrate a conscientious experimentation with color. Putting aside variations in dress and background color, it is fascinating to note that he also changed the color of his own eyes to suit the mood or impression of each painting. He wrote to Theo, "I prefer painting people's eyes to cathedrals for there is something in the eyes that is not in the cathedral, however solemn

and imposing the latter may be."[26] His irises are greenish in his earliest self-portraits (and perhaps therefore in reality), but they are portrayed yellow-brown in a 1888 portrait dedicated to Paul Gauguin (see fig. 10.6) and appear bluish in the self-portraits with a bandaged ear (early 1889) and in later portraits with a blue background (1889–1890). Since van Gogh's eyes cannot have changed color, the shifts must be artistic rather than anatomical, and they underscore his long-standing belief that color can be used impressionistically and independent of reality. He wrote his youngest sister, Wilhelmina, that the colors of one self-portrait included "a pinkish-gray face with green eyes." Then he added: "This, in my opinion, is the advantage that Impressionism possesses over all other things; it is not banal and one seeks after a deeper resemblance than the photographer's."[27]

An example that may serve to show the difficulty in documenting a medical influence on van Gogh's intense explorations of color is his painting *The Raising of Lazarus (after Rembrandt)* (see fig. 10.7), which is patterned after an etching by Rembrandt. At first glance, the painting appears to offer proof of xanthopsia: The ground and sky are yellow and the figures are dressed in green. However, van Gogh's description of it suggests that the colors were chosen for contrast rather than the color aura. Vincent wrote to Theo that "the cave and the corpse are white-yellow-violet. The woman . . . has a green dress and orange hair and a gown of striped green and pink. In the background a countryside of blue hills, a yellow sunrise. Thus, the combination of colors would itself suggest the same thing which

the chiaroscuro of the etching espresses."[28] Van Gogh hardly needed drugs to stimulate his imagination with respect to color. He wrote to Theo from Antwerp in 1885, long before his most famous canvases (and color effects) were produced: "Although the quality of color is not everything in a picture, it is what gives it life."[29]

Yet another example is the famous *The Night Café* (*Le Café de nuit*) (see fig. 10.1), which is bathed in yellow illumination. Van Gogh was so captivated by the scene that "for three nights running I sat up to paint and went to bed during the day . . . The room is blood red and dark yellow with a green billiard table . . . there are four citron-yellow lamps with the glow of orange and green. Everywhere there is a clash and contrast of the most disparate reds and greens . . . sleeping hooligans . . . in violet and blue." He added, "The white coat of the landlord . . . turns citron-yellow or pale luminous green."[30] These notes are testament to a thoughtful study of the effects of artificial lighting as opposed to an impulsive recollection of a yellow scene. Van Gogh returned repeatedly to the model, rather than use his memory, and he carefully noted colors, such as blues and whites (turned yellow under the artificial light), that would not be perceived with true xanthopsia.

Paul Gauguin offered this commentary on the glorious effect of the yellow in one of van Gogh's yellow sunflower paintings: "Oh yes! he loved yellow, this good Vincent, this painter from Holland—those glimmers of sunlight rekindled his soul, that abhorred the fog, that needed the warmth." [31]

NOTES

1. Jamison and Wyatt, "Vincent van Gogh's Illness" (1992); Jamison and Wyatt, "Ménière's Disease? Epilepsy? Psychosis?" (1991).
2. Gastaut, "La maladie de Vincent van Gogh envisagée a la lumière des conceptions nouvelles sur l'épilepsie psychomotrice" (1956).
3. Loftus and Arnold, "Vincent van Gogh's Illness: Acute Intermittent Porphyria?" (1991).
4. Witts, "Porphyria and George III" (1972).
5. Gachet, *Les 70 jours de van Gogh à Auvers* (1994), p. 161.
6. Marie, "Van Gogh's Suicide" (1971).
7. Arnold and Loftus, "Xanthopsia and van Gogh's Yellow Palette" (1991).
8. Gastaut, "La maladie de Vincent van Gogh envisagée a la lumière des conceptions nouvelles sur l'épilepsie psychomotrice" (1956).
9. Doiteau, "La curieuse figure du Dr. Gachet." (1923).
10. Hug, "Le Docteur Gachet et l'homéopathie" (1990).
11. Gachet, "L'ophtalmie des armées en Europe" (1887).
12. Hahnemann, *Traité de maitière médicale, ou de l'action pure des médicamens homoéopathiques* (1834), vol. 2, pp. 219-241.
13. Gachet, *Les 70 jours de van Gogh à Auvers* (1994), p. 242.
14. Goodwin and Jamison, *Manic-Depressive Illness: Bipolar Disorders and Recurrent Depression* (1990), pp. 56–73.
15. Falret, "Mémoire sur la folie circulaire" (1854).
16. Gachet, *Étude sur la mélancolie* (1858).
17. Arnold and Loftus, "Xanthopsia and van Gogh's Yellow Palette" (1991).
18. Arnold, *Vincent van Gogh: Chemicals, Crises, and Creativity* (1992), pp. 58 and 215.
19. Arnold and Loftus, "Xanthopsia and van Gogh's Yellow Palette" (1991).
20. Arnold, *Vincent van Gogh: Chemicals, Crises, and Creativity* (1992), pp. 58 and 215.
21. Lanthony, "La xanthopsie de van Gogh" (1988); Leid, "La vraie dyschromatopsie de van Gogh" (1992).
22. Marmor, "Wilson, Strokes and Zebras" (1982).
23. Hummelen and Peres. "'To Paint Darkness That Is Nevertheless Colour': The Painting Technique of The Potato Eaters" (1993).
24. *The Complete Letters of Vincent van Gogh* (1959), letter 459a.
25. Ibid., letter 429.
26. Ibid., letter 441.
27. Ibid., letter W4.
28. Ibid., letter 632.
29. Ibid., letter 441.
30. Ibid., letter 533.
31. Gauguin, "Natures mortes" (1984).

Fig. 11.1 Georges Seurat, *Sunday Afternoon on the Island of La Grande Jatte*, 1884–86. Oil on canvas, 81 ³/₄ x 121 ¹/₄ in. (207.5 x 308 cm). Seurat's masterpiece is huge, and the dimensions in this book are less than 10 percent of the original.

SEURAT, COLOR SCIENCE, AND NEO-IMPRESSIONISM

*"They see poetry in what I have done.
No, I apply my method and that is all there is to it."*

—SEURAT [1]

The vibrant surfaces of the paintings made by the Neo-Impressionists, who constructed images from small colored dots, have fascinated viewers since the late nineteenth century, when the style was developed. The leader of this group was Georges Seurat (1859–1891), who, despite a short life, produced a group of works that changed the course of modern painting. He quickly became notorious when *Sunday Afternoon on the Island of La Grande Jatte*, the best known of his masterpieces (see fig. 11.1), was shown at the eighth and last exhibition of the Impressionists in 1886. As with many major innovations in art and science, acceptance of something new did not come easily. Although some critics admired and supported the new style, others saw it as too great a break from tradition. Our interest in Seurat and Neo-Impressionism lies in two features of the movement. First, it is rooted in the visual science—particularly color theory—of its day. Second, the visual impact of the paintings is highly dependent on the principles of perception that we have discussed previously (see chapter 8).

A NEW ARTISTIC MOVEMENT

Until the late nineteenth century most viewers of art paid little attention to artists who had not participated in the Salon, the sanctioned, juried art exhibition that was held in Paris nearly every year. But audiences were increasingly jaded by the classical subject matter and academic style of painting, which, though technically proficient, had become repetitive, artificial, and irrelevant to the lives of average citizens. The Impressionists offered an alternative view of nature and art, using broad brushstrokes and bright colors to emphasize light and color over scenic detail and narrative, and in 1874, they established their own series of exhibitions.

At first, many critics viewed this new style negatively. They declared the works technically inept, slapdash, poorly drawn, and badly painted. The Impressionists were sometimes considered "lunatics, maniac, and worse."[2] The caricaturist Cham suggested that pregnant women risked miscarriage when looking at the new art.[3] The critic Huysmans wrote that Paul Cézanne, one of the artists who exhibited at the first Impressionist show, had defective eyesight and that he was "an artist with diseased retinas who, in his exasperated visual perceptions, discovered the premonitory symptoms of a new art."[4] The frequently repeated assertion that the Impressionists in general suffered from ocular problems probably originated from this critic's pronouncements.[5] Another nineteenth-century critic gave an opposing point of view by claiming that Claude Monet and his friends had supernormal vision and, unlike most mortals, could see into the ultraviolet range.[6] Others defended the style as consistent with recent scientific developments, especially improved understanding of light and color inspired by the work of Sir Isaac Newton. When buyers, particularly affluent Americans, began purchasing Impressionist works at steadily rising prices, the public finally took notice.

The Impressionists had already been showing their work for a dozen years when Seurat first exhibited his paintings at their final exhibit in 1886. The paintings that Seurat and the other Neo-Impressionists displayed at this show represented a major stylistic shift. Seurat was twenty-six years old at the time, about two decades younger than the major Impressionists, so he also represented a youthful challenge. While Impressionist paintings emphasize spontaneity and suggest movement, Seurat's compositions were thoroughly planned and his subjects static.[7] Seurat was not the only artist to exhibit paintings done in the new style. Three Impressionists had adopted his method—Camille Pissarro, Camille's son Lucien Pissarro, and Paul Signac. This quartet was given a separate room in which to show their works. Neo-Impressionism weakened the solidarity of the Impressionist group, which had already experienced major rifts and now included artists who painted in diverse manners. Several other prominent artists soon took up Neo-Impressionist techniques, including Vincent van Gogh, Paul Gauguin, and Henri de Toulouse-Lautrec, but their fascination with the style did not last long.

Several terms have been used to describe the avant-garde movement initiated by Seurat. Neo-Impressionism, the most familiar, was coined by Félix Fénéon, a critic who reviewed the 8th Impressionist exhibition in 1886.[8] Seurat preferred "chromo-

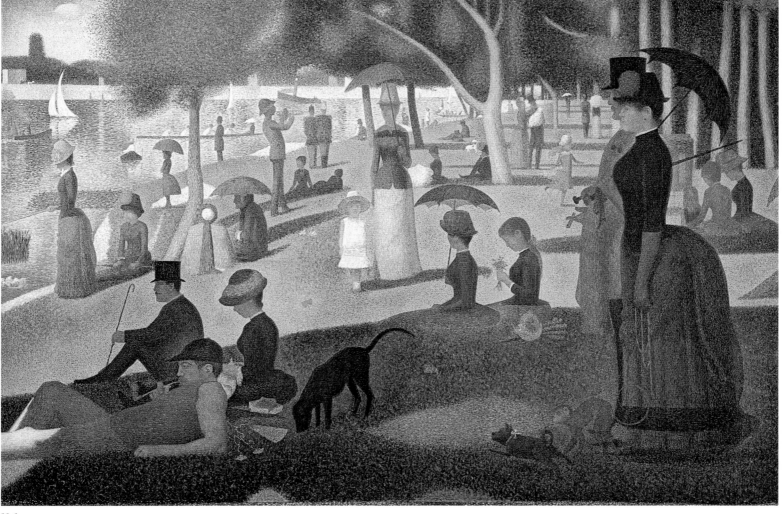

11.1

luminarism," since it embodied his interest in color and light. Fortunately, this cumbersome phraseology never caught on. Seurat's main disciple, Signac, used the word *Divisionism* to describe his separation of color into patches. Divisionism connotes the separation of the dots but does not define the size of them. Nevertheless the term is usually applied to paintings composed of large, distinct dots that do not overlap. Pointillism, which is a subcategory of Divisionism, refers to the technique of using small, distinct dots—or points—of pigment. When the work of Seurat, Signac, and the Pissarros was exhibited in 1886, commentators noted that the individual brushstrokes looked like tapestry stitches; and so *point,* the French word for stitch, became the foundation for *Pointillism.* (Because this term was often used derogatorily, however, the artists disliked it.)

NEO-IMPRESSIONISM AND SCIENCE

The rapid pace of scientific advances during the nineteenth century intrigued the public and provided an optimistic view of the future. Color scientists were exploring the nature of light and pigment, and the Neo-Impressionists believed this new knowledge to be relevant to how paintings are perceived, and thus to the technique of painting. With better scientific insight, they aimed to depict light and color in their paintings more faithfully

than the Impressionists did, by replacing traditional brushstrokes, which they viewed as arbitrary, with regular dots of color. When he was about sixteen years old Seurat read *Grammaire des arts du dessin: architecture, sculpture, peinture,* a basic yet influential text about art. The author, Charles Blanc, was a high French government official as well as a leading critic, historian, and first editor in chief of the important journal *Gazette des Beaux-Arts.* Several editions and translations of the book were published, and it was read carefully by many artists, including not only Seurat, but also Signac, van Gogh, and Gauguin.

Blanc derived many of his ideas about color from chemist Michel-Eugène Chevreul (1786–1889), director of the dye works at the Gobelins tapestry works, and author of the famous book *The Principles of Harmony and Contrast of Colors and Their Application to the Arts.* While Chevreul confused effects of pigment and light, he made insightful observations about simultaneous contrast (colors seen next to each other) and successive contrast (colors seen one after the other). He explained, for example, why placing red next to blue will make the blue seem slightly greenish. Blanc quoted Chevreul, and Seurat, who considered Blanc an authority, took many ideas directly from this analysis. Blanc's concept of *mélange optique,* or "optical mixture," within the eye of the observer as opposed to on a palette, was essential to Seurat's aesthetic thinking. Seurat also gleaned from

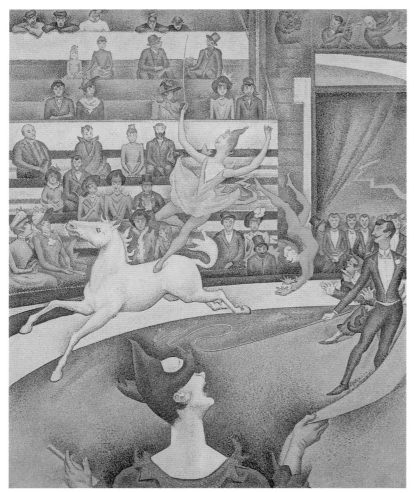

11.2

Fig. 11.2 Georges Seurat, *Le Cirque (The Circus)*, 1891. Oil on canvas, 73 x 60 in. (185.5 x 152.5 cm). Much of this image is a study in contrast more than color, with a mix of blue and yellow dots creating shades of gray.

It was mainly Rood who gave Seurat the most detailed scientific support for using a *mélange optique* for painting. Rood wrote that artists for some time had practiced the technique of "placing a quantity of small dots of two colors very near one and other, and allowing them to be blended by the eye placed at the proper distance . . . This method is almost the only practical one at the disposal of the artist whereby he can actually mix, not pigments, but masses of colored light."[10] Seurat may have understood this explanation to be an instruction on how to achieve a realistic color mixture within the eye. In reality, there is a problem with the concept as applied to art: The reflected light off of dots of paint is not necessarily pure spectral color, and it lacks the intensity of light from bright sources. Since the optical mix is not of itself so vibrant, it will not yield true spectral mixtures (e.g., yellow from red and green), without the addition of white for brightness. In studies he made in 1887 and 1888, Seurat still utilized the color theory that he had learned from Blanc.[11] Though *Modern Chromatics* became a manifesto for the Neo-Impressionist movement, Rood was not pleased with how the Neo-Impressionists applied his principles. After seeing their paintings he said: "I always knew that a painter could see anything he wanted to in nature, but I never before knew that he could see anything he chose in a book."[12]

Another scientist who influenced Seurat and the other Neo-Impressionists, particularly Signac, was Charles Henry. Seurat met Henry after the opening of the 8th Impressionist exhibition. A mathematician, Henry applied mathematical principles to phenomena in psychology, biology, and aesthetics. He advocated using specific colors and specific orientations of lines to reveal emotion, and Seurat did vary hues and lines depending on whether he wanted to achieve a sense of calmness, gaiety, or sadness. Although Seurat undoubtedly got ideas from Henry for some of his stylized representations of form and angles (see fig. 11.2), he did not follow Henry's mathematical proportions with any precision.

In judging the value and impact of color theories, Seurat was also influenced by the painting and writing of the Romantic painter Eugène Delacroix (1798–1863). Delacroix had read Chevreul many years before Seurat, and was aware of Chevreul's explanation of how adjacent colors, especially complementary ones, affect each other. Chevreul had written: "The greater the difference between the colors, the more they mutually beautify each other; and inversely, the less difference there is, the more they will tend to injure one another."[13] Delacroix achieved powerful results by bold use of colors, and he often juxtaposed hues rather than blending them in the traditional manner. Seurat incorporated two features of Delacroix's technique into his style. He surrounded colors with their complementary hues (red with green, blue with orange, and yellow with purple) and also divided fields of color into several closely related tones. Although Delacroix broke from tradition in using flecks of color and high contrast, he never made an entire painting out of small, colored dots. Delacroix's *Journal* contains many provocative comments that undoubtedly appealed to Seurat. For example, Delacroix stated that gray is the enemy of painting. While Delacroix and later Seurat advocated avoiding earth colors, since these hues would decrease the brilliance of a painting, neither artist fully followed his own advice.

Blanc the idea that he should limit colors to those found in Sir Isaac Newton's prismatic spectrum, as well as exclude brown and other earth tones. Seurat used Blanc's term "analogy of similarities" to describe colors that are nearly the same and "analogy of opposites" to describe complementary colors. Even Seurat's definition of painting as "the art of hollowing out a surface" was derived from Blanc's clearer description of painting as "hollowing out fictional depths on a flat surface."[9] Despite his early interest in Blanc's writings, Seurat had some difficulty incorporating Blanc's theories into practice. He did not begin to paint using multiple dots for several years. This technique was a later invention, inspired by a variety of sources, in particular the work of Ogden Rood.

In 1881 *Le Figaro* carried a notice that a popular scientific book on color theory, *Modern Chromatics*, by Ogden Rood, had just been translated from English into French. Continually searching for the ideal method of optical painting, Seurat consulted the book for technical information. Rood was a professor of physics at Columbia College in New York. His book incorporated concepts from several scientists, including Hermann von Helmholtz, the nineteenth-century German physician who invented the ophthalmoscope (the optical instrument that allows a view inside the eye to examine the retina) and identified the primary colors of light as red, green, and blue-violet. Helmholtz explained that the retina contains three sets of color receptors, each of which is most sensitive to one of the three primary wavelengths of light.

Behind a tall, handsome facade, Seurat was shy and retiring, yet he was voluble with colleagues and took great pride in his theoretical approach to art and his technical innovation of Pointillism (although he didn't like that term). In 1890 a journalist asked Seurat to describe his aesthetics. Seurat never sent his reply, but in a draft he wrote that his theory is "grounded on Delacroix and oriental precepts, supported by Chevreul, Rood, Helmholtz, C. Henry."[14] That same year Félix Fénéon wrote an article about Seurat's friend and fellow Neo-Impressionist Signac but failed to mention Seurat. Seurat was offended and wrote a detailed letter explaining why "[Camille] Pissarro's and Signac's evolution was slower," and why he should be recognized as the true founder of Neo-Impressionism. Seurat related how he had been "searching for an optical formula" for painting "ever since I held a brush . . . having read Charles Blanc in school."[15] He described being "struck by the intuition of Monet and Pissarro" and mentioned all of the scientists we have discussed as well as Delacroix. Signac and Pissarro may have been better known early in the history of Neo-Impressionism, but Seurat wrote: "There is a nuance here and that if I was unknown in '85, I nonetheless existed, I and my vision . . ."[16]

TECHNIQUE AND VISUAL EFFECTS OF POINTILLISM

Seurat was educated for two years at the state-supported fine arts school, the École des Beaux-Arts, where he learned the traditional method of painting, that of rendering form on a tinted ground before adding color. The subject would first be modeled in light and dark earth tones and then translucent colored glazes were added in layers. Early in their careers the Impressionists also painted on tinted grounds. They later switched to painting directly on white canvas, and often applied only a single layer of pigment. Lightening up the palette and loosening the brushstroke gave their paintings a free, spontaneous character as compared with the more studied look of traditional painting. Seurat was well aware of the Impressionist technique and made some changes from the academic method in which he had been trained. He, too, turned from painting on brown panel or canvas surfaces to white canvas, and he brightened his choice of colors.

While we think of Seurat's Pointillism as a formalized mechanism for rendering color, his search for aesthetic formulas has firm roots in his drawings. His figures in studies as well as in paintings such as Sunday Afternoon on the Island of La Grande Jatte (see fig. 11.1) appear stiff and flat, more akin to ancient Egyptian sculpture or folk art than traditional painting, so some critics termed them "primitive."[17] And he studied effects of contrast as intensively as effects of color. His black-and-white drawings are, in fact, almost Pointillist in character because he used a rough paper and applied the crayon to it gently, so that the finished drawings seem to be made up of rows of fine dots. The scientific inspiration of Charles Blanc is again applicable, since Blanc described the use of dots as a means of highlighting contrast. Chevreul also discussed contrast effects of light and dark as well as of color. These concepts can be traced to Leonardo da Vinci, who stated that a light-colored object should be ringed by a dark background, and vice versa. In many of Seurat's drawings (see fig. 6.7), in earlier paintings such as Bathers at Asnières, and then again in late works such as Le Cirque (The Circus) (see fig. 11.2) and a portrait of his companion Madeleine Knoblock

(see fig. 11.3), Seurat consciously and noticeably adjusted the immediate surround of his figures to achieve contrast, even if it meant that a lawn, lake, circus ring, or interior wall would waver between light and dark. These effects are not so intense in Sunday Afternoon on the Island of La Grande Jatte, but are quite obvious and almost distracting in Le Cirque (The Circus) and the Knoblock portrait, once they are noticed.

This formalized approach to contrast remained a feature of Seurat's paintings and helps us to understand his choice of colors (which are seen more clearly in preliminary studies, such as fig. 11.4). With few exceptions, his colors tend to be subdued or to "gray out" when dots of complementary colors merge (see discussion in chapter 8). In his last major painting, Le Cirque (The Circus), much of the painting is colored with blue and yellow spots, effectively substitutions for black and white, which blur to a gray when the dots optically mix, since they are relatively complementary colors. Seurat's concept of color mixing is an extension of his understanding of contrast, not independent of it. In Le Cirque (The Circus) we also see extensive shading of Mach bands, reminiscent of Asian brush paintings or foretelling the work of Georgia O'Keeffe (see chapters 6 and 37).

The dots in Seurat's canvases are clearly visible and not always regular in size or shape, and he varied them depending upon the subject he was painting. He composed tree trunks, for example, of larger rectangular spots of paint that, as the branches curve away from the trunk, diminish in size and curve toward the horizontal plane. The dots fascinate and perhaps even overwhelm the observer, who may notice the technique more than the subject matter. The dots may have appeared even more striking to nineteenth-century than twenty-first–century observers, since today's viewer has been routinely exposed to fragmented images unknown in 1886, such as hazy television screens and pixelated computer images. Seurat and the Neo-Impressionists were well aware that the effect of dots, whether to achieve color mixing or to create visual interest, was dependent on their size—or more precisely, size relative to viewing distance. In small studies, Seurat applied larger dabs of paint relative to the image size to explore color relationships, but his finished canvases are made up of relatively tiny dots and were described as Pointillist. Compare the dot sizes used in figures 11.3 and 11.4, which are respectively a finished work and a study of the same subject. Signac, Camille Pissarro, and many of the other Neo-Impressionists soon began to use somewhat larger paint dots in a technique that they described as Divisionist. These dots did not blend as well, but in general created contrast effects between the different colors and a vibrant feel in large areas that were covered with spots of similar color, as in The Chateau des Papes, Avignon and Entrance to the Grand Canal, Venice (see figs. 11.5 and 8.7).

Why do dots of paint appear so different from mixed paint on a canvas? As discussed in chapter 8, much of the answer lies in the organization of our eyes and visual system, which can resolve objects with high contrast (e.g., black and white) at much smaller size than objects that differ in color alone. Or stated differently, an array of colored dots will blend long before we lose the ability to distinguish and recognize the individual dots. This phenomenon means that there are three somewhat distinct ways that we perceive a Pointillist painting, depending on distance from the canvas: At close range a viewer with normal vision can see clearly the shape and colors of the individual dots. The dots interact by simultaneous contrast, but

11.3

11.4

they do not fuse, so there is no optical mixture. At intermediate viewing distances the observer still recognizes the presence of separate dots, but now also sees the colors blend to produce a properly colored image of the scene. The result is shimmering, or vibratory, and this simultaneous awareness of matrix and blend is what gives Pointillism its distinct character.[18] If the observer moves still farther away, the separate dots are no longer visible and there is complete optical mixture. The distance required for fusion depends upon the size and separation of the dots. The mixture creates different hues from their components. Seurat often juxtaposed complementary colors, such as blue and orange, or violet and yellow, which will mix optically but produce a nondescript gray. Thus, the colors of many of his paintings (as in examples of this chapter and also fig. 8.6), seen at a long distance, are disappointingly dull.

As a general rule, observers view Neo-Impressionist works at distances too close for complete fusion to take place. Blanc advised viewing a canvas from no farther than three times a painting's maximum dimension. Seurat must have known that at the typical viewing distance, the optical mixture in his own canvases would be incomplete, and we must presume that he liked the result.[19] In this respect the visual effects of Pointillism were more important than theory to these artists. "We are in a

studio, not a laboratory," as the critic Fénéon liked to say.[20] In a similar fashion, Chuck Close (see chapter 13) evolved his style as he explored the effects of pixel size. His early works are made up of small elements that blend in a typical Pointillist fashion, but he challenges viewers in later works with paintings on such a huge scale that one cannot really fuse the pixels.

The Neo-Impressionists wanted to create a realistic sense of color and hoped to use new scientific understanding of color and light to implement their goal. They were aware of the differences between subtractive colors in pigment and additive colors in light, but probably did not appreciate the difference between impure paint colors and pure spectral colors of light, nor the confounding of theory that would occur if some of the dots were overlapped or mixed together. The Neo-Impressionists preferred and generally sought additive mixtures of light, believing that the result would be more intense and luminous than subtractive mixtures of paint. However, their paintings made up of tiny dots, such as *Sunday Afternoon on the Island of La Grande Jatte,* are almost invariably a combination of additive and subtractive effects, since portions of many dots do overlap.

The Divisionist dots of Signac, Pissarro, and others have much less overlap relative to their larger size. Thus, they are more pure with respect to mixing light versus pigment—but the

11.5

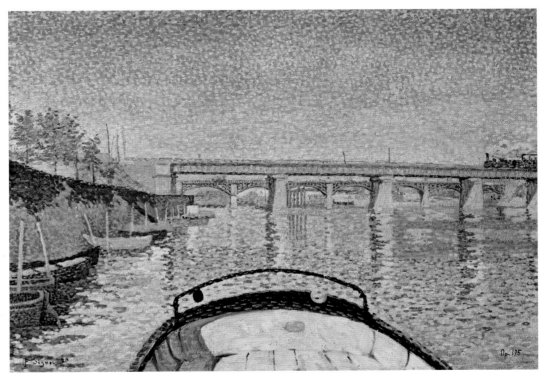

Fig. 11.3 Georges Seurat, *Young Woman Powdering Herself*, c. 1888–90. Oil on canvas, 37 ¹/₂ x 31 ¹/₄ in. (95.5 x 79.5 cm). The colors in this painting appear relatively faded and gray, in part because the dots are often juxtaposing complementary colors.

Fig. 11.4 Georges Seurat, *Young Woman Powdering Herself*, 1889. Oil on canvas, 10 x 6 ⁵/₈ in. (25.7 x 16.8 cm). This work, a small study for the painting of the same name (see fig. 11.3), shows Seurat's exploration of color mixtures using dots of paint that are much larger in relation to the subject.

Fig. 11.5 Paul Signac, *The Chateau des Papes, Avignon*, 1900. Oil on canvas, 29 x 36 ¹/₂ in. (73.5 x 92.5). Large fields of similar-colored but discrete dots of paint give this work a vibrant appearance.

Fig. 11.6 Paul Signac, *The Bridge at Asnières*, 1888. Oil on canvas, 18 x 25 ¹/₂ in. (46 x 65 cm). This early Signac painting is largely Pointillist and shows the graying of the bridge and riverbank, as seen in Seurat's paintings. But Signac also experimented with larger dabs of paint in the water near the boat to give a sensation of ripples.

11.6

larger dot size means that it is harder for the colors to blend, since even the color-sensitive visual pathways can distinguish the larger spots. The Divisionists tended to cover much of their canvases with dots of similar colors (e.g., shades of red and orange) rather than complementary ones. When contrast is used, the effect is more jarring, but also brighter and without as much tendency to "gray out." Signac's paintings in the 1880s, such as *The Bridge at Asnières* (see fig. 11.6) were similar to those of Seurat, and he often used dots of complementary color just as Seurat did in sections of *Sunday Afternoon on the Island of La Grande Jatte*. However, in an 1899 book on Neo-Impressionism, Signac made clear that he was aware of the problem of spot size relative to the "gray-out" effect, saying "the technique of *dotting* . . . renders a painting's surface more vibrant, but it does not ensure brightness, intensity of coloring or harmony . . . A red surface and a green surface, contrasted, stimulate each other, but red dots mixed with green dots form a gray, colorless mass."[21] Sadly, Seurat died suddenly of meningitis in 1891, so we will never know where his research and aesthetic philosophies might have led.

CURRENT ASSESSMENT

Critical thinking has been moving away from the view that science, especially color theory, governed Seurat's aesthetic choices. Despite the huge volume of historical study that has attempted to link nineteenth-century progress in science and avant-garde movements in painting, some influential art historians remained skeptical. Long ago an astute historian warned us: "The concept of fusion of light rays within the eye, with its apparent scientific basis, has been with us for a long time, but it obscures rather than illuminates what happens in the pictures."[22] Robert L. Herbert, the scholar who edited the catalogs for two recent Seurat exhibitions,[23] has downgraded an earlier assessment of the importance of science to Seurat's painting. In the introduction to the latest catalog he writes of Seurat: "Although a distinct individual with unique procedures, he was like other artists who built up experience through the act of painting, and I realized that I had greatly exaggerated the role of scientific color theory in his development. If he can be called 'scientific' at all, it would be from his use of trial and error, constantly shifting his practice according to the results of what he was making."[24]

There is no question that Seurat read avidly about science, and even copied segments of books longhand into his journals. But he was an artist and not a scientist. We can recognize where color theory inspired his ideas, and our modern understanding of color helps us to understand the effects of what he ultimately put onto the canvas. Yet much of Seurat's work was artistic investigation rather than scientific exploration. For example, he may have had theories about techniques for showing color, but his formalized, stiff compositions were created for reasons that have nothing to do with the physics of light. He was intrigued by classical art and aesthetic theories, and it is these, rather than color theory, that led to the curious rigidity of design in his Pointillist paintings. We can see many modern extensions of the same visual principles in computer screens and magazine illustrations as well as in the massive images of Chuck Close. Pointillism was neither an end in itself nor the solution to a visual dilemma; it is simply one phase of an ongoing exploration of science and art, but one that fortuitously has left us with some of the most captivating paintings of the modern era.

NOTES

1. Gallatin, *Of Art: Plato to Picasso—Aphorisms and Observations* (1944), p. 21.
2. Moffat, *The New Painting: Impressionism 1874–1886* (1986), p. 17.
3. Ibid.
4. Huysmans, "Trois peintres" (1888 and republished in *Cezanne. The Late Work*, 1996), p. 27.
5. Hamilton, "Cezanne and His Critics" (1997), p. 148.
6. Lostalot, "Exhibition of the Works of M. Claude Monet" (1883 and republished in Stuckey, 1985), p. 104.
7. Herbert, *Seurat and the Making of "La Grande Jatte"* (2004), p. 22.
8. Fénéon, "Les Impressionistes" (1886 and republished in Halperin, 1988), p. 92.
9. Herbert, *Georges Seurat 1859–1891* (1991), p. 384.
10. Rood, *Modern Chromatics: Students' Text-book of Color, with Applications to Art and Industry Including a Facsimile of the First American Edition of 1879* (1973), p. 140.
11. Smith, *Seurat and the Avant-Garde* (1997), pp. 29–30.
12. Rood, *Modern Chromatics: Students' Text-book of Color, with Applications to Art and Industry Including a Facsimile of the First American Edition of 1879* (1973), p. 28.
13. Homer, *Seurat and the Science of Painting* (1964), p. 29.
14. Herbert, *Georges Seurat 1859–1891* (1991), p. 383.
15. Ibid.
16. Ibid.
17. Ibid., pp. 174–175.
18. Ratliff, *Paul Signac and Color in Neo-Impressionism* (1992), pp. 36–37.
19. Smith, *Seurat and the Avant-Garde* (1997), p. 47.
20. Fénéon, "Les Impressionistes" (1886 and republished in Halperin, 1988), p. 134.
21. Signac, quoted in Ratliff, Paul Signac and Color in Neo-Impressionism (1992), pp. 261–262.
22. Webster, "The Technique of Impressionism: A Reappraisal" (1945), pp. 3–22.
23. Herbert, *Seurat and the Making of "La Grande Jatte"* (2004), p. 22; Herbert, *Georges Seurat 1859–1891*, (1991), p. 384.
24. Herbert, *Seurat and the Making of "La Grande Jatte"* (2004), p. 24.

MATISSE AND
THE IMPLICATIONS
OF COLOR

Henri Matisse (1869–1954) painted in a variety of styles over his long career, but a common thread was his intense concern over the effects and interrelationships of color.[1] To "copy nature stupidly," as he was taught in art school by masters of traditional French Salon painting, had no value to him.[2] Rather, he believed that the artist must study "drawing, color, values, composition; to explore how these elements could be combined into a synthesis without diminishing the eloquence of any one of them by the presence of the others."[3] He vigorously denied any application of color theory. Indeed, he decried the formulative approach of Seurat and the Neo-Impressionists, and built images based on colors and color relationships that pleased his eyes. Nevertheless, in looking at the evolution of his work, and the ways in which he used color, we can recognize many principles of color perception that underlie how we see the world—and art. Understanding how Matisse exploited these principles gives insight into aspects of his work, and perhaps explains why he made certain choices he did. This chapter is based on a study by Anne Kemble.[4]

EARLY PAINTINGS: 1890S

Having studied law, Matisse did not begin painting until his twenties, when his mother gave him a box of paints to divert him while he recovered from appendicitis. Not long after, he read Frédéric Goupil's "*Manuel général de la peinture à l'huile*," which taught painting as an art of imitation, and moved to Paris to train at the Académie Julian under William-Adolphe Bouguereau (see fig. 2.1). In early paintings, such as *Woman Reading, Paris, Winter* (see fig. 12.1), Matisse relied heavily on traditional technique and perspective to make a realistic representation of his subjects. Unhappy with Bouguereau's technically stringent approach to painting, Matisse initially failed the entrance exam to the École des Beaux-Arts, but he was eventually accepted as a student under Gustave Moreau, who encouraged individual creativity and stressed the value of simplification.

EXPERIMENTS WITH IMPRESSIONISM AND DIVISIONISM: 1898–1905

Never afraid of the influence of other artists, Matisse experimented with various styles of painting throughout his lifetime. In the late 1890s, he explored Impressionist techniques. He incorporated color shifts that are not entirely realistic to create a sense of atmosphere, but still portrayed spatial depth and subjects more or less realistically. He also experimented with divisionism. In Divisionist works such as *Luxe, calme et volupté* (see fig. 12.2), he constructed images from regions of similarly colored patches that consist of large brushstrokes on a white background. This technique was done in conscious distinction to Seurat's Pointillism, in which images were constructed from

Fig. 12.2 Henri Matisse, *Luxe, calme, et volupté*, 1904. Oil on canvas, 38 ½ x 44 in. (98 x 111.8 cm). This brilliant Divisionist painting reveals multiple visual effects. The discrete dabs of paint give vibrancy to the scene. The strong colors contrast and stimulate the viewer. One also sees assimilation effects (as in figure 8.8) in that the interspersed white background lightens and brightens colors, while interspersed dark spots make the same colors appear darker. Look at the sharp curve of the beach at the left of the canvas: Pinks appear darker amid the blue spots than amid the white areas below, and the same is true for green on the hillside as opposed to the green near the beach.

Fig. 12.3 Henri Matisse, *La Gitane (Gypsy)*, 1905–06. Oil on canvas, 21 ½ x 18 in. (55 x 46 cm). **(a)** This Fauvist painting is somewhat grotesque, with colors that are unusual at best. **(b)** Despite the unusual colors, the brightness relationships make the subject seem relatively natural in a luminance (black-and-white) image.

Fig. 12.4 Henri Matisse, *Gate of the Casbah*, 1912–13. Oil on canvas, 45 ⅝ x 31 ½ in. (116 x 80 cm). **(a)** Despite the striking red path, this painting seems curiously flat, and it is hard to separate interior from exterior. **(b)** The luminance (black-and-white) image reveals that the red path differs in brightness from much of the surrounding blue, and that the yellow couch on which a person is sitting is similar in brightness to the wall.

much smaller and more closely placed dots of complementary colors that mix optically when viewed from far enough away (see chapter 11). Matisse's larger strokes of color, without the addition of interspersed complementary colored dots, reduce the occurrence of optical mixing and encourage interactions of contrast, and sometimes the von Bezold effect, the assimilation between colors in a pattern (see chapter 8). Matisse's writings suggest that he had awareness of these phenomena aesthetically if not physiologically. Ultimately he rejected the complexity of Divisionist color effects, writing: "My dominant colors, which were supposed to be supported by contrasts, were eaten away by these contrasts . . . This led me to painting with flat tones: It was Fauvism."[5]

THE LIBERATION OF COLOR: THE FAUVIST PERIOD, 1905–1918

Regarding the origins of Fauvism, Matisse wrote: "I started painting in planes, seeking the quality of the picture by an accord of all the flat colors." He described his new goal as follows: "Construction by colored surfaces. Search for intensity of color, subject matter being unimportant."[6] Color had become itself the subject—or focal point—of his paintings, as opposed to something applied for the purpose of enhancing a subject.

From 1905 to 1906, Matisse experimented with starkly unrealistic or nonrepresentational color hues to portray subjects, such as *La Gitane (Gypsy)* (see fig. 12.3a). The results are captivating, and yet it is important to note that when viewed in black and white, the relative darkness or lightness of his color choices is generally realistic (see fig. 12.3b). Since the components of our visual system that recognize form and depth are color-blind (see chapter 8), this careful attention to luminance, or the value of colors, ensures that we recognize subjects easily and independently of their color. Matisse wrote: "I express variety of illumination through an understanding of the differences in the values of colors."[7]

By 1908 Matisse was exploring an even greater independence of color. He constructed images with broad expanses of color, and minimal cues of orientation or depth; and perspective is often distorted if used at all. Examples include the famous panels *Dance* and *Music*, in each of which the figures are portrayed on an ill-defined expanse of color, and *The Red Studio*, in which scattered chairs and other objects are the only cues to where the floor becomes the wall. *Gate of the Casbah* (see fig. 12.4a) shows an additional level of color manipulation. Although a red carpet leads inward, it does not convincingly convey depth because the value (luminance) of the red is so close to that of the surrounding blue walls. As discussed in chapter 8, equiluminant colors are not effective for spatial orientation because the visual mechanisms for discerning form and depth rely on brightness rather than color. Fig. 12.4b shows the same image in black and white, and it is hard to separate walls and floor, or near from far. The lighter turquoise panel on the left is the only perspective element that stands out, and it is not sufficient by itself to resolve ambiguities between the blue expanses that have minimal borders. Even the figure and the yellow couch to the left are hard to discern in gray scale because the colors are equiluminant. This technique makes color dominant over form and depth, and creates an intriguing visual tension between color and object, and between depth and flatness.

In an influential essay that Matisse wrote in 1908,[8] he

12.3 a

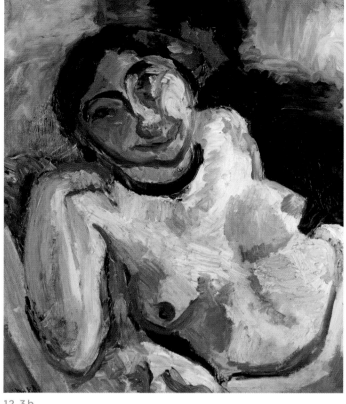

12.3 b

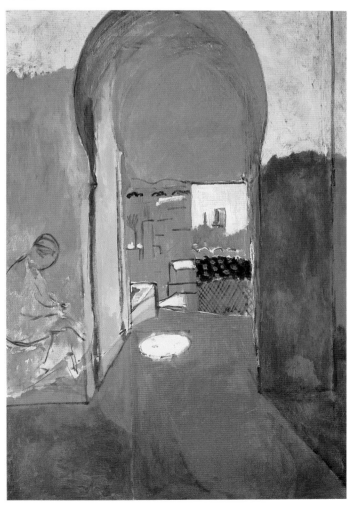

12.4 a

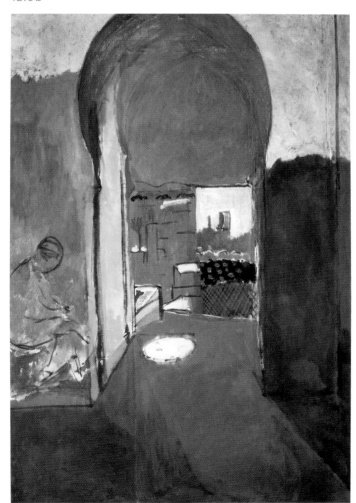

12.4 b

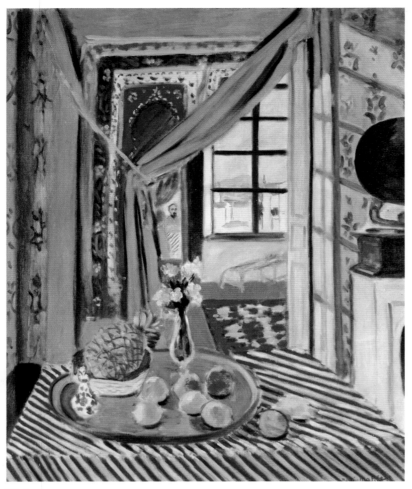

12.5

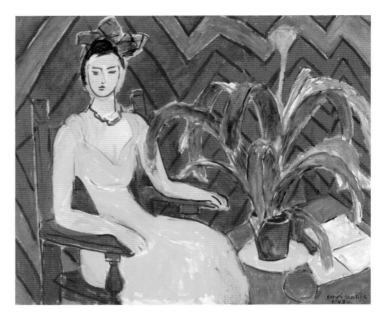

12.6

described his process of choosing colors, which began through observation and his sensations, but then became a study of color relationships quite independent of the original subject: "Suppose I have to paint an interior: I have before me a cupboard; it gives me a sensation of vivid red, and I put down a red that satisfies me . . . Let me put a green near the red, and make the floor yellow; and again there will be relationships between the green or yellow and the white of the canvas which will satisfy me. But these different tones mutually weaken one another. It is necessary that the diverse marks [*signes*] I use be balanced so that they do not destroy each other . . . A new combination of colors will succeed the first . . . until finally my picture may seem completely changed when, after successive modifications, the red has succeeded the green as the dominant color. It is not possible for me to copy nature in a servile way; I am forced to interpret nature and submit it to the spirit of the picture . . . there must result a living harmony of colors, a harmony analogous to that of a musical composition."

THE "NICE PERIOD": 1918–1929

Around 1918, Matisse returned to a more Impressionistic style of painting at about the same time he moved to Nice. He said in a 1919 interview: "I first worked as an Impressionist, directly from nature; I later sought concentration and more intense expression both in line and color, and then, of course, I had to sacrifice other values to a certain degree, corporeality and spatial depth, the richness of detail. Now I want to combine it all."[9] With this new set of goals, Matisse moved away from the singular focus on color and the flat representations of his Fauvist period. He began to paint people and indoor scenes with decorative details and a core of realism, as in *Interior with a Phonograph* (see fig. 12.5). He still used vibrant colors, and he took liberties with perspective, but these were no longer the dominant features of his paintings.

Matisse wrote little about his work during this period, but in the 1930s he expressed a growing discontent with the Nice style, indicating that he had regressed too far from the pure use of color and space. He described a need to restore the dominant role of color, which was the "essential core" of his approach to art: "Pictures . . . call for beautiful blues, beautiful reds, beautiful yellows—materials to stir the sensual depths in men. This is the starting point of Fauvism: the courage to return to the purity of the means."[10]

1930S AND BEYOND

After the Nice period, Matisse simplified his designs again and made color more central, but he did not totally abandon the decorative and representational elements of that time. He continued to explore the relativity of color versus form, although he could not have been aware of the physiological separation of these elements, something that would not be recognized for many decades. In 1948 he wrote of drawing as the domain of the spirit, and of color as the domain of sensuality. He considered drawing as "the female" and painting as "the male."[11] This visual dichotomy can be seen in many paintings of the 1940s, for example *Michaela (The Yellow Dress)* (see fig. 12.6), in which he separated line and color by outlining the subject but applying swaths of color with casual regard to that outline. This disparate depiction of shape and color space still allows for recognition of the subject because the visual pathway that perceives form and fine detail is distinct from the one that perceives color (see chap-

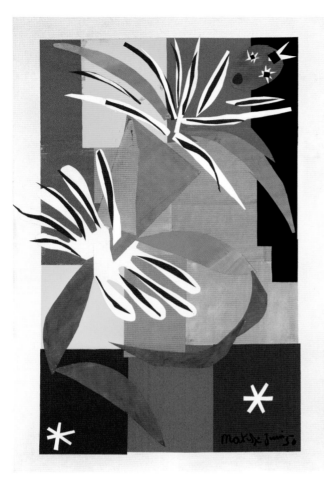

12.7

Fig. 12.5 Henri Matisse, *Interior with a Phonograph*, 1924. Oil on canvas, 34 ⅝ x 31 ½ in. (100.5 x 81 cm). This painting is busy with objects and designs, and even some shadows, although it reflects Matisse's personal approach to perspective.

Fig. 12.6 Henri Matisse, *Michaela (The Yellow Dress)*, 1943. Oil on canvas, 23 ⅝ x 28 ⅜ in. (60 x 72 cm). The colors are not applied accurately within the outlines of objects in this painting, yet features such as leaves, the woman's dress, and hair ribbons are easily recognizable. Compare this image with Dufy's *Boardwalk in Nice* (see fig. 8.10).

Fig. 12.7 Henri Matisse, *Female Creole Dancer*, 1950. Cutout, 80 ½ x 47 in. (205 x 120 cm). Color relationships dominate this image constructed from cut paper.

ter 8). Since form is primary in our consciousness, we recognize and accept these images even if the secondary characteristic of color is not applied accurately.

In 1941 Matisse underwent surgery for colon cancer, after which he suffered a long series of postoperative complications that left him largely confined to a wheelchair or bed. Often too weak to paint, his physical limitations forced him to explore new means of expression. He began to cut out colored paper shapes and paste them onto paper to make works such as *Female Creole Dancer* (see fig. 12.7). He found that the cutouts allowed him to "draw in color" instead of filling colors into the outlines of a drawing, calling it "a simplification [that] ensures an accuracy in

the union of [drawing and color] . . . It is not a starting point but a culmination"[12] In 1951 he explained: "There is no break between my early pictures and my cutouts, except that with greater completeness and abstraction I have attained a form filtered to its essentials."[13] Returning to the analogy between the expressiveness of music and art, Matisse wrote: "Colors have a beauty of their own which must be preserved, as one strives to preserve some tones in music."[14]

CONCLUSION

Matisse wrote in 1908: "My choice of colors does not rest upon any scientific theory: It is based upon observation, upon feeling, upon the experience of my sensibility."[15] Throughout his career, he decried painting by theory or fixed method. His devotion to color and form, independent of subject, led him intuitively to use physiological principles of color perception in new and unusual ways. Understanding these principles gives us insight into some of his visual effects, and into the rationale for some of his color choices. But it cannot explain why the specific combinations of subject, form, and color in his paintings are so uniquely effective and compelling to us in the twenty-first century. This is where art transcends science—and where we must acknowledge the hand of a master.

NOTES

1. Benjamin, *Matisse's "Notes of a Painter": Criticism, Theory, and Context, 1891–1908* (1987); Flam, *Matisse on Art* (1995); Spurling, *Matisse the Master: A Life of Henri Matisse; The Conquest of Colour, 1909–1954* (2005).
2. Matisse, "La Chapelle du Rosaire" (1951). Quoted in Flam, *Matisse on Art* (1995), p. 196.
3. Ibid.
4. Kemble, "Matisse" (2008-09).
5. Matisse, "Matisse Speaks." Statements to E. Tériade in 1950, published in *Art News Annual 21* (1952). Quoted in Flam, *Matisse on Art* (1995), p. 202.
6. Tériade, "Visite a Henri Matisse" (1929). Partially reprinted as "Propos de Henri Matisse a Tériade," *Verve IV*, no. 13 (December 1945). Quoted in Flam, *Matisse on Art* (1995), p. 84.
7. Charles, "Des tendances de la peinture moderne: Entretien avec M. Henri-Matisse" (1909). Quoted in Flam, *Matisse on Art* (1995), p. 52.
8. Matisse, "Notes d'un peintre" (1908). Quoted in Flam, *Matisse on Art* (1995), pp. 40–41.
9. Hoppe, "På visit hos Matisse" (1919). In *Städer och Konstnärer, resebrev och essäer om Konst* (1931), pp. 193–191. Quoted in Flam, *Matisse on Art* (1995), pp. 75–76.
10. Tériade, "Constance du fauvisme" (1936). Quoted in Flam, *Matisse on Art* (1995), p. 122.
11. Matisse, "Letter from Matisse to Henry Clifford" (1948). Quoted in Flam, *Matisse on Art* (1995), pp. 181–183.
12. Lejard, "Propos de Henri Matisse" (1951). Quoted in *Henri Matisse: Paper Cut-Outs* (1977), p. 17.
13. Luz, "Témoignages: Henri Matisse" (1952). Quoted in Flam, *Matisse on Art* (1995), p. 209.
14. Matisse, "Rôle et modalitiés de la couleur" (1945). Quoted in Flam, *Matisse on Art* (1995), p. 155.
15. Matisse, "Notes d'un peintre" (1908). Quoted in Flam, *Matisse on Art* (1995), pp. 40–41.

CHUCK CLOSE AND THE PIXELATED IMAGE

Chuck Close (1940–) is one of the most famous American artists working today. While not a Pointillist, his work involves similar principles of vision insofar as images are broken up into a myriad of components whose size, color, and brightness determine the visual effect. His recent work consists of huge portraits on canvas, which are constructed of many small geometric forms (usually squares or rectangles) called pixels. The word *pixel*, a combination of the words *picture* and *element*, is a neologism used in computer technology to describe any of the small, discrete forms that constitute a digitized image. These unusual paintings raise important questions concerning visual perception. What determines our ability to perceive many small geometric units as a coherent image? How many different elements are needed to create an image? What are the effects of changing colors within the elements?

THE IMAGES

When first confronted with one of Closes's massive eight- to ten-foot-tall faces (see figs. 13.1 and 13.2), a typical viewer is struck by the magnification of the image and its details. After this initial response, the observer may note that the head is painted without context (similar to a passport photograph), and then he or she will probably become fascinated by the technique. Close's compositions are usually based on photographs he has taken with a large-format camera, and in his paintings, he retains the distortions induced by the subject's proximity to the camera. The artist Alex Katz has complained that the camera exaggerated the size of his nose in the portraits Close has made of him (see fig. 13.2).[1]

To facilitate transferring the image from the photograph to the canvas, Close or an assistant pencils a grid pattern and coordinates onto the photograph and then a corresponding grid pattern onto the canvas. Comparison of the photographs and the finished paintings often reveals that the artist has subdivided the source grid, so that a single square in the photograph may be represented by multiple squares on the canvas. The number of pixels making up any one portrait varies from a few hundred to more than one hundred thousand, and the individual pixels range widely in size. In recent works, Close has filled each pixel with irregular forms (see fig 13.1 detail). Sometimes he has united two or more pixels to emphasize a particular feature, such as a portion of the nose or spectacle frames.

Close's technique has affinities to the techniques of other artists. The late twentieth-century American artist Roy Lichtenstein (1923–1997) used multiple small circles of variable size to mimic the character of cartoon art (see fig. 13.3). The early twentieth-century Austrian artist Gustav Klimt (1862–1918) incorporated geometric elements, not unlike Close's pixels, into many of his paintings. Brilliant irregular shapes, usually rectangular, cover much of the canvas in many of his portraits, most notably his masterpiece, the 1907 portrait *Adele Bloch-Bauer I* (see fig. 13.4). The Pointillist and Divisionist artists, such as Georges Seurat and Paul Signac (see chapter 11), who painted in France during the late nineteenth and early twentieth centuries, applied small dots of paint as they sought a means of mixing light rather than pigment to create colors in the viewer's eye. There is an even earlier precedent: Mosaics from Greek and Roman antiquity were made of stone, metal, and glass fragments, and their regularly spaced colored elements are comparable to Close's pixels. However, when Close was asked in 2005 if any of these earlier approaches influenced him, he replied that he was not thinking of any of them when developing his style.[2] He explained that he was working from photographs and was aware of the small, regular elements that are visible in photomechanical reproductions of magazine and newspaper illustrations. His goal was to use this feature of the photomechanical reproductions as a source for something new and different in art.

BIOGRAPHY

Chuck Close was born in Monroe, Washington, in 1940. Although he was a dyslexic child, he adapted well enough to receive an undergraduate degree from the University of Washington and a master of fine arts degree from Yale University. A Fulbright grant enabled him to study in Vienna at the Akademie der Bildenden Künste, which, he notes with irony, was the same school Hitler attended. He then taught art at the University of Massachusetts and worked in an Abstract Expressionist style typical of that era. One of his students there, Leslie Rose, became

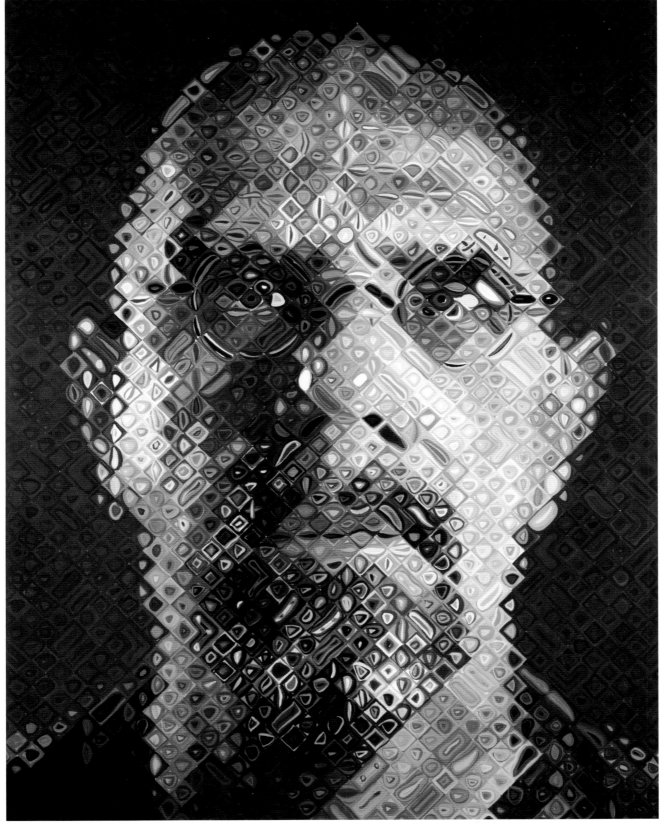

13.1

Fig. 13.1 Chuck Close, *Self-Portrait*, 2000–01. Oil on canvas, 108 x 84 in. (274 x 213 cm). The pixels contain a surprising mix of shapes, colors, and brightnesses. A detail (from above the right eyebrow) shows that some pixels contain different colors of equal luminance.

13.1 (detail)

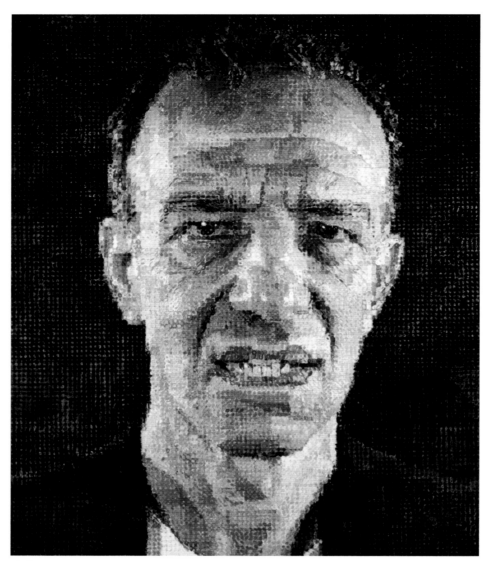

13.2

Fig. 13.2 Chuck Close, *Alex*, 1987. Oil on canvas, 100 x 84 in. (254.6 x 213 cm). This portrait of fellow artist, Alex Katz, was the last painting Close made before his vascular accident of 1988.

Fig. 13.3 Roy Lichtenstein, *Peace Through Chemistry I*, 1970. Lithograph and screenprint on wove paper, 38 x 63 ½ in. (96 x 162 cm). This image is pixelated with dots as in cartoons, mostly with fields of a single color.

his wife. Following their marriage in 1967, the two moved to New York City, where Close taught drawing, painting, and design at the School of Visual Arts.

In the late sixties, Close turned away from Abstract Expressionism toward realism. He began to work from photographs, in essence carefully reproducing the reproductions. He created dramatic, unemotional, large-scale portraits that magnified facial details, whether flattering or not. Critics of the time described him as a photo-realist. He experimented with different means of registering the images as well as a variety of media, including airbrush, fingerprints, fragments of paper pulp, acrylic, oil, watercolor, printmaking, and even daguerreotype photography.

Close's great tragedy occurred in 1988, when an anterior cervical artery became occluded, leaving him partially quadriplegic. In retrospect he dates his symptoms back eleven years before the occlusion occurred. In 1978 he developed chest pain and was medically examined. While a heart attack was ruled out, the cause of his symptoms remained elusive. Though chest pains recurred, cardiac evaluations continued to be normal. On a December evening in 1988 he was a guest of Mayor Ed Koch, who was hosting a dinner at the official New York may-

oral residence, Gracie Mansion, to honor achievement in the arts. During the presentations, Close suddenly experienced back, chest, and arm pain. A policeman helped him to an emergency room, and a recent biography describes what occurred: "His wife, Leslie, was waiting for an elevator in their apartment building when she heard the phone ring. 'As soon as I got to the hospital,' she remembers, 'he had some kind of episode—chest pains. He said he couldn't move—he couldn't feel anything. The nurses were kind of dismissing it, thinking it might be the result of whatever they had given him intravenously. By the end of that night he was paralyzed.' The seizure went on for about twenty minutes, until he finally lapsed into a calm state. By then, he was almost totally paralyzed from the shoulders down. He could barely move his head and neck; breathing was almost impossible because only the upper part of his lungs was working, the lower having filled with fluid. After extensive tests, his seizure was diagnosed as the result of an occluded spinal artery."[3] Close spent a month in intensive care, another month in critical care, and then six months in rehabilitation.

Close's quadriplegia is incomplete. Although he has no function of the lower extremities, he has retained enough movement of his arms and hands to paint from a wheelchair without assis-

13.3

tance. The disability has not affected his style of painting. He is a strong-willed, determined individual who has sought to minimize the limitations placed upon him by his disability.

With Close's permission, we can report direct information about his visual status from his ophthalmologist of many years, Peter Odell, MD.[4] Close is a moderately high myope, but with corrective lenses he has visual acuity of 20/20 for both distance and up close. As a young man, his eyes would often drift apart while trying to read, but this was successfully treated with exercises in 1974. He also has an intermittent upward drift of his eyes, but this is controlled with prisms in his glasses. These eye-movement findings all predate his quadriplegia, but they have not interfered with his art and precision of depth perception.

SCIENTIFIC CORRELATIONS

Close first exhibited a pixelated portrait in the fall of 1973. Just after the show opened, he was amazed to see the November 1973 issue of *Scientific American* at a newsstand, since the cover contained a pixelated, computer-generated color portrait of George Washington.[5] The convergence of methodologies astonished him. Evidently, computer scientists were experimenting with portraits in a manner comparable to his own; like him, they were using multiple small rectangles within which brightness and color could be manipulated. However, Close did not work from computer-generated images then and still does not.

Also in 1973, a pixelated image of Abraham Lincoln was published on the cover of the journal *Science*, along with an article by Leon D. Harmon and Bela Julesz.[6] Bela Julesz, the pioneer of random-dot stereoacuity imagery, first described random-dot technology in 1960.[7] The story in *Science* showed that Lincoln's facial features could be recognized from a very low-resolution computer-generated image consisting of only 216 black-and-white squares, and that the minimum number of squares required to allow facial identification could be as low as 108.[8] Lincoln's face is so distinctive that he is recognizable from fewer pixels than Washington's face is. In comparison, the eight-foot-high portrait Close made of the artist Alex Katz in 1987 consists of 14,896 pixels, each less than two centimeters across (see fig. 13.2).

As viewers of Seurat's masterpiece *Sunday Afternoon on the Island of La Grande Jatte* (see fig. 11.1) in the Art Institute of Chicago will attest, individual spots of color seem to disappear as one moves farther away from the canvas. Individual fragments making up the mosaics from Greek and Roman antiquity seem to do the same. Salvador Dalí enjoyed experimenting with this illusion. Three years after the pixelated image of Abraham Lincoln was published, Dalí incorporated it into a painting, *Gala Contemplating the Mediterranean Sea which at 30 Meters Becomes the Portrait of Abraham Lincoln (Homage to Rothko)*. In this work, he consciously made the pixels far too large for the edges of the separate elements to blur out at any reasonable viewing distance. Neither the Pointillist painters, nor the ancient mosaic makers, nor Dalí exploited the impact of this phenomenon to the extent that Close has. If the observer moves closer to one of Close's images, he or she is well aware that it is made up of multiple pixels. The individual elements predominate, and the figure diffuses into a mass of geometric forms. One must step back, or consciously defocus the image, to make it coherent and to recognize the existence of features, such as the eyes and nose.

13.4

13.4 (detail)

Fig. 13.4 Gustav Klimt, *Adele Bloch-Bauer I*, 1907. Oil, silver, and gold on canvas, 54 ¹/₃ x 54 ¹/₃ in. (138 x 138 cm). Much of this painting is pixelated with unusual shapes and color contrasts, especially in her dress (see detail), prescient of Close's technique a century later.

Fig. 13.5 Chuck Close, *Self-Portrait*, 2000–01. Oil on canvas, 108 x 84 in. (274 x 213 cm). This black-and-white version of figure 13.1 shows luminance relationships. Compare the detail views in color versus black and white. Within some pixels there is a mixture of light and dark, as well as color; within other pixels Close uses equiluminant colors that give vibrancy while brightness is constant. The combined (overall) brightness of each pixel is carefully calibrated so that the blended image looks like a proper photograph.

Close began with small pixelated forms, just a few millimeters wide, and has been steadily increasing their size (in recent work they may be ten centimeters wide). He has been enlarging the paintings as well, although not necessarily proportionately to the pixel size. Pixel size is only meaningful relative to the size of the image and the viewing distance, and Close now incorporates elements that are so large that it is difficult to avoid the complex effects of image fragmentation simply by moving farther away from the canvas.

Close takes advantage of another aspect of visual perception: the need for luminance differences in order to recognize shapes and depth. This feature of vision is relevant to art from many eras, as discussed in chapter 8. Close makes the *overall* luminance of each pixel in his paintings match closely that of each corresponding area in the photograph, so that the faces look normal from far away (see fig. 13.5). But *within* each pixel he often uses a diversity of colors and contrasts (compare details in figs. 13.1 and 13.5). Sometimes there are strong contrasts within a pixel, which give the painting a vibrancy much like Pointillism. At other times, as Margaret Livingstone has pointed out,[9] he juxtaposes colors that are equiluminant so that the viewer perceives vibrancy of color with poor form recognition of the pattern within the pixel. The varying conflicts and equilibria of color, brightness, and pixel size are central to the tension and fascination of Close's paintings.

NOTES
1. Close et al., *The Portraits Speak: Chuck Close in Conversation with 27 of His Subjects* (1998), p. 319.
2. Ravin and Odell, "Pixels and Painting: Chuck Close and the Fragmented Image" (2008).
3. Friedman, *Close Reading: Chuck Close and the Artist Portrait* (2005), p. 16.
4. Ravin and Odell, "Pixels and Painting: Chuck Close and the Fragmented Image" (2008).
5. Harmon, "The Recognition of Faces" (1973).
6. Harmon and Julesz, "Masking in Visual Recognition: Effects of Two-Dimensional Filtered Noise" (1973).
7. Julesz, "Binocular Depth Perception of Computer-Generated Patterns" (1960).
8. Harmon and Julesz, "Masking in Visual Recognition: Effects of Two-Dimensional Filtered Noise" (1973).
9. Livingstone, *Vision and Art: The Biology of Seeing* (2002), pp. 46–52.

13.5 (detail)

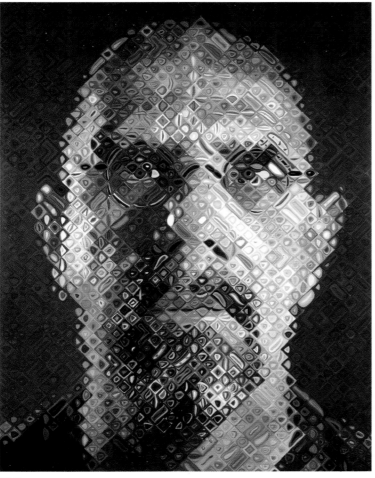

13.5

Fig. 14.1 Inheritance of X-linked color deficiency.

Fig. 14.2 Normal (left) and color-defective (right) color circles. The red–green color-deficient person perceives only gradations of short wavelength hues (blue) and long wavelength hues (yellow). Between the blue and yellow (at either the green or violet pole of a normal color circle) the perception is gray and devoid of color (corresponding to a mix of all colors, like white light).

COLOR DEFICIENCY: A DIFFERENT VISION

Color vision is normally trichromatic. In other words, it is mediated through three different cone visual pigments with peak sensitivity to red, green, and blue wavelengths of light (see chapter 8). However, some people cannot see a full spectrum of color because they are born without a full set of normal visual pigments. The term *congenital color blindness* is commonly used to describe people who have trouble distinguishing red and green, although it is not an accurate description since these individuals do in fact see color. They just see a world with less color and different color. The term *color deficiency* is more precise, and more appropriate. There are some individuals who are truly color-blind and see no colors at all. But this condition, called achromatopsia, is extremely rare and is generally associated with poor visual acuity, so it is not an issue with respect to art.

Ordinary congenital red–green color deficiency, however, is an issue with respect to art because it is not rare at all. Red–green color deficiency is primarily a disorder of males, because the genes for the red and green visual pigments are found on the X chromosome.[1] Females have two X chromosomes, while males have only one—males are males because they also have one Y chromosome. However, the Y chromosome does not carry much genetic information. There are a number of different gene abnormalities, each relatively infrequent, that can affect the X chromosome and cause a degree of color deficiency. If a male has an abnormal X chromosome for color vision, he will be color deficient. However, even if a female has one abnormal X chromosome for color vision, she will almost always have normal color vision because her second X chromosome is unlikely to be affected by the same uncommon gene. Females who have one affected X chromosome are called carriers and on average, 50 percent of their sons will be color deficient since it is fifty-fifty as to which of her two X chromosomes will be passed on to any given son (see fig. 14.1).

Red–green color deficiency affects 8 to 10 percent of males, so it is not uncommon. But the severity of color deficiency depends on how the red or green genes are affected. If the abnormality is mild, an affected person may have trouble distinguishing red from green only in dim light or if colors are very pale. But if one of the genes is truly nonfunctional, the person cannot distinguish red and green at all, even in good light. Severe color deficiency affects about 2 percent of males. It is not necessary to understand all of these nuances to understand the implications for art. Mild color deficiency can be difficult to discover or evaluate from an artist's work, since artists have so much license in their choice of colors and style. An artist with a mild abnormality might not even be aware of it himself. However, a severely color-deficient artist cannot distinguish colors on the palette, let alone in the world; without help or advice, he would have no idea whether grass is green or red.

Given the incidence of color deficiency, it would seem likely that a recognizable percentage of artists would have congenital abnormalities of color vision that could (or should) be taken into account in interpreting their work. However, there is no major painter who is known to be color deficient. The possibility of congenital color deficiency has been raised with respect to many painters on the basis of retrospective analysis of their work, but post hoc analyses are fraught with potential error.[2] Are there truly no color-deficient artists, or have they just not been recognized? How does the world appear to a severely color-deficient individual, and how might a color-deficient artist compensate for the perceptual abnormality? Are there telltale signs of color deficiency in art, or is this a diagnostic dilemma that belies solution?

It is likely that in past eras, when painting was primarily representational, severely color-deficient men were culled from the pool of students and apprentices. Color deficiency was not understood genetically until the nineteenth century, and in ages when art was expected to reflect the reality of the world, there would have been little room for error or ambiguity. The nineteenth-century French etcher Charles Meryon realized that he was color deficient and decided to work only in black and white (see chapter 15). Paul Manship, a twentieth-century American artist famous for his art deco sculptures in Rockefeller Center, made a similar discovery:[3] A colleague in art school asked why he was painting a brown jug green; while he invoked artistic license to explain, he had truly thought that he was matching the jug's true color. He realized then that sculpture might be a safer artistic pursuit than painting. On the other hand, the Irish painter Paul Henry developed a style of painting that was not dependent on critical color discriminations (see chapter 16). Of course, in our modern era of nonrepresentational art it may be

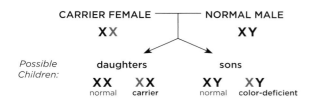

INHERITANCE OF X-LINKED COLOR DEFICIENCY

Each child randomly gets one or the other chromosome from each parent.

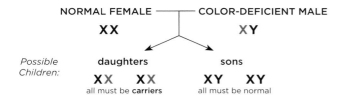

CARRIER FEMALE ——————— NORMAL MALE

X X **X Y**

Possible Children:

daughters | sons

X X **X X** | **X Y** **X Y**
normal carrier | normal color-deficient

NORMAL FEMALE ——————— COLOR-DEFICIENT MALE

X X **X Y**

Possible Children:

daughters | sons

X X **X X** | **X Y** **X Y**
all must be **carriers** | all must be normal

KEY: **X** = normal x-chromosome
X = color-deficient x-chromosome
Y = (male) y-chromosome

14.1

THE NATURE OF COLOR-DEFICIENT PERCEPTION

It is difficult for a normally sighted individual to interpret what a severely color-deficient individual perceives. Since color is fundamentally a subjective sensation (see chapter 8), a color-deficient male cannot tell us truly what he sees, any more than a normal-sighted individual can explain the difference between green and red to a color-deficient individual.

It is possible, nevertheless, to describe scientifically what the eyes are capable of recognizing. Severely color-deficient individuals perceive a world of only two colors, one comprising the blue part of the spectrum, the other comprising the red-to-green part of the spectrum (with yellow in the middle).[6] Furthermore, colors appear washed out and are not subjectively a strong sensation. Figure 14.2 shows an approximation (to normal-sighted eyes) of how the spectrum of colors might appear to a severely red–green color-deficient individual.

Because colors are less subjectively intense, the color-deficient person—and artist—tends to be more sensitive to subtle lights and darks which may be obscured by colors that distract our attention (as in camouflage). It is rumored that the military has at times used red–green color-deficient men to spot camouflage, with the idea that they will be less influenced by the colors and thus more sensitive to distinguishing a camouflaged object from the surrounding environment.

THE TECHNIQUE OF A COLOR-DEFICIENT PAINTER

Jens Johannsen studied art in Los Angeles but has lived and worked in Paris for more than twenty years. He is a skilled draftsman and a committed colorist, and his work is always at least partly representational. Extensive evaluation of his color vision has shown that he is a dichromat who sees no distinction between different admixtures of red and green.[7]

Despite his deficiency in color perception, Jens[8] (as he signs his paintings) is surprisingly adept at naming colors in the real

difficult (and perhaps irrelevant) to know whether an artist is color deficient—but this is a different issue.

While there have been attempts to define a set of color characteristics that would identify (or perhaps betray) color-deficient painters,[4] these are not definitive because artists can learn from experience and rely on outside advice to produce works that contain a variety of colors and that are pleasing to color-normal individuals. Thus, the manifestations of color deficiency in art can be surprisingly complex, and the retrospective assumption of color deficiency from an artist's works is hazardous in the absence of clinical documentation.[5]

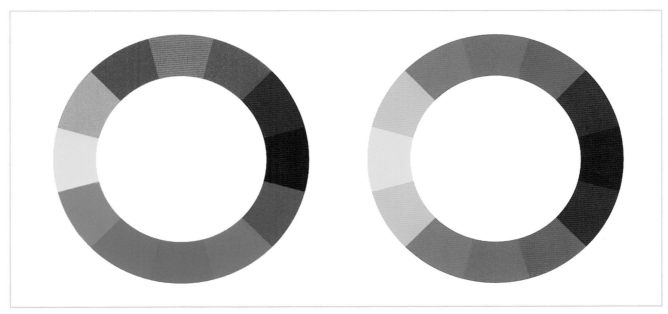

14.2

14.3

14.4

Fig. 14.3 Jens [Johannsen], *Haystacks*, 1987. Oil on canvas, 39 ³/₈ x 39 ³/₈ in. (100 x 100 cm). This painting features a limited palette of amber, gray, and blue.

Fig. 14.4 Jens [Johannsen], *Landscape*, 1987. Oil on canvas, 33 ⁷/₈ x 44 ⁷/₈ in. (86 x 114 cm). In this painting Jens used predominantly blue and gray, as did Paul Henry in some of his paintings (see fig. 16.5).

Fig. 14.5 Jens [Johannsen], *The Hotel*, 1981. Oil on canvas, 29 x 36 in. (73 x 92 cm). This painting is predominantly yellow and brown with some reddish highlights that do not mix with other colors.

Fig. 14.6 Jens [Johannsen], *Flowers*, 1997. Oil on canvas, 12 x 12 in. (30.5 x 30.5 cm). In this painting Jens used unusual red-violet colors that he likely chose by name or through advice, but he applied them as flat, unmixed fields to avoid color confusion.

world. This ability is due in part to his knowledge of objects, but also to his awareness of the relationships and relative brightnesses of colors. For example, he has difficulty recognizing pale blue as a color on a white background (the pale blue could be gray), but if the blue is placed next to gray, yellow, or green, he recognizes it immediately as a color and names it correctly. He says that the world is "not a gray place but it is certainly subdued from what you [normal-sighted individuals] see. What I recognize that relates to what you see, are values of blue and yellow."

Jens first realized that he had trouble recognizing colors as a young child. "I'd put on different colored socks. It was fine with me but the maids would say that this is red and this one is blue or something, but it didn't make any difference to me, and I said 'why don't we make them all the same color then I don't have to bother?' . . . When I went to school it was a whole new problem. They gave me these things to color and they said, 'This is an apple and it's red,' but at that time they had a big box of all these crayons and they were all the same to me."

Although Jens recognizes certain colors, colors clearly do not have the same importance in the visual world for him as they do for a normal-sighted individual. When asked if the world is a colored or a gray place, he responded: "You think of [Paris] as colorful and so forth, but Paris is basically a black-and-white city if you think about it . . . Sometimes they put orange or blue on the buildings here, and [my neighbors] say they find that offensive. It doesn't bother me."

When asked about colors in the countryside, he responded: "Well mostly these are known, and my mind tells me one thing and my eyes [another]. Essentially I am seeing a lot of contrast. I like things with contrast in them. And therefore I think I start to associate colors with contrast and what I perceive as yellow could be sunlight reflecting off something that maybe is just a brightness difference . . . I don't think I could actually recognize a red or a green if you put them side by side. Depending on the intensity, I could distinguish one from the other from what I know . . . Yellow is like a white for me." When asked what the term *color* means to him, he responded perceptively: "You know I can't tell you because I don't know what you see."

Jens usually works with a limited palette based on just two colors, typically a blue or blue-gray tone and a second tone that is often derived from raw umber (see figs. 14.3 and 14.4). These hues are modulated by adding white or darkening with Prussian blue (a pigment that Jens prefers to black). He avoids green pigments and is careful not to mix yellows and blues. Although reds are rarely used as a predominant color by Jens, he will often put red accents (e.g., cadmium red or cadmium orange) on small areas of his works, using brightness as opposed to color as a guide (see fig. 14.5). He controls against poor color choices by keeping a limited array of paint tubes in his possession. Some of his paintings (for example, of flowers) may include a purplish or reddish field (see fig. 14.6), though Jens has a hard time explaining why he chose these colors. He cannot distinguish spectral red from yellow, but he does sense a quality in reddish paints or objects—perhaps in part because reds are darker and he knows intellectually that certain flowers or objects have red, but also because paint pigments and colors in the real world do not create one pure wavelength and their complex qualities may give him other cues.

One may ask why Jens works in color when he is well aware of his perceptual limitations. There are probably several answers.

14.5

14.6

He has a great appreciation for the paintings of the old masters, and they are in color; as a student, he was taught techniques for identifying and working with colors by name; pride has encouraged him to meet a challenge; and he has been commercially successful, which is the bottom line. Although color is not a strong sensation for him, his sensitivity to craftsmanship, shading, and contrast allows him to paint with colors to his own satisfaction and standards.

Is Jens bothered by the fact that most of the public sees his paintings differently than he does? "I don't paint to please or sell. It's all a product of experience. People who buy my work—it's good they see them differently . . . I am very content to know that my work sells—apparently the buyers see something I don't in many instances. This is what paintings are all about—to not try to figure out the painter but to enjoy the finished product . . ."

THE DILEMMA OF COLOR DEFICIENCY IN ART

It is almost certain that some artists, over the centuries, have been color deficient, given the frequent occurrence of this genetic abnormality in the male population. In fact, examinations of practicing twentieth-century artists in Dresden showed a 9 percent incidence of color vision abnormalities among males,[9] an incidence similar to that in the general population. Even if many of these cases were mild ones, it is likely that at least a few were severe. Because of the striking perceptual difference between normal and red–green deficient vision, one might think that this aberration would be easy to recognize in a painter's work. One might in theory expect a severely color-

deficient artist to confuse blue-green, violet, and gray (which appear similar—and relatively colorless—to him), and of course to confuse red, orange, yellow, and green (which appear identical). Thus yellows, greens, and reds would have an equal chance of being painted orange, and a purplish sunset might in theory come out gray or blue-green. But as noted earlier, artists do not paint with unlabeled colors, and in fact, few of the works by the color-deficient artists in Dresden appear unusual.[10] Reputed signs, such as rooftops painted red in the sunlight and green in the shade,[11] are of doubtful validity,[12] and would not have helped us to diagnose Jens's color deficiency, since he avoids reds and greens and chooses colors by a predetermined method.

It is particularly difficult to separate color style from necessity in retrospect, because artists are aware not only of what they see but also of what they are expected to see. It is common knowledge that grass is green, and an artist will reach for a green-labeled tube of paint without necessarily perceiving the color in a normal manner. If there is any consistency in style, it appears (on the basis of the work of Jens, Meryon, Henry, and others)[13] that severely color-deficient artists tend to use a limited palette of blues and ambers. This choice of color is not made because they see only these colors (red or green would appear equally amber) but because they have learned through experience and advice that they avoid problems and errors when they use them.

However, the converse is not true: Neither a blue-and-yellow nor a relatively colorless palette is diagnostic of color deficiency because painters may choose these tonalities for many valid artistic reasons. For example, nineteenth-century painter, sculptor, and printmaker Honoré Daumier used little color, but there is no evidence that he had any problems with color discrimination. Eugène Carrière, a late eighteenth-century artist, is known for his monochromatic style, which is so striking that even his contemporaries questioned his ability to see colors. As a result, he submitted to examination by a specialist, who found that his color perception was quite normal.[14] The coloration of his paintings was an artistic decision, and not a result of retinal pathology.

Fernand Léger (1881–1955) has been suspected of color deficiency for a different reason, because he used strong unmod-

14.7

Fig. 14.7 John Constable, *The Cornfield*, 1826. Oil on canvas, 56 1/4 x 48 in. (143 x 122 cm). Many of Constable's paintings have an autumnal quality and a limited color palette, which has led to speculation that he may have been color deficient.

Fig. 14.8 John Constable, *Malvern Hall, Warwickshire, 1821*. Oil on canvas, 21 x 30 3/4 in. (53.5 x 78 cm). Other Constable paintings, such as this one, are brighter. Almost all of his landscapes show subtle variations of greens in lawns and trees, and sometimes mixtures of green, orange, and amber in ground areas, coloration which would be almost impossible to achieve, or at least to control, with a severe degree of color deficiency.

ulated colors that could have been chosen either by observation or by name. However, it is highly doubtful that Léger was color deficient. In his writings, he spoke frequently about the pleasures of color: "It was about 1910 that [Robert] Delaunay and I began to liberate pure color in space . . . Color was free; it had become a new reality."[15] Furthermore, his widow, who had worked with him for thirty-two years, apparently never noticed any abnormalities in his color vision.

There are, however, some artists from earlier times who are likely to have been color deficient, although we have no medical proof. Giorgio Vasari (1511–1574), who wrote a massive multivolume biography of the painters of his time, made some telling observations about the artist and sculptor Baccio Bandinelli (1493–1560). He wrote that "Baccio's drawings were very beautiful, but in colours he executed them badly and without grace, and therefore he resolved to paint no more with his own hand; but he took into his service one who handled colours passing well, a young man called Agnolo."[16] The fact that the artist asked for the help of another painter is suggestive, as is the fact that Bandinelli worked mainly in design (drawings) and sculpture. Similar behavior was related by a later biographer, Luigi Lanzi, about the Venetian painter Nicolo Bambini (1651–1736): Lanzi praised Bambini's designs but noted that it would have been "fortunate, indeed, had he succeeded as well in his colouring; in which branch he was so sensible of his own mediocrity, as to forbid his [students] practising the art from his pictures." It was only in works that "were afterwards re-touched and animated, as it were, by Cassana, the Genoese, [that] he shines as a great

portrait-painter, and a very powerful colourist."[17] Of course, because of the help that these two artists had from colleagues, examination of their finished works will not reveal much about their color deficiency.

Lanzi wrote of another artist, Pietro Rotari (1707–1762), whose skill and delicacy in design "would have left him second to none of his age, had he possessed, in an equal degree of perfection, the art of colouring. But his productions often partake so much of the chiaroscuro, or at least of a strong ash colour, as to render them remarkable among all. Some, indeed, have attributed this deficit to a want of clearness of sight . . ."[18] Since Rotari's contemporaries did not confirm that he had a visual problem, we are faced with the usual dilemma of interpreting a painter's colors retrospectively.

The famous English landscape painter John Constable (1776–1837) has been suspected of color deficiency because many of his paintings are brownish-green, or autumnal, in tone and do not depict strong colors (see fig. 14.7). The artist Henry Fuseli is reported to have written: "I like the landscape of Constable, but he always makes me call for my great coat and umbrella."[19] However, other examples from Constable's work are colored quite normally. Even though his paintings are often devoid of bright colors, he regularly used many different and subtle shades of greens and browns (see fig. 14.8), which would be highly unusual for a color-deficient artist, who would generally find these tones hard to distinguish and dangerous to use. Issues such as artistic license, conventions of the time, and aged varnish aside, Constable's complex use of these hues argues strongly against his having had any major degree of color deficiency.[20]

CONCLUSIONS

It is highly likely, given the frequency of the genes for color deficiency, that some well-known artists were in fact color deficient to one degree or another. But we may never know for sure. Just as artists have overcome limitations in visual acuity (such as Edgar Degas), and physical mobility (such as Henri de Toulouse-Lautrec, the elderly Henri Matisse, Pierre-Auguste Renoir, and the modern artist, Chuck Close), so have color-deficient painters adapted well to their disability to produce effective art that satisfies a high artistic standard.[21] The color-deficient painter can read the labels on his tubes of paint, he knows the names of common object colors, and he usually has established a formula for working that avoids inappropriate colors. The paintings that result may not appear perfect as representational art, but art is not necessarily expected to be a surrogate for photography, and many styles are acceptable to serve many purposes.

14.8

These observations do not minimize the value of look-ing at the effects of color deficiency upon an artist, when they are known. We can appreciate better the evolution of Jens's or Henry's painting styles and understand their somewhat uncon-ventional color schemes by knowing the perceptual machinery with which they worked. We can admire the skill they display in manipulating design and shading within a framework of limited sensations. It can be amusing to hypothesize medically about the visual function of great artists, but the retrospective diagnosis of color deficiency from an artist's paintings alone is fundamen-tally speculative. When medical confirmation is unavailable, the diagnostically inclined observer may be best advised to simply enjoy the art.

NOTES

1. Neitz and Neitz, "Molecular Genetics of Color Vision and Color Vision Defects" (2000).
2. Marmor and Lanthony, "The Dilemma of Color Deficiency and Art" (2001); Trevor-Roper, *The World Through Blunted Sight* (1970), pp. 75–93 or (1988), pp. 84–100.
3. Manship, *Paul Manship* (1989), p. 15.
4. Lanthony, "Daltonisme et peinture" (1982); Liebreich, "Turner and Mulready—On the Effect of Certain Faults of Vision on Painting, with Especial Reference to Their Works" (1872); Strebel, "Quatre manières d'un peintre daltonien" (1944).
5. Marmor and Lanthony, "The Dilemma of Color Deficiency and Art" (2001); Trevor-Roper, *The World Through Blunted Sight* (1970), pp. 75–93 or (1988), pp. 84–100; Lanthony, "Daltonisme et peinture" (1982); Pickford, "The Influence of Colour Vision Defects on Painting" (1965).
6. Neitz and Neitz, "Molecular Genetics of Color Vision and Color Vision Defects" (2000); Neitz, "Society and Colorblindness" (1997); Viènot et al., "What Do Colour-Blind People See?" (1995).
7. Lanthony, "J. J. peintre daltonien" (1994).
8. Marmor and Lanthony, "The Dilemma of Color Deficiency and Art" (2001).
9. Münchow, "Colour Vision Deficiencies in Painting" (1978).
10. Ibid.
11. Liebreich, "Turner and Mulready—On the Effect of Certain Faults of Vision on Painting, with Especial Reference to Their Works" (1872).
12. Trevor-Roper, *The World Through Blunted Sight* (1970), pp. 75–93 or (1988), pp. 84–100.
13. Ibid.
14. Polack, "A propos d'une erreur d'interprétation des oeuvres du peintre Carrière" (1908).
15. Léger, *Functions of Painting* (1973), p. 150.
16. Vasari, *Lives of the Most Eminent Painters, Sculptors, and Architects* (first published in 1550). Translation (1912–1914), pp. 69–70.
17. Lanzi, *The History of Painting in Italy* (1828), pp. 353–354.
18. Ibid.
19. Trevor-Roper, *The World Through Blunted Sight* (1988), p. 88; Lanthony, *An Eye for Painting* (2006), p. 136.
20. Marmor and Lanthony, "The Dilemma of Color Deficiency and Art" (2001).
21. Ibid.; Lanthony, "Daltonisme et peinture" (1982); Münchow, "Colour Vision Deficiencies in Painting" (1978); Pickford, "Two Artists with Protan Colour Vision Defects" (1965).

AN ARTIST WITH A DEFECT IN COLOR VISION: CHARLES MERYON

15.1

It is unusual for an important artist to have abnormal color vision. Artists who become aware of a defect in their color vision will usually stop working in color. They may utilize other media, such as sculpture or printmaking, which do not necessarily require normal color vision. One important figure in the history of art who had a congenital defect in his color vision and who was aware of his abnormality was the Romantic etcher Charles Meryon (1821–1868) (see fig. 15.1). While in art school, Meryon realized that his abnormal color perception would prevent him from being successful with oil paints, and he turned to printmaking.

EARLY LIFE

Meryon was the illegitimate child of a Paris opera dancer and an English physician. Meryon's parents had a liaison in London, but a few months before his birth, his mother left England permanently. She detested England, calling it a "wretched country where it is always raining."[1] Meryon's father acknowledged his son a few years later and allowed him to take the Meryon name; however, Dr. Meryon was never able to provide the emotional support his son desired. Though Meryon's mother had implored Dr. Meryon to recognize their son legally, saying any "man who cannot name his father is very unhappy,"[2] the doctor was constrained by the fact that he was married to an Englishwoman by whom he had two children. This lack of paternal affection troubled the artist throughout his life.

Dr. Meryon did, however, maintain a written correspondence with Meryon's mother and with their son, as well as pay for his son's education. Meryon and his father corresponded for most of the artist's life. Meryon's letters reveal his feelings about himself and his art and provide us with much that we know about his color perception.

Meryon grew up in Paris with his mother and half sister. In a letter to his father, his mother described their son's traits as an eight-year-old boy: "My Charles has a thousand good qualities, excessively sensitive, generous, sweet, spiritual, studious, diligent and somewhat unhappy. He hasn't the least self control. He is too young to have any strong feelings but his desires never end. If one cannot please him immediately he becomes most unhappy."[3] At age fourteen, Meryon wrote to his father, describing his desire to join the navy and his intention to illustrate the naval voyages he might undertake. Two years later, in 1837, he entered naval officers' school. His mother died the following year. His first voyage with the French navy was a Mediterranean cruise in 1840. Upon returning to France, he began formal art lessons. In 1842, at age twenty-one, he embarked on a four-year naval journey circumnavigating the globe, stopping in Brazil, New Zealand, Australia, and Tahiti. One of his goals during this voyage was to carefully observe and illustrate the exotic places he visited. He drew records of the natives and the landscape. Years later he utilized these drawings as source material for other works. He made several lifelong friendships on this voyage. One of these close friends, Edouard Foley, became a physician who would aid him during periods of personal crisis.

A career as a military officer, in Meryon's opinion, was highly respectable. But at age twenty-five he wrote to his father, describing his decision to leave the navy: "I have become tired of the profession which I have followed until now and I am still young enough to take up another. I am preparing to devote myself entirely to the study of art and to sacrifice everything I own to this end. I do not know what will happen to me. Perhaps I will become miserable, but I assure you that if I do not do this I will regret it for the rest of my life."[4]

This frank statement must be one of the clearest expressions of an artist's goals ever written. Meryon went on to study at the Louvre and with a pupil of the famous Neoclassical artist Jacques-Louis David. His resignation from the navy became final in 1848, and that same year he achieved official artistic recognition when he exhibited a large-scale drawing at the Salon. However, Meryon was never able to translate his drawing skills into oil painting. He realized that his congenital defect in color vision made work in oils too difficult. Although his drawing at the Salon did not garner the attention of journalists, the composition was admired by an etcher Eugène Bléry. The two artists met, lived, and worked together for about two years. In 1849 Meryon began his most famous series of etchings, the *Eaux-fortes sur Paris* (*Scenes of old Paris*) (see figs. 15.2 and 15.3), the medieval city that Napoleon III and Baron Haussmann demolished during the Second Empire (1852–1870).

THE COLOR DEFICIT

Meryon's abnormal color vision apparently was not discovered when he entered the navy. (Color testing was not part of the admission process at that time.) During his early artistic studies, however, he realized that his color vision was defective. He wrote to his father that he hoped to overcome this obstacle through practice. In 1846, only a few weeks after devoting himself to art, he faced the color problem directly. "This color defect of which I speak is such that I often prefer beautiful black prints, in which one can see the graduation of shading, to the more vivid effects of painting."[5] Despite this admission, Meryon did not give up painting immediately. He wrote his friend, the medical student Foley, that he intended to continue his plan to paint noble themes. He drew up plans for future subjects. One was Joan of Arc surrounded by her executioners. Others included whaling subjects and themes he had encountered during his voyage to the South Seas. For many of the compositions, Meryon envisioned evening light. The dramatic possibili-

ties of oblique lighting with strong contrasts of light and shade planned for oils became important features of his later etchings. However, only one oil painting by Meryon is known today, from a photograph in the Bibliothèque Nationale in Paris. There is also a colored pastel entitled *Ghost Ship* (*Ship in a Storm*) (see fig. 15.4).[6] Undoubtedly he created this work from his imagination, after becoming aware of his abnormal color vision. In making this pastel, Meryon avoided red and green, the colors that give color-deficient artists the most difficulty.

As discussed in chapter 14, hereditary color deficiency generally results from an absence or abnormality of the gene for the red- or green-catching pigment in the retina. The genes for red and green color sensitivity are on the X chromosome, making color blindness almost exclusively a disorder of males. Severely color-deficient individuals lack the perception of either green or red, so every color at the warm end of the spectrum looks the same (and is most often called, subjectively, yellow). In other words, the world—and for an artist, the palette—is comprised of only two colors: blue and yellow. White light for these individuals is a mixture of blue and yellow (their whole spectrum); and by analogy, pigments that lie between blue and yellow on the palette (at either the green or violet poles of a color wheel)

15.2

Fig. 15.1 Félix Bracquemond, *Portrait of Charles Meryon*, 1853. Etching, 4 3/16 x 4 x 7/16 in. (10.6 x 8.7 cm). Bracquemond, an important figure in Parisian avant-garde art and literary circles, depicted his friend Meryon at a quiet moment.

Fig. 15.2 Charles Meryon, *Le stryge*, from Eaux-fortes sur Paris (scenes of Old Paris) 1853. Etching, 6 1/8 x 4 1/2 in. (15.6 x 11.5 cm). A spectacular view of a gargoyle on the cathedral of Notre-Dame, with the tower of the destroyed church of Saint-Jacques-de-la-Boucherie in the background.

Fig. 15.3 Charles Meryon, *Le petit pont*, from Eaux-fortes sur Paris (Scenes of Old Paris), 1856. Etching, 9 5/8 x 7 1/4 in. (24.5 x 18.5 cm). A bridge across the Seine with the cathedral of Notre-Dame behind. Meryon acknowledged that he used an optical aid, a camera lucida, to project an image on paper as the starting point for this print. The strong black-and-white contrasts and lack of atmospheric perspective create an eerie feeling.

15.3

15.4

will appear relatively uncolored and grayish (see fig. 14.2). The result is that the color-deficient artist who desires to reproduce a blue-green tint (i.e., a color that falls in the gray zone between warm and cool colors) hesitates in choosing among a purplish-red, a gray, and a blue-green, all of which appear to him to be nearly the same. He has one chance in three to be correct. In the same fashion, outside of the gray or uncolored zone, he will confuse yellow, green, and orange, and perhaps confuse blue and purple as well. It would require a bit of luck for the color-deficient artist to choose colors that appear the same to a normal-sighted individual.[7] Meryon's choices of colors in the phantom ship reveal the color-deficient artist's characteristic division of the world into blue and yellow. The sky has an unusual cast to it, being overly yellow-orange, and the sea is overly blue, lacking the normal green component.

Despite his defect in color vision, Meryon was able to successfully depict contrasts in light and dark. Certainly the medium of etching stresses the nuances of contrast. In some of his prints, Meryon used two inks: red and black. Although we do not completely understand how he perceived red, he probably saw it as lighter than black. He did not own a press, so he took his plates to be printed. His prints were printed on a variety of papers—fine light-cream laid paper, white paper, thicker beige-colored paper, and green paper. Again, we are not certain how he perceived the tones of these papers. Since it is likely that he recognized few differences himself, others may have influenced his selection.

Utilizing stark contrasts of black and white with little gradation of tone, Meryon depicted a chillingly eerie atmosphere, which is particularly effective in his etchings of the medieval aspects of Paris. These prints were admired by the poet Charles-Pierre Baudelaire and the writer Victor Hugo. In a letter to Baudelaire, Hugo wrote, "Since you know Meryon, tell him that his splendid etchings, with nothing but shadow and brightness, light and dark, have dazzled me."[8]

A SAD ENDING

Vincent van Gogh, one of the great colorists of all time, was well aware of Meryon's work in black and white. He wrote: "Meryon, even when he draws bricks, or granite or iron bars, or a railing of a bridge, puts into his etchings something of the human soul."[9] Unfortunately, like van Gogh, Meryon's life came to a tragic end. He, too, developed a mental illness that overcame him. In 1868 Meryon was admitted to the asylum of Charenton, where he died. Paul-Ferdinand Gachet, MD, best known for his relationship with van Gogh, visited Meryon and sketched several portraits of him at the asylum. The admitting diagnosis was "lypemania," now an obsolete term denoting a form of depression. Hints of depression were present during his year in the navy, when he experienced long periods of ennui and inaction. Later he developed hallucinations and feelings of persecution. He stopped eating and then died in an unfortunate state at the age of forty-seven. He is survived by his brilliant creations.

NOTES

1. Fama, "Charles Meryon: A Biographical and Psychiatric Reassessment" (1973).
2. Chaspoux, letter dated July 1829. Reprinted in *Charles Meryon* (1968), number 297.
3. Chaspoux, letter dated March 30, 1823. Reprinted in *Charles Meryon* (1968), number 287.
4. Meryon, letter. Reprinted in *Charles Meryon* (1968), number 366.
5. Meryon, letter. Reprinted in *Charles Meryon* (1968), number 367.
6. Collins, "The Landscape and Historical Paintings of Charles Meryon" (1975); Meryon, letter. Reprinted in *Charles Meryon* (1968), number 781.
7. Lanthony, "Dyschromatopsies et art pictural" (1991).
8. Meryon, letter. Reprinted in Charles Meryon (1968), number 449.
9. Van Gogh, *The Complete Letters of Vincent van Gogh* (1959), letter 136.

Fig. 15.4 Charles Meryon, *Ghost Ship (Ship in a Storm)*, 1857. Pastel, 14 x 26 ½ in. (35.3 x 67 cm). This work illustrates the color choices typical of an individual with an inherited color-vision defect.

THE SECRET
OF PAUL HENRY

The Irish painter Paul Henry (1876–1958) is famous for his enchanting views of misty lakes and rustic fields. He captivates the viewer not only through his skillful framing of his subjects but also with his singular color palette, typified by works such as *A Sunny Day, Connemara* (see fig. 16.1). While many artists have used similar colors to illustrate the blue haze of morning or the dry, amber grass of summer, in Henry's case his selection of colors and painting technique may not have been entirely a matter of artistic choice, since he was color deficient. While Henry's paintings must be judged on their own merits in the end, an understanding of retinal color processing gives insight into his choices of color and shows how his work may, in some respects, have gained from his visual struggles.

THE MAN

Henry[1] was born into a middle-class family in Belfast. His father was a Baptist pastor who broke with the Baptist church but continued to form congregations. Henry began drawing as a young child and seemed to love art more than schoolwork. After his father's death when Henry was fifteen, his family agreed to let him attend art school. In 1898 he made a pilgrimage to Paris, where he lived for two years, studying art and absorbing the enormous changes that had taken place in the world of art since Impressionism had challenged the rules of the Salon. In his autobiography,[2] written many years later, Henry describes this time in his life, although he mentions little about color. He was intrigued by the work of the Neo-Impressionists, but declared it "minute patches of pure colour" and "a study of light for its own sake." He noticed that Jean François Millet's painting *Le Printemps* "seemed to lack vitality," while Millet's drawings "are so satisfying." While he attributes the difference between the two to the loss of spontaneity in a finished painting, it is clear that Henry had a fondness for drawings. In fact, after having a huge color canvas rejected by the Salon, he "decided, with many regrets and forebodings, that London was the place where I would be most likely to make my living as a 'black and white' artist."

It is noteworthy that Henry did not write about his color deficiency, nor did he ever mention it publicly. Our knowledge of his abnormality comes from his ophthalmologist later in life,

Dr. Beecher Sommerville-Large, who revealed the information to the Irish geneticist George Dawson after Henry's death. Dawson made the information public in the introduction to a 1973 exhibition of Henry's work: "Sommerville-Large told me about 1960 that Paul Henry was totally red–green colour-blind and that he had never revealed this during Paul Henry's lifetime because it could have affected his reputation as a painter."[3]

Dawson states that Henry's wife was unaware of her husband's color deficiency, but we find this hard to believe. Individuals with mild degrees of color deficiency (see chapter 14) may not be aware of their limitations unless challenged by a color test (or a situation where colors are faint). But those who cannot discriminate red and green discover at a young age that they are different from others, having misnamed the colors of colored objects, mixed up colored socks, or otherwise made confusions that a normal-sighted person would not have made. Of course Henry could not appreciate what he could not see, so his world was to him what it was: colored by blues and yellows alone. This limitation is apparent in the unschooled paintings of his youth, such as *Landscape with Cornfield* (see fig. 16.2). Once in art school, it is hard to imagine that Henry, like Charles Meryon, would not have recognized that his choices of color posed problems that were not encountered by the other students (see chapter 15).

In 1910, on the recommendation of a close friend, Henry traveled to the Irish island of Achill. This visit marked a turning point in Henry's career. He was enthralled by the scenery and the rustic life, as exemplified in *Woman Cutting Rye* (see fig. 16.3), and he began to paint in earnest. He used the muted colors typical of the island landscape (see fig. 16.4), which, to some degree, matched the limited palette he saw. Some canvases, such as *Killary Bay* (see fig. 16.5), are nearly monochromatic. He painted mainly in the early morning, and sometimes in the evening, when colors tend to be cool and the distant mountains seem blue.[4] His works began to sell, and he eventually moved from London to Dublin. He revisited Achill for many years and later painted other sites in the Irish countryside that had similar scenery.

Tragically, other visual problems plagued him in his waning years. In 1946 he suffered an acute illness, possibly a stroke, which left him with little sight. He now could only see "light and dark," and "neither read nor write."[5] He never painted again,

but he began to write of his early life and his experience as a painter. He died at Bray, Ireland, in 1958.

Henry's autobiography concerns places and people more than art and offers few clues to his color perception. He makes note of an aquarium he visited while living in Paris and of watching a group of goldfish there that he describes as "lemon-colored."[6] It would be characteristic of red–green color deficiency to find yellow and orange indistinguishable. He comments on the color and variety of women's dresses in Achill,[7] and the paisley shawls whose "orange and red . . . gave them an almost oriental appearance." The women's dresses made "lovely spots of color against the dark peaty soil and the blue or brown mountains." These descriptions perhaps seem odd, if the spectrum from red to yellow appeared as one color to him, but he may have sensed differences in brightness or saturation to characterize what others would describe as different colors; and he may have known that many dresses, if not blue, are declared red or orange depending on the brightness. There is never any mention of green which, for the color-deficient person, lies in a "gray zone" between the two ends of the spectrum. Yet green is typically a color that artists mention in descriptions of rural scenes. Henry describes a village boy, who borrowed his father's paints, as having only "a vile Prussian blue, an orange-red, and black" with which he "produced something that amazed me."[8] One may speculate that Henry knew the names of the paints that were used.

THE PAINTINGS

As Henry himself notes, he began his career primarily in black and white. He was a skilled draftsman and drew predominately in charcoal until his visit to Achill. This revelation is telling for a budding artist. It is perhaps relevant as well that his early work consists largely of portraits and images of people, painted in near-monochromatic hues, with only a small number of general scenes. The few extant paintings from his pre-Achill days, such as *Landscape with Cornfield* (see fig. 16.2), were made using little color, or a limited palette consisting mainly of blue and yellow tones—not unlike Charles Meryon's *Ghost Ship (Ship in a Storm)* (see fig. 15.4).

When Henry experienced the scenery and people of Achill, he began to paint in oil and in color, and the vast majority of his mature work consists of landscapes or views of peasant life. Though he produced many sensitive portraits in charcoal, he painted only two major portraits in oil over thirty-six years of work. This pattern is consistent with color deficiency. Skin tone in Ireland is typically a complex and subtle mix of colors in the red-yellow part of the spectrum—and these colors were indistinguishable to Henry. Both portraits depict curious, flat skin tones (in one slightly reddish, and in the other yellowish) and the paintings are essentially drawings made upon a base of color. We guess that Henry recognized his limitations

16.1

with the use of flesh tones, and thus he avoided portraiture in color. Even Henry's peasant scenes show little flesh, and his subjects are often positioned with their backs or sides toward the viewer.

Throughout his career, Henry's choice of colors remained consistent. He never experimented with different approaches to color, although there was certainly ample opportunity (and models) in the first half of the twentieth century as art evolved through abstraction and other movements. In his work, he tended to use relatively monochromatic colors, and modulation of brightness rather than color. Most of his paintings have either a predominant blue-gray tone, as in *Killary Bay* (see fig. 16.5), or two broad fields of color, one bluish and the other amber, as in *A Sunny Day, Connemara* and *Woman Cutting Rye* (see figs. 16.1 and 16.3). Henry avoided the hazardous color green, which would have appeared grayish to him and been hard to evaluate on a palette or canvas. He did only a few odd paintings with green fields, or a greenish overtone to the morning haze. But in those, the green has not been mixed or modulated, and in the case of grass, the color might well have been chosen on the advice of his wife or someone else. In general, his lack of green fields or trees becomes curious for paintings of a rural land with plenty of rain! Interestingly, a number of paintings include dark but rich vermillion highlights, as in *Woman Cutting Rye* (see fig. 16.3), most often in a peasant skirt. But these, too, could easily have been inserted with the help a normal-sighted person, and he never blended this color with the others or modulated its character.

This last point is an important one, and it is also discussed within the context of Monet's struggles with color-distorting cataracts (see chapters 30 and 38). Most painters mix paints on

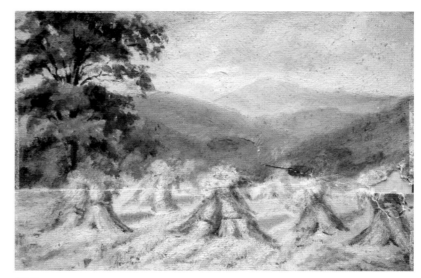

16.2

the palette, and then work and rework their canvases to achieve the ideal color balance. An artist with limited color *discrimination* faces a serious handicap in this regard, since there is risk of error if different colors are mixed. Monet's world, through his cataract, became a murky yellow-green, to the point that he could no longer judge the effect of adding a little more white, yellow, or green to the canvas. Similarly, if Henry had mixed red and yellow, he would have had no awareness of orange, except as a darker yellow, and mixtures of blue and yellow would have tended to gray out so that he could not judge the type of green he produced. This explains why he was forced to choose colors that fell within his perceptual range and to minimize adjustments as much as possible, except for lightening and darkening the hues.

Fig. 16.1 Paul Henry, *A Sunny Day, Connemara*, c.1940. Oil on canvas, 16 x 20 in. (40.5 x 51 cm). This painting is typical of Henry's work, with amber fields and blue-gray mountains over the sea.

Fig. 16. 2 Paul Henry, *Landscape with Cornfield*, 1899–90. Oil on paper, 5 x 8 in. (12.5 x 20.5 cm). This painting was done when Henry was between twelve and fourteen years old. His preference for blue and yellow was already clear, and the reddish highlights appear to be used more for darkening than as true color.

Fig. 16.3 Paul Henry, *Woman Cutting Rye*, 1910–11. Oil on canvas, 14 x 16 in. (35.5 x 40.5 cm). The dominant color in this painting is yellow, but Henry painted one feature (the dress) in red. The red in Henry's work is always a cohesive field of unmodulated color.

16.3

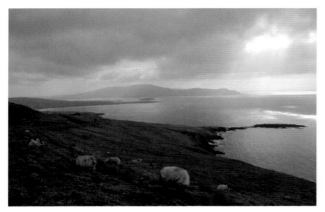

16.4

Fig. 16.4 Photograph by S. B. Kennedy of the sea from Achill. Gray-blue and amber dominate the island landscape.

Fig. 16.5 Paul Henry, *Killary Bay*, 1919. Oil on canvas, 13 x 16 in. (33 x 41 cm). A number of Henry's paintings are almost monochromatic.

16.5

We emphasize in chapter 14 that a painter need not paint from a randomly arranged palette or work in isolation from friends and advice. The color-deficient painter can read the labels on the tubes of paint, select the desired pigments, and arrange them carefully on the palette. It does not take long to learn that red is a poor choice for sky or grass, or that tubes of green are hard to work with. So if the color-deficient painter wishes to use colors, he (and color-deficient painters are almost universally male) must learn to adapt. He can do abstract work, where no one can tell what color was intended—or he must choose to work with colors within a range that he can perceive, or select the colors by name and according to the conventions of normal-sighted people. Over a long career, Henry carefully utilized early morning landscapes and amber farm scenes that maximized (and were appropriate for) his use of the colors he could distinguish: blues, grays, and ambers.

One may wonder whether Henry's images would have been so evocative without his color deficiency, or if their character is a result of it. Meryon abandoned color and worked in black and white (which Henry also recognized as his strength when he was young). Perhaps fortuitously, Henry found a style and inspiration for painting that utilized his limited color perception to good advantage and gave his works a distinctive and compelling character. His style does appear to have evolved out of his color deficiency, given his preference for drawing and his chance exposure to the landscape of Achill. Furthermore, Henry's history does not demonstrate any experimentation with other styles, which is virtually always a component of a young artist's journey toward a mature style. At the same time, it would be naive and erroneous to say that Henry's color deficiency explains his success as an artist. There is much more to artistic skill than palette alone, and Henry's approach to framing his subjects, modulating lighting, and drawing the scene all contribute to the power of his paintings.

Henry is arguably the most important Irish painter of the twentieth century, and his work is much beloved. By understanding Henry's visual limitations, we understand why he made many of the choices that captivate us today, and which are responsible for the unique character that sets his art apart from the work of other artists of his time.

NOTES

1. Kennedy, *Paul Henry: Paintings, Drawings, and Illustrations* (2007).
2. Henry, *An Irish Portrait: An Autobiography of Paul Henry* (1951), pp. 23–28.
3. Dawson, introduction to *Paul Henry 1876–1951* (1973), pp. 2–4.
4. Kennedy, *Paul Henry: Paintings, Drawings, and Illustrations* (2007); Dawson, introduction to *Paul Henry 1876–1951* (1973), pp. 2–4.
5. Kennedy, *Paul Henry: Paintings, Drawings, and Illustrations* (2007), p. 83.
6. Henry, *An Irish Portrait: An Autobiography of Paul Henry* (1951), p. 20.
7. Ibid., pp. 51 and 56.
8. Ibid., p. 64.

PERSPECTIVE ON PERSPECTIVE

17.1

Perspective is a natural feature of art to those of us raised in Western culture. We are accustomed to images of the world, in which the depiction of buildings and objects strictly follows the laws of linear perspective relative to a fixed vantage point. Children in school learn how to pick a vanishing point and make objects appear "realistic"; and we apply the term "naive" to unschooled painters in whose work perspective is distorted. Indeed "proper" or "linear" perspective almost seems a natural part of our process of seeing, an extension of our vantage point. There is some physiologic truth to this notion, to the extent that true judgment of depth is only possible because each of our eyes sees the world from a slightly different angle, and our brain is able to analyze these differences as a means of calculating distance. For the most part, however, perspective merely represents the transformation of the three-dimensional world onto a two-dimensional plane held in front of the eyes; and while it may represent reality in the sense of a mathematical transfer of images, it does not necessarily, let alone always, serve the purposes of art (or life).

HISTORY OF PERSPECTIVE

Perspective that appears distorted to our Western eyes is not uncommon in art. Distorted or stylized perspective is evident in the art of ancient cultures, in most of the art of the Middle Ages, in Asian art up to modern times, and in many works of modern artists from Henri Matisse to David Hockney. It is tempting to look at paintings from the Renaissance and beyond, which display magnificent perspective, and wonder how it is possible that great painters of earlier eras, such as Giotto, or countries such as China and India, could have failed to recognize the distortion in their works. How could they paint beautiful figures or haunting landscapes and not find "inconsistencies" that would be noticed by the average modern third grader? We have no evidence that the eye has changed over the past few millennia, and in fact the use of perspective was quite sophisticated in ancient Greece and Rome. Trompe l'oeil wall paintings were created in many of the villas of Pompeii to enhance the architecture and give an illusion of space (see fig. 17.1). In other words, careful observers throughout history had the ability to produce reasonable (if not necessarily mathematical) perspective, even if they only selectively took advantage of it.

Did artists who ignored perspective do so from lack of interest or skill, from failure to perceive their "errors," or from a desire or need to portray different kinds of information in their work? We would suggest that the latter of these scenarios is most likely (see chapter 18), and this notion is supported by evidence that artistic conventions for distance and depth have existed throughout the history of art. Even in the ancient world, philosophers argued about whether art should be representational and whether perspective is valid. In a famous passage, Plato wrote: " . . . You may look at a bed or any other object from straight in front or slantwise or at any angle. Is there any difference in the bed itself, or does it merely look different? . . . Does painting aim at reproducing any actual object as it is, or the appearance of it as it looks? In other words, is it a representation of the truth or of a semblance? . . . The art of representation, then, is a long way from reality."[1] In fairness, Plato was judging art against his philosophical ideal of truth and reality, rather than as an aesthetic endeavor, but this passage clearly shows that people in ancient times were no less aware of these issues than we are today.

Although perspective may have been largely lost or consciously omitted from Western art for centuries—it reappeared

17.2

17.3

with a vengeance in the early part of the fifteenth century. The Italian masters of the late 1300s had begun to explore limited use of it, but as in Duccio's *Jesus Before Herod* (see fig. 17.2), they still focused primarily on subjects as opposed to architectural precision. Around 1420, the great Florentine architect Filippo Brunelleschi (who later built the dome of the great cathedral in Florence) devised a "demonstration," in which he made an accurate illusionistic painting of the baptistry, as viewed from the door of the cathedral. A viewer who stood at the proper spot and looked through a peephole could hardly tell if the scene was real or rendered. The impact of Brunelleschi's technique was enormous, perhaps because the cultural and political changes of the Renaissance made the public (and the Church) more worldly and scientific, and realism in art was more acceptable—and even demanded. Within a decade Masaccio had painted his famous fresco *The Trinity* on the wall of the Santa Maria Novella church, which gives the illusion of a chapel receding into the wall (see fig. 17.3); by 1435 another architect and painter Leon Battista Alberti had written the treatise *On Painting,* which provides a do-it-yourself manual for creating a vanishing point and the receding rays of linear perspective.

Word traveled fast, and by the mid-1400s all of the major Italian painters were incorporating linear perspective. Indeed, some paintings, such as Piero del Pollaiuolo's *The Annunciation* (see fig. 17.4), were virtual treatises on perspective technique, in addition to—or sometimes to the exclusion of—other artistic merits. The love for perspective almost got out of hand in the ensuing centuries, when painters such as Canaletto and Pieter Janz Saenredam constructed large and complex views of cities, cathedrals, and other structural entities to highlight the power of perspective in generating an illusion of space. These illusions could be so powerful that Baroque architects placed perspective murals on the low-domed ceilings of many churches, such as Andrea Pozzo's *The Glorification of Saint Ignatius* (see fig. 17.5), to provide a sense of space and height without having to incur the cost of building a higher dome. The architect Francesco

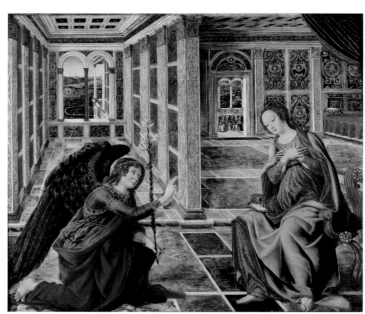

17.4

17.5 a

Fig. 17.2 Duccio di Buoninsegna, *Jesus Before Herod*, from the Maesta altarpiece, 1308–11. Oil on panel, 19 ³/₄ x 22 ¹/₂ in. (50 x 57 cm). The figures are beautifully rendered, but building elements recede in a variety of different directions.

Fig. 17.3 Tommaso Masaccio, *The Trinity* (detail), 1427–28. Fresco, overall 263 x 127 in. (667 x 317 cm). Precise perspective makes this fresco appear like a deep crypt in the wall.

Fig. 17.4 Piero del Pollaiuolo, *The Annunciation*, c. 1470. Oil on poplar wood, 59 ¹/₄ x 68 ³/₄ in. (150.5 x 174.5 cm). Compare this image with figure 17.1, a Roman wall painting done one thousand five hundred years earlier.

Fig. 17.5 Andrea Pozzo, *The Glorification of St. Ignatius*, 1691–99. Ceiling fresco, 1417 ¹/₂ x 669 in. (3600 x 1700 cm). **(a)** Viewed properly from a disk at the center of the floor, the ceiling appears to soar upward, supported by tall columns. **(b)** These features are all painted, however, and if the ceiling is viewed from the wrong part of the church, as in this smaller view, distortion becomes obvious.

17.5 b

17.6 a

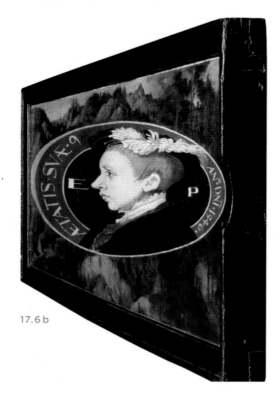

17.6 b

Fig. 17.6 William Scrots, *King Edward VI*, 1546. Oil on panel, 16 1/2 x 63 in. (42.5 x 160 cm). **(a)** This anamorphic portrait is unusually wide, and while the background scenery seems normal, the images in the central oval are strangely distorted. **(b)** The portrait appears normal when viewed through an indentation in the frame. This effect can be duplicated by tilting the page to look at the anamorphic image from a very oblique angle.

Fig. 17.7 Drawings from Hudson.[2] Three drawings to evaluate, in different cultures, the perception of distance in pictures. These test recognition of cues from **(top)** size, **(middle)** superimposition, and **(bottom)** perspective.

Fig. 17.8 Test figure (after a diagram from Deregowski[3]). The drawing is subject to different interpretations, depending on cultural experience in viewing three-dimensional representations.

Fig. 17.9 "Impossible" trident figure. Most people raised in Western culture have difficulty drawing this figure after brief observation. Without studying the image any further, try to duplicate it on a piece of blank paper. Individuals who do not see the three-dimensional paradox may find it easier to duplicate the figure as a simple pattern of lines.

places in ordinary life where one cannot avoid an angled view: For example, markedly elongated letters are routinely painted on the street to warn drivers to stop or yield.

PHYSIOLOGY VS. PSYCHOLOGY

Is there any extent to which linear perspective is a part of innate perceptual machinery? In other words, will a naive observer or one unschooled in Western tradition perceive three-dimensionality in perspective drawings or recognize objects that are drawn in perspective? In Western society, of course, it would be hard to find a one-year-old child who has not had long experience with picture books and perspective renditions of objects, or one who has not spent most of his or her life in an environment of rectilinear objects. Thus, much of the data on this issue comes from studies of isolated and/or primitive peoples. A classic series of experiments was performed by William Hudson, who showed a set of pictures featuring different types of depth and perspective cues (see fig. 17.7) to tribal subjects in Africa.[2] He found that these people often saw the pictures as flat and did not seem to recognize the difference in distance between the antelope and elephant (a difference which is obvious to Westerners). Jan Deregowski observed that these individuals also had more trouble recognizing the diagram in figure 17.8 as a three-dimensional object, although curiously this test proved less sensitive than Hudson's.[3] On the other hand, most of us in Western culture find an "impossible figure," such as the trident in figure 17.9, difficult to draw from memory (try it yourself!), while tribal subjects, who had difficulty perceiving three-dimensional drawings, were better able to reconstruct such illusory figures. This type of spatial ambiguity underlies William Hogarth's famous (and tantalizing) frontispiece to a textbook on perspective (see fig. 17.10), as well as M. C. Escher's impossible architecture (see fig. 21.2).

Borromini made a short passageway appear to be a long colonnade by physically narrowing the width and height to confound assumptions of perspective (see fig. 19.13).

One problem with painted perspective is that even the finest perspective image will appear distorted when viewed from an "incorrect" vantage point. This effect is accentuated with architectural trompe l'oeil paintings, which is the reason Brunelleschi required his viewers to use a specific peephole. The trompe l'oeil ceiling paintings in churches give a wonderful sense of height when you stand at the exact center of the floor, but from the side of the church one sees strangely tilted structures and figures (see fig. 17. 5). The Dutch painter Samuel van Hoogstraten painted scenes on the interior walls of boxes that look bizarre when viewed from the front, but reveal a precisely drawn scene when viewed through a peephole in one wall. This distortion of objects to compensate for oblique views is called anamorphism. Hans Holbein, the Younger's great painting *The Ambassadors* (in the National Gallery, London) has a curiously elongated object near the bottom that is seen to be a skull when viewed at a very shallow angle through a peephole in the frame of the painting. This same technique allows one to decipher the famous anamorphic portrait of Edward VI (see fig. 17.6). The use of anamorphic projections is not merely a game, however, since there are

17.7

17.8

17.9

As intriguing as these observations may be, the results of studies in this field have not been consistent. Some groups of unschooled subjects have performed remarkably well on tests of picture recognition, whereas even Western children will occasionally have difficulty. Testing of perceptual ability is tricky, because results can be biased by subtle cues, and sometimes confounded for unexpected reasons. For example, scholars trying initially to test a remote Ethiopian tribe called the Me'en found that children took the sample pictures, smelled them, crumpled them, and sometimes even tasted them—but totally ignored the images.[4] The apparent reason was unfamiliarity with paper as a material, and the test proceeded more smoothly when the images were printed on a familiar type of cloth.

Could there be any biologic differences among people to account for different views of perspective? It is highly doubtful that the visual system differs among races, but visual perception can be influenced biologically by events during early childhood. For example, an eye that has been occluded, is badly out of focus, or has turned inward or outward during the first few years of life may permanently lose the ability to see, because the brain circuits which serve visual acuity need stimulation and usage in order to become permanently established. This visual condition (amblyopia) is sometimes called "lazy eye." It can often

be reversed if the underlying problem is discovered and fixed promptly, so that the child uses the abnormal eye while the brain circuitry is still plastic—up to about age six. (For this reason, children should have a screening test of vision in each eye during the preschool years.)

There are interesting data from animal experiments that also bear on this issue. When kittens are raised inside an enclosure that contains only vertical elements, no horizontal ones, the cells in their brains lose the ability to recognize horizontals.[5] Thus, it is not inconceivable that children raised in environments that are singularly lacking in certain visual elements could be physically less capable of recognizing them. On the other hand, it is hard to assess whether the real world can ever provide a sufficiently skewed visual input for this effect to be significant. It has been argued that the "carpentered" world of Western society helps children to recognize right angles and perspective representations compared to individuals raised in a forest or plain where there are no boxlike structures. However, even nature is dominated by verticals (trees and cliffs) and horizontals (the ground and horizon) so that it would be surprising to find major organic differences in visual capability, even among groups living in disparate environments. Culture and environment may, under certain circumstances, influence the perception of perspective, but even if present, such an effect would be only one factor among many that interact to determine how individuals create art, perceive art, and use art.

IMPLICATIONS FOR ART

While linear perspective in painting is an important artistic tool that mimics a photographic view of the world, it is not the only tool for evoking a sense of depth. Awareness of depth is achieved through many visual (and artistic) cues, such as relative size of familiar objects, the overlapping of one object by another, the fading of colors with distance, and shadows. All of these indications are used routinely in art to enhance the sense of distance, along with perspective—or sometimes in lieu of it, as in Asian art, such as *Wooded Mountains at Dusk; Zhenglan Hunluan* by

17.10

17.11

Kuncan (see fig. 17.11). The presence of shadows is also linked to realism in artistic representation, and their appearance has to a large degree followed the use of perspective (see also chapter 7). For example, shadows are found in many Roman wall frescoes (see fig. 17.1), but are absent from Egyptian painting and from the iconographic art of the Middle Ages (see fig. 17.2). They began to appear again in pictures of the early Renaissance, but were represented accurately only as linear perspective was perfected. This omission of shadows in most nonperspective art supports the thesis that perspective has been used (or avoided) more for reasons of convention or style than for lack of observation or skill, since no special geometric techniques are needed to place a shadow behind a person standing in the sun. Would functionally one-eyed individuals have an advantage as artists, because they see only a two-dimensional world? This theory has been postulated, but it seems unlikely, given that we all use and recognize monocular cues as well as perspective to judge depth.

Some contemporary artists are drifting away from the use of linear perspective, as they seek out new purposes and new ways that art can stimulate the viewer without arbitrary constraints of technique, a development discussed in the chapter that follows. Where art functions for the purpose of strict representative illustration, perspective is essential; however, where art tells a story, conveys emotion, or shocks the senses, perspective may divert attention from the primary features of the painting. Anyone who has attended a movie in recent years is aware that form and space are now moldable through computer manipulation, and our societal attraction to rectilinear representations may become less rigid in the years to come. The facts of photographic perspective are immutable; but the role of perspective in art may be best understood as a matter of perspective.

NOTES

1. Plato, *The Republic*, Book 10 (360 BCE), p. 328.
2. Hudson, "Pictorial Depth Perception in Sub-cultural Groups in Africa" (1960).
3. Deregowski, "Real Space and Represented Space: Cross-Cultural Perspectives" (1989).
4. Blakemore, "Development of the Brain Depends on the Visual Environment" (1970).
5. Ibid.

Fig. 17.10 William Hogarth, Frontispiece to *Method of Perspective* by Dr. Brook Taylor, 1754. Engraving, 8 ¼ x 6 ⅔ in. (21 x 17 cm). Hogarth depicts a variety of perspective illusions, much as M. C. Escher would do centuries later.

Fig. 17.11 Kuncan, *Wooded Mountains at Dusk; Zhenglan Hunluan*, 1666. Hanging scroll; ink and color on paper, 49 ½ x 24 in. (125.7 x 61 cm). In this landscape, the sizes of the trees, hills, and waterfalls change relatively little beyond the foreground, and the buildings lack perspective. Depth is indicated primarily by location higher in the painting. Overlap and atmospheric haze aid in the judgment of depth.

Fig. 18.1 Tutankhamun (c.1370–52 BCE) and his wife, Ankhesenamun, from his tomb, New Kingdom, Egyptian 18th Dynasty, c.1567–1320 BCE. Painted limestone. These representations are highly stylized, with twists of the body that no real person could duplicate.

18.1

ART WITH DIFFERENT PERSPECTIVES

In chapter 17 we reviewed the "discovery" of linear perspective in the Renaissance, and its seeming importance (or at least pervasiveness) in Western culture. But as noted, issues of perspective have been treated in different ways over the centuries and in other cultures—and in fact in our modern era, as well, when artists have broken away from traditional constraints. It is instructive to examine some of this diversity and history, both to appreciate the scope of art and to better understand the role and limitations of perspective in viewing or reproducing the world.

Perspective may be analyzed in two related—but not identical—contexts: distance and realism. With respect to distance, perspective constitutes a geometric system whereby size and location of objects in space are depicted accurately from one vantage point. Strictly speaking, these cues are independent of secondary or monocular ones, such as overlap, size of familiar objects, shadowing, or brightness. Perspective is also synonymous with realism, and thus a necessity if a painting is to accurately illustrate a scene. But herein lies the problem: Painting is not as objective as photography, and furthermore, even in ancient times, there were many pressures on artists in terms of economics, cultural standards, politics, technology, and patronage. Given the demands of each, representational accuracy was not always a primary goal, nor was perspective necessarily the ideal technique.

The art of ancient times, for example, displays a surprising range of perspective sophistication. Cave paintings tend to depict figures or animals in a shallow space, with little depth suggested other than through overlap or sometimes a small difference in size. However, by Hellenistic and Roman times, painters had grasped many of the principles of linear perspective, even though there was no formalized, geometric method. As noted in chapter 17, wall paintings from Roman villas reveal an awareness of recession toward a vanishing point, and artists painted effective trompe l'oeil images onto walls and door frames to give an illusion of deeper space or more complex architecture. While this form of perspective is a simplified one by modern standards—usually featuring parallel lines for the horizontal demarcation of objects in the frontal plane and angled lines to suggest depth—the basic concept is there.

In contrast, in ancient Egypt, figures were painted in a flat and stylized manner (see fig 18.1), typically with the head and feet directed to the side, while the eye and chest faced the viewer. It is doubtful that anyone not working as a contortionist could duplicate this stance, but to the Egyptians it was an essential part of their visual and symbolic language. The Egyptians were no strangers to three-dimensional representation, as evidenced by their magnificent sculptures, but they were unconcerned about the lack of realism in their paintings and reliefs. It was only important that their pictures told the stories that they were commissioned to tell.

In ancient times, as today, the purpose of art influenced the format and style in which it was created. Works done for decoration might have a different aesthetic than those made to enhance an estate, convey faith, reinforce a government, or sell a product. "Art for art's sake" was not always pursued as it is has been in modern times. But even today, images created for promotion and sales, political protest, or a company portrait are governed by different standards than images sold for aesthetic import. Within this context, perspective is but one technique among many for selling a product, which may be a religious belief, a ruler's spin on history, or a record of a wealthy man's property for his tomb.

18.2

A similar rationale probably lies behind the curious loss of perspective when the Greek and Roman civilizations faded and Western Europe entered the Dark Ages: Byzantine artists (see fig. 18.2) focused on religious figures and stories, for which the message was paramount and the scenic background was secondary (or might have been considered an unholy diversion if too perfect). Sometimes, to illustrate a narrative sequence, the same biblical character appears several times in one picture. The purpose of these pictures was not to illustrate heaven for those who had not yet made the trip, but to serve as a vehicle for teaching the Gospel. In effect, the message dictated the style, and it would have been undesirable to distract the viewer with irrelevant realism. Similar reasoning is thought to explain the lack of shadows in Byzantine paintings, despite the effective use of them in Roman murals. The holy figures of Christianity were considered ethereal so did not cast shadows—and as they were the primary subjects of art of this era, shadows were simply left out altogether.

Despite the visual impact of perspective as used in Western art, quite different conventions of perspective are found in the art of China and Japan, as well as in traditional Islamic art. Asian paintings (see fig. 18.3) are characteristically flat in appearance, with distances indicated by overlap, by position on the page from bottom to top, and by progressive haze in the distance.[1] Size cues are used to a limited degree, and convergent perspective is used very little. The traditional rule was that parallel lines on a structure should remain parallel, rather than converge with distance. As in ancient Egypt, this style, understood by the culture within which it was created, conveyed important information without regard for whether it represented reality. The artist told a story, imparted a sense of emotion, or illustrated a quality of nature as opposed to illustrating nature itself. Issues of depth or distance were not ignored per se—they were simply expressed by, and understood by, different conventions.

In some Asian paintings, but more strikingly in work from the Islamic and Indian empires, objects are drawn in "reverse perspective," i.e., drawn so that parallel lines *diverge* with distance (see fig. 18.4). Divergent perspective is also seen in many Western paintings from the Middle Ages (see fig. 18.2), in ancient primitive art, and in modern naive painting. How does

one explain this technique, which seems not merely to deviate from, but to totally controvert, visual experience? First, of course, we return to earlier arguments that the purpose of art is not necessarily representational, and that one must inquire as to what information the artist was aiming to convey. As Plato argued, a bed is the same no matter how it is viewed, and thus a rectangular or divergent image may serve an artist's purpose better than a perspective image if it provides more room on which to draw the design of the bedspread or to show the bed's occupants. Linear perspective ensures a sense of three-dimensionality, but it also reduces the amount of detail one can provide for distant objects because of their shrunken size. One motivation for neutral or divergent perspective may be a desire to grant equal importance to, or give equal detail of, objects at different depths within a scene. For example the Persian prince sitting at the back of a pergola should not, within the context of Persian culture, appear smaller than a courtier in the foreground.

Since we can only touch upon the variety of perspective techniques in ancient and non-Western art in this short chapter, it is important to emphasize that none of these descriptions should be considered absolute for any given time period or culture. Artists have experimented, used their innate visual judgment (when it was not prohibited), and learned from each other throughout history. Particularly within Asian and Islamic painting, one finds a variety of schemes for portraying depth, and often a combination of techniques (e.g., some variation in object size, but a rigid use of parallel lines or reverse perspective for the sides of buildings). Furthermore, cultural traditions have not been absolute, and have evolved over time. Western art (and even some manuals on painting) were brought selectively into the palaces of China, Japan, and old Persia, so that the rulers and their court artists saw—and began to copy—Western perspective techniques. In the 1500s and 1600s, Mughal princes in India collected examples of Western art, and all of a sudden painted miniatures from the court of Akbar began to feature vanishing points.[2] Western manuals of painting, and prints of Western art, were available in Japan in the 1700s, and inspired a new school of painting, *uki-e* (not to be confused with *ukiyo-e*). Interestingly, because much of this art was derived from Western print material, *uki-e* painting was considered a low-class style, for casual decoration and entertainment, rather than a serious cultural pursuit.[3]

In the late nineteenth and early twentieth centuries, Western art evolved in many different directions. Artists could sell works independent of patrons or the Salon and create works that embodied new aesthetic concepts, such as fauvism (with its non-representational colors), cubism, and abstraction. Without representational constraints, Western artists re-examined the use (or avoidance) of perspective. For example, both Paul Cézanne and Henri Matisse deformed perspective consciously to emphasize different aspects of a scene, such as fruit on a table. The tabletop in Cézanne's *Nature morte avec pommes* (*Still Life with Apples*) (see fig. 18.5) tilts precariously but provides a full view of the objects on it—which makes artistic if not physical sense.

Of course, as we have emphasized previously, even though a perspective view may seem representative of true vision, it is nonetheless artificial. A perspective painting presents a scene from a single vantage point, like one frame of a motion picture. Many artists, such as Pablo Picasso (see fig. 18.6) and David Hockney (see fig. 18.7), have created distorted or multifaceted images to illustrate the fact that natural vision is always moving

18.3

18.4

18.5

Fig. 18.2 *The Birth of Mary*, 1295. Although the religious figures in this fresco are fairly realistic, furniture and buildings are in reverse perspective and reflect a strange diversity of size and apparent position in space (see also fig. 17.2).

Fig. 18.3 Attributed to the studio of Tawaraya Sotatsu, detail from a screen illustrating *The Tale of Genji*, Edo Period, 1634–43. Album leaf, ink, color, and gold on paper, 57 x 5 ½ in. (144 x 14 cm). Note the strict use of parallel lines for all sides of the structures.

Fig. 18.4 *The Old Moghul Aurengzeb on His Throne*, early 18th century. This miniature shows reverse perspective as seen often in Muslim art. The divergence with depth is so extreme for the canopy that the artist has altered the apparent location of the legs to avoid obscuring the subjects. The result is a spatial illusion reminiscent of impossible figures and prints by William Hogarth (see fig. 17.10) and M. C. Escher (see fig. 19.17).

Fig. 18.5 Paul Cézanne, *Nature morte avec pommes (Still Life with Apples)*, 1893–94. Oil on canvas, 25 ¾ x 32 in. (65.5 x 81.5 cm). The table seems tilted, and the green jug appears to have its base and mouth at different angles (see also fig. 24.8).

18.6

and scanning. Picasso's fascinating portrait of his wife Jacqueline shows her face simultaneously in frontal view and in profile, simulating the reality that no person exists only in one view and at one moment in time. This same idea appears frequently in Native American art, where two profiles of a face or animal may be melded into a single image.

Hockney put this concept into words: "Perspective makes you think of deep space on a flat surface. But the trouble with perspective is that it has no movement at all. The one vanishing point exists for only a fraction of a second to us . . . My point about the desk photograph is that if you are seeing around the corners of the desk, you are seeing yourself move. It isn't just the desk, it is you and the desk. You are united with it, in the process of looking. You are aware of yourself in space."[4] Linear perspective remains a compelling facet of much art, and serves it well when a single view of the world serves the artist's purpose. However, when artistic license takes the artist beyond its limitations, painters for millennia have found different perspectives.

NOTES

1. March, "Linear Perspective in Chinese Painting" (1931).
2. Rogers, *Mughal Miniatures* (1993).
3. Screech, "The Meaning of Western Perspective in Edo Popular Culture" (1994).
4. Hockney, *Hockney on Photography: Conversations with Paul Joyce* (1988), pp. 30 and 140.

18.7

Fig. 18.6 Pablo Picasso, *Portrait Bust of a Woman*, 1960. Oil on canvas, 36 ¼ x 28 ¾ in. (92 x 73 cm). Picasso elegantly superimposed frontal and profile views of his wife Jacqueline.

Fig. 18.7 David Hockney, *The Desk, July 1st 1984*, 1984. Photographic collage, 48 x 46 in. (122 x 117 cm). This collage shows multiple views and features of the desk simultaneously, which could not have been done with strict linear perspective.

ILLUSION AND ART

Pictorial representation is by nature illusory. Perspective is designed to fool us into seeing a three-dimensional world within a two-dimensional canvas, and philosophers as far back as Plato (see chapters 17 and 18) have argued over the wisdom of such artifice. However, representation is not the only purpose of art, and through the ages paintings have served to decorate, document, inform, educate, indoctrinate, record, trigger emotion, shock, and occasionally fool the eye—consciously or unconsciously. Most notably in modern times, paintings have been created solely for their visual effect, independent of other contexts. Some of these works have been categorized as optical art, commonly called Op Art. Within this range of roles for art, illusion is no longer merely a device to create a sense of depth or space; in some cases the illusion itself has become the image. Psychologists and art historians have debated for centuries about the function and/or importance of illusion in art, and visual scientists have struggled to explain and classify visual illusions.[1] Books have been written on the subject—including the wonderful monographs by Rudolf Arnheim[2] and Sir Ernst Gombrich.[3] These issues will not be resolved in the space of a few pages, but in this chapter we offer a framework for thinking about visual illusions (and why they work in the eye and in art) that we hope will provide some insight—or encouragement to appreciate—this visual aspect of art.

Visual illusions are, by definition, phenomena that fool us. However, one could argue about whether the definition should be "fool the eye" or "fool the brain." The distinction is quite important, if one interprets "brain" to include the psychological components of how we recognize, interpret, and appreciate what we see. The eye, of course, can only respond to images in a physical way, with circuits that are hardwired essentially the same way in all people. These circuits are the hardware in our visual "computer." Conscious visual perception, however, is influenced by what we have learned, by peer pressure, by interest, and by attention. The enormous power of the brain to recognize, interpret, and appreciate objects represents the software in our visual "computer"—and different individuals may process this information using different "programs."

To the extent that we can recognize hardware and software components of visual perception, we can also distinguish between illusions that depend upon hardwired circuitry and illusions that depend primarily upon soft-wired acculturation or experience. Some illusions bridge the gap and rely on a mixture of hard- and soft-wired mechanisms, but the dichotomy can still be helpful in understanding their impact in art.

HARDWIRED ILLUSIONS

Perhaps the most prevalent example of a "hardwired" illusory phenomenon is the Mach band, which represents an enhancement of perceived contrast at edges (see chapters 5 and 6). Mach bands are a perceptual manifestation of the fact that the retina and primary visual pathways are designed to emphasize contrast between light and dark as a means of simplifying and coding visual images. The number of nerve fibers between the eye and the brain is much smaller than the number of photoreceptor elements in the retina, and as visual information converges on these nerve fibers, the circuitry automatically enhances the response to contrast while minimizing the response to diffuse light or darkness. Thus, the perception of illusions based on Mach bands or similar contrast phenomena is inherent in humans. Mach bands appear in many types of art, as discussed in chapter 6; although we can learn from experience to recognize them and to make brightness judgments cautiously where they might cause confusion, the illusion is always there—for the young and old, for the naive and the sophisticated.

A related illusion is the Hermann grid (see fig. 19.1). When looking at this pattern of white lines on a dark background, we see evanescent gray spots at the intersections of the white lines, which disappear curiously when we look directly at them. These fleeting spots are thought to arise from the center-surround organization of the retinal bipolar and ganglion cells (see chapter 5). This figure shows diagrammatically that the center of each intersection will appear darker because there is more inhibitory input to the cells whose receptive field is centered on the intersection. But why do the dark spots disappear when we look right at them? The answer lies in the fact that the center of the retina is specialized for sharp vision, while side vision is rather fuzzy and serves mainly for orientation and the detection of motion. The receptive fields for each cell in the center

Fig. 19.1 Hermann grid. Evanescent gray spots are perceived at the intersections of the white lines. The diagram below shows a proposed explanation for the phenomenon. At each intersection there is twice as much light on the inhibitory surround region of the receptive fields of the retinal neurons (see chapter 5).

Fig. 19.2 Victor Vasarely, *Supernovae*, 1959–61. Oil on canvas, 95 ¹/₄ x 60 in. (241.9 x 152.4 cm). The flickering gray spots at every intersection of the white lines add to the effect of this painting.

19.1

19.2

of the retina are very tiny (which enables us to read fine print), but become larger away from the center. As we look directly at an intersection, the tiny receptive fields of our central vision fall entirely within the white space so there is no difference between the line and the intersection. Only in off-center vision, where the center-surround areas are large enough to correspond to the width of the lines, does the Hermann grid phenomenon occur. These evanescent spots are hard to find in classical painting amid complex shapes and images. However modern artists, such as Victor Vasarely, have constructed images such as *Supernovae* (see fig. 19.2), whose fascination and vibrancy are, in part, the result of these inescapable, fleeting spots.

Some illusions (see fig. 19.3) depend upon distortion of our sense of directionality when angled lines impinge upon a straight line. In the Zöllner illusion, for example, parallel lines appear to diverge or converge, depending upon the direction of the angled cross-hatching. In the Poggendorff illusion, a single line drawn at an angle to a rectangular bar seems to show displacement of the two segments of the single line. In the Hering illusion, parallel lines that cross a set of radiations appear to bulge. The physiologic basis of these illusions is unknown, and may involve a component of experience or acculturation, insofar as they evoke some memory of familiar objects or shapes. However, it is also quite likely that these phenomena depend upon the interaction

19.3

Fig. 19.3 Three illusions of
direction. **(left)** Zöllner illusion:
The longer lines do not appear
parallel. **(middle)** Poggendorff
illusion: The line "behind" the
rectangle does not appear
continuous. **(right)** Hering illusion:
The central lines do not appear
parallel.

Fig. 19.4 Bridget Riley,
Descending, 1965–66. Emulsion
on board, 36 x 36 in. (91.5 x 91.5
cm). The captivating design of this
painting is enhanced by illusory
effects such as those shown
in figure 19.3, and by shimmer
(because ocular fixation on the
fine pattern is difficult).

19.4

19.5

Fig. 19.5 Navajo, Tec Nos Pos, Arizona, M. Benally, woven rug, late 20th century. This "eye-dazzler" pattern is difficult to stabilize in gaze.

19.6a

of visual cortical cells that are specialized for directional sensitivity. The brain combines information from myriads of directionally sensitive cells to judge "straightness" of a line, or to interpret the significance of an angled junction. When the continuum is interrupted by a gap as in the Poggendorff illusion, or is so overloaded with information as with the angled lines in the Zöllner and Hering illusions, the interpretations may become biased as the brain attempts to integrate all of this input into a cohesive scheme. These illusions contribute to the complex effects of contemporary artist Bridget Riley's *Descending* (see fig. 19.4).

Another effect of *Descending* comes from the juxtaposition of closely spaced lines. It is difficult to fix one's gaze precisely on one line of this pattern, which seems to move or "shimmer." The physiological basis of this effect is the fact that absolutely stable images on the retina fade out within seconds, because the cells adapt. Retinal cells require contrast (i.e., a change in brightness) to stimulate them, and to provide this contrast, the eyes are continuously in motion with a very fine quivering that we do not consciously recognize. Because of this movement, gaze is shifted continuously from one line to another with any closely spaced pattern, and the pattern will appear to have a shimmering quality. This property of vision has been exploited not only by modern Op artists but by others intrigued with visual effects. Navaho weavers make "eye-dazzler" rugs in which they juxtapose colors in patterns so fine that the images seem to shimmer (see fig. 19.5); and the patterns on some Native American pottery are equally evocative (see fig. 19.6). The Acoma seed pot design shown in figure 19.6a not only has a fine pattern, but the lines arcing out from the core create ambiguity between circles and spirals in the intersecting pattern. A *mucahua* bowl from the Ecuadorian Amazon (see fig. 19.6b) shows geometric designs that not only shimmer and confuse, but confound one's assumption that patterns should be regular. The design seems

19.6 b

Fig. 19.6 Native American pots, viewed from above. **(a)** Acoma, New Mexico, B. and J. Cerno, seed pot, 1989. The vibrant pattern on this pot creates illusory circles and spirals. **(b)** Quichua, Amazon region, Ecuador, mucahua bowl, 2008. The fine lines on the interior of this bowl create instability, and the design unexpectedly juxtaposes three elements in the base and five around the rim.

Fig. 19.7 Kanizsa triangle. A white triangle is seen although no lines define it.

Fig. 19.8 Paul Cézanne, *The Lime Kiln*, also called the *Watermill at the Bridge of Trois-Sautets*c. 1890–1894. Watercolor, 16 ½ x 21 in. (42 x 53.1 cm). Partial lines convey a sense of building outlines and corners. We also "fill in" colors from only a few dabs, as discussed in chapter 8.

19.7

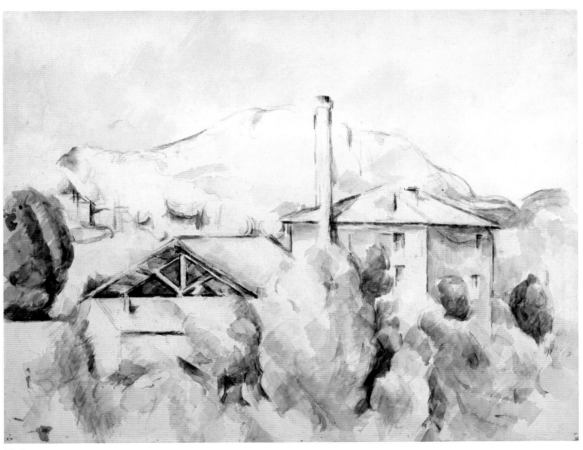

19.8

19.9

straightforward until you look more carefully and realize that the pattern has three radiating elements in the core, but five in the rim—a visual equivalent of a hemiola in music.

Another set of illusions that may invoke hardwired circuitry are those that produce illusory contours. A classic example is the Kanizsa triangle (see fig. 19.7): One perceives a well-defined white triangle between the three corner wedges, although there is no border and the figure is essentially a figment of the imagination. A number of artists have made paintings that invoke this illusion, causing the viewer to perceive lines where none actually exist. In Paul Cézanne's watercolor *The Lime Kiln* (see fig. 19.8), the outlines of buildings, chimney, windows, and even mountains, are incomplete—yet we perceive the objects as if they are fully demarcated. The physiological basis for these illusions is not fully understood. Undoubtedly some of these perceptions derive from our experiential familiarity with shapes

and our tacit assumption that the aim of every drawing is to depict a real object. However, part of the illusion derives from a fundamental characteristic of our visual system: the tendency to fill in space using border information. The fact that information from every photoreceptor cannot be transmitted unmodified to the brain requires visual information to be simplified, and one mechanism by which the eye and brain accomplish this is to minimize the expenditure of neural energy on images that do not change.

An example of this phenomenon is the blind spot in everyone's eye, which corresponds to the place where the optic nerve fibers enter the eye (see fig. 19.9). The most interesting thing about the blind spot is the fact that we hardly ever notice it! Even if you look about with one eye closed, you will not perceive a gap in ordinary images unless you carefully watch for a specific object to seem to disappear. This is the case because the brain

19.10

19.11

Fig. 19.9 Recognizing the blind spot. Look at the diagram with one eye only: Fixate on the X with the left eye (or the spot with the right eye) and the other mark will disappear. Some adjustment of distance may be necessary.

Fig. 19.10 Joseph Albers, *Study on Vibrating Boundaries*, 1963. These strong colors, which have similar luminance, conflict and create instability of the image.

Fig. 19.11 Illusions of perspective and size. **(left)** Ponzo illusion: The upper bar appears longer. **(right)** "The Man in the Tunnel": A perspective drawing giving the illusion that the figures increase progressively in size.

uses edges and contrast to define a new object or pattern, and the blind spot is *not* an edge or contrast—it is simply a lack of information. Thus, the brain fills in the void with the pattern or color that surrounds it. The eminent neuroscientist Karl Lashley suffered from occasional "ocular migraines," in which his central vision would temporarily black out and produce a large blind spot in the center of his vision. During one of these attacks he looked directly at a friend and was shocked to find that not only had his friend's head disappeared, but the wallpaper pattern behind him had filled in the gap and extended down to his collar.[4] Had Lashley suddenly obtained X-ray vision? In the absence of any new edges or contrasts to interrupt the wallpaper pattern, his brain had simply extended "perception" of the pattern through the blind area until he recognized the collar.

Some of the color effects in Op Art may also derive from hardwired physiological properties of vision. Figure 19.10 shows a work by Josef Albers in which blue-green circles lie on a bright orange-red background. Color information is processed in the retina and brain by cells that are specialized for the recogni-tion of color contrasts, particularly between red and green, and between blue and yellow (see chapter 8). Thus, these strong color juxtapositions represent intrinsically conflicting sensa-tions. This same painting in green and yellow, or in purple and blue, would be interesting, but it would lack the vibrancy and disturbing contrast that reflect the separation of red and green within the nervous system. The jarring and vibrating effect is enhanced by the fact that the strongly contrasting colors have much less contrast in brightness, i.e., they are relatively equi-luminant (again, see chapter 8), making the uneven pattern of circles hard to define spatially.

SOFT-WIRED ILLUSIONS

In contrast to the illusions described above, there are illusory phenomena that are dependent primarily on past experience or expectations. The prototypes are illusions based on perspec-tive, such as the Ponzo illusion or the illusion of "The Man in the Tunnel" (see fig. 19.11). Our perception that the top bar is longer than the bottom one (in fig. 19.11a) or the second and third figures are larger than the first (in fig. 19.11b) is a direct result of our assumption that the angled lines signify reced-ing space. As we've previously discussed (see chapter 17), such perspective illusions are sometimes less effective for individuals raised in a primitive culture, who have not seen photographs or perspective drawings. One could argue that much of art is dom-inated by perspective illusions, either as devices used to enhance the sense of reality or, by their omission (as in Byzantine, Egyp-tian, or Asian art) to focus our attention on other meanings,

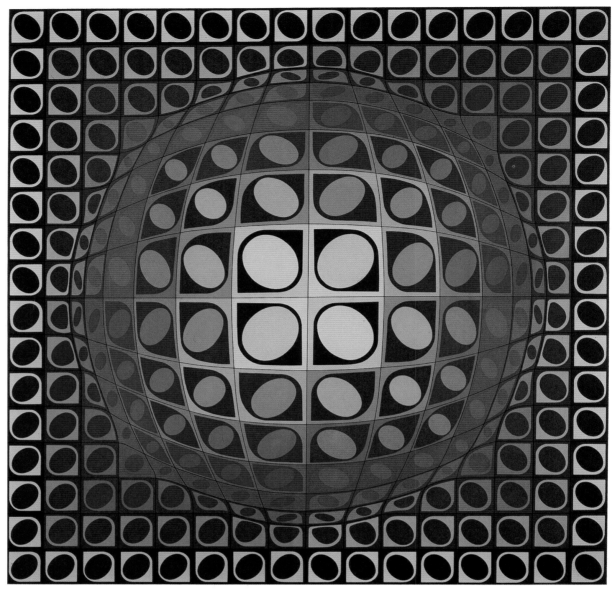

19.12

such as religious symbolism, documentation of events, or the transmittal of an emotional sensation. Modern Op artists have exploited our strong Western sense of perspective and our firm expectation of seeing objects in art to make paintings that explicitly play upon our sensations and our expectations. The sensuous bulge of Vasarely's lithograph *Boyar* (see fig. 19.12) occurs because our experience with light and shadow, as well as our sense of perspective, cause us to see three-dimensionality in the image rather than a uniformly flat pattern of colors and shapes. Perspective illusions are not limited to Op Art or even to two-dimensional images. The famous colonnade in the Palazzo Spada (see fig. 19.13), designed in 1632 by architect Francesco Borromini, is the Ponzo illusion in reverse! What we assume to be a long receding hall is actually very short, and as one walks through the passageway, it tapers in both width and height. It resembles the perspective illusion of Masaccio's fresco *The Trinity* (see fig. 17.3).

Other soft-wired illusions that depend upon experience and expectation are those of impossible figures and ambiguity. One such figure is the Necker cube (see fig. 19.14), which may be visualized in two orientations. It has formed the basis of art for millennia and was a frequent design in Greco-Roman mosaics (see fig. 19.15). The impossible triangle and never-ending staircase of Penrose[5] (see fig. 19.16) were immortalized artistically by M. C. Escher, who transformed the triangle into a series of unending waterfalls (see fig. 19.17). Other examples include the "impossible" cube, a Necker cube with a twist (see fig. 19.18); the familiar "impossible" trident figure (fig. 17.9); and the impossible figure of Vasarely's *Torony III* (see fig. 6.11). All of these illusions depend upon our innate desire to find real and familiar objects in what we see. William Hogarth toyed with these effects of misdirected imagery and expectation in his engraving about the (mis)use of perspective (see fig. 17.10).

Another classic example of a soft-wired ambiguous figure is

Fig. 19.12 Victor Vasarely, *Boyar*, 1978. Lithograph, approximately 28 x 28 in. (71 x 71 cm). Cues of perspective and lighting make us see a sinuous bulge in this print, rather than just a design.

Fig. 19.13 Francesco Borromini, *Perspective Gallery*, Palazzo Spada, Rome, 1632. The apparent (illusory) length of this short gallery is four times that of its real length. The passageway is actually narrower and lower at the end than at the front. Compare with figure 17.3.

Fig. 19.14 Necker cube—an ambiguous object. This structure can be seen in two different orientations.

19.13

19.14

the vase (see fig. 19.19)—or is it two faces in profile? Since we must be familiar with vases and profiles to perceive the ambiguity, this is an illusion of culture and experience rather than neurology. Artists have explored variations on this theme. Some cubist portraits, such as Pablo Picasso's *Portrait Bust of a Woman* (see fig. 18.6), depict faces that may be perceived as fully frontal (with two eyes, a mouth, a nose, and two ears)—or one half may be perceived as frontal while the other half is perceived as a face in profile (also a familiar image). Other artists, such as Escher (see figs. 21.3 and 21.4) and Vasarely, created interlocking figures, which flip back and forth in our perception.

A set of illusions in which the role of acculturation is probable, but less certain, are those that involve misjudgment of length or size (see fig. 19.20). In the Müller-Lyer illusion, the line with flared ends appears to be longer than the one with arrowheads on the ends—but in reality the two lines are of equal length. In the top-hat illusion, the hat appears much taller than wide, although the height and width are actually identical.

19.15

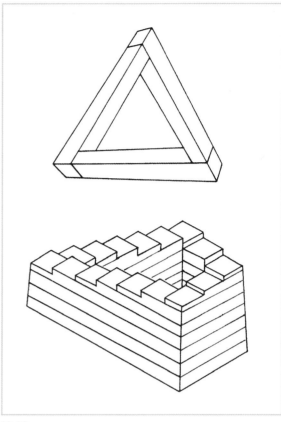

19.16

Neural phenomenon may play some role in the way comparisons of size are formulated in the brain, but it seems likely that these judgments are also conditioned by our expectations of relative size based on experience. These illusions appear in pictorial art, as they do in the world, whenever the subject matter meets the necessary conditions. For example, towers often appear taller than they may be, relative to other structures, as in Giorgio de Chirico's painting of *The Return of the Poet* (fig. 19.21). The tower seems taller than it actually is relative to the width of the hill on which it rests. The contemporary Op artist Peter Silten has combined several types of these illusory effects in *Manhattanization* (see fig. 19.22), which vacillates and intrigues with alternating figures, impossible structures, angular interactions, and perspective effects.

THE ROLE OF ILLUSION IN ART

Given the diversity of illusory phenomena, and the complexity of how art has been constructed and used throughout history, are there any general principles to be gleaned with regard to the influence or role of illusions in art? Illusions have appeared and have been used in art in three general ways: as a device or tool for influencing the viewer's interpretation of the image; as an incidental or accidental aspect of art, perhaps related to the artist's acuity of observation without consciously trying to be illusory; and as the aesthetic focus and visual purpose of the art. The conscious use of perspective (or its conscious avoidance by certain cultures) exemplifies the first category of illusion in art. The second includes many examples of Mach bands, which we

surmise were recognized by the artists without being understood physiologically. The third category is in the purview of Op Art, using the term broadly to include ancient mosaics and some aspects of Native American art, as well as modern art. In these works, images are designed to be visually stimulating independent of whether they illustrate a scene, convey a narrative, or suggest some other message.

An essential dilemma in this discussion, with respect to illusions and art, is whether the experiential framework from which we view art is an asset or an impediment. Would art in some measure be truer if we could free ourselves from the preconceptions of our upbringing and culture—or would it lose much of its significance? Gombrich phrased this paradox well: "X-ray specialists, basing a diagnosis on the faintest of shadows visible in a tissue, learn in a hard school how often 'believing is seeing,' and how important it therefore is to keep their hypothesis flexible. The art lover adopts the opposite mental set. Unless he is a restorer, he may go through life without ever realizing to what extent the pictures he loves are crisscrossed by subjective contours of his own making. If he were ever to strip them of these projections, merely a meaningless armature might well be all that would remain."[6]

We are not sure that the remnants of a Rembrandt, a Monet, or a Picasso would be "meaningless armatures" if stripped of their cultural frameworks, but they would certainly lack the power that comes from our accepted standards of beauty, our appreciation of rectilinear structures, and our sense of titillation at the games artists have played with these established concepts. On the other hand, it is doubtful that the ancient Egyptians

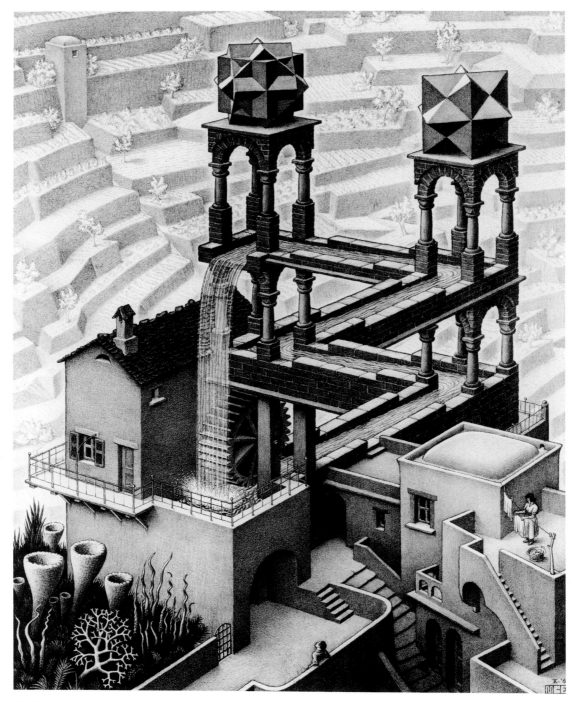

19.17

would have appreciated or tolerated paintings by Rembrandt, Monet, or Picasso, since their representations would not have had a place or purpose within ancient Egyptian society. Similarly, most of us raised in Western society have difficulty understanding many of the nuances of Asian art, for what we recognize as beautiful often had different meaning or different standards of excellence for the culture in which it was created. We may marvel at the shading yet miss entirely the fact that the picture is expressing a special state of mind. There is nothing wrong, of course, with the concept that art may mean different things and serve different purposes to different people, but it is a sobering fact that our critical judgments are very much rooted

Fig. 19.15 Mosaic design, House of Trajan's Aqueduct, Antioch, 2nd century CE. The cubes in this pattern flip back and forth between two orientations, much like the Necker cube (see fig. 19.14).

Fig. 19.16 Impossible figures drawn originally by L. S. and R. Penrose,[5] and used by M. C. Escher as the basis for several of his well-known lithographs.

Fig. 19.17 M. C. Escher, *Waterfall*, 1961. Lithograph, 15 x 12 in. (38 x 30 cm). One of Escher's realizations of the Penrose illusions shown in figure 19.16.

in cultural bias. As the old adage goes: Beauty is in the eye of the beholder.

Some modern artists have tried to create works that liberate the viewer from preconception, that are without titles, that offer no other guidance by the artist as to meaning, and that are intended to be appreciated or discovered anew by each viewer. A lot of contemporary Op Art falls into this category. However, even though each viewer may indeed see different meaning in such works, an artist is naive if he or she believes that the effects of a work of art can be truly independent of the experience of one's time and culture, for that is a framework from which neither artist nor viewer can ever escape. Even though some illusions are hardwired in the nervous system, the degree of their acceptance or appreciation in a work of art is soft-wired.

Although Gombrich pointed out that the art lover is inherently gullible, his statement leaves uncertain the role of the artist. The artist may also be gullible, insofar as he or she paints according to the rules and conventions of society; however, the artist is, like Gombrich's X-ray specialist, a pro, and it can be argued that it is the artist's job to see the faintest shadows and to be aware of illusions. We can only guess the extent to which the early Chinese artist (see fig. 6.4), using Mach bands to create lightness and darkness, or Correggio and Pierre-Auguste Renoir (see fig. 6.12), using thick borders to soften faces, or Edvard Munch with his tree in the forest (see fig. 20.1), were consciously trying to create illusions or were simply using their skills as observers. In current times, it would be hard to find an artist unaware of common illusions, because art schools (and many high schools) teach about vision as it relates to color. But it is still incumbent upon the artist to choose if and how to incorporate such phenomena.

The work of modern Op artists such as Albers, Richard Anuszkiewicz, Escher, Riley, and Vasarely includes many images that contain elements found in common psychology textbooks. Did these artists discover these shapes for themselves; are they merely decorating textbook figures; or are they using these illusory figures, like Rembrandt used light or Monet used the Rouen cathedral, as a technical foundation for artistic expres-

sion? We would not accuse Rembrandt of shallowness for choosing an oblique source of light, or Monet of "stealing" his cathedral subject, yet there is a tendency to minimize the accomplishments of Op artists for incorporating illusory elements into their work.

The question is not whether an Escher is equivalent to a Rembrandt, or a Vasarely to a Monet, but whether any or all of these artists created new sensations, pleasures, and ideas for the viewer. Understanding the scientific basis of vision and the hard- or soft-wired nature of illusions should not diminish the appreciation of optical art; if anything, it allows the viewer to better appreciate the artists who built upon these phenomena (which are common to all of us) to create effects that are special to *human* experience and appreciation.

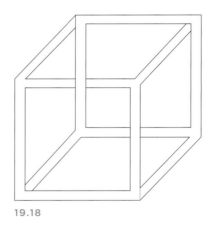

19.18

Fig. 19.18 Impossible cube. Compare with the Necker cube (see fig. 19.14).

Fig. 19.19 Vase illusion. Is this a picture of a vase or of two faces in profile?

Fig. 19.20 Illusions of length. **(left)** Müller-Lyer illusion: The two central lines appear to be different lengths. **(right)** Top-hat illusion: The hat appears to be taller than it is wide.

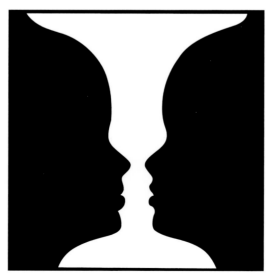

19.19

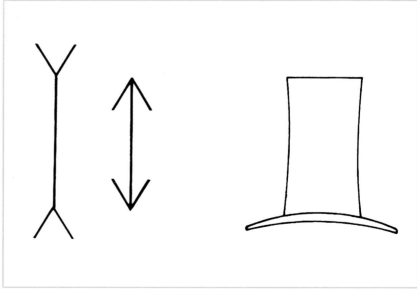

19.20

It is hard to leave the subject of illusion without considering, at least briefly, Surrealism. In Surrealism, illusion is used not so much for its visual effects as for its intellectual effects. When René Magritte (see fig. 19.23) depicted fragments of a scene upon the broken panes of a window, he not only created a visual illusion (in the sense that we are not sure what is the painting and what is real), he has asked us to ponder the nature of the dilemma itself (which is not so far from Plato's question about whether any representation can in fact be reality). Another Surrealist, Yves Tanguy, painted strange landscapes, filled with tantalizing objects we sense we should somehow recognize. The power of these images comes from our expectation of what we think we should see, as much as from our recognition of what we do see. The illusions of Surrealism lie in the realm of soft-wiring because they are intended for our mind as much as our eye. Like Op artists, the Surrealists have at times been criticized as "non-artists," because their paintings are a means to an intellectual end, for which the artistic expression may seem secondary. We find these arguments irrelevant, because in any artistic endeavor, the eye and the intellect cannot be separated. The melted clocks of Dali are disturbing in large measure because of the stark and pseudo-realistic landscapes in which Dali has placed them. Westerners view Asian art in terms of beauty, but many Asians view it in terms of content. The glorious triptychs

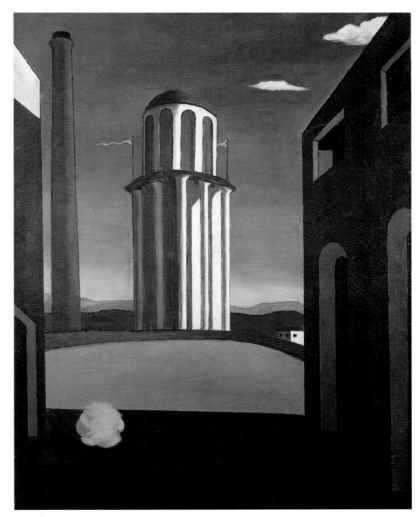

19.21

Fig. 19.21 Georgio de Chirico, *The Return of the Poet*, 1911. Oil on canvas. The central tower in this Surrealist painting looks taller than the width of the hill on which it rests. However, the hill is actually wider than the tower, an example of the Top-hat illusion.

Fig. 19.22 Peter Silten, *Manhattanization*, 1998. Acrylic on paper, 23 x 29 in. (58.5 x 73.7 cm). In this intriguing painting, Silten mixes a variety of illusory effects, including perspective, impossible figures, and angular interactions.

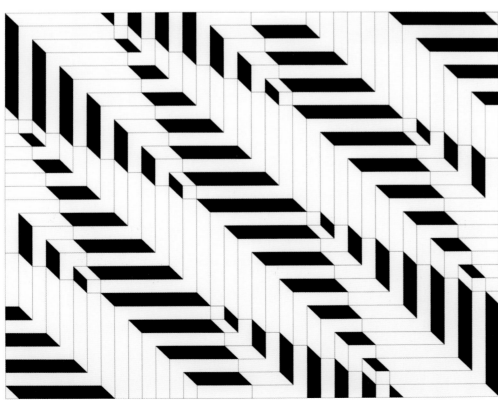

19.22

19.23

of Byzantine art were designed to teach the catechism to the masses, but beauty was vital to catching the audience's eye in the first place.

This chapter has emphasized that some illusory sensations have a physical origin within retinal or visual cortical circuitry, while others depend on cultural bias or past visual experience. However, psychology itself has a neural basis, and no hardwired illusion is free of psychological overlay. Furthermore, few illusions fall purely or totally within either category. Part of the problem is that the very concept of illusion is in some respects illusory. Ernst Mach pointed out over a hundred years ago that "the expression 'sense-illusion' shows that we have not yet become conscious of the fact that the senses neither falsely nor correctly manifest external events . . . the only exact thing we can say about the sense organs is that under different circumstances they produce different sensations and perceptions."[7] Illusions are but one facet of biological and psychological visual processing—and as such they are but one tool (and one constraint) among many that contribute to the construction and appreciation of art.

NOTES

1. Rock, *Perception* (1984).
2. Arnheim, *Art and Visual Perception: A Psychology of the Creative Eye* (1974).
3. Gombrich, *Art and Illusion: A Study in the Psychology of Pictorial Representation* (1969).
4. Lashley, "Patterns of Cerebral Integration Indicated by the Scotomas of Migraine" (1941).
5. Penrose and Penrose, "Impossible Objects: A Special Type of Visual Illusion" (1958).
6. Gombrich, *Art and Illusion: A Study in the Psychology of Pictorial Representation* (1969), pp. 210–211.
7. Mach, "On the Dependence of Retinal Points on One Another" (1965).

Fig. 19.23 René Magritte, *La clef des champs (The Door to Freedom)*, 1936. Oil on canvas, 32 x 23 ½ in. (81 x 60 cm). This Surrealist painting evokes the questions "What is a painting?" and "What is reality?"

Fig. 20.1 Edvard Munch, *The Yellow Log*, 1911–12. Oil on canvas, 51 ½ x 63 in. (131 x 160 cm). The log appears to point at the viewer, no matter from where the painting is viewed.

PORTRAITS (AND PAINTINGS) THAT FOLLOW YOU

A favorite of schoolchildren who visit the Munch Museum in Oslo is the forest scene of Edvard Munch's *The Yellow Log* (see fig. 20.1). The painting shows cut logs in the snow, and as you walk by it, the central log seems to move so that its end is always pointing toward you. Why does this illusion occur, and is it unique to this painting?

The effect depends upon our interpretation of—and expectations from—the pictorial clues that make the log appear like a real object in space. If we were to walk right or left in the actual forest, we would recognize changes in the scene (e.g., an interjection of trees, and more or less visibility of the sides of the log) that would tell us that the log has a fixed position in space. However, when we move in front of the painting of the scene, none of these real-world changes take place within it. No matter where we stand, the same trees still frame the same space about the log, making the log seem to recede in the general direction of our gaze.

While this effect is present in any representational painting, we rarely notice it because most scenes are complex and lack a distinct target (such as the log) upon which to fixate. However, there is one genre of painting in which this illusion is persistently striking: portraits. Have you ever had the eerie sensation that a *portrait* is following you with its eyes? This phenomenon is largely the result of fixed directional cues, as with the log, but is also influenced by cues that tell us where a person is looking.

20.1

20.2

Fig. 20.2 Illustrations from W. H. Wollaston.¹ In these two portraits the eyes are identical, but the face beneath turns in different directions. We perceive the subject to be looking in the direction of the face, although the eyes do not change.

Fig. 20.3 Illustrations from W. H. Wollaston.¹ The eyes are identical in all four pictures, but adding a nose or adding the forehead changes the apparent direction of the gaze.

DIRECTION OF GAZE

It may seem obvious that the direction of a person's eyes is the direction of their gaze. This is true for the person who does the gazing, but judging where someone else is looking is not so simple. The eyes are only one cue among many that guide our sense of another's gaze and emotion, a fact that becomes relevant when the appearance of the eyes is used to analyze direction of gaze and ocular straightness—whether in life or in art. Back in 1824 William Hyde Wollaston published a series of plates that cleverly illustrate the complexity of facial perception.[1] He had an artist draw a set of eyes looking straight ahead, which he then superimposed upon drawings of other parts of the face. The first of these demonstrations (see fig. 20.2) shows that we perceive the subject as looking in one direction or another, depending on whether the rest of the face is turned slightly to the left or slightly to the right—even though the ocular positions are identical. Similar effects, more or less powerful, occur by appending a nose, or adding a forehead, in varying orientations (see fig. 20.3).

Thus, our judgment of the direction of someone's eyes is linked, in part, to the direction we *believe* that person to be looking. And the psychological complex of eyes and face will similarly influence the interpretation of ocular straightness that we will discuss in chapter 27.

PICTURES THAT FOLLOW US

The sensation that a portrait is following us with its gaze is neither a planned illusion, nor an outtake from a horror movie. It is a natural and expected consequence of the fixed two-dimensionality of facial representation on a canvas.[2] The facial cues on a real person, such as those noted above, change as we walk from side to side (see fig. 20.4): We see one side of the nose, then the middle of it, then the other side of it. Furthermore, if we stand directly in front of someone who is looking straight ahead, the whites of the eyes appear equal on either side of the pupil. If we walk to one side (while the person continues to look straight ahead), there will be more white on the side of the eye closest to us.

In a portrait, however, all of these landmarks are fixed. Thus the face continues to gaze directly at us as we walk by it (see fig.

20.3

20.4c). You can duplicate this effect by turning a portrait in a book from side to side (as long as the turning is not too extreme). Try it with portraits in this book! A wonderful, if slightly disturbing, example is Joseph Ducreux's *Portrait of the Artist with the Features of a Mocker* (see fig. 20.5). Ducreux's gaze will follow you, and his finger point at you, no matter where you go (like Uncle Sam in the famous World War I U.S. Army recruiting poster). These effects do not take place with sculpture, of course, since sculptures are true three-dimensional objects.

This illusion of eyes following the viewer is not a new discovery, but is likely as old as painting itself and was mentioned by ancient Greeks and Romans, Arabic sources, and reportedly Leonardo da Vinci (1452–1519).[3] Pliny the Elder (23–79 CE), a Roman scholar, commented on the skill of portrait painters whose works could be "absolutely lifelike." He described an artist named Famulus who painted "a Minerva who faced the spectator at whatever angle she was looked at."[4] A few years later, Ptolemy (c. 100–170 CE), a scholar of Greek descent living in

20.4a 20.4b 20.4c

Fig. 20.4 Images of a person looking straight ahead. **(a)** Photograph taken from directly in front. **(b)** Photograph taken from 30° to the side: The face is now in partial profile and no longer appears to be looking at us. **(c)** The frontal photograph viewed from 30° to the side (on a computer screen), as if we had walked by the portrait in a gallery: The subject still appears to stare at us because the ocular and facial cues of direct gaze have not changed.

Fig. 20.5 Joseph Ducreux, *Portrait of the Artist with the Features of a Mocker*, 18th century. Oil on canvas, 36 x 28 ½ in. (91.5 x 72.5 cm). Even if the book is turned from side to side, Ducreux continues to stare at you and point menacingly.

Alexandria, wrote: "The image of a face painted on panels follows the gaze of [moving] viewers to some extent even though there is no motion in the image itself, and the reason is that . . . the gaze remains fixed solely along the visual axis . . . Thus, as the observer moves away, he supposes that the image's gaze follows his."[5]

We should not be surprised that eyes "follow" us in a gallery. It would be more surprising if they did not!

NOTES

1. Wollaston, "Apparent Direction of Eyes in a Portrait" (1824).
2. Koenderink, van Doom, and Kappers, "Pointing Out of the Picture" (2004); Gombrich, *Art and Illusion: A Study in the Psychology of Pictorial Representation* (1969), pp. 276, 414, and 430.
3. Koenderink, van Doom, and Kappers, "Pointing Out of the Picture" (2004); Gombrich, *Art and Illusion: A Study in the Psychology of Pictorial Representation* (1969), pp. 276, 414, and 430.
4. Pliny, *Natural History* (1st century CE), p. 349.
5. Ptolemy, *Theory of Visual Perception* (2nd century CE), p. 124.

20.5

ESCHER AND THE OPHTHALMOLOGIST

Maurits Cornelis Escher (1898–1972) (see fig. 21.1) came from an educated family in Holland.[1] His father was a highly respected engineer, and a brother became a professor of geology who wrote a handbook on crystallography. However, Escher was not particularly interested in science or mathematics as a student and, in fact, did poorly in secondary school.[2] He learned the craft of printmaking and set out in his early twenties to make that his career. He moved from Holland to southern Italy for inspiration and made mostly landscapes and still lifes. He was also fascinated by patterns, and he kept sketches that he made of intricate interlocking light-dark designs that he saw in the Alhambra on a trip to Spain in 1922. However, it was not until Escher left Italy in 1934 that he began to seriously explore the interlocking figures, representations of crystal shapes, mathematical progressions, and illusions of perspective and space (see fig. 21.2) for which he is best known today.

Prior to the 1950s Escher denied having any scientific background or foreknowledge and declared himself an artist, not a scientist. He spent hours experimenting with patterns and filled notebooks with geometrical constructions,[3] yet he sought empirical rather than theoretical solutions to the visual problems he set for himself. His success eventually changed this situation because, as he became famous, people from many disciplines were inspired by his work and wrote to him to comment on the scientific and psychological implications of it. For example, an exhibition of Escher's work inspired the mathematician Roger Penrose to devise and publish drawings of an impossible triangle and an endless staircase (see chapter 19 and fig. 19.16).[4] He sent a copy of the article to Escher, who used his illusions (with credit given) as the basis of several famous prints, including the magical *Waterfall* (see fig. 19.17).[5] Another of Escher's correspondents was the Dutch ophthalmologist Johan W. Wagenaar, MD, who helped him to understand how his designs are interpreted by the visual system. The story of their friendship and exchange is an interesting ocular footnote to the life of this fascinating artist.[6]

INTERLOCKING FIGURES

A recurrent theme in Escher's work is the use of interlocking figures to fill a space and blur the distinction between object and background. Escher called this technique "regular divi-sion of the plane." In an early article,[7] published in 1941, he explained: "What fascinated me most of all is the double function of the line of separation between two contiguous figures. It is just as indispensable for one motif as it is for the other." He had already been exposed to crystallographic patterns, perhaps by his brother, and he wrote that he now dared "to work on the problem of expressing unboundedness in an enclosed plane." He experimented with filling a plane with interlocking figures that had no independent boundaries, and this soon led to compositions depicting the evolution or metamorphosis of figures. For example, his woodcut *Sky and Water I* (see fig. 21.3) shows black birds on a white sky that transform into white fish in a black sea. In Escher's words: "The white motifs open up and lose their function as silhouettes suggesting fish. They flow into each other and change into a background of white sky in which the birds are flying."

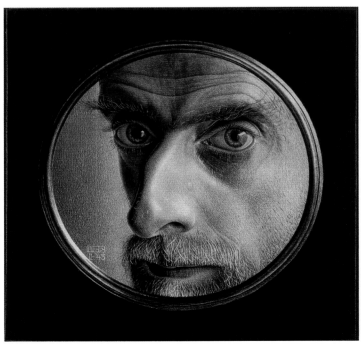

21.1

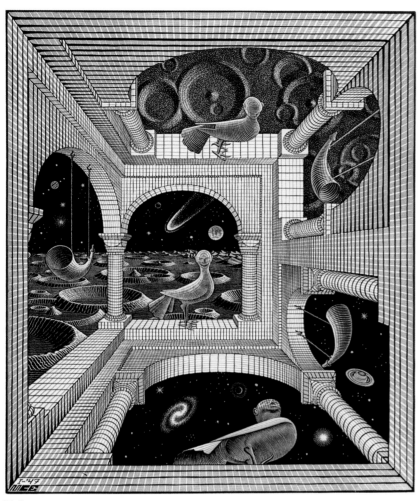

21.2

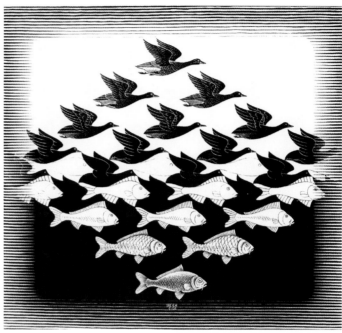

21.3

Fig. 21.1 M. C. Escher, *Self-Portrait*, 1943. Lithograph, 10 x 10 in. (25.5 x 25.5 cm). This self-portrait, in almost photographic realism, highlights the intensity of the artist.

Fig. 21.2 M. C. Escher, *Another World*, 1947. Woodcut, 12 ⁷/₁₆ x 10 ³/₄ in. (31.5 x 26 cm). This image illustrates Escher's fascination with illusions of perspective and space.

Fig. 21.3 M. C. Escher, *Sky and Water I*, 1938. Woodcut, 17 ⁵/₁₆ x 17 ⁵/₁₆ in. (44 x 44 cm). Fish and birds transform seamlessly into one another, both as shapes and as light versus dark.

In *Day and Night* (see fig. 21.4), gray fields transform into the interlocking shapes of birds flying in opposite directions from mirror-image towns, one in daylight and the other in darkness. Although Escher was fascinated by interlocking and crystalline shapes, at this stage of his career he was not interested in the theory or mathematics of design. He described in notes what his pictures revealed physically, but never what they meant or represented theoretically.[8] A mathematician friend wrote: "He did not work like a mathematician but much more like a skilled carpenter who constructs with folding rule and gauge, and with solid results in mind."[9] Nothing in Escher's writings or in biographies suggests that, early in his career, he studied or even concerned himself with the psychological or physiological implications of his designs.

Johan W. Wagenaar, MD, was born in 1911 and studied in Utrecht, where he was also trained in Gestalt psychology, which argues that the "whole" of perception is often greater than its parts (such as with illusions where the brain fills in boundaries or shapes that aren't strictly there). He was intrigued by Escher's prints that divided the plane and illustrated the perceptual ambiguity of interlocking objects. He first noticed these designs in 1942, in an article in a magazine in his own waiting room, and went on to use Escher's prints to illustrate a lecture (and in 1952 an article) that addressed visual problems during night driving (when oncoming headlights would transiently reverse light-dark relationships). Wagenaar's article[10] begins by stating the psycho-logical dogma that we cannot see an object or figure without also seeing a background: "It is the essence of the 'gestalt' of our perception [that] . . . figure and ground form an insepa-rable optical unit in our consciousness." Thus, patterns such as a chessboard, in which figure and ground are in equilibrium, pose a visual challenge and there is "competition between white and black squares." Escher prints, such as *Sky and Water I* and *Day and Night*, exemplify this same ambiguity: There is competition, both physiologically, between black and white, and psychologi-cally, between subjects such as birds and fish, so that "a situation of confusion and uncertainty arises."

When Escher learned that Wagenaar was using his prints as illustrations, a correspondence and mutual respect developed between the two men. Wagenaar visited Escher's studio in 1952 and noted that it was bedecked with models of regular polyhe-drons. By this time Escher had become well known, and many people were explaining his works on the basis of various sci-ences. Though his process was still empirical, he was becoming more interested in understanding *why* his pictures have a par-ticular form or effect. When Wagenaar sent Escher a copy of his paper, Escher replied in terms he probably would not have used in 1941: "Many thanks for sending me your paper about figure and ground! The theoretical aspect of the problem interests me even more than the practical aspect (for the car driver), as you will understand from someone who spends a large proportion of his working hours on the constructions of images without

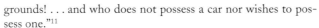

21.4

grounds! . . . and who does not possess a car nor wishes to possess one."[11]

Escher was sufficiently impressed by Wagenaar's arguments to quote from his correspondence in a privately commissioned book of 1958 entitled *The Regular Division of the Plane*. Escher wrote: "Is it possible to create a picture of recognizable figures without a background? After years of training in the composition of lines dividing equal units, I thought I could answer this question affirmatively, until I encountered some doubts through a correspondence with the ophthalmologist Dr. J. W. Wagenaar. He is better qualified than I to judge this matter from a scientific point of view. I quote the following extract from his letter: 'In my opinion you do not in fact create pictures without a background. They are compositions in which background and figure change functions alternately; there is a constant competition between them and it is actually not even possible to go on seeing one of the elements as the figure . . . It is like seeing the world with a red glass in front of one eye and a green glass in front of the other: In that case the world does not look either red or green but constantly changes from one to the other and back again.'"[12]

Escher's fascination with boundaries, mentioned in his 1941 article, continued unabated in 1952, but he now realized that "unboundedness" was not truly reachable in terms of the perception of forms and figures. There has been some discussion of when Escher first became aware of these psychological principles of perception, and how they might have influenced his work. An article in *Scientific American*[13] argued that Escher was influenced very early by pioneering Gestalt psychologists such as Edgar Rubin, who wrote in 1915 about figure-ground distinctions, and Kurt Koffka, whose book on Gestalt principles was published in 1935. However, Escher's son pointed out[14] that the "evidence" for this judgment was commentary by Escher in a book[15] that was not written until 1960 (well after the 1952–53 correspondence with Wagenaar). Escher's statements in that book, such as "The chief characteristics of the . . . prints is the transition from flat to spatial and vice versa," are simply descriptive (and typical of his writing style) and do not prove a linkage to writers such as Koffka and Rubin (even though similar statements appear in their work).

Escher stated in the introduction to his 1960 book: "Although I am absolutely without training or knowledge in the exact sciences, I often seem to have more in common with mathematicians than with my fellow artists." The same may be said with respect to psychology, for which Escher's work is highly relevant though it was not created with that discipline in mind. On one visit that Wagenaar and his son made to Escher's workshop, a discussion developed about the various ways to draw spirals. Wagenaar would explain a mathematical principle, and Escher would reply: "Yes, that is how it could be done, but it's not how I did it."[16]

Escher's correspondence with Wagenaar helped to shape his insight into the visual effects of his figure-ground work, but it did not change or inspire his designs. Escher was also introduced formally during the 1950s and 1960s to concepts such as the Moebius strip (see fig. 21.5), geometrical mathematical progressions, and psychological illusions (such as the endless waterfall), and he freely absorbed and credited material from various disciplines. However, it is clear from his writings that the final designs of his work were the result of careful and exhaustive experimentation with patterns that intrigued him. It is inter-

esting that he ended his 1958 book *The Regular Division of the Plane*[17] not with an acknowledgment of debt to science but with an analogy to music. He noted: "Musical canons incorporate concepts such as augmentation, diminution, retrogression, and even mirroring. These are visually indicated in the score in a way directly comparable with the figures of the regular division of a plane." Escher was particularly influenced by Bach and wrote that this was the case because of "his rationality, his mathematical order and the strictness of his rules . . . His music, more than any other classical or modern composer's, reveals something self-evident to me . . . I reach out to Bach's music to revive and fire my desire for creativity."

NOTES

1. Locher, *M. C. Escher: His Life and Complete Graphic Work* (1982).
2. Ernst, *The Magic Mirror of M. C. Escher* (1976).
3. Schattschneider, *Visions of Symmetry: Notebooks, Periodic Drawings, and Related Work of M. C. Escher* (1990).
4. Penrose and Penrose, "Impossible Objects: A Special Type of Visual Illusion" (1958).
5. Penrose, remarks in *The Fantastic World of M. C. Escher* (1980).
6. Marmor and Wagenaar, "Escher and the Ophthalmologist"(2003).
7. Escher, "How Did You as a Graphic Artist Come to Make Designs for Wall Decorations?"(1941).
8. Schattschneider, *Visions of Symmetry: Notebooks, Periodic Drawings, and Related Work of M. C. Escher* (1990); Escher, *The Graphic Work of M. C. Escher, Introduced and Explained by the Artist* (1967).
9. Ernst, *The Magic Mirror of M. C. Escher* (1976).
10. Wagenaar, "The Importance of the Relationship 'Figure and Ground' in Fast Traffic" (1952).
11. Correspondence between Escher and J. W. Wagenaar (c. 1952), translated by W. A. Wagenaar. See Marmor and Wagenaar, "Escher and the Ophthalmologist" (2003).
12. Locher, *M. C. Escher: His Life and Complete Graphic Work* (1982); Escher, *The Regular Division of the Plane* (1958). Reprinted in Locher, *M. C. Escher: His Life and Complete Graphic Work* (1982), and Escher, *Escher on Escher: Exploring the Infinite* (1989); Escher, *Escher on Escher: Exploring the Infinite* (1989).
13. Teuber, "Sources of Ambiguity in the Prints of Maurits C. Escher" (1974).
14. Escher, G.A., letter to the editor, *Scientific American* (1975), pp. 8–9.
15. Escher, *The Graphic Work of M. C. Escher, Introduced and Explained by the Artist* (1967).
16. Correspondence in possession of the Wagenaar family, and Wagenaar family's personal communication with authors.
17. Escher, *The Regular Division of the Plane* (1958). Reprinted in Locher, *M. C. Escher: His Life and Complete Graphic Work* (1982), and Escher, *Escher on Escher: Exploring the Infinite* (1989).

Fig. 21.4 M. C. Escher, *Day and Night*, 1938. Woodcut, 15 5/16 x 26 1/4 in. (39 x 68 cm). The birds transform from black to white, as the underlying landscape changes from day into night.

Fig. 21.5 M. C. Escher, *Moebius Strip II*, 1963. Woodcut, 17 1/4 x 7 7/8 in. (45 x 20 cm). As envisioned by Escher, a mathematical construct becomes art.

21.5

Fig. 22.1 Bridget Riley, *Pink Landscape*, 1960. Oil on canvas, 40 x 40 in. (101.5 x 101.5 cm). Riley sought a shimmering effect in this early Neo-Impressionist-style painting. She achieved it by using dots of paint that not only contrast in color but also are relatively equiluminant to create spatial instability.

BRIDGET RILEY AND THE RATIONALE FOR OP ART

Bridget Riley (1931–) is one of Britain's foremost living artists, and she has been a leader in the genre known as Op Art for nearly fifty years. She continues to challenge viewers with new images that are aesthetically captivating as well as visually intriguing, and her work exemplifies many of the powers of optical art. She has also been very willing to discuss her methodology and her rationale for painting with optical imagery.[1] Other Op artists, such as Victor Vasarely, Richard Anuszkiewicz, and Yaacov Agam to name a few, are also well known and have been equally prolific, but we cannot cover all of them. An examination of Riley's work and philosophy gives insight, which in principle, if not specifics, has application for other works and artists.

Riley trained for many years in art school and is a skilled draftsman. Her eventual choice to use optical imagery was not for lack of painterly skills. Indeed she has special fondness for Neo-Impressionism, a style that she adopted and elaborated upon early in her career, and she produced interesting paintings that presage the visual effects in her later works. *Pink Landscape* (see fig. 22.1), an iridescent Divisionist landscape in the style of Paul Signac, is an example of her early work. The distant sky and mountains are mixtures of pinks and blues, the near foothills are mixtures of blue and yellow, and the colors shimmer in both areas since there is little brightness difference (i.e., there is relative equiluminance) between the dots of paint (see chapter 8). Riley said: "The heat coming off that plain was quite incredible . . . the local color was unimportant—the important thing was to bring about an equivalent shimmering sensation on the canvas."[2] Riley would return to similar color and brightness combinations many years later in purely abstract works.

On a trip to Italy in 1960, Riley studied the work of Neo-Impressionist Georges Seurat and the Futurists, among other artists. She realized that a key facet of artistic technique is contrast—and that to truly understand and create contrast it would be instructive to work in black and white. For much of the next decade she explored relationships of shape, pattern, and contrast to create a remarkable series of images that had immediate impact on art and popular culture. When she arrived in New York in 1966 for a major Op Art show at the Museum of Modern Art, she found that her optical designs had already been pirated by designers for everything from women's dresses

22.1

to napkins. She tried to sue for infringement, but copyright law at the time did not cover art images. (Our present protection for artists' designs is sometimes called the Riley law.)

Fall and *Hesitate* (see figs. 22.2 and 22.3) as well as *Descending* (see fig. 19.4) are examples of the different styles and effects that Riley explored during this period. Almost all of her work from this time relies not only on a masterful sense of composition but also on an innate awareness of how contrast affects our perception of shape, form, and perceived movement. *Fall* features some of the effects of *Descending* in that the finely spaced lines ripple and simulate a flow of water because of the innate micro-movements of our eyes. In *Hesitate*, Riley varied the spacing and shape of the dots to create a sense of three-dimensionality beneath a pattern of light and shadow.

The illusory effects of some of these works are so striking that

Fig. 22.2 Bridget Riley, *Fall*, 1963. Emulsion on hardboard, 55 ½ x 55 ½ in. (141 x 140.3 cm). Unconscious fine eye movements make this painting appear to shimmer and flow like falling water.

Fig. 22.3 Bridget Riley, *Hesitate*, 1964. Oil on canvas, 42 x 44 ¼ in. (106.7 x 112.4 cm). Our expectations of photographic perspective and lighting give this painting an illusion of three-dimensionality. Compare it with figure 19.12.

critics have asked repeatedly whether Riley has studied psychology, optics, or physiology. She remains clear on this point, and on the distinction between science and art: "I have never studied 'optics' and my use of mathematics is rudimentary and confined to such things as equalizing, halving, quartering and simple progressions. My work has developed on the basis of empirical analyses and syntheses." She added: "The fact that some elements . . . can be interpreted in terms of perspective or trompe l'oeil is purely fortuitous and no more relevant to my intentions than the blueness of the sky is relevant to a blue mark in an Abstract Expressionist painting."[3] She later commented: "I proceed by trial and error—exploring and slowly establishing a particular situation."[4] In other words, the patterns of her art may have illusory content (or origins) but the final expression of her paintings is a result of independent experimentation and artistic judgment.

She wrote in another context, "When I made the first black-and-white painting, I did not intend to make more than one. And then I became interested . . . People at the time thought, some people still seem to think, that they were paintings having to do with optical experiment (and with what was called 'Op Art' later on); really they were an attempt to say something about stabilities and instabilities, certainties and uncertainties. They were never simply about how frustrating it might be to take black and white and put them together into those optically dynamic configurations."[5]

It should be emphasized that Riley's views are Riley's alone, and many different motives, techniques, and analyses have been put forward to explain the Op Art movement and its evolution. The movement has roots in Futurism, abstraction, Surrealism, and Dada—if not in every genre of art if one looks carefully enough. For example, Vasarely worked with optical effects (see figs. 6.11, 19.2, and 19.12) but he also explored representational correlates in the manner of Escher. His son and a group of artists in Paris formed in 1960 the Groupe de Recherche d'Art Visuel, which sought to formally explore the optical and psychological effects of art as ends in themselves. Riley even participated in one of their exhibits. However, that group lasted less than a decade. Purely visual effects are still paramount in the work of many modern artists, including Dan Flavin, who creates ethereal experiences in environments lit with colored fluorescent tubes. Most Op artists have argued strongly that the final judgment in creating their art is personal, aesthetic, and observational, as opposed to scientific.

In the late 1960s Riley began to experiment with color and has continued to explore new effects up to the time of this writing. Initially she minimized contrast to see what colors meant in and of themselves. Then in later works she combined color, luminance, contrast, and patterns. As in the works of Seurat, Chuck Close, and many others, the visual impact of Riley's work is dependent on the ways in which colored fields create contrast or, when equiluminant, produce instability and vibrancy—the exact issues that had intrigued Riley in her early studies of Neo-Impressionism. Some of her later images reveal flowing patterns of lines that have subtle colors of similar brightness. In *Evoë 3* (see fig. 22.4), strong contrasts in color (e.g., reddish pink versus green) as well as in brightness appear to create the pattern. However, seeing the image in gray scale shows that the reddish pinks and greens are nearly equiluminant, which makes these regions visually unstable, creating tension between areas that contrast in brightness and those that contrast in color.

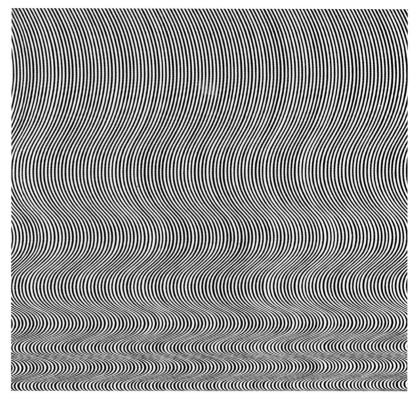

22.2

22.3

22.4a

22.4b

Riley's paintings are complex. She herself points out: "Everyone knows by now that neuro-physiological and psychologic responses are inseparable."[6] While an understanding of vision gives some insight into her works, it does not explain their power. We should judge artists not by the nature of their chosen subjects (whether landscape, portrait, or illusion), but by what they do with those subjects aesthetically. No one period or style of art is intrinsically "better" than another and each—including Op Art—brings different qualities to the table.

NOTES

1. Riley, *The Eye's Mind: Collected Writings 1965–1999* (1999).
2. Riley and Sausmarez, "Bridget Riley and Maurice de Sausmarez, a Conversation" (1967). Quoted in Kudielka, *The Eye's Mind*, p. 52.
3. Riley, "Perception Is the Medium" (1965). Quoted in Kudielka, *The Eye's Mind*, pp. 66–68.
4. Riley, "In Conversation with Robert Kudielka" (1973).
5. Riley, "Talking to Mel Gooding" (1989).
6. Riley, "Perception Is the Medium" (1965). Quoted in Kudielka, *The Eye's Mind*, pp. 66–68.

Fig. 22.4. Bridget Riley, *Evoë 3*, 2003. Oil on linen, 76 ¼ x 228 ¼ in. (193.7 x 579.8 cm). (a) This painting is a study in contrasts of color and brightness. (b) Seeing it in gray scale reveals a different appearance, and surprising complexity, as the reddish pink and green are almost indistinguishable in terms of brightness.

THE AGING EYE: VISION AND DISEASE

Our eyes, like the rest of the body, age with time. The process is slow and subtle, but inexorable. And while most healthy people maintain 20/20 visual acuity all of their lives, many do not, even in the absence of overt disease. Furthermore, the quality of 20/20 vision in the elderly is not what it was at age fifteen. Just as hair turns gray, skin becomes less supple, and muscles lose tone, so do the vital structures of the eye—the cornea, lens, and retina—undergo changes. We tell our patients that the solution to this problem is simple: "Just get younger each year." But somehow patients don't listen! (We are no more successful at this program than they are.) We can expect the aging artist to face these same visual issues, and can reasonably ask whether these issues might affect their style or technical abilities.

While we will discuss some diseases that are prevalent in older eyes, it is important to understand first what aging does to vision in a healthy elderly individual. The visual limitations of old age are subtle, for the most part, but not irrelevant to the artist, who must judge subtleties of light, dark, and color, as well as show imagination and draftsmanship. Many of the aging changes in vision come from within the eye, from the structures that modulate the transmission and initial processing of images; however, there are also changes in the brain, where images must be interpreted. The basic optics of the eye (near- or farsightedness) do not usually change with age, but the loss of elasticity in the lens will cause the need for bifocals for reading. The eye makes fewer tears; the cornea may lose some clarity; the pupil stays smaller in both light and dark; the lens becomes thicker, denser, more yellow, and less elastic; and the retina loses a small percentage of its nerve cells every year . . . as does the brain. Thus, the elderly eye receives slightly less light, transmits images of slightly less clarity and color spectrum, and there are fewer retinal cells to pick up the images and code them properly for the brain. Within the brain, the machinery for recognition and interpretation is just a bit less effective. To explain these changes would be a treatise in geriatrics—and we don't have most of the answers. The eye differs from some internal tissues in that it is exposed to light and to high oxygen (the retinal blood supply is vigorous), which take a toll over the years. There are built-in protective mechanisms, but it is wise to use sunglasses and a cap in the bright sun; nevertheless, even living in a cave would not prevent most of the changes that we have described.

What does this mean functionally? Relative to a young adult, an elderly individual does not adjust to the dark quite as well, has slightly less robust visual acuity, has less contrast discrimination, and is more sensitive to confounding factors, such as poor lighting, glare, and distortion. Under ideal conditions (e.g., reading a book under a good lamp), the elderly have no trouble at all. But try to read a book at dusk, or in the glare of sun on the beach, and it can be difficult. Faces, scenes in the garden, etc., will be similarly difficult to discriminate when contrast is not strong; and in general, the elderly are much more sensitive to a need for "optimal" lighting, whether from the sun or from a well-placed lamp. Colors are not a problem when the lighting is good, since a mild degree of yellowing from the lens does not prevent the critical *comparisons* of colors. Remember that our discrimination of colors is based more on the relative amounts of red, green, and blue than on absolute wavelength (see chapter 8). However, colors, especially blues and greens, become harder for the elderly to distinguish in either dim light or very bright light.

How do these observations impact the artist? He or she will face more difficulty in painting under conditions of poor lighting and in discriminating subjects where the contrast is poor. Colors can still be judged accurately in good lighting, but some of the subtlety may be lost, especially at dawn or dusk. There could be a slight bias toward the yellow end of the spectrum, but this change is hard to evaluate because (as noted above) the effects of normal lens-yellowing on color discrimination are small, and the artist has many tools to compensate for the spectral shift with age (including knowledge of pigments used over a lifetime, memory of scenes, and feedback from viewers). For most aging artists, these mild visual effects will be less critical than nonvisual effects of age, such as maturation of style and technique, the evolution of art historically, economic pressures to continue or discontinue a mode of painting, and technologic advances in paints and other equipment.[1] One should certainly be aware of the visual capabilities of the aging artist, but at the same time, one should not jump to conclusions about cause and effect regarding an entity as complex as artistic style.

Many famous artists have lived long and productive artistic lives, including Leonardo da Vinci, Rembrandt, Michelangelo, Frans Hals, Peter Paul Rubens, Titian, Charles Willson Peale, Camille Corot, Edgar Degas, Paul Cézanne, James McNeil

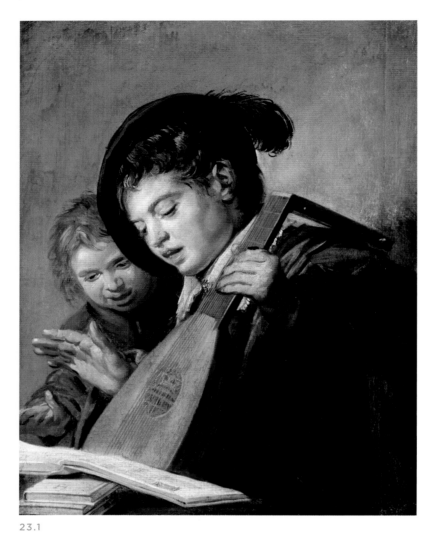

23.1

Whistler, Winslow Homer, John Singer Sargent, Henri Matisse, Claude Monet, Pablo Picasso, and Georgia O'Keeffe. For only a few do we know of documented eye disease that interfered with their art, including Degas, Monet, and O'Keeffe. For the others one can only speculate about vision relative to their art, and this kind of guesswork is risky since older artists may modulate their style for many reasons other than vision, and some artists painted consistently even into old age. Franz Hals (1581–1666) was known for brilliant portraits, often with an expressive application of paint that goes beyond the photographic (see fig. 23.1). He lived into his eighties, and in his later years, his application of paint grew less precise, and his palette became grayer, as in *The Man in the Slouch Hat* (see fig. 23.2). Was this the result of fading vision and a weakened sense of color, or simply the changing outlook of an elderly man? Camille Corot (1796–1875) was famous for landscapes that evolved early in his career from pre-

Fig. 23.1 Franz Hals, *The Singing Boys*, 1623–27. Oil on canvas, 26 1/4 x 20 1/2 in. (66.8 x 52.1 cm). This midcareer work is typical of Hals's style, with some freedom in the application of paint but the rendering of precise details where needed.

Fig. 23.2 Franz Hals, *The Man with the Slouch Hat*, c. after 1660. Oil on canvas, 31 1/4 x 26 5/16 in. (79.5 x 66.5 cm). This late work shows broader, less precise brushwork and drab colors (even in the face).

Fig. 23.3 Jean-Baptiste-Camille Corot. *Italian Landscape*, 1838. Oil on canvas. The Barnes Foundation, Merion, PA. Example of an early and realistic landscape.

Fig. 23.4 Jean-Baptiste-Camille Corot, *The Goatherds of Castel Gandolfo*, 1866. Oil on canvas, 23 5/8 x 30 11/16 in. (60 x 78 cm). This misty scene anticipated the work of the Impressionists.

Fig. 23.5 Charles Willson Peale, *Self-Portrait*, 1824. Oil on canvas, 26 1/4 x 22 in. (66.6 x 55.8 cm). This precise and realistic painting was done by Peale in his eighties.

23.2

23.3

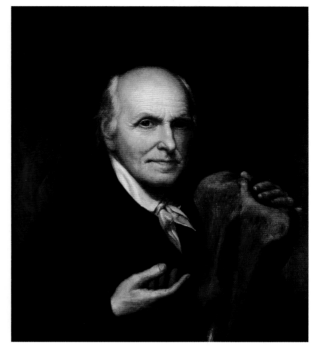

23.4

23.5

cisely drawn images such as *Italian Landscape* (see fig. 23.3) to more Impressionistic canvases midcareer. In his last decades the paintings became suffused with soft light and mystery, as in *The Goatherds of Castel Gandolfo* (see fig. 23.4). Was this a change in style or in vision? We know that he took an interest in photography late in life and may have tried to mimic the muted tones of early photographs. On the other hand, the great American archivist of colonial personages, Charles Willson Peale (1741–1827), did his portraits in a precise representational style—and the same was true for self-portraits done in his eighties (see fig. 23.5).

Chapter 24 will consider more fully these issues of style versus age and disease, using Titian and Cézanne as primary examples. The difficulty in making judgments is complicated by the fact that several eye diseases have special affinity for older eyes, and the dividing line between aging and disease is not always a sharp one. The point at which mild cataract or early macular degeneration becomes "pathologic" may be more a matter of when a patient becomes troubled than when the doctor becomes troubled. Nevertheless, one needs to understand the nature and impact of the three major aging disorders of the eye—cataracts, glaucoma, and macular degeneration—in order to judge if and how they might impact an artist's work. Discussion of these issues will occupy much of the remainder of this book.

CATARACT

Cataract means a clouding or opacification of the lens. The lens in every eye grows new tissue throughout life and becomes gradually thicker, denser, and more yellow. One could say, in that context, that past fifty years of age, everyone has a degree of cataract. But in functional terms, ophthalmologists reserve the term *cataract* for degrees of yellowing, density, or clouding that affect useful vision—mostly visual acuity, but also contrast sensitivity and color discrimination. Visually significant cataracts are uncommon at age fifty, but by age seventy a substantial percentage of people in modern society have had cataract surgery.

Not all cataracts are alike. The most common type of lens-aging, and cataract, is called nuclear sclerosis, which means, simply, hardening of the central portion of the lens. This is an extension of the aging process that we have described, to the point that there is so much darkening, blurring, or color distortion through the progressively brownish lens that it is hard to read, drive, or paint. Nuclear sclerosis is probably the type of cataract that afflicted Monet. Another type of cataract is called "posterior subcapsular" and is often secondary to diseases such as diabetes, ocular inflammation, or retinitis pigmentosa. In this type, a whitish opacity forms in the center of the back capsule of the lens, where it blocks clear images and affects visual acuity. This may have been the problem for Mary Cassatt (1844–1926), whose cataracts seemed to have become problematic relatively quickly.

We have mentioned several times that the artist with a yellow nuclear sclerotic lens sees a yellow world but also is so adapted to it that the actual perception of "yellow" is weakened rather than strengthened. Since a yellow filter blocks blue, the artist would use less blue if matching paints to his or her true perceptions; but the memory of scenes such as skies or water may lead the artist to try to compensate and brighten blues. This compensation is itself complex, since a yellow filter (e.g., sunglasses) will darken blue crayon or paint. However, if the cataract is not too dense, lighter and brighter blue can be added to make sky or water appear more "normal" to the artist. An example of this effect is shown in figure 23.6. The artist was a woman with cataracts under the care of Gösta Karpe, MD, in Sweden. After Dr. Karpe removed one cataract, she called the picture "horrible" and "too blue" and gave it to the hospital.[2] When cataracts are removed, patients often note an immediate brightening of colors because the hazy and yellowish filter is no longer present (see chapter 30 for Monet's reactions). It is said that blues often become deeper and brighter postoperatively, but some patients may perceive yellows to be brighter (perhaps because they now can be discriminated from white and other colors).

23.6

23.7

In modern society, cataracts are rarely a major visual problem because surgery to remove them is highly successful and the cataract can be replaced with a plastic lens implant inside the eye. However, cataract surgery was dangerous and only marginally successful in ancient times, and as late as the start of the twentieth century, it was still fraught with many potential complications. Even when it was successful, thick and uncomfortable spectacles were required postoperatively. Before the late 1700s, cataracts were not removed, but simply broken up or pushed aside by a quick needle insertion into the eye (a technique called "couching" that goes back literally thousands of years). We don't know which artists in pre-Renaissance times had their careers shortened by the development of cataracts. None are specifically recorded to our knowledge, although it is highly likely that some artists with long lives were afflicted. In the Renaissance, and beyond, there are records of some artists who had cataracts (and cataract surgery). These cases are discussed in later chapters.

GLAUCOMA

Glaucoma is a different type of disease, one that does not involve the clarity or focus of imaging, but concerns potential damage to the ganglion cells (the last neurons in the retina) and optic nerve (an extension of ganglion cell processes, which carry visual information into the brain). Glaucoma was once believed to be a disease of pressure within the eye, because severe or chronic elevation of intraocular pressure eventually damages the optic nerve at the vulnerable spot where it leaves the eyeball (just as an overinflated tire may burst through a weak spot in the wall). However, the visual effects come from gradual atrophy of the optic nerve, and we now know that some patients with glaucomatous changes to their optic nerves have perfectly normal pressure within their eye. Somehow, their optic nerves are more susceptible to atrophy, and even normal pressures can be too high. Chronic "open-angle" glaucoma is most prevalent after age forty, perhaps for two reasons: (1) The drainage channels in the eye tend to become less flexible and porous, so that intraocular pressure can slowly rise. (2) The optic nerve ages, and may become less resistant to stress from external factors such as pressure or lessened blood supply. There are also acute types of glaucoma which can raise pressure to very high and damaging levels (e.g., "angle-closure" glaucoma or glaucoma from disease); they are not our concern here with respect to aging.

Glaucoma is a potentially blinding disease that, in the late stages, may leave no sight at all. However, it is often called the "thief of sight" because the early stages characteristically damage the optic nerve fibers that supply peripheral vision. People tend to be aware of what is in front of them and can lose a great deal of peripheral vision before realizing that something is wrong (e.g., by starting to trip over, or bump into, things). For this reason, its impact upon art may not be distinctive. Most painted scenes or portraits cover a relatively small field of the artist's view, and even wide landscapes generally derive from the artist looking progressively at different components of the scene. In other words, a person with "tunnel vision" would not paint a canvas with a small circle of scenery within a huge expanse of darkness; rather, he or she would scan the scene, and scan the canvas while painting it, to produce a normal-appearing image. Perhaps a person with severe tunneling might recognize the problem and try to portray it, but we don't know of any examples in art. This may be, in large measure, because central vision is eventually affected so that in the late stages of the disease, most sufferers are losing sharp vision as well, and this blurring, as opposed to the tunnel vision, becomes the limiting factor for their work.

For example, the early twentieth-century American modernist Abraham Walkowitz stopped painting in his sixties because of severe glaucoma. But one cannot really see changes in his paintings right up to the time that he was forced to quit. This may in part reflect relatively frontal subjects—such as the dancer Isadora Duncan (see fig. 23.7), or barns in Kansas—and when

Fig. 23.6 Painting made by an amateur artist with cataracts. She intensified the blue to compensate for her reduced sensitivity, and after surgery she thought the image was too blue.

Fig. 23.7 Abraham Walkowitz, *Isadora Duncan*, c. 1910. Watercolor and ink on paper, 9 x 6 in. (23 x 14.5 cm). This type of subject in a small painting will not be affected by peripheral vision loss. Note how one perceives a colored dress, even though the paint washes over the outline of the dancer (see chapter 8).

Fig. 23.8 Drawing by a patient with macular degeneration illustrating her visual problem. The word "CROSBY" is distorted and partially obscured.

23.8

he could no longer see them well enough he simply quit. Artists with this affliction are discussed in more detail in chapter 31.

MACULAR DEGENERATION

The macula is the central portion of the retina where cones are most dense, and where the retina becomes specialized for high-resolution visual acuity. It contains mostly cones, and a high number of bipolar and ganglion cells to process information with as much precision as possible. For reasons that are not yet understood, this part of the eye is also more susceptible to aging. The macula receives more light and has more vigorous metabolism, and these cause the production of metabolic waste products that accumulate in, and damage, a critical layer of cells beneath the retina called the retinal pigment epithelium. This damage to the retinal pigment epithelium affects the transport of nutrients and can result in progressive atrophy of the overlying retinal cells (chronic or "dry" macular degeneration). In some patients, when damage is severe, the altered retinal pigment epithelium allows scar tissue to grow up into the retina and bleed, which is called "wet" or acute macular degeneration.

The result of this process is not simply a blurring of vision. Early in macular degeneration, if the cellular loss is irregular, affected individuals may experience waviness or distortion of letters, or small blind spots that make just part of a word or face disappear. Figure 23.8 was drawn by a patient to show how her sight had become fragmented and distorted, although her peripheral vision was unaffected. Eventually people with macular degeneration are left with a large central blind spot that forces them to look eccentrically to see things. The one saving grace is that this process is almost always limited to the macula, so that side vision remains good, and people with macular degeneration never go totally blind.

In our Western world, where people are living longer and longer, macular degeneration is becoming a major health problem. After age sixty-five as much as 25 percent of the population has some degree of visual loss or visible change in their retina that can be attributed to this process. So we can presume that it must have affected a good percentage of individuals in earlier times, if they lived long enough. However, there is no way of knowing for sure much before the late 1800s, since the instrument for looking inside the eye, the ophthalmoscope, was not invented by Hermann von Helmholtz until 1850. Might Titian or Rembrandt have suffered some visual loss from macular degeneration to account for their increased use of a thick application of paint, called impasto, and less attention to fine detail? We will never know, and there is nothing in letters or the history

of the times to document that either artist complained of poor vision. However, they probably did not have wet macular degeneration with severe loss of vision, since details are still evident in the late paintings. This is in contrast to other artists with documented macular degeneration (Degas and O'Keeffe, among others), whose vision fell to low levels and who showed a distinct degradation of their style or stopped painting. (In fairness, Degas' macular problem was long-standing and progressive, rather than age-related, but the visual implications were the same.)

CONCLUSIONS

We have introduced the major afflictions of age upon the eye, both in terms of normal visual changes that will affect most of us and true eye disease. Subsequent chapters will discuss in more detail the issue of stylistic change in elderly artists and the work of artists with cataract, glaucoma, macular degeneration, and other specific diseases. There are ocular diseases that do not affect vision directly, but may nevertheless affect the ability to function visually, such as severe dry eyes or uncontrolled tearing, as experienced by Pissarro. And the ocular problems of the Spanish painter Francisco de Goya and twentieth-century writer and cartoonist James Thurber were probably inflammatory in nature, although the inflammation ultimately caused varying degrees of cataract, glaucoma, and retinal damage.

This complexity of eye diseases is intriguing, but also demonstrates that many different disease processes may produce a similar end result in terms of visual loss from retinal or optic nerve damage or the production of cataract. We have emphasized repeatedly that it is difficult to diagnose visual loss from an artist's work since so many other factors contribute to style and technique. It is even harder to diagnose a specific disease, since a similar degree of visual loss or color distortion may result from a plethora of causes. It is instructive to see how these various aspects of aging and disease can alter vision, because they undoubtedly have been factors in art throughout the ages. However, we can critically analyze these effects on a specific artist's work only where there is good documentation of the artist's visual status or disease.

NOTES

1. There has been much written about the aging artist and his or her late style. Examples include Philip Sohm's *The Artist Grows Old: The Aging of Art and Artists in Italy 1500–1800* (2007) and Thomas Dormandy's *Old Masters: Great Artists in Old Age* (2000).

2. Anecdote related by Peep Algreve, MD, then of St. Erik's Eye Hospital, Stockholm.

Fig. 24.1 Titian, *Self-Portrait*, c. 1560. Oil on canvas, 33 ⅞ x 25 ½ in. (86 x 65 cm). Though the artist was in his seventies when he made this portrait, he was in full command of his powers.

THE DILEMMA OF LATE STYLE: TITIAN AND CÉZANNE

"May those who do not know what old age means bear it with what patience they may when they reach it."
—MICHELANGELO[1]

Style, the term used to describe the characteristic features of an artist's work or of a historic period, is one of the most difficult and contentious subjects in the history of art.[2] Traditionally, historians have explained the complex question of style by dividing an artist's career into three stages: early, middle, and late. Sometimes other words have been used, such as rise, culmination, and decline. These distinct phases are easily understood since they are parallel to the youth, maturity, and old age of human life and to the budding, flowering, and decay of plant life.

The first attempt to describe three typical periods of an artist's career may have been by seventeenth-century French writer Roger de Piles. In youth, he explained, artists follow the methods of their teachers, and in maturity they develop their own characteristics. But in old age they return to previously developed styles that may even parody their earlier work.[3] This categorization was widely accepted and applied into the nineteenth century. In the twentieth century, however, these concepts have been difficult to apply as artists moved toward abstraction and other nonrepresentative styles.

The notion that prior to the twentieth century artists tended toward a late style with universal characteristics may be debatable, but in a recent survey, a group of art historians broadly characterized the late period of most classical artists' work as bold, complex, intense, spontaneous, serene, and sophisticated, in contrast to the precisely detailed and realistic style of youth.[4] Certainly, many factors affect the development of an artist's style, including his or her age (which may involve deterioration of the eye, as discussed in the preceding chapter), goals, ability, training, the standards of the time, and the opinions of dealers and patrons. And late in life many artists do develop a different manner of working, often painting more freely, with broader, looser brushstrokes and depicting details less precisely, with darker or fewer colors. Since these changes mimic some of the symptoms of visual loss, one may wonder whether the "late style" in some artists' careers were influenced by the ocular

changes of aging, or by eye disease, and further, the extent to which artists who had long careers had ocular problems.

Not every artist's style evolves to include a characteristic late phase. One remarkable example of consistency over an extensive period of time is the work of Henri-Joseph Harpignies (1819–1916), the long-lived French landscape painter. Harpignies was still painting and exhibiting at age ninety-three, four years prior to his death, and the style of his rural landscapes was essentially unchanged from his earlier years (showing no influence from Impressionism, Fauvism, or the other movements through which he had lived). However, his late works do seem to include fewer details and a more limited range of colors than his early paintings, suggesting that his eyesight may have been weakening (possibly from mild age-related macular degeneration; see chapter 33). The American portrait painter Charles Willson Peale continued to make finely detailed renditions into his eighties (see fig. 23.5) as well. And the exceptionally talented French artist Jacques Louis David (1748–1825) painted with a high degree of precision from the beginning to the end of his long career.

However, historically, most long-lived artists did loosen their styles later in their careers. The examples of Frans Hals and Camille Corot are presented in chapter 23. Italian Renaissance artists frequently cited as having clear early, middle, and late stages include Donatello, Michelangelo, and Titian. Each encountered artistic difficulty in his late period, which may or may not reflect visual loss. Donatello is best known for his sculpture, and a contemporary said that Donatello's famous late work, the bronze doors and pulpits in the church of San Lorenzo, were the coarsest things that he ever made and that "he was so old that his eyesight no longer permitted him to judge them properly."[5] But we don't know if this comment is medically correct or just a catty remark by a rival: His vision would be hard to judge from sculpture as he undoubtedly had help from assistants, and these sculptures are masterpieces by our current standards. The late works of Michelangelo and Titian are darker in theme and in color than either's earlier works; both artists created gloomy Pietàs for their personal tombs. Michelangelo was said by a contemporary to have been so blind late in life that he relied on his sense of touch to model and mold sculpture.[6] Again, however, the historical record is unclear as to cause or severity of

any visual loss. Early self-portraits by the seventeenth-century Dutch master Rembrandt reveal an energetic and self-confident man, yet in his seventh decade he represented himself as brooding and introspective, and used heavier impasto and broader brushstrokes (see chapter 25). Early works by the Spanish artist Francisco de Goya are light and cheerful, but his late paintings at La Quinta del Sordo (The House of the Deaf Man), made in about 1820, are morose and even bizarre (see chapter 34). However, the works that these artists created toward the ends of their lives are often considered more profound and powerful than those they made during their early and mature periods.

Many of the Impressionists were fortunate to enjoy long careers and continued to modify their styles into old age. Claude Monet's late paintings, including many large water lily canvases, were painted in a broad, sweeping manner and are the admirable creations of an octogenarian who continued to paint almost to the end of his long life despite ill health, which included ocular problems. His late style did not require precise eyesight, so he was able to paint in spite of declining vision due to cataracts until the cataracts were very dense (see chapter 30). Degas experimented with many media, including paint, pastel, prints, sculpture, and photography during his late years; he, too, was able to adapt, despite eyesight that was compromised by retinal disease (see chapter 35). He worked in less detail late in life, but these late works are nonetheless well composed. Some were made with coarse lines of cross-hatched color to demark shape, and while their low level of resolution suggests reduced visual acuity, this impairment obviously did not prevent their creation. The Impressionists Camille Pissarro (see chapter 26) and Pierre-Auguste Renoir (see chapter 2) were productive into their eighth decades. Pissarro was plagued by recurrent inflammation and infection of his lachrymal system, but these problems were a severe annoyance rather than a reason for compromising his vision, and he was still able to produce many admirable works. Renoir developed a distinctive late phase characterized by dominance of red colors and distorted anatomy. As far as we know, these stylistic features were not due to an abnormality of his eyes or to his severe arthritis. When arthritic complications made it difficult for him to mould sculpture, however, he collaborated with a colleague who performed the physical tasks. Mary Cassatt loosened her manner of working as her vision decreased due to cataracts late in life (see chapter 29). The cataracts were removed, but her vision did not improve and she was unable to work during the final dozen years of her life. However, other artists fared well after cataract surgery, even without a replacement lens. Most likely, Cassatt had damage to the macular region of her retinas after surgery, possibly complicated by diabetes, and this problem is what kept her from resuming painting.

Not every important artist blessed with longevity has had a late period that measures up to his or her early or middle period, although such evaluations are subjective. Late works made by some well-known twentieth-century artists, including Georges Braque, Marc Chagall, and Pablo Picasso, are so near to us in time that analysis can be difficult. While each of these three has his advocates, the late works of each have been critiqued as not up to earlier standards. Braque and Picasso founded Cubism, and their early Cubist works often cannot be told apart. Their partnership ended with the onset of the World War I. For two decades after the war Braque remained actively creative, but his work of this

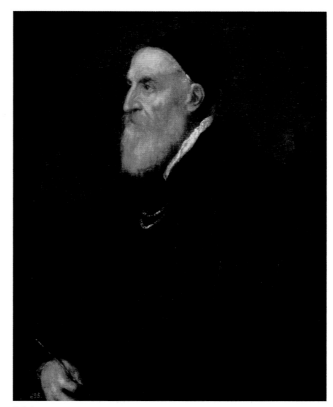

24.1

time has been described as rough, complex, and difficult to understand. Picasso's work was innovative during his Rose and Blue periods, and with his explorations of Cubism and abstraction, but his late style, which is characterized by simpler color and forms, has received mixed reviews. Though some critics have admired the work of this period, others have deemed it crude or repetitive.

Two artists often cited as having clear early, mature, and late styles are Titian and Paul Cézanne. And with both, historians have speculated about the possible role of vision in the evolution of their late works.

TITIAN

The Venetian Renaissance artist Titian (circa 1485–1576) was highly successful during his lifetime and has always been considered one of the most important painters to ever wield a brush (see fig. 24.1). Although his date of birth is unknown, he lived into at least his ninth decade. (During the sixteenth century birthdates were considered less important than they are today, so Titian probably did not know when he was born. The age given on his death certificate, 103, cannot be substantiated.[7])

Major changes took place in his style over time, which is not surprising, given his long life and lengthy career. His early work shows the influence of the fifteenth-century fashion for precise finishes and brilliant colors. Beginning in his sixth decade, however, he developed a style characterized by darker colors and less distinct representation of details.[8] The differences in his style over sixty years may be seen by comparing two of his most famous paintings, the early *Amor sacro e Amor profano* (*Sacred and Profane Love*) (see fig. 24.2) and the late *The Flaying of Marsyas* (see fig. 24.3). The earlier painting features a great deal of detail and vivid colors, while the late

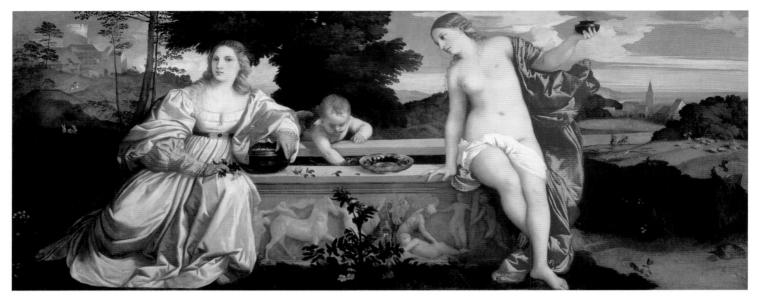

24.2

24.3

Fig. 24.2 Titian, *Amor sacro e Amor profano (Sacred and Profane Love)*, c. 1515. Oil on canvas, 46 ¹/₂ x 110 in. (118 x 279 cm). This early work by Titian was painted with great precision, using brilliant colors.

Fig. 24.3 Titian, *The Flaying of Marsyas*, 1570–75. Oil on canvas, 83 ¹/₂ x 81 ¹/₂ in. (212 x 207 cm). This late work shows less detail and marked changes in color as compared to figure 24.2.

Fig. 24.4 Paul Cézanne, *Self-Portrait with a Beret*, c. 1898–99. Oil on canvas, 25 ¹/₄ x 22 in. (64.1 x 53.3 cm). This self-portrait was done when the artist was nearly sixty years of age.

work is sketchy and brown with but a few flecks of different colors. Other well-known late paintings are at least as brown, including *Pietà* and *The Crowning with Thorns*. These were all in Titian's studio at the time of his death, and since *The Flaying of Marsyas* is signed, the artist probably considered it finished. (Titian was never fully consistent in his technique and he continued to experiment throughout his lifetime, so it is difficult to know when he decided that a work was completed.)

Titian's technique of painting toward the end of his life was described by another Venetian artist Palma Giovane (1544–1628). Palma explained that Titian would begin with a base layer of color painted rapidly, without any sketching or drawing underneath. "With the same brush dipped in red, black, or yellow he worked up the light parts and in four strokes he could create a remarkably fine figure . . . Then he turned the picture to the wall and left it for months without looking at it, until he returned to it and stared critically at it, as if it were a mortal enemy . . . If he found something which displeased him he went to work like a surgeon . . . Thus, by repeated revisions he brought his pictures to a high state of perfection and while one was drying he worked on another. The final touches he softened, occasionally modulating the highest lights into the half-tones and local colours with his finger; sometimes he used his finger to dab a dark patch in a corner as an accent, or to heighten the surface with a bit of red like a drop of blood. He finished his figures like this and in the last stages he used his fingers more than his brush."[9] Giorgio Vasari, the sixteenth-century artist who is most famous for being the biographer of his colleagues, described Titian's youthful works as careful and delicate and pointed out that they can be examined effectively up close or far away. He said that Titian's method of painting late in life was far different than earlier. The late works, "executed in bold strokes and with dashes, can scarcely be distinguished when the observer is near them, but if viewed from the proper distance they appear perfect."[10] Documents from Titian's lifetime indicate that he was not healthy when he was painting the late works. In 1568 an art dealer reported: "He no longer sees what he is doing, and his hand trembles so much that he cannot bring anything to completion."[11] Friends and patrons became concerned about his ability to paint. The Spanish ambassador to Venice wrote: "Titian is too advanced in

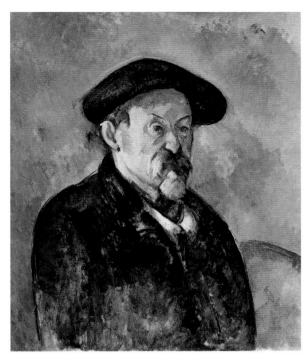

24.4

years to go on producing good painting."[12] Despite Vasari's comment that the paintings appeared perfect at a distance, many late works lack this quality. As one Titian expert has put it, they "deceived viewers into mistaking controlled artifice for random splatter." Toward the end of his life, he went on, they became "just what they appeared to be, messes."[13] Nevertheless, some of these "freestyle" late works contain surprising islands of detail and precision. Since he lived a very long time, even by twenty-first century standards, Titian would likely have developed cataracts; the lack of details and predominance of brown tones in his very late works are certainly consistent with the known effects of this ocular disease. Age-related opacities of the nuclei of his lenses would have scattered incoming light rays, causing objects to appear blurred. The yellow-brown cast of the age-related cataracts would have filtered out the short wavelengths of the color spectrum, so that he would have had difficulty perceiving violet, blue, and some greens. No medical records have survived to help us in our diagnosis, and even if they had, sixteenth-century technology may not have revealed much. But Titian's paintings are excellent demonstrations of a late style that undoubtedly reflects the judgments of a long artistic lifetime, but that may also have been influenced by changes common to aging eyes.

CÉZANNE

One of the most important painters from the second half of the nineteenth century, Paul Cézanne (1839–1906) (see fig. 24.4) is also frequently cited as a good example of an artist whose work went through the three distinct phases. He exhibited with the Impressionists, but his work is better classified as Post-Impressionist. He strongly influenced the development of painting in the twentieth century, particularly the Fauvist and Cubist movements. Cézanne was the son of an affluent banker and grew up at Aix-en-Provence in the south of France. At his father's insistence he studied law at the University of Aix for two years, but law did not interest him. He followed the author Emile Zola,

his boyhood friend, to Paris, where he studied the old masters in the Louvre but was refused admission to art school at the École des Beaux-Arts. His submissions to the official Salon were consistently refused as well, and he participated in the famous Salon des Refusés of 1863. His early paintings, those made before 1870, are generally dark, brutal, and violent. The "dean" of French Impressionism, Camille Pissarro, influenced the young artist, whose goal was to transform the ethereal nature of Impressionism into something more solid, like that found on the walls of the Louvre. Cézanne worked in the Impressionist mode for about a decade, and while his work was included in both the first (1874) and third Impressionist exhibitions (1877), the critics attacked it in the press more than any of the work of his colleagues.

Defiant, shy, volatile, and unsociable, he returned home to Aix after the first Impressionist exhibition and spent much of his time there. He remained at Aix during the second Impressionist exhibition (1876), and did not take part in it. His works were included at the third Impressionist exhibition, but the ridicule he received from the critics made him resolve never to exhibit with his Impressionist friends again. He had been rejected by the Salon repeatedly, so this decision meant that his works were cut off from public display. Cézanne then developed his mature style. He thinned down his paint and concentrated on landscapes, particularly views of Mont Sainte-Victoire, the mountain that dominates the city of Aix (see fig. 24.5). Toward the end of the nineteenth century Cézanne was working alone, almost a hermit. He was aware that he was getting older and had lost his youthful vigor. Always a slow and deliberate painter, as he moved into his late period, he struggled with how to translate his perceptions, which he called "sensations," onto canvas. The calm, broad view of nature evident in his mature midcareer works was replaced by a more disturbing, tumultuous point of view, as in a later version of a painting of Mont Sainte-Victoire (see fig. 24.6). His forms became less defined, and he laid down his paint more thickly and in darker colors. His late self-portraits reveal a weaker, less robust man. In one made as he approached the age of forty, he looks healthy, but by the turn of the century he depicted himself as wizened and in decline (see fig. 24.4). In a letter from this period, he states: "I am getting old. I shall not have time to express myself . . . Perception of the model and its realization are sometimes very long in coming."[14]

CÉZANNE'S HEALTH

No medical records exist concerning Cézanne's care. What little we know about his health comes from his letters, notes by friends and acquaintances, and inferences from the works he created, although there is little information about his vision. The letters he wrote during his last six years of life, from 1900 until his death in 1906, reveal that his health was failing. He frequently described lethargy, even severe fatigue, which kept him from finishing his paintings. He had always been a slow, painstaking artist, but this seems to have been more than just an ordinary artist's block. In 1895 one of his friends wrote to Zola: "Cézanne is very depressed and often attacked by fits of melancholia." The following year Cézanne told one of his biographers: "I'm in bad shape." He added, "It's the eyes, yes, my eyes . . . Straight lines look like they are falling sometimes."[15] He admired the self-portrait by Jean-Baptiste-Siméon Chardin, in which the artist depicted himself wearing a visor and glasses to avoid glare (see

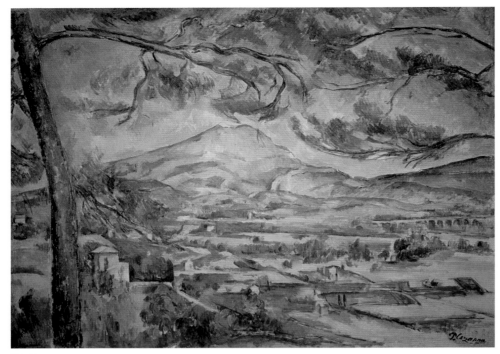

24.5

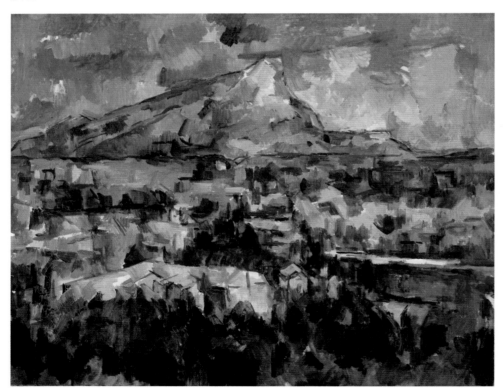

24.6

Fig. 24.5 Paul Cézanne, *Mont Sainte-Victoire with Large Pine Tree*, c. 1887. Oil on canvas, 26 1/4 x 36 1/2 in. (66.8 x 92.3 cm). Mont Sainte-Victoire is painted in Cézanne's mature style.

Fig. 24.6 Paul Cézanne, *Mont Sainte-Victoire*, 1902–04. Oil on canvas, 29 x 36 in. (73 x 92 cm). This later painting of Mont Sainte-Victoire shows experimentation with large dabs of paint that verge on abstraction.

Fig. 24.7 Jean-Baptiste-Siméon Chardin, *Self-Portrait*, 1775. Pastel on paper, 18 x 15 in. (46 x 38 cm). Relatively few artists have chosen to portray themselves with glasses, let alone with an eyeshade. Cézanne also tried wearing an eyeshade and found that it brightened colors.

Fig. 24.8 Paul Cézanne, *Still Life with Ginger Jar, Sugar Bowl and Oranges*, 1902–06. Oil on canvas, 23 7/8 x 28 7/8 in. (60.6 x 73.3 cm). Although this still life is a very late work, it is painted realistically. Compare it with figure 18.5.

24.7

fig. 24.7). In a letter written two years before he died, Cézanne described trying on an eyeshade and noted that it made colors appear more distinct. He added: "Verify this fact and tell me if I am wrong."[16] Cézanne was not wrong: This phenomenon is the same one discussed at the end of chapter 7, whereby looking through cupped hands in a gallery will brighten the paintings by blocking out the surrounding light.

Cézanne was on good terms with several physicians, including Paul-Ferdinand Gachet, MD, who is most famous for being Vincent van Gogh's last doctor. Gachet was an early collector of Cézanne's paintings and owned an important one, *A Modern Olympia*, which he lent to the first Impressionist exhibition in 1874. Gachet favored homeopathic medications, and may have advised Cézanne to use this type of therapy.

DIABETES

About 1890 Cézanne was found to be diabetic, but exactly how this diagnosis was established is not known. Unfortunately, no effective medication to treat diabetes was available during his lifetime. His housekeeper kept him on a strict diet. Not uncommonly, longstanding diabetes has retinal complications. The novelist and critic Joris-Karl Huysmans raised the possibility that Cézanne had retinal difficulties as early as 1883, several years before the diagnosis of diabetes was made. Huysmans described Cézanne as "a revealing colorist who contributed more than did the late [Edouard] Manet to the Impressionist movement," and also reported that he was an "artist with a diseased retina."[17] (Though Huysmans may have been satirical, since the unusual painting styles of Cézanne and the Impressionists offered critics ample opportunity for humorous reviews.)

Recently, the Cézanne scholar George Heard Hamilton has written that Cézanne's late series of paintings of Mont Saint-Victoire give indications that his visual acuity was worsening as he aged.[18] He notes that a painting of the mountain dating from the late 1880s depicts a smooth continuous slope, but in the same scene painted two decades later, the mountain is fragmented and the brushstrokes conflict with each other. Hamilton feels that the differences may have been unintentional, due to declining eyesight. In a letter written the year before he died, Cézanne said that he could not see well enough to complete a canvas; the translation is cumbersome, but gives a sense of what he was noticing: "Now, being old, nearly seventy years, [my reduced visual perception does not] allow me to cover my canvas entirely nor to pursue the delimitation of the objects [which] are fine and delicate; from which it results that my image or picture is incomplete."[19] And yet, he was consciously exploring the sparse delineation of objects early in the 1890s, long before visual changes were any issue. The month before he died, he wrote: "Will I ever attain the end for which I have striven so much and so long? I hope so, but as long as it is not attained a vague state of uneasiness persists which will not disappear until I have reached port, that is until I have realized something which develops better than in the past."[20]

In fact, Cézanne continued to paint in a variety of styles late in life, which suggests that many of the "late" characteristics of his work are a result of choice rather than necessity. In some works, much of the canvas is unpainted and the composition is sketchy, prefiguring abstract art of the twentieth century. Yet other late works echo his mature style, in which scenes or objects are rendered more fully. For example, he painted a number of still lifes from 1902 to 1906 (see fig. 24.8) that mirror closely his techniques from earlier years (see fig. 18.5), and his late self-portrait is revealing and poignant. It is hard to argue that poor vision was preventing Cézanne from painting in a traditional style, although it is possible that visual changes had made doing so more challenging, and encouraged his exploration of other approaches.

For Titian, Cézanne, and many others, visual aging was inevitably a factor in life and to some degree in art. However, it is difficult to separate possible effects of visual dysfunction from explorations of style that are a part of the search for perfection by most great artists.

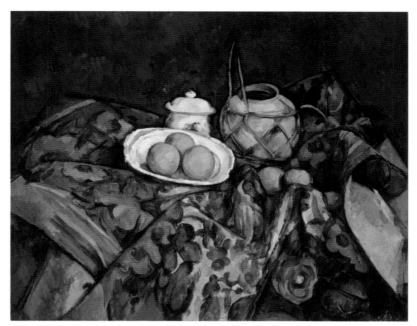

24.8

NOTES

1. Michelangelo, letter to Luca Martini (1547). In Sohm, *The Artist Grows Old: The Aging of Art and Artists in Italy 1500–1800* (2007), p. 3.
2. Elkins, "Style," In Turner, *The Dictionary of Art* (1996), pp. 876–879.
3. de Piles, Roger. In Sohm, *The Artist Grows Old: The Aging of Art and Artists in Italy 1500–1800* (2007), p. 8.
4. Lindauer, "Old Age Style." In Runco and Pritzker, *Encyclopedia of Creativity*, vol. 2 (1999), pp. 314–315.
5. Sohm, *The Artist Grows Old: The Aging of Art and Artists in Italy 1500–1800* (2007), p. 77.
6. Ibid.
7. Ibid, p. 83.
8. Gould, "Titian," In Turner, *The Dictionary of Art* (1996), pp. 31 and 38. See also Sohm, *The Artist Grows Old: The Aging of Art and Artists in Italy 1500–1800* (2007), p. 77.
9. Humfrey, Titian (2007), pp. 200–201.
10. Vasari, *Lives of the Most Eminent Painters, Sculptors and Architects* (first published in 1550). Translation (1917), vol. 4, p. 291.
11. Humfrey, *Titian* (2007), p. 206.
12. Sohm, *The Artist Grows Old: The Aging of Art and Artists in Italy 1500–1800* (2007), p. 96.
13. Ibid., p. 80.
14. Rewald, *Paul Cézanne: Letters* (1976), p. 255.
15. Doran, *Conversations with Cézanne* (2001), p. 118.
16. Rewald, *Paul Cézanne: Letters* (1976), p. 305.
17. Huysmans, *Certains* (1889), p. 43.
18. Hamilton, "The Dying of the Light: The Late Work of Degas, Monet, and Cézanne." In Rewald and Weitzenhoffer, *Aspects of Monet* (1984), pp. 220–241.
19. Rewald, *Paul Cézanne: Letters* (1976), pp. 316–317.
20. Ibid., pp. 329–330.

Fig. 25.1 Rembrandt van Rijn, *A Polish Nobleman* (detail), 1637. Oil on panel, 38 1/8 x 26 in. (96.8 x 66 cm). This early work shows fine brushstrokes and is precisely drawn, as is Rembrandt's early *Self-Portrait* (see fig. 27.3).

Fig. 25.2 Rembrandt van Rijn, *Saint Matthew and the Angel* (detail), 1655–60. Oil on canvas, 26 x 20 1/2 in. (66 x 52 cm). This later painting has rough brushstrokes and a thick application of paint called impasto, although Rembrandt still painted details such as strands of hair. Impasto was used more expressively for the elderly Matthew than the young angel. See also Rembrandt's late *Self-Portrait* (see fig. 27.4).

Fig. 25.3 Rembrandt van Rijn, *Portrait of Rembrandt's Mother* (detail), c. 1629. Oil on canvas, 29 x 24 1/2 in. (74 x 62 cm). Rembrandt's mother is wearing reading glasses, readily available in the seventeenth century.

THE AGING REMBRANDT: MATURITY VS. DISEASE

Rembrandt van Rijn (1606–1669) is perhaps the most singularly famous painter—the one whose name immediately symbolizes fine art. He did not live to extreme old age, but his late works reveal stylistic changes that have led critics and physicians to speculate that he may have had ocular difficulties, such as cataract or macular degeneration (compare figures. 25.1 and 25.2, and also figures 27.3 and 27.4). On the other hand, there is no historical evidence of disease from letters or contemporary documentation, and many artists experienced an evolution in style in their older years, typically showing more freedom and breadth in technique (see chapter 24). Rembrandt can serve, therefore, as an example of the dilemma we face in analyzing older artists: To what extent are the "normal" ocular changes of age, or the ocular diseases of age, relevant to their art? Or are the stylistic changes in their late works the result of nonvisual factors, such as economic independence, continued exploration, and maturation?

REMBRANDT'S CONTEXT IN HOLLAND

There is a romantic myth that Rembrandt was a genius working in isolation, but this story does not stand up to historical scrutiny. He worked within the culture of seventeenth-century Holland and was well received in society, despite his ecclesiastical censure for licentious behavior and financial overextension that was followed by a very public bankruptcy.[1] He was ambitious, self-conscious of his role as an artist, and—despite our twenty-first–century reading of a warm disposition into his self-portraits—he could be difficult.[2]

Following his early career in Leiden, he moved to Amsterdam in 1631 where he quickly achieved great success with the wealthy burghers. By 1640 he had a large home, a beautiful, aristocratic wife, and was purchasing expensive works of art by other artists. He had a large number of students, including most of the best-known artists of his generation. Sadly, his wife died in 1642, possibly from tuberculosis, and their six-month-old child was the only one of their four children to survive childhood. The Anglo-Dutch War of 1652–54 caused an economic recession in Amsterdam, stagnated trade, and left fifteen hundred homes vacant. In 1656 plague struck the Dutch capital and killed nearly

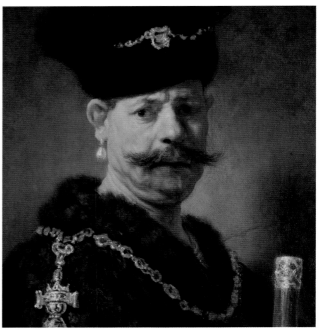

25.1

eighteen thousand people, and that same year Rembrandt was forced into bankruptcy. He had overextended himself with an expensive home, purchases of art, and possibly investments that failed during the war. Bankruptcy cost him some upper-class friends, but he maintained links to several middle-class merchants and prominent physicians, and continued to have wealthy clients for the rest of his career.

Rembrandt's work has been reassessed for centuries. Critical expectations were changing in the seventeenth century along with a reexamination of standards of representation and technique, and these changes took place independent of Rembrandt. It is interesting to note that Rembrandt's self-portraits were not given special attention during his lifetime.[3] A few of his contemporaries also made a large number of self-portraits, including his student Gerrit Dou (1613–1675), and collections of self-portraits were assembled. But there was no particular fashion for this type of work that explains why Rembrandt devoted 10 percent of his oeuvre to it.

Rembrandt's works up to his midcareer were drawn with precision and detail (see figs. 25.1 and 27.3). Around 1655, near age forty-five, he began to alter his style and to show more interest in creating effects of mood and spirit, as opposed to rich clothing and materials. And during the last two decades of his life, he became less interested in the allegorical and mythological themes

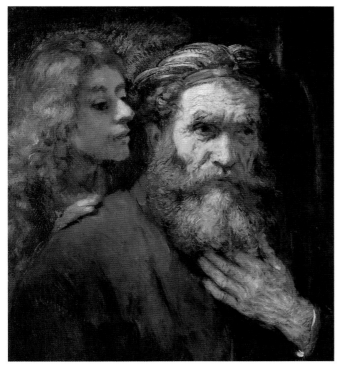

25.2

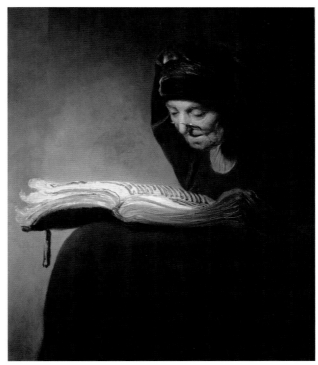

25.3

he had used often in earlier years. Rembrandt also moved to a thicker, broader method of applying paint, as evident in figures 25.2 and 27.4. In general, his later works are drawn less smoothly, the colors are bolder, and the brushstrokes are broader, although he would add fine touches where needed. Some of his contemporaries felt that the paintings of this time appeared unfinished, and that the thick applications of paint, called impasto, did not enhance the images.[4] With 350 years intervening since their creation, additional changes have taken place, such as chemical alterations, the effects of pigment drying, and aging varnish. These transformations have muted Rembrandt's colors and complicate the analysis of whether the effect is the result of personal style or disease. Multiple cleanings and restorations have modified the appearance of some works, but removing old varnish and accumulated surface grime may change the appearance of the paintings, in particular the color, making the paintings look less yellow or brown. Judgments made from our current view of these works are, as a result, fraught with potential error.

PRESBYOPIA

The most obvious, and necessary, ocular difficulty that must have plagued Rembrandt in his fifties was presbyopia, which affects all of us after fifty. Could his use of impasto late in his career have had something to do with this age-related difficulty?[5] Perhaps, but there are many reasons to doubt that presbyopia was a primary cause. For one thing, reading glasses were readily available in Rembrandt's era, and he depicted members of his own household wearing them (see fig. 25.3). He did not depict himself wearing glasses, but in fact would probably have needed them only for close detail work while painting. He certainly had the option to use them if and when they were necessary, and it seems unlikely that he would have changed his overall style of paint-

ing solely for fear of putting on "readers" while working. We also see evidence in his late work that he could paint details when he desired. Despite the heavy impasto and a less photographic rendition of the subjects, he was still able to highlight delicate aspects of jewelry. Some of his late drawings depict aspects of eyes and other structures that would not be possible for an elderly person to see without some form of visual aid. Furthermore, there are occasional late paintings, such as *Lucretia* (see fig. 25.4), with relatively little impasto and with many fine details, suggesting that his stylistic choices (like those of El Greco) were for aesthetic and intellectual reasons as opposed to optical ones.

CATARACT

Rembrandt near age fifty would have been relatively young for cataracts, but it is conceivable that he was developing them. Cataracts could have blurred his vision and made it difficult for him to paint precisely. His later paintings were seen by some contemporaries as poorly finished, with coarser brushstrokes and thick impasto.[6] A smooth, velvety style was still preferred during the second half of the seventeenth-century in Holland over the rougher, less-finished late manner of Rembrandt.[7] However, many artists tend to work more loosely as they age (see chapter 24), and Rembrandt had achieved enough seniority to express himself artistically as he saw fit. His visual acuity could not have been too poor, given that he still painted details, and we have no record of failing sight (e.g., difficulty with reading). The applications of paint that characterize his mature style are much larger than would be required by mild loss of vision. Furthermore, Rembrandt worked in this style for more than a decade (1655–1666) with relatively little change, whereas a cataract that compromised vision in 1655 would surely have been much more severe and more compromising nearly fifteen years later.

A more serious issue with respect to cataract is the possibility that his color vision was compromised.[8] We comment at length elsewhere about the effects of a progressively yellow or brownish filter in front of the eye, which alters an artist's view of the world and an artist's ability to distinguish colors on the palette (see chapters 30 and 38). Rembrandt's late works have an over-riding amber tonality, to be sure, but the same might be said of many of his earlier works as well, not to mention paintings by many other artists of that period. This tonality may have several causes, including conventions of the day, usage of warm lighting (from candles or lamps), and the effects of time upon varnishes that were used to cover paintings. Similar tonality diffused early paintings by van Gogh, who found special meaning in yellow (see chapter 10), and many paintings by Turner (see chapter 9), at ages when cataract was not an issue. Furthermore, as we have also noted elsewhere, the yellowing of the world from cataract does not necessarily or simply translate into the painting of yellow canvases, since the person with a cataract has no "white" to compare with. The problem that Claude Monet faced as his cataracts grew dense was not a brown world, but one in which many colors were merged and indistinguishable. It seems inconceivable that Rembrandt had suffered this degree of difficulty. Severe cataracts were well recognized by his day, and probably would have been mentioned somewhere in the historical record.

Having made these arguments against severe cataract, there is no way to judge whether Rembrandt might have had a degree of mild cataract. Cataract is a common feature of aging, and the division between normal aging of the lens and an early cataract signifying disease is not a sharp one. Rembrandt could well have had some early nuclear sclerosis of his lens to the point of mild loss of visual acuity and mild loss of color discrimination. However, these effects would be impossible to judge in his art since a painter can compensate for mild visual loss by simply moving closer to the canvas, and Rembrandt did not use colors as critically or with such subtle distinctions as Monet did.

AGE-RELATED MACULAR DEGENERATION

The issues with macular degeneration are much the same as for cataract. It seems highly doubtful that Rembrandt had severe loss of visual acuity, and thus would not have had "wet" macular degeneration, as was the case with Georgia O'Keeffe (see chapter 37) and probably the English Impressionist Philip Wilson Steer as well (see chapter 33). He may have suffered a mild loss of acuity from "dry" changes, although most people do not have such effects until past sixty years of age. As with cataract, it would be unlikely that macular disease severe enough to cause a stylistic change would have held steady for more than a decade.

STRABISMUS

Strabismus is a collective term for abnormalities of ocular alignment, and commonly refers to a condition in which an eye turns in or out. Some of Rembrandt's self-portraits give an impression that one eye may turn outward to a mild degree, and some authors have hypothesized on the possible significance of such a finding.[9] Others have questioned this finding,[10] however, and we suspect that the appearance of the eyes in these paintings is an artifact of artistic intention and direction of gaze, rather than

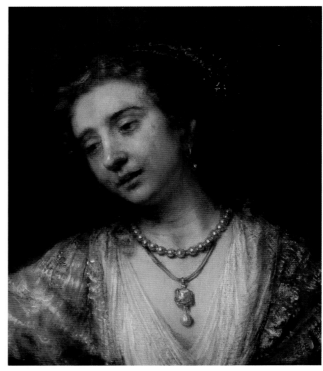

25.4

a sign of eye disease. This issue is discussed further in chapter 27, and in any event it is not a function of aging, which is our primary concern in this chapter.

REMBRANDT'S EYE "DISEASE": CONCLUSIONS

There is no convincing evidence that Rembrandt had any eye disease beyond routine aging and presbyopia. It is possible (or at least impossible to rule out) that he had early and mild difficulties with cataract or macular degeneration, but neither appears to have been a major problem in his life nor would they, in our estimation, explain his late stylistic changes. Analogous stylistic freedom characterizes the late works of many other artists and may to a large degree be explained by art historical rather than medical reasons. Rembrandt provides an example of the limitations of medical hypotheses about an artist's eyes, and the need for caution where there is no direct evidence of eye disease.

NOTES

1. Zell, "Why Rethink Rembrandt?" (2002).
2. Schwartz, *Rembrandt: His Life, His Paintings* (1985), p. 36.
3. Ford, "Rembrandt's Self-Portraits as a Category" (2002).
4. Bailey, *Responses to Rembrandt* (1994), p. 92.
5. Trevor-Roper, *The World Through Blunted Sight* (1988), pp. 45–49; Weale, "Painters and Their Eyes: Age and Other Handicaps" (2006).
6. Bailey, *Responses to Rembrandt* (1994), p. 92.
7. Ibid., p. 88.
8. Weale, "Painters and Their Eyes: Age and Other Handicaps" (2006).
9. Ibid.; Livingstone and Conway, "Was Rembrandt Stereoblind?"(2004).
10. Marmor and Shaikh, response to "Was Rembrandt Stereoblind?" (2005).

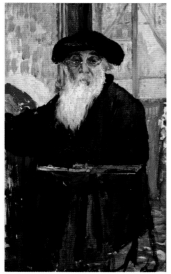

Fig. 25.4 Rembrandt van Rijn, *Lucretia* (detail), 1664. Oil on canvas, 47 ¼ x 39 ¼ in. (120 x 101 cm). Although this is a very late work, it features finer brushstrokes and much less impasto than *Saint Matthew and the Angel* (see fig. 25.2), suggesting that Rembrandt's late style was more of an artistic choice than a consequence of visual degeneration.

Fig. 26.1 Camille Pissarro, *Self-Portrait*, c. 1898. Oil on canvas, 20 ⅞ x 12 in (53 x 30.5 cm). Pissarro peers over his reading glasses at his image in a mirror.

26.1

PISSARRO: THE LACHRYMOSE IMPRESSIONIST

Camille Pissarro (1830–1903) was the elder statesman of French Impressionism (see fig. 26.1). He was, with Claude Monet, a founder and leader of the movement. He was also a colleague and friend of Edgar Degas, Pierre-Auguste Renoir, Georges Seurat, Mary Cassatt, and Vincent van Gogh. Pissarro was the only member of the Impressionist group to show his work at all eight of their annual exhibitions, which took place from 1874 to 1886. His productivity during the last two decades of his life was hampered by recurrent infections around his right eye and tearing. These problems were great irritants and made it necessary for him to travel to Paris frequently to consult his ophthalmologist. When he was able to work, these ocular problems influenced his method of painting. The history of Pissarro's malady is interesting for the light it sheds on a major artist's means of dealing with adversity. It also provides an interesting viewpoint on medical care near the beginning of the twentieth century.

Pissarro was an ardent follower of homeopathic therapy, a form of complementary or alternative treatment that was founded in the eighteenth century by a German physician, Samuel Hahnemann, MD (1755–1843). Hahnemann claimed to be able to treat imbalances in vital forces using very dilute formulations of substances that, in large quantities, would cause symptoms similar to the disease being treated. Homeopathy has had many advocates for more than two centuries in the United States, and proportionately even more in France. Pissarro acquired his mother's faith in homeopathy during an illness she had suffered many years earlier. He frequently consulted a book of homeopathic remedies that he kept at home and often mailed medical advice to his children after they had grown and moved away.

Pissarro found an ophthalmologist who utilized homeopathic therapy in Daniel Parenteau, MD (1842–c. 1935). Parenteau was trained in traditional allopathic medicine but used homeopathic medications, and even though he followed the homeopathic formulary, he was not opposed to surgery. He was president of the homeopathic medical society of France for two years early in the twentieth century and wrote a textbook on homeopathic therapy that is still consulted by its advocates today.[1]

OCULAR PROBLEMS

During the last two decades of his life, Pissarro suffered from chronic infection of the tear sac, which drains tears from the eye to the nose. The recurrent infections were complicated by formation of abnormal drainage channels, or fistulae. The date he first developed the problem is not known, but it was certainly present by 1889 when he consulted Parenteau. Parenteau found that the tear drainage system on the right side of Pissarro's face was blocked. He threaded a fine metal probe through the tear duct and found that the obstruction lay in the bone just before the duct normally enters the nose. He told the artist that attempting to force the probe through the blocked area could lead to disastrous complications. Instead, Parenteau prescribed an oral homeopathic medication, a dilute solution of gold called Aurum metallicum, in the hope that this would allow the tissue around the bone to heal. He told Pissarro that healing would take at least six months and that he should take care to "avoid wind and dust, and wash the eye immediately with boric acid should anything get in it." Pissarro noted: "All that is hardly easy for a painter who ought to face the elements."[2] As an Impressionist landscape painter, Pissarro enjoyed painting outdoors and facing his subject matter.

Seven weeks later Pissarro reported: "Dr. Parenteau found that the lachrymal sac has flattened out but swelling persists near the lachrymal canal, at the inner corner of the eye. Because of this, I have to keep a dressing over my eye for at least a month . . . If after a month things have not improved, it will be necessary to make a small incision in the swollen area to allow the tissues to heal properly, so that tears can flow normally."[3]

Nearly a year and a half later, in January 1891, Pissarro wrote his son Lucien: "I am very troubled at this moment. My eye has been irritated by the intense cold weather and is swollen. It is threatening to turn into an abscess. I must see Dr. Parenteau."[4] Later that month he reported: "Parenteau has found me much better . . . I must keep a bandage over the eye for ten more days. This is very annoying."[5] He continued: "I shall try to work with one eye. Degas does it and gets good results."[6]

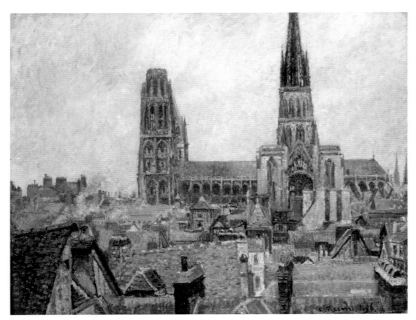

26.2

SECOND AND THIRD OPINIONS

Pissarro sought advice from other doctors. One young physician told him that "destruction of the sac was not a good answer to his problem, since tears would continue to flow copiously."[7] For a painter this would be a serious difficulty, one that could prevent him from working. This physician advised Pissarro that the only reasonable thing to do would be to find a passage through bone into the nose surgically. This would require breaking through the bone and using sounds (metal probes) of progressively larger size to maintain the opening or removing the bone that was blocking the canal and obstructing tear flow. Pissarro met an older physician who told him that he had the same problem for forty years. His colleagues had advised surgery, but he declined, and the tear sac eventually closed itself off. He had been able to tolerate the occasional bit of tearing. Pissarro then questioned Parenteau further about the alternatives, surgery or watchful waiting. At age sixty Pissarro no longer felt young and was deathly afraid of possible complications from surgery. He felt Parenteau had managed his case well and, after discussing the possibilities with him, concluded that he should continue the course of therapy that Parenteau had recommended.

On May 7, 1891, Pissarro wrote his son Lucien: "Parenteau has found my status exceptionally good. In fact, in all usual cases of my type, the practice is to operate to make an opening into the nose, so the tears can flow normally. But it appears that in my case, this procedure would be useless. The tears would not follow the normal pathway because the abscess had created passages in abnormal directions. According to him, there is only one thing to do, to obliterate the tear sac . . . Parenteau has injected the area with silver nitrate, to close off the abnormal passageways created by the abscess and to destroy the sac, while waiting to see if another abscess will form. For the time being he is allowing the inflammation to destroy the sac. I am now in remission. I will probably have abscesses less frequently in the future, and this will allow me to work a little bit. Besides, I am getting used to the idea of having only one eye for working. This is much better than having none at all."[8]

As a typical parent, Pissarro finished this letter to his son by giving him advice on how to take care of himself: "You told me you have a bad cold. Take care of yourself. Do not neglect yourself, because so-called minor problems can become very serious. If you find that your nose is blocked, see an eye doctor. If I had known Parenteau earlier, I would not have had my problem. The same thing can occur to you, considering the shape of your nose."[9]

PISSARRO'S PROBLEM PERSISTED

In July 1891 Pissarro wrote his son, telling him that the abscess was still present and that Parenteau was planning to cut into the the canaliculus, or drainage canal, and cauterize the tear sac and fistulae. "The only thing to fear," he wrote, "is erysipelas [severe infection under the skin], which can prevent the operation from being successful. I am taking large doses of quinine as a preventive measure. I hope to be rid of my problem for a long time. But to be sure of a cure, it will be necessary to avoid a recurrence for a year or two. The tears must keep the normal passages open and carry away debris or foreign matter. Recently, while I was working in a field, in good weather, I got a bit of dirt in the eye. Two days later an abscess formed and broke through."[10] Parenteau drained the abscess and inserted a piece of linen to keep the orifice open until it scarred in from below. He allowed Pissarro to work, but only indoors with the windows shut, despite it being the middle of summer.

Late in 1893 Pissarro was taking six different homeopathic medications orally that were recommended by Georges de Bellio, MD, a homeopathic physician who was a major collector of Impressionist works. However, nothing was working. In 1894 Parenteau continued to cauterize the area. Pissarro associated recurrences with changes in the weather. Two years later, there was still inflammation in the nasal cartilage, drainage, and conjunctivitis. Leon Simon, MD, another homeopathic physician, examined Pissarro, and agreed that Pissarro did not need surgery. What bothered Pissarro most was that he could not paint outdoors.

EFFECT ON HIS PAINTING

Pissarro adapted to the situation. Unable to work outside, he merely painted the scenes looking out the window, of his home or hotel. The cityscapes he made in Paris and Rouen, such as *The Roofs of Old Rouen, Gray Weather* (see fig. 26.2) and *Pont Boieldieu, Rouen, Sunset, Foggy Weather* (see fig. 26.3) are triumphs. Admittedly some of them were painted during cold weather, when he would have been unlikely to be out of doors for very long anyway.

In 1897 he began a letter to his son Lucien, prodding him: "You ought to write me from time to time, to exercise your hand a little bit." He then described his ocular status: "I am afraid of complications for my eye. I have gone daily for a dozen days to Parenteau, who has been cauterizing me and putting an astringent on the veins of the eye." Lucien was about to depart for London, to visit his brother, Titi, who was moribund from tuberculosis. Pissarro continued: "I hope that you do not go, that you are busy with your work. Aren't you afraid that the London fog will be unfavorable for you? The weather has been exceptional here since you left. Now it is 3:30 and there is a beautiful sun outside with a slight mist."[11]

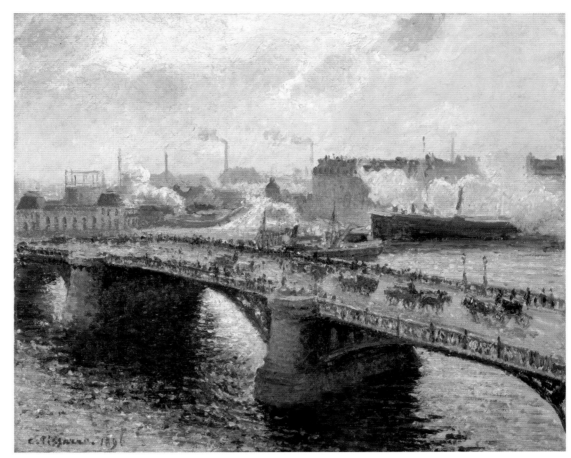

Fig. 26.2 Camille Pissarro, *The Roofs of Old Rouen, Gray Weather.* 1896. Oil on canvas, 28 1/2 x 36 in. (72.3 x 91.4 cm). Pissarro worked on this late painting from indoors.

Fig. 26.3 Camille Pissarro, *Pont Boieldieu, Rouen, Sunset, Foggy Weather*, 1896. Oil on canvas, 21 1/4 x 25 1/2 in. (54 x 65 cm). This outdoor scene was painted from a high vantage point indoors.

26.3

Titi died four days later, in November, at age twenty-four. Pissarro consoled Lucien: "I am happy to learn that you have been able to face the disastrous news of the death of our poor Titi, whom we loved so much, our hope, our pride . . . But in such sad circumstances we must resign ourselves and think of those who are with us . . . Finally, my dear Lucien, let us work to treat our wounds. I hope that you will be strong and that you will wrap yourself up, so to speak, in your art . . . I must return to Parenteau, for cautery. I am improving, but I must persist."[12] Two years later, in 1900, things had not changed: "The grippe has left me with inflammation of the eye. Parenteau is going to cauterize me."[13]

Shortly thereafter he wrote: "Sadly, while I am not troubled by the eye, I have had a severe pain in the kidneys, thick, red and infrequent urine and constipation. Opium and nux vomica [a homeopathic medication containing strychnine] have stopped the constipation and probably have acted favorably on the congestion of the eye."[14]

In 1901, Pissarro's seventy-first year, cauterization was continued as had been done for many years. He died two years later in 1903. A new era in surgery to correct tearing was being developed while Pissarro was treated with late nineteenth-century methodology. Dr. Adeo Toti, an Italian ophthalmologist, revived ancient techniques of drainage through the nose with his new procedure, dacryocystorhinostomy, which he published in 1904.[15] As the eminent English ophthalmologist Sir Stewart Duke-Elder, put it, the history of inflammation of the tear sac is "interesting not only because of its antiquity and the many expedients which have at various times been tried since the Code of

Hammurabi (c. 1760 BCE) but also because it exemplifies vividly the tendency for advances in knowledge to move in circles rather than in straight lines: There are few things under the sun which are really new. The story certainly serves to show how resourceful is the ingenuity of man and how great the toleration of a sick body." [16]

NOTES

1. Parenteau, *Leçons de clinique ophtalmologique* (1881).
2. Pissaro, *Correspondance de Camille Pissarro* (1986–1991), vol. 2, pp. 270–271.
3. Ibid., vol. 2, pp. 285–286.
4. Ibid., vol. 3, p. 9.
5. Ibid., p. 13.
6. Ibid., p. 18.
7. Ibid., p. 73.
8. Ibid., pp. 74–75.
9. Ibid.
10. Ibid., p. 106.
11. Ibid., vol. 4, p. 409.
12. Ibid., p. 418.
13. Ibid., vol. 5, p. 65.
14. Ibid., p. 118.
15. Toti, "Nuovo metodo conservatore de cura radical delle suppurazioni croniche del saco lacrimale (dacriocistorinostomia)" (1904).
16. Duke-Elder, *System of Ophthalmology*, vol. 13, *The Ocular Adnexa* (1974), pp. 714–717.

ARE THE EYES STRAIGHT?: PORTRAITS AND REMBRANDT

27.1

The straightness of eyes is not merely a cosmetic question, although looking at a person with a deviating eye can be unsettling. The issue from an ophthalmologic vantage point is visual: Our eyes are linked as we look about the world in order to keep nearly identical images on both retinas. The slight disparity between right and left views allows true depth perception as opposed to the use of secondary cues such as object size or shadowing of one object by another (see chapter 17). If eyes are even a few degrees out of alignment, a person will have double vision. Double vision is distressing psychologically; and in children it may have dire consequences because the developing brain may "choose" to ignore images from a deviating eye. If the brain does not learn to recognize input from an eye by about age six, it becomes a "lazy eye," which will never be able to see well.

When the eyes turn in or out (i.e., have a "squint"), the condition is called strabismus. Congenital strabismus is present in roughly 3 percent of the population. If the eyes turn *out* the person has an "exo" deviation; if they turn *in* there is an "eso" deviation. Few artists are known to have had strabismus,[1-3] and it is hard to judge from portraits, for a multitude of reasons that we will discuss in this chapter. Giovanni Francesco Barbieri is portrayed with crossed eyes in portraits, and these are probably true portrayals since his nickname was Il Guercino, which means "the squinter" (see fig. 27.1). Perhaps the most famous artist for whom there is evidence of strabismus in both portraits and written material is Albrecht Dürer (1471–1528). Dürer is best known for his engravings, which are expressive and meticulous. He shows himself with a deviating right eye in several self-portraits done as a young man (see fig. 27.2). Assuming he drew this image accurately in a mirror, it would indicate that his left eye turned outward. This curiosity is perhaps just a cosmetic one, but some have speculated that the lack of true stereopsis, or depth perception, may actually be an advantage to an artist, who must reduce the three-dimensional world onto a two-dimensional plane.[4] This notion, however, seems far-fetched to us. After all, everyone uses and recognizes two-dimensional cues for depth; and indeed two-dimensional cues are critical in the real world when looking at faraway objects because depth perception is only accurate at distances where the difference in gaze angle of the two eyes is sufficient for the eye and brain to recognize. Furthermore, it is not a sophisticated trick to close one

eye, should an artist want to simulate a monocular view of the world. Virtually all artists throughout history have dealt with this problem, and it would be a stretch to claim that strabismus is an artistic advantage.

If one looks at portraits and self-portraits over the centuries, many subjects do appear to have slightly divergent eyes. In 2004 two neurophysiologists described the appearance of exo-deviation in Rembrandt's self-portraits (see figs. 27.3 and 27.4) and concluded that this problem would have prevented the artist from having normal depth perception.[5] Another visual researcher came to similar conclusions,[6] as confirmed by portraits *of* Rembrandt made by fellow Dutch artists Ferdinand Bol (see fig. 27.5) and Gerrit Dou (also pupils of Rembrandt). However, Bol and Dou also painted self-portraits, many of which show exactly the same apparent deviation of the eyes (see fig. 27.6)! Thus, this manner of portraying the eyes may have been a convention of that era. We also are skeptical that Rembrandt had any ocular deviation for a variety of other reasons.[7] For example, when an artist looks at the image of one eye in a mirror, and then shifts the gaze to the other eye, the shift causes a bit more of the white of the eye to become apparent on one side of the nose or the other. The commentators above had looked at the amount of white showing around the pupils, while the most accurate indicator of eye direction is the light reflection from the cornea (called a light reflex) rather than the location of the pupil. If an artist paints this light reflection at the same position in both eyes, it gives some credence to the claim that the artist did not intend to show strabismus.

Perhaps the most critical factor in this type of analysis, which cannot easily be controlled, is the role of artistic license. Wide eyes have been considered noble at various times in history, and some great works of art depict grossly deviating eyes. For example, both Michelangelo's sculpture of David (see fig. 27.7) and El Greco's painting of St. Luke feature large divergences, perhaps for a combination of nobility and other reasons (e.g., for St. Luke to be looking up toward heaven, or to accommodate the difficulty in viewing Michelangelo's huge statue from below). It is unlikely that the historical David had strabismus,

as he would have had trouble aiming his slingshot with faulty depth perception. While it would be fatuous to argue that most portrait subjects have exo-deviation (which occurs in only about 1 percent of the population), it is not fatuous to recognize that artists can adjust their portraits to meet personal, aesthetic or social standards. It is easy to move the pupil slightly one way or the other, and even easier to adjust the location of the light reflex that shows the location of the light source. This factor is especially relevant in self-portraiture since an artist looking in a mirror can only fix his gaze on one eye at a time. As the gaze shifts from one eye to the other, the eyes move and the position of the light reflex can shift (depending on the direction of the light source). In other words, self-portraits cannot portray eye position and light reflexes with strict accuracy from mirror observation alone, and we suspect that these reflexes are often estimations by the artist, at the canvas, of how they *think* their eyes should look in the final image.

Furthermore, artists have often modified self-portraits to correct or hide facial abnormalities, including ones with the eyes. In his self-portraits, Barbieri, "the squinter," showed his eyes to be straight; and most of Dürer's later self-portraits do the same. These artists may not have wished to show themselves with abnormalities—perhaps analogous to the fact that there are few self-portraits with glasses. Just as the eyes must be imagined in paintings of historical or mythological subjects, the portraitist will typically finish details in the studio and can make the eyes conform to any desired standard of propriety or experience.

How about Rembrandt? Many of his self-portraits do seem to show a slight exo-deviation, but a fair number do not. Figures 27.3 and 27.4 are examples of gaze in different directions. How do you perceive the eyes? We have found that different observers see these portraits differently, because the appearance of straightness or divergence is dependent on which eye is perceived to be fixating and in which direction, something that is unclear in many portraits, including these examples, and

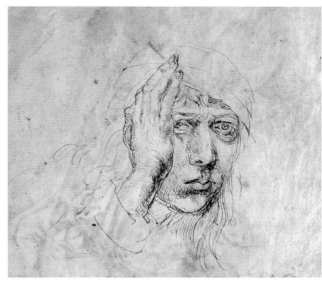

27.2

Fig. 27.1 Ottavio Leoni, *Portrait of Giovanni Francesco Barbieri, called Guercino*, 1623. Engraving, 5 ¼ x 4 ⁹/₁₆ in. (14.61 x 11.59 cm). In this portrait done by a friend, Barbieri shows a striking eso-deviation (in-turn) of his eyes. In Barbieri's self-portraits, however, the eyes are straight.

Fig. 27.2 Albrecht Dürer, *Self-Portrait Aged Twenty-One*, c 1492. Ink on paper, 8 x 8 in. (20.3 x 20.3 cm). This painting probably represents Dürer's image in a mirror: He holds his left hand over the deviating left eye, and fixates with the other.

Fig. 27.3 Rembrandt van Rijn, *Self-Portrait with Bare Head* (detail), 1633. Oil on canvas, 23 ½ x 18 ½ in. (60 x 47 cm). Ocular straightness is hard to judge in this early self-portrait, and depends on the presumed direction of the gaze (which can be influenced by non-ocular factors such as facial orientation as shown in figures 20.2 and 20.3). At first glance, the eyes may seem divergent.

Fig. 27.4 Rembrandt van Rijn, *Self-Portrait* (detail), 1659. Oil on canvas, 33 ¼ x 26 in. (84.5 x 66 cm). In this late self-portrait Rembrandt portrays himself looking in a different direction from that in his self-portrait from 1633 (see fig. 27.3). The eyes may appear either straight or divergent to a viewer, depending on where the viewer believes Rembrandt is looking.

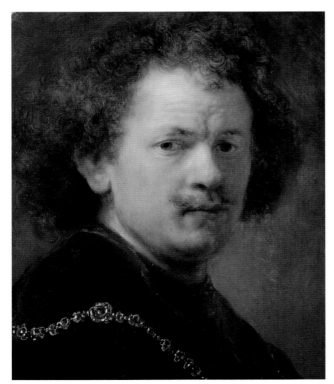

27.3

27.4

27.5

27.6

27.7

is biased by facial clues (as noted in chapter 20). Making such judgments from art is complicated in many paintings by poor delineation of the eyelids or light reflexes. We also do not know if Rembrandt intended to paint himself as if he were focusing on his mirror image, or as if he were focusing at a distance (as might be the case for many portrait subjects). This difference is critical, because a near gaze brings the pupils of the eyes together, while they move apart for distance. In many self-portraits Rembrandt's gaze is somewhat lateral which can make deviation hard to judge, even in photographs (see fig. 27.8), let alone in art. A lateral gaze also means that the artist must have painted the eyes from memory (or from a different model) since a mirror image *must* look directly back at the viewer. Finally, we do not know how Rembrandt wanted to portray himself to the world. He was a consummate artist and surely had the capability of adjusting his eyes to match whatever characteristic of portraiture he considered optimal. For all of these reasons, we are not convinced that he had any ocular deviation.

The Rembrandt Research Project (RRP)[8] has been evaluating Rembrandt's works for forty years and has published four massive volumes devoted to the artist, with more in the offing. No other artist's works have ever been subjected to this level of scrutiny and examination. The RRP warns us to be careful in the analysis of Rembrandt's features. The most recent volume, which was published after the report by the neurophysiologists appeared, states: "Rembrandt apparently had difficulty in achieving a convincing likeness in his self-portraits." There are "remarkable differences" in facial features of the self-portraits

that the committee considers to be authentic, "in particular there are major differences in the way the eyes are painted." The RRP notes that some of the differences in his depictions are due to how complete the portraits are, what damage may have occurred during the three-hundred-plus years since their creation, and the effects of restoration.

Look at portraits and self-portraits the next time you are in a gallery or museum. We have not done any controlled study (and that is almost impossible, since there are many different artists painting with different purposes), but we have the strong impression that there is a tendency for a moderate percentage of the eyes to appear slightly divergent at first glance. This is especially evident when the subject is looking off into the distance or to the side, although you may be able to vary the appearance by imagining one or the other eye as fixing the direction of gaze. However, it is unreasonable to assume that a high percentage of either artists or subjects had strabismus, given the low incidence of this condition.

We noted earlier the powerful influence of facial cues and orientation as a confounding factor in judging eye position (see chapter 20). A portrait may appear to gaze toward one side or the other with identical representation of the eyes (see fig. 20.4). Conversely, the straightness of the eyes in such pictures will be judged differently according to where we think the eyes are looking (since the amount of white showing may be more or less appropriate). Studies have shown that even experienced observers require a moderate ocular deviation before strabismus can be reliably recognized.[9] Unless all of these factors are taken into account, estimations of an artist's ocular straightness from portraits or self-portraits will be hazardous.

We offer a photographic demonstration to further illustrate that the visual impressions of divergent gaze are not always evidence of ocular misalignment, except in severe cases (see fig. 27.8). From certain vantage points, the eyes of a normal person can appear quite divergent. Look at figure 27.8a, which mimics the gaze of many portraits by and of Rembrandt (e.g., figures 27.3–27.5), and ask yourself whether you would call the eyes straight or deviated. They may also seem divergent in figure 27.8b, where the gaze is to the other side. However, figure 27.8c (looking straight ahead) shows that the subject does *not* have strabismus (confirmed by ophthalmic examination). The varying straightness of the eyes in these images is an artifact of eye and head position relative to the camera. If photographs can lie, then surely we need extreme caution in interpreting paintings, in which the image is less clear and the artist may have added interpretation.

NOTES

1. Linksz, *An Ophthalmologist Looks at Art* (1980).
2. Trevor-Roper, *The World Through Blunted Sight* (1988).
3. Lanthony, *An Eye for Painting* (2006).
4. Livingstone and Conway, "Was Rembrandt Stereoblind?" (2004).
5. Ibid.
6. Weale, "Painters and Their Eyes: Age and Other Handicaps" (2006).
7. Marmor and Shaikh. Response to "Was Rembrandt Stereoblind?" (2005).
8. van de Wetering, Ernst, ed. *A Corpus of Rembrandt Paintings*, vol. 4, *The Self-Portraits* (2005), pp. xxix, 94, 96, 139, 211.
9. Larson, Keech, and Verdick, "The Threshold for the Detection of Strabismus" (2003).

Fig. 27.5 Ferdinand Bol, *Rembrandt van Rijn*, 1640. Chalk, pen and ink, brush and wash on sheet trimmed with gold paper, 7 1/4 x 5 3/16 in. (18.2 x 13.2 cm). While Rembrandt may appear to have divergent eyes in this portrait, Bol depicts himself in exactly the same way in his *Self-Portrait* (see fig. 27.6).

Fig. 27.6 Ferdinand Bol, *Self-Portrait*, 1647. Black crayon and gray wash, 6 1/4 x 5 in. (16 x 13.2 cm). The eye positions in this self-portrait are the same as in Bol's portrait of Rembrandt (see fig. 27.5), suggesting that this head and gaze position may have been a stylistic convention of their time.

Fig. 27.7 Michelangelo Buonarroti, *David* (detail), 1501–04. Marble, post-restoration, height 204 in. (518 cm). David's eyes are quite divergent, presumably for stylistic reasons and to accommodate viewing the sculpture from below.

Fig. 27.8 Photographs of an individual with straight eyes. (Light reflexes have been minimized as they are not always visible or necessarily realistic in painted portraits.) **(a)** Head turn and gaze in a similar direction as portraits of Rembrandt's era. The right eye may seem divergent (although it is not). **(b)** Looking to the other side. In this image the left eye may appear to be divergent. **(c)** Head and gaze forward. The eyes appear to be straight.

27.8 a

27.8 b

27.8 c

CATARACTS AND THE ARTIST: CARRIERA, MARTIN, AND OTHERS

I n this section we consider lens changes that have gone beyond the stage of an accompaniment to aging (see chapter 23), and have begun to interfere seriously with vision. As cataracts of any type become dense enough to impair visual acuity or confound color discrimination, they compromise the artist's craft. It becomes harder to see the subjects of a painting, but of equal or even greater importance, it becomes harder to judge (or refine) what is being laid on the canvas. An artist with severe cataracts may have a mental image of the scene to be painted, and can choose tubes of paint by name; but he or she cannot see accurately what is on the easel.

Prior to the 1700s, when cataracts could not be treated except by the rather crude and infrequently successful technique of couching, which is discussed later in this chapter, there must have been artists forced to give up painting because of this disease. The earliest documentation of cataract surgery upon artists comes from chronicles in the Renaissance. In Europe, the artist Antonio Verrio (1639–1707) was said to have undergone treatment of cataracts, but the result was blindness.[1] The eyesight of a contemporary of his, Fernando Galli-Bibiena (1656–1743), was said to have improved after treatment.

ROSALBA CARRIERA (1675-1757)

A painter whose saga with surgery has been well documented is Rosalba Carriera (see fig. 28.1). The "divine Rosalba" was a complex individual who strongly influenced the style of her contemporaries.[2] Early in her career she helped develop the Rococo style, which is characterized by the delicate, graceful forms and lighthearted, sometimes erotic, subject matter reflected in *Spring* (see fig. 28.2). (Later in life she became a pious spinster.) By 1705 Carriera was one of the most famous artists in Europe, and was made a member of the Academy in Rome, an honor for anyone, but especially for a woman working in a field dominated by men. Royalty of several European countries commissioned her to create portraits, and she had more work than she could complete in her lifetime. However, near 1721, when she was forty-six, she began to notice that her vision was failing. Perhaps initially this development was just the onset of presbyopia, the difficulty with near vision that begins in the fifth decade of life for most people. But her loss

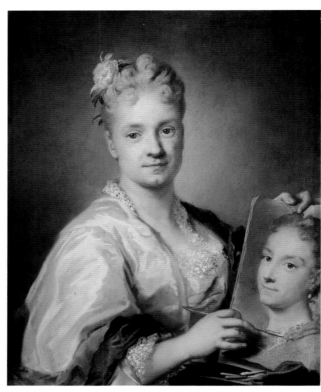

28.1

of vision became severe in 1726, and at age fifty-one, she was diagnosed with cataracts.

Cataract surgery was undergoing a great revolution around this time. Previously, cataracts were displaced ("couched," i.e., were pushed out of the pupillary opening) or disrupted *within* the eye, by quickly inserting a needle and manipulating the lens). However, lens fragments often persisted in the visual path, and many eyes succumbed to inflammation or infection as a result. Dr. Jacques Daviel (1696–1762), a physician working in France, performed the first planned surgical *removal* of a cataract (i.e., taking it *out* of the eye) in 1748.[3] Daviel's remarkable innovation was an important step toward modern technique. However, Carriera's surgery was performed with the older technique of couching. When it worked, the procedure had definite advantages. The eye was punctured with a small needle, a process that was not very painful, in contrast to Daviel's method, which required a large opening be made with scissors. The size of the incision was important since no topical or general anesthetic agents were available other than applications of ice, alcoholic beverages, and swallowed or smoked hashish. In about 1746, Carriera's right eye was operated on by a professor from Padua, whose name is not known. The surgery was followed by severe inflammation, and she never recovered useful vision in that eye. Her left eye was operated on in 1749 by Dr. Giano Reghellini (1710–1772), a prominent physician and surgeon in Venice. Unfortunately, this procedure was also unsuccessful. Reghellini was a friend of the famous adventurer, author, and womanizer Giacomo Casanova (1725–1798), and he is mentioned in Casanova's memoirs.[4] Fifteen years after he operated on Carriera, Reghellini published a book concerning noteworthy cases, *Osservazioni sopra alcuni casi rari medici, e chirurgici* (1764). It includes interesting commentary about Carriera and sheds light on the status of cataract surgery at that time. Rhighellini was aware of Daviel's method

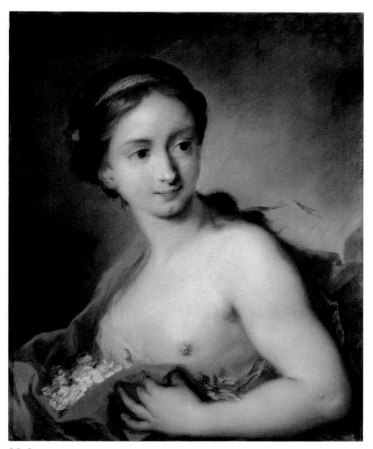

Fig. 28.1 Rosalba Carriera, *Self-Portrait Holding Portrait of Her Sister*, 1715. Pastel on paper, 28 x 22 ½ in. (71 x 57 cm). The artist near age forty.

Fig. 28.2 Rosalba Carriera, *Spring*, c. 1720. Pastel on paper, 21 x 16 ¾ in. (53 x 42.5 cm). This pastel is typical of Carriera's style before she developed cataracts. She stopped painting when her vision failed.

28.2

point was excellent, and if her failing vision compromised her work, the changes are subtle and certainly not obvious to us. Her colors remained true and delicate as did her rendering of fine details, such as strands of hair. This observation might suggest the sudden onset of a complicated type of cataract, perhaps secondary to glaucoma or an inflammatory process (as hinted at by her doctor), as she stopped painting abruptly, when she could not produce work that met her standards.

CHANGES IN COLOR AND STYLE

In the 1800s, we know of a few artists who underwent cataract surgery, but little about the effects on their art. Claude François Devosge (c. 1732–1811) apparently did well. Honoré Daumier (1808–1879), who had cataract surgery at age seventy, suffered from a stroke shortly thereafter, which made painting impossible. One might comment on his brownish and relatively colorless paintings, except that he worked in that style for many years as an outgrowth of his youthful success with drawing and caricature. Mary Cassatt and Claude Monet had cataract surgery with different degrees of success (see chapters 29 and 30).

Much of the discussion of the effects of cataracts on art has centered on the possible differences in color perception or color usage (see also chapters 23 and 38). There is a well-known tendency among older artists to paint in a freer style and sometimes to use less intense or varied colors. Are these stylistic shifts indicative of, or caused by, cataracts? J. M. W. Turner used a great deal of yellow in many of his impressionistic scenes, e.g., *Mortlake Terrace* (see fig. 9.4), but he painted in this style without major change over many years (he lived almost twenty-five years after *Mortlake Terrace*), which would have been unlikely if cataracts were progressing. And even very late works contain points of detail and color that would have been impossible to see with a dense cataract (see chapter 9). Claude Monet used stronger colors, not muted browns, as his cataracts grew (see chapter 30). Rembrandt's late works are not known for vivid color, and some of the yellowing in them may be due to aging varnish. There is an increasing looseness in Rembrandt's works as he aged, which is consistent with, but not diagnostic of, the development of cataracts. We analyze Rembrandt's work in more detail in chapter 25. It is not improbable that the elderly Rembrandt, Titian, or other older artists had some degree of cataract. The problem is that we don't know for sure who did, or to how severe a degree. And many of these artists painted in a consistent, fluid style or with impasto (rough applications of paint) over decades or more, while a significant cataract would tend to get worse and result in an obvious progression of stylistic change.

Some have speculated that the last works of Georges Rouault (1871–1958) show a shift in colors suggestive of cataract.[8] For example, *Holy Face* (*Copper Harmony*) (see fig. 28.3), made when he was in his eighties, reveals an overall reddish-yellow tone and is constructed with rough strokes of paint. However, Rouault never painted in much detail and often used strong colors to connote feelings, so that comparisons to paintings from different periods of his life, such as *Pierrot with a Rose* (see fig. 28.4) are difficult and not so convincing. Failing vision may have contributed to the unusually coarse brushstrokes in the last few years of his life, but his paintings were never delicate and he always used warm and primary colors. He is also modern enough that

and criticized it for "leading to numerous failures." He described Carriera's surgery as difficult and unusual. He wrote: "Before removing the needle I saw behind the pupil certain greenish filaments shaped like an *h*, which I pressed, but they seemed ominous, leaving me with the likelihood that others would form and cloud the sight of this lady . . . If the cataract in the left eye was similar to that in the right, it is now evident why the eminent professor in Padua decided against operating on it."[5]

Soon after the surgery to her left eye, Carriera sent a letter to a friend in France, although it is likely that someone else did the actual writing: "For three years I have been deprived of my sight. I wish you to learn from my own that thanks to the Divine Goodness I have recovered it. I see but as one sees after an operation, that is to say very dimly. Even this is a blessing for one who has had the misfortune to become blind."[6] But Carriera's eyesight worsened, and she underwent another procedure. After this surgery she said: "I am entirely deprived of sight. I do not see any more than if I were plunged into the darkness of night."[7]

Carriera continued to draw pastel portraits that can be dated until 1746, the year of her surgery. Her technique up to this

28.3

28.4

Fig. 28.3 Georges Rouault, *Holy Face (Copper Harmony)*, c. 1953. Oil, crayon, and gouache on paper, 12 x 8 in. (30.8 x 20.6 cm). This late work features rough application of paint and strange tonality.

Fig. 28.4 Georges Rouault, *Pierrot with a Rose*, c. 1936. Oil on canvas, 36 ¹/₂ x 24 ³/₁₆ in. (92.7 x 61.7 cm). This mid-career painting shows more precise brushstrokes than the later *Holy Face (Copper Harmony)* (see fig. 28.3) but is similar in concept and general color scheme.

one might have expected some documentation of cataract in biographical or historical material, and that is lacking. He may be a better example of why retrospective (and undocumented) diagnosis is problematic than of cataract effects.

As cataract surgery improved in the 1800s and became relatively routine in the 1900s, visual loss from routine age-related cataracts was no longer a serious, or at least a persistent, reason for painters to alter their style or to stop painting. We see a dramatic example of cataract effects in Monet's late works prior to surgery, only because he was fearful of the operation and put it off for many years during which he struggled to paint (see chapters 30 and 38). However, cataract surgery was much less successful when the cataracts were compounded by other ocular or systemic disease, which could cause persistent inflammation, glaucoma, and other complications. Cassatt (see chapter 29) probably had cataracts associated with inflammation within the eye, possibly associated with diabetic disease. James Thurber (see chapter 32) had a cataract associated with deep "sympathetic" inflammation in his only good eye (the other was lost in a childhood injury).

HOMER DODGE MARTIN (1836–1897)

The American landscape painter Homer Dodge Martin had cataracts that were but a part of a complex set of ocular difficulties. Although Martin is not well known by the public today, his paintings were avidly sought at the beginning of the twentieth century. He is considered a transitional artist who links two important nineteenth-century schools of painting: the Hudson River artists who were active during the first half of the century and the American Impressionists who followed.[9] Early works,

such as *A North Woods Lake* (see fig. 28.5) fit into the former style, but his mature style, reflected in works after the late 1870s, such as *Wild Coast, Newport* (see fig. 28.6) and *View on the Seine: Harp of the Winds* (see fig. 28.7), is Impressionistic, although not as free as Monet's.

Martin was able to paint well despite several ocular problems. At the beginning of the Civil War, while in his mid-twenties, he was rejected for military service due to poor eyesight. In his forties he developed additional eye problems, cataracts and optic nerve disease, yet he still managed to create a body of work that maintained consistent style and quality. Estimating the effect of Martin's failing eyesight on his paintings is difficult. The American paintings catalogue of the Metropolitan Museum of Art describes one of his best known works (done after cataracts were evident), *View on the Seine: Harp of the Winds*, as follows: "Martin's poor eyesight may account for the passages of awkward and undisciplined brushwork as well as the enormous size of the poplars."[10] The early onset of his cataracts (in association with other ocular disease) is in contrast to Monet's cataracts, which were not diagnosed until his eighth decade. Chronic age-related cataracts become progressively brownish, and difficulties with color vision are likely to be the greatest problem for an affected artist. Early disease-associated cataracts, as Martin seems likely to have had, are often whitish and primarily cause blur; depending on the cause, they may stabilize or change minimally over many years.

Martin's family members have said the artist's vision was never particularly good. And according to a family legend, something unusual about his vision kept him from being able to draw a straight line. Although he was still able to paint well, his penmanship in letters he wrote in the 1880s is nearly inde-

Fig. 28.5 Homer Dodge Martin, *A North Woods Lake*, 1867. Oil on canvas, 18 ⅛ x 32 in. (46 x 81.3 cm). This painting was done in the Hudson River style.

Fig. 28.6 Homer Dodge Martin, *Wild Coast, Newport*, c. 1885–95. Oil on canvas, 15 x 24 in. (38.1 x 61.1 cm). Martin's later painting is often described as American Impressionism.

Fig. 28.7 Homer Dodge Martin, *View on the Seine: Harp of the Winds*, 1893–95. Oil on canvas, 28 ¾ x 40 ¾ in. (73 x 103.5 cm). This late work was finished in the studio from a study done a decade earlier.

28.5

cipherable. In several he complains of difficulties seeing. In one he states: "I must stop now for my eyes are tired; I write such a fiendish hand I fear you can't make out all I say."[11] In another he complains, "My eyes are getting tired and I must stop."[12] Occasionally, Martin would blame his visual difficulties on his working conditions, stating he needed "better light to paint in."[13]

Despite his poor vision Martin never underwent cataract surgery, and he was able to complete several paintings at the end of his life that are now considered among his best works. Like *View on the Seine: Harp of the Winds* (see fig. 28.7), they were painted in his studio but based on sketches he had made in France a decade earlier. He and his wife summed up his achievements at about this time. While looking at one of his paintings, which was on display at the Century Club in New York, she said: "Homer, if you never paint another stroke, you will go out in a blaze of glory!" He replied: "I have learned to paint, at last!" and continued: "If I were quite blind now, and knew just where the colors were on my palette, I could express myself."[14]

28.6

NOTES

1. Trevor-Roper, *The World Through Blunted Sight* (1988), pp. 94–95.
2. West, "Gender and Internationalism: The Case of Rosalba Carriera," in *Italian Culture in Northern Europe in the Eighteenth Century* (1999), p. 53.
3. Daviel, Letter. *Mercure de France* (1748) and *Sur une Nouvelle method de guerir la cataracte par l'extraction du crystalline* (1753). In *The History of Ophthalmology* (1984), edited by Julius Hirschberg and translated by Frederick C. Blodi, vol. 3, pp. 158–211.
4. Casanova, *History of My Life*. Translation (1969), vol 1, pp. 164 and 335.
5. Rhigellini. *Osservazioni sopra alcuni casi rari medici, e chirurgici* (1764), pp. 100–104.
6. Blashfield, "Rosalba Carriera," in *Portraits and Backgrounds* (1917), pp. 486–487.
7. Ibid., pp. 487–488.
8. Trevor-Roper, *The World Through Blunted Sight* (1988), pp. 94–95.
9. Mandel, "Homer Dodge Martin: American Landscape Painter 1836–1897" (PhD diss., New York University, 1973), p. 252.
10. Spassky. *American Paintings in the Metropolitan Museum of Art* (1985), vol 2, p. 425.
11. Mandel, "Homer Dodge Martin: American Landscape Painter 1836–1897" (PhD diss., New York University, 1973), p. 148.
12. Ibid., p. 175.
13. Ibid., p. 177.
14. Martin, *Homer Martin: A Reminiscence* (1904), p. 49.

28.7

CATARACTS, DIABETES, AND RADIUM: THE CASE OF CASSATT

29.1

Mary Cassatt (1844–1926) (see fig. 29.1) is the only American artist who exhibited with the Impressionists, and she did so at four of their eight shows. Her accomplishments are extraordinary for a woman of the nineteenth century, when traditionally women were expected to remain close to home and occupied with household duties. She studied at the Pennsylvania Academy of Fine Arts in Philadelphia for four years, and during the American Civil War she pursued further study in Europe. Her father was not pleased by her choice to travel abroad alone and exclaimed: "I would almost rather see you dead."[1] She would have liked to study at the official French school, the École des Beaux-Arts, but at that time women were not admitted there as students, due to restrictions on working from nude models. Instead, she studied privately with highly respected artists who also taught at the École, and she learned much from visiting the Louvre.

Cassatt found the artistic environment in Europe especially encouraging and spent most of the rest of her life in France. By age twenty-four she had achieved success in the French art establishment by having her paintings accepted several times to the Salon. The Salon, an important annual exhibition, was a fixture in Paris for more than two hundred years. Originally sponsored by the government, it was under the control of academic artists by the time Cassatt participated. By the late nineteenth century, it had become a conservative, inbred institution and frequently rejected work by avant-garde artists, including the Impressionists. Beginning in 1874, the Impressionists held their own exhibitions. Cassatt became particularly friendly with one of them, Edgar Degas, who encouraged her to stop sending her work to the Salon. She found Degas' concepts to her liking, particularly when one of her paintings was rejected by the Salon jury for being "unfinished," this after four years of her paintings being accepted. She willingly joined the Impressionists, whom she found more egalitarian than the Salon system, with its juries and awards.

Cassatt is classified as an Impressionist but her work differs from the other Impressionists in several ways. Furthermore, she preferred to be considered an independent rather than an Impressionist, due to the original derogatory connotations of the term *impressionism*. Most of her works are portraits, such as *Woman with a Pearl Necklace in a Loge* (see fig. 29.2), and indoor scenes as opposed to landscapes. She was not concerned with depicting the variable effects of sunlight characteristic of Monet, nor did she use the fragmented brushstrokes typical of his and Pissarro's paintings. She worked in both oil and pastel, and limited herself to the more forgiving medium of pastel when poor vision became a problem. The witty and sarcastic Degas admired her ability: "I am not willing to admit that a woman can draw that well."[2] She achieved recognition early in Europe but remained relatively unknown in America; many years would pass before she was recognized as a significant artist in her native country. When she returned to Philadelphia in 1898 after spending several decades in France, a local newspaper carried this casual note in the society column: "Mary Cassatt, sister of Mr. Cassatt, president of the Pennsylvania Railroad, returned from Europe yesterday. She has been studying painting in France, and owns the smallest Pekingese dog in the world."[3]

CASSATT'S CATARACTS

Cassatt was born in 1844 in what is now Pittsburgh and died in 1926 at her chateau in northern France. She first experienced visual problems in the early twentieth century but available information does not allow us to pinpoint the date. Cataracts were diagnosed by 1912 when she was sixty-eight years of age. In 1913 she consulted Edmond Landolt, MD, the distinguished French ophthalmologist who also cared for Degas. Unfortunately, his records no longer exist. By 1915, during World War I, poor vision forced her to stop creating artwork altogether. Her late pastels became less refined and do not feature the smooth texture of earlier portraits. Her mature pastels ranged from extreme delicacy in works such as *Mother Feeding Child* (see fig. 29.3) to works in which the faces are precise but the rest of the drawing is "roughed in," such as in *Mother and Child* (see fig. 29.4). In the last few years before she stopped painting, even

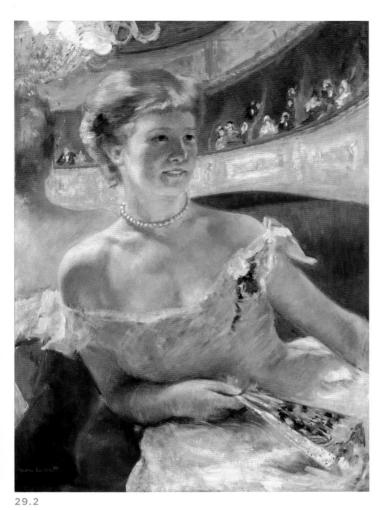

29.2

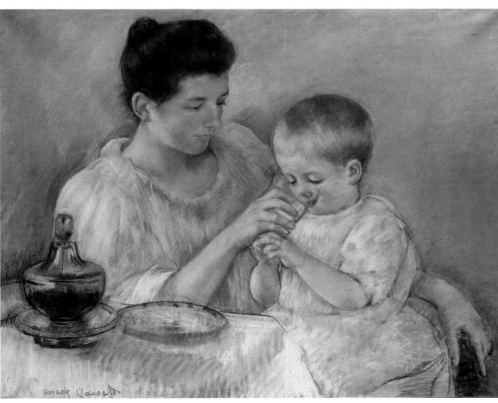

29.3

the faces lost some of their delicacy, such as in *Mother and Child* (see fig. 29.5).

Cassatt's visual problems reached a climax during the war, when few physicians were available to treat civilians. She found a capable ophthalmologist in Paris, Louis Borsch, MD, who treated other well-known individuals, including the Irish author James Joyce. In 1917 Borsch performed cataract surgery on her right eye. Following the procedure, she developed an opacity of the posterior lens capsule, so Borsch made an opening in the capsule surgically. In 1919 he operated on the cataract in her left eye, but her vision in both eyes remained poor for reasons which remain unknown. As she continued to age, other health problems became major issues—diabetes, hypertension, and arthritis; however, the relationship of these other medical issues to her poor vision is speculative.

Cassatt's correspondence reveals crucial information about her declining eyesight as well as her interpretation of what was occurring. She wrote many letters to Louisine Havemeyer, a good friend who became an important donor to the Metropolitan Museum of Art in New York. On July 16, 1913, she wrote: "My eyes have been greatly changed, my eyesight disturbed by incessant motoring in the south . . . My eyes, which have always been my strong point, are troubling me. If only I was sure of a good oculist, but Dr. Whitman [her family physician] is again away. I don't know for how long."[4] The term *oculist*, now obsolete, describes a physician who specializes in diseases of the eye. In the early twentieth century, some oculists were not well trained and did not do surgery. Other medical specialists in eye care preferred to call themselves ophthalmologists, and this word, despite its more difficult spelling, is still in use today.

In a telegram dated August 21, 1915, from Paris, Cassatt

Fig. 29.1 Edgar Degas, *Portrait of Mary Cassatt*, c. 1880–84. Oil on canvas, 28 ⅛ x 23 ⅛ in. (71.4 x 58.7 cm). Cassatt as depicted by her fellow Impressionist Edgar Degas.

Fig. 29.2 Mary Cassatt, *Woman with a Pearl Necklace in a Loge*, 1879. Oil on canvas, 32 x 23 ½ in. (81.3 x 59.7 cm). Most of Cassatt's subjects are women and children.

Fig. 29.3 Mary Cassatt, *Mother Feeding Child*, 1898. Pastel on wove paper, mounted on canvas, 25 ½ x 32 in. (64.8 x 81.3 cm). Cassatt's pastel technique could be very refined and delicate.

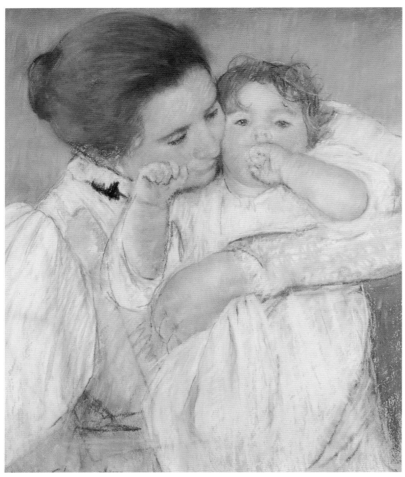

29.4

sight in that eye! The cataract over the left eye, which is the eye in which depends my hope of future sight, is not nearly ripe or I could not write you this. I do not believe it will be ripe this year."[9] Her poor result was unfortunate and contrasts with the case of Claude Monet, who also underwent cataract surgery in 1923 to his right eye with very good visual acuity following. Later in 1919 Cassatt's other eye was operated on for cataract. In a letter dated November 14, 1919, she wrote: "The operation was done on October 22 . . . The operation was a very daring one as the cataract was not ripe but he staked his reputation on the result. He is the only man in Paris capable of doing such an operation and I am told few anywhere in the US . . . I must write only a little with one eye as I did before as the cotton is over the other still, and I must not use the other much."[10] But surgery done to Cassatt's left eye also did not produce the desired result, for on March 28, 1920, she wrote: "I am old and so blind that I don't feel up to much . . . I see less with the eye that was operated in October than I did with the one with a secondary cataract in it!"[11]

By this time, her other health issues had become critical. In 1911 she had gone on a vacation to Egypt with her brother Gardner and his family. Many of their party became seriously ill on the trip. Her brother died soon after they returned to Paris; the cause was said to be "Nile fever." Mary lost twenty pounds during this vacation and carried less than one hundred pounds on her 5' 6" frame after the travel was over. She advocated many forms of alternative medical therapy she had learned about through reading popular literature, including camphor, carbolic acid (phenol) smoke balls, and morning dew.[12] She described receiving a curious form of treatment in 1911, the same year as the fateful Egyptian venture: "I am at the doctor's taking inhalations of radium. This is the eighth day, and I am suffering very much, which it seems would prove that it is doing me good, that it will be a success, provided I can stand it."[13] Which aspect of Cassatt's health was being treated in this manner is not clear. We know that her diabetes was diagnosed about this time and that cataracts were present by 1912. Insulin was not described as useful in treating diabetes until 1920 and effective oral agents came much later. Radiation therapy was attempted for many diseases at that time, even for cataracts. Two articles published in 1920 gave anecdotal evidence that radiation might improve cataracts.[14] Today, of course, we know that the opposite is true: Radiation of the lens will opacify it, *creating* a cataract, and furthermore, radiation can damage blood vessels in the retina and lead to progressive damage and visual loss. We do not know if radiation was used to treat Cassatt's cataracts, or if any radiation retinopathy contributed to her visual problems. However, Paris was an early center for study of radiation and its use therapeutically. Marie Curie, the esteemed Nobel Prize winner and pioneer of the study of radium in Paris, also developed cataracts; and it is quite likely that her cataracts were a result of her work. Like Cassatt, Curie underwent bilateral cataract surgery.

EFFECTS ON HER ART

Although we know that Cassatt had cataracts and failing vision, and that she stopped painting as a result, it is not easy to discern changes in her style. Indeed, the difficulty in recognizing effects on her art highlights some of the challenges one faces and cautions one must observe in analyzing art in terms of eye

wrote: "Am here care of oculist. Must not read or write."[5] In another telegram dated September 8, 1915, she stated: "Sick eyes. Iritis with adhesion under treatment. Famous ophthalmologist if he succeeds. Operation to be necessary."[6] Her description of "iritis with adhesion" (inflammation and scarring within the eye) indicates that her case was a complicated one and that the cataracts were not the type typical of the elderly. It may also be the reason for her poor result after surgery, since complicated cataracts may be associated with retinal disease or other inflammation within the eye that prevents clear vision despite a well-performed surgical operation.

In an undated letter from about July 1916, Cassatt reported: "Dr. Borsch [is] treating my eyes, which keeps up hope, he still maintains though that I shall see to work, but I do not believe it."[7] Her right eye was operated in October 1917. In a letter dated December 28, 1917, she revealed: "I am nearer despair than I ever was. Operating on my right eye before the cataract was ripe is the last drop. I asked Borsch if it was ripe and he assured me that it was! The sight of that eye is inferior but still I saw a good deal in spite of the cataract. Now I see scarcely at all."[8] At that time many ophthalmologists did not like to operate on cataracts that were not mature (i.e., totally opaque), since doing so risked greater complications.

The following year, on July 13, 1918, Cassatt wrote: "The operation which was made in October and was followed by so long a treatment was a complete failure and ought not to have been attempted, if only it has not injured what there was of

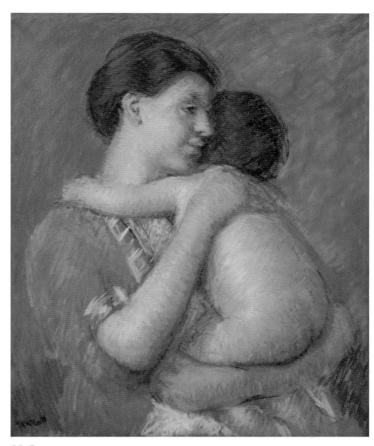

Fig. 29.4 Mary Cassatt, *Mother and Child*, 1897. Pastel on paper, 21 × 18 in. (53 × 45 cm). In many of her pastels, Cassatt mixed delicate treatment of faces with rough framing of the background scene.

Fig. 29.5 Mary Cassatt, *Mother and Child*, 1914. Pastel on wove paper, mounted on canvas, 26 ⅝ × 22 ½ in. (67.6 × 57.2 cm). In this pastel, one of Cassatt's last, she maintained the warmth of the scene but drew the face with less precision and subtlety.

29.5

disease or visual loss. As Cassatt's cataracts advanced during the second decade of the twentieth century, she became unable to paint in the finely detailed manner of her previous years. But she worked for decades with pastels, which do not require the sharp acuity of oil paints. Cassatt created many pastels with exquisite delicacy (see fig. 29.3), but others were more free in the application of pigment (see fig. 29.4). After 1912, as her vision became compromised, she used pastel exclusively. Her very late works (see fig. 29.5), still resemble earlier examples, but lack precise and delicate facial details. She ceased painting when she felt she could no longer maintain her usual style, so we do not find huge drawings or extremely rough images as we do with Degas' last pastels (see chapter 35). In essence, Cassatt's failing vision limited her to a single component of her style, that is, less detail—rather than forcing a new one—before she was forced to withdraw from art.

Deeply embittered, depressed, and disappointed by her ocular problems, Cassatt stopped all artistic production after 1915, and by 1918 she was unable to read. The loss of vision shortened her career by a dozen years. She died at age eighty-one in 1926, the same year that Monet died. Cassatt was a remarkable individual. In an era when most women stayed close to home, she traveled across the Atlantic to earn fame in Europe. Degas said of her work: "That is genuine. That is one who does as I do."[15] Her art is beloved today, with its combination of skillful drawing, forms simplified by Asian influence, tender subjects, and bright Impressionist colors.

NOTES

1. Hale, *Mary Cassatt: A Biography of the Great American Painter* (1975), p. 31.
2. Ibid., p 193.
3. Sweet, *Miss Mary Cassatt: Impressionist from Pennsylvania* (1966), p. 150.
4. Cassatt correspondence, Metropolitan Museum of Art, New York, NY, and the National Gallery of Art, Washington, DC.
5. Ibid.
6. Ibid.
7. Ibid.
8. Ibid.
9. Ibid.
10. Ibid.
11. Ibid.
12. Mathews, *Mary Cassatt: A Life* (1994), p. 272.
13. Hale, *Mary Cassatt: A Biography of the Great American Painter* (1975), p. 244.
14. Franklin and Cordes, "Radium for Cataract" (1920); Levin, "The Technic of Radium Application in Cataracts" (1920).
15. Bullard, *Mary Cassatt: Oils and Pastels* (1972), p. 13.

30

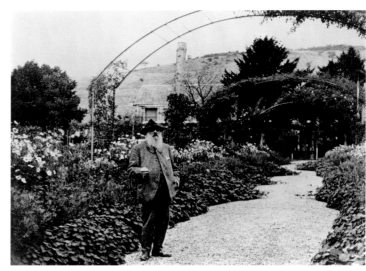

30.1

CATARACTS, SURGERY, AND COLOR: THE CASE OF MONET

Claude Monet (1840–1926) was the quintessential Impressionist, and his 1872 painting *Impression: Sunrise, Le Havre* (see fig. 8.17) gave Impressionism its name. He lived to the ripe old age of eighty-six (see fig. 30.1) and died in 1926, well past the height of the Impressionist movement (the eight Impressionist exhibitions were held between 1874 and 1886). There is a distinct difference between Monet's paintings of the 1870s and 1880s and his paintings from World War I to the end of his life. His cataracts are known to have been present by 1912, and there certainly is a temporal correlation between his cataract problem and his shifts in style. The changes occurred slowly, but there can be no mistaking the late works: Many depict the world in broad swirls and splashes of color, and when viewed up close, the forms within them seem to dissipate. For this reason Monet's late paintings are often considered a link to artistic movements that followed, and particularly to Abstract Expressionism. The paintings of Jackson Pollock and Willem de Kooning seem almost to be part of a natural evolution from the late canvases of Monet—but Monet's intentions were, in fact, very different.

Cézanne once quipped: "Monet is only an eye, but what an eye."[1] Monet's close friend, the French statesman and physician Georges Clemenceau described how Monet's vision differed from his own: "We do not see things in anything like the same manner. I open my eyes and I see forms, shades of color which I take, until disproved, for the passing aspect of things as they are. My eye stops at the reflecting surface and goes no deeper. With you, it is entirely different. The steel of your eyesight breaks the crust of appearances, and you penetrate the inner substance of things in order to decompose it into projectors of lights which you recompose with the brush, so that you may reestablish subtly upon our retinas the effects of sensations in their fullest intensity. And while I, looking at a tree, see nothing but a tree, you . . . eyes half closed, think to yourself, 'How many tones of how many colors are there in the gradations of light on this simple trunk?'"[2]

What happened, then, toward the end of Monet's career? The problem was that his cataracts caused not only blur but a severe loss of color discrimination, so that the artist was no longer able to make those subtle and critical color distinctions upon which Clemenceau had commented. The artist was forced to compensate for these profound changes in his vision, and the results are evident in his late paintings.

TRANSITIONS AFTER REACHING THE AGE OF FIFTY

By 1890 Monet had lived half a century and was working toward the ambitious goal of creating several paintings in series. Throughout the day, as lighting conditions changed, he would move from canvas to canvas, a process that allowed him to present the same subject under a variety of light and atmospheric conditions. These series paintings include some of his best-known themes: the haystacks, poplars, and Rouen cathedral.

In 1890 Monet's eyes were not yet giving him the problems he was to develop during the first decade of the twentieth century. The difficulties he encountered with his work at this time were not ocular. Rather, he was struggling with the problem of motivation. In July 1890 he wrote: "I am feeling very low and profoundly disgusted with painting. It is nothing but constant torture! Don't expect to see any new works; the little I have managed to do is destroyed, scraped off, or staved in."[3] A few years later, as he approached the age of sixty, Monet reminisced: "What I do know is, that life with me has been a hard struggle, not for myself alone, but for my friends as well. And the longer I live and the more I realize how difficult a thing painting is, and in one's defeat he must patiently strive on."[4] Self-confidence was never Monet's strength, but fortunately, he was able to count on family and friends for encouragement. His wife, Alice, his stepdaughter Blanche (who was also his daughter-in-law), and Clemenceau were reliable supports for him as he aged. Near the turn of the twentieth century he produced some of his most endearing images of his lily pond, Japanese bridge, and garden at Giverny, such as *A Pathway in Monet's Garden, Giverny* (see fig. 30.2).

Monet's eyesight became a problem early in the new century, and by 1908 he was aware of his diminished vision. During a painting expedition to Venice in that year, he encountered difficulty in handling colors. He may have relied on others for help in choosing pigments, for the problem of color is not noticeable in the canvases he produced at that time, although his depiction of space and depth in some of the Venetian scenes is not particularly skillful. An article about the artist, published in 1908, described his struggles in sad terms: "Partly because of overstrain, partly because of dissatisfaction, M. Monet became extremely irritable and morose, and at last actually cut a few of his canvases to shreds."[5]

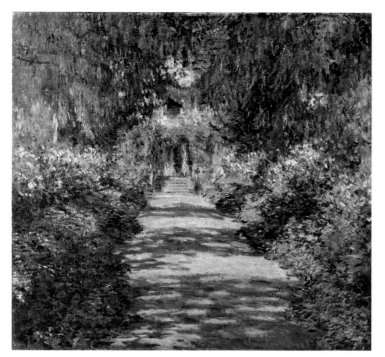

30.2

30.3

Fig. 30.1 Photograph of Claude Monet in his garden at Giverny, c. 1925. The elderly Monet is wearing a broad-brimmed hat and tinted glasses as protection from the sun. He holds a cigarette, one cause of the pulmonary diseases that ended his life.

Fig. 30.2 Claude Monet, *A Pathway in Monet's Garden, Giverny*, 1902. Oil on canvas, 35 x 36 ¼ in. (89 x 92 cm). This painting depicts the same scene shown in figure 30.1.

Fig. 30.3 Claude Monet, *The Rose Path, Giverny*, 1920–22. Oil on canvas, 35 x 19 ⅜ in. (89 x 100 cm). In this late painting of a similar view, the application of paint is almost abstract, without the subtle interplay of light and color that is so characteristic of Monet's earlier work.

THE CATARACT PROBLEM

By 1912 Monet was having a great deal of trouble with his eyesight. His doctor in the countryside, Jean Rebiere, MD, diagnosed bilateral cataracts. The artist consulted several ophthalmologists in Paris, including Aron Polack, MD, who must have been especially sympathetic to Monet's plight, since he also was an artist. Polack confirmed the diagnosis of Monet's cataracts but advised that surgery be deferred.[6] Monet discussed his problem in depth with Clemenceau, who reassured him in a letter that he was not in danger of becoming blind. Clemenceau wrote that the nearly mature cataract in Monet's right eye, which was by this time virtually useless, could be operated on so that a "continuation of vision is assured."[7] Monet, however, deathly afraid of surgery and ever anxious, preferred to do nothing more than to try eye drops.

Monet was elated when he met, in Paris, a German ophthalmologist named Count Maximilian Wiser, who promised him a nonsurgical cure for cataracts if he would come to Germany for treatment. The charming but controversial Wiser practiced ophthalmology in a German spa town, Bad Liebenstein, and utilized the doubtful therapeutic methods of William Horatio Bates, MD (see chapter 37). The radical politician Emma Goldman describes Wiser at length in her autobiography. Upon entering his clinic, she was handed a leaflet that appealed to the medical department of the German War Ministry to have Wiser "sup-

pressed on grounds of professional incompetence, quackery and dishonesty," and it was signed by twenty-two of the foremost eye specialists of Germany.[8] Though Goldman found Wiser kind and sympathetic, Monet heard concerns about him and never crossed the Rhine to visit his clinic.

In 1913 Monet consulted the eminent ophthalmologist Richard Liebreich, MD, chair of ophthalmology at St. Thomas Hospital and Medical School in London.[9] Liebreich had studied at the École des Beaux-Arts in Paris and was an accomplished artist (he created the illustrations for his own important *Atlas of Ophthalmoscopy*). His article on the effect of eye disease on the artists J. M. W. Turner and William Mulready had already been published separately on both sides of the English Channel and had been influential for decades. Monet's fellow Impressionist Edgar Degas was well aware of it (see chapter 35). Liebreich described two changes in visual perception that occur with aging and that are due to alterations in the lens of the eye. First, he noted that as the lens thickens with age, it can scatter light. He believed that this change had occurred with Turner, although we take issue with that diagnosis today (see chapter 9). Second, as the lens thickens, it develops a yellowish discoloration that prevents some colors from reaching the retina. Liebreich believed that the shifts in the colored pigments used by the artist Mulready were due to this type of change, a diagnosis that also may be questioned today (see chapters 23 and 38). In 1913 Liebreich was eighty-three years old, and near the end of a brilliant career. His examination of Monet revealed that the artist had no useful vision with his right eye, and so he prescribed glasses which had no power for that eye. For the left eye, his prescription was -1.75 diopters for distance, indicating the artist was moderately nearsighted. For reading, he prescribed +1.50 diopters.[10]

During the next few years, Monet painted less. Furthermore, he refused to have anything done about his cataracts, although he was interested in the cataract problem of Mary Cassatt, the American Impressionist who was living in France (see chapter 29). Cassatt underwent cataract surgery to one eye in 1917

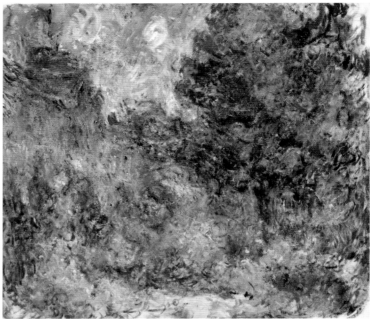

30.4

30.5

and to the other in 1919, but the results were poor for both eyes, and she was forced to give up her artistic career. She probably had other ocular disease that complicated her surgery, but irrespective of that, her unfortunate surgical results did not encourage Monet to undergo the same procedure. He described his curiosity about Cassatt's vision in a letter to Clemenceau in November 1919. Aware she had just been operated on, he said he would find out about her condition and then make up his mind. After learning more, he made up his mind to wait longer.

In a 1918 interview, Monet described his troubles of the last five years: "I no longer perceived colors with the same intensity, I no longer painted light with the same accuracy. Reds appeared muddy to me, pinks insipid, and the intermediate or lower tones escaped me. As for forms, they always appeared clear and I rendered them with the same decision. At first I tried to be stubborn. How many times, near the little bridge where we are now, have I stayed for hours under the harshest sun sitting on my campstool, in the shade of my parasol, forcing myself to resume my interrupted task and recapture the freshness that had disappeared from my palette! Wasted efforts. What I painted was more and more dark, more and more like an 'old picture,' and when the attempt was over I compared it to former works, I would be seized by a frantic rage and slash all my canvases with my penknife."[11]

For a brief period Monet convinced himself that his eyesight was better, though he continued to have difficulties with subtle, delicate colors viewed up close. (He felt he could see better when he stepped back a few feet.) Furthermore, he had trouble distinguishing between colors that were similar. He could still recognize vivid colors, especially if they were seen against a dark background. Since bright sunlight overwhelmed him, he stopped painting during the middle of the day. To avoid confusing pigments, he examined the labels on his tubes carefully and kept his paints organized on his palette in a regular, unvarying sequence.

His paintings of water lilies and willows between 1915 and 1919 are intriguing in light of his growing cataracts and the problems he described in 1918. Most of the water-lily canvases are large, and depict a broader view than the detailed views of 1899–1901. Most strikingly, many of them are intensely blue with less subtle modulations of color (see fig. 38.8a). This shift may have been the result of conscious experimentation with a grander scale that would envelop the viewer (as do the paintings, which encircle the viewer completely, in Paris's Orangerie Museum). He may also have begun to compensate for his cataracts, which blurred the distinction between blue and green (see fig. 38.8b). To him, these powerfully blue canvases must have elicited some of the sensation of the blue that was undoubtedly in his mind's eye. His willow paintings of this same period reflect a different type of exploration in their portrayal of the leaves and in the use of stronger colors in the red-yellow end of the spectrum (which would have been brighter through the cataracts).

In 1914 Clemenceau and a few others encouraged Monet to donate a group of his water-lily paintings to the government of France, as a contribution to the war effort. Monet agreed and reported to Clemenceau on November 12, 1918: "Dear and great friend, I have stayed up late to finish two decorative panels that I would like to sign the day of victory, and I am going to ask you to act as intermediary to offer them to the country."[12] Another plan to donate twelve large canvases was announced officially in 1920, but in 1921 Monet tried to extricate himself from this obligation. He felt that he was incapable of completing the task. Clemenceau, who realized that failure to complete this project would be an embarrassment to himself and to his friend, persuaded Monet to sign a notarized document in which the artist formally agreed to donate nineteen panels to France. The government in turn agreed to house them permanently in the Orangerie Museum, a small art museum in the center of Paris, just off the Place de la Concorde.

Monet's eyes continued to cause him difficulties. He described the problem he was having in complying with the terms of his agreement in a letter dated May 8, 1922: "I wished to profit from what little [remained of] my vision in order to bring certain of my decorations to completion. And I was gravely mistaken. For in the end I had to admit that I was ruining them, that I was no

longer capable of making something of beauty. And I destroyed several of my panels. Today I am almost blind and I have to renounce work completely."[13]

Nevertheless, Monet continued to paint. Between 1919 and 1922, he turned to smaller canvases, which reveal a remarkable freedom of expression, with rough applications of paint, tenuous linkage to the physical details of the garden, and strong and unusual colors. For example, *The Rose Path, Giverny* (see fig. 30.3) is dominated by bright oranges and dark shadows. Two exemplary paintings of the house at Giverny (see figs. 30.4 and 30.5; note the chimney) show disparate tones: One is yellow-red while the other is intense dark blue. Similarly, different paintings of the Japanese bridge from the same period (see figs. 38.9a and 38.9c) are dominated respectively by orange or blue. Scholars have puzzled and argued over the dates of these relatively abstract paintings, as Monet dated only a few Japanese bridge canvases from 1919 and one canvas of the house and garden from 1922. While these paintings are typically listed as circa 1918–24 in catalogues prepared many years later, we think it likely that all of them were done before his cataract surgery because of their similar size, subject matter, style, and use of color (that would reflect his visual loss). It is conceivable, of course, that Monet reworked some of his preoperative paintings after his surgery, and some have speculated that the more orange views represented vision through his cataract while the blue canvases represent his postoperative view. We are skeptical, since Monet certainly had good reason prior to surgery to be experimenting with strong colors at both ends of the spectrum, to get some relief from his relatively monochromatic world. We discuss this issue further, and show simulations of his vision through the cataracts, in chapter 38.

By this time, having outlived two wives and one of his two sons, Monet relied heavily on Clemenceau for support (see fig. 30.6). As Clemenceau was a physician and knew many members of the medical community, he had a strong influence on his friend when questions of health arose. At Clemenceau's urging, Monet consulted yet another ophthalmologist, Charles Coutela, MD, in September 1922. Coutela was an accomplished surgeon, who was later named a Commander of the Legion of Honor and a member of the prestigious Academy of Medicine.[14]

Coutela found that, with his right eye, Monet could see only light and the direction from which a light source was projected. With the left eye, the artist could read only 20/200. Monet was still psychologically unprepared for surgery so Coutela prescribed eyedrops to dilate the pupil of the left eye, in the hope that doing so would allow more rays of light to penetrate the cataractous lens and reach the retina. Monet must have been extremely anxious that this experiment would succeed. Before a week was up, he wrote enthusiastically to Coutela: "It is all simply marvelous. I have not seen so well for a long time, so much so that I regret not having seen you sooner. The drops have permitted me to paint good things rather than the bad paintings which I had persisted in making when seeing nothing but fog."[15]

The effect was short-lived, however, for Monet wrote Coutela again, in October 1922, to make plans for surgery to his right eye.[16] But in November he wrote Clemenceau of his apprehension and his nightmares and said that he just was too tormented to have the surgery yet.[17] Clemenceau utilized all of his persuasive powers to convince Monet to have the operation, reminding him of the agreement to finish the paintings for France.

SURGERY

Finally, in January 1923, Monet underwent a two-stage cataract operation to his right eye. A preliminary procedure to remove part of the iris was first, as this made the later cataract removal easier and safer. This was done at the Ambroise-Paré Clinic in Neuilly, a suburb of Paris. Later that month Coutela performed a second procedure, removal of the cloudy core of the lens.[18] Still extremely nervous, Monet became nauseated and vomited during

Fig. 30.4 Claude Monet, *The House Seen from the Rose Garden*, 1922–24. Oil on canvas, 31 ⁷/₈ x 36 ¹/₄ in. (81 x 92 cm). This image might not be recognized as the house and the garden, except for the chimney. The yellowish tonality is unusual for Monet's garden views.

Fig. 30.5 Claude Monet, *The House at Giverny Viewed from the Rose Garden*, 1922–24. Oil on canvas, 35 x 39 ³/₈ in. (89 x 100 cm). This painting is dark in contrast to figure 30.4. It is unlikely that it was done postoperatively, when the blues would have been much brighter and Monet would also have been able to perceive yellows and greens.

Fig. 30.6 Photograph in the garden at Giverny , c. 1921. (left to right) Madame Kuroki, Claude Monet, Alice Butler, Blanche Hoschede-Monet, and Georges Clemenceau.

30.6

Fig. 30.7 Photograph by Henri Manuel of Claude Monet in his studio at Giverny, c. 1920s. Monet is shown at work in his third studio, surrounded by panels of water lilies. His cataract glasses are on the end table.

Fig. 30.8 Photograph of a pair of glasses and a pipe belonging to Claude Monet, c. 1923 or later. These glasses have two different lenses: a thick right lens to compensate for the cataract that was removed and a thinner, cloudy left lens to blur images so that they would not interfere with vision in the right eye after surgery.

Fig. 30.9 Claude Monet, *The House at Giverny Under the Roses*, 1925. Oil on canvas, 36 7/16 x 29 in. (92.5 x 73.5 cm). This postoperative painting shows plants and flowers in a style consistent with Monet's work before his cataracts became dense (see fig. 30.2).

30.9

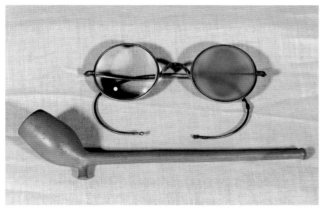

30.8

Monet complained that objects curved abnormally with his new glasses, and that colors were strange. Coutela was not so troubled. On August 21, 1923, he wrote Clemenceau: "His vision at near may be considered nearly perfect after correction . . . For distant vision the result is less extraordinary: Mr. Monet has 3/10 vision [20/50–20/70], which is not bad, but he will require a little bit of training because the vision for distance is more or less restricted. In brief, I am very satisfied.["22] Monet wrote a sad letter to Coutela on August 27, 1923, describing the difficulties he was having with the glasses: "I have just received them today but I am absolutely desolated for, in spite of all my good will, I feel that if I take a step, I will fall on the ground. For near and far everything is deformed, doubled, and it has been intolerable to see. To persist seems dangerous to me.["23]

Three days later Monet wrote Clemenceau again: "To confirm what I said in my telegram after new trials with the lenses and with small doses, on Coutela's advice: I'm doing exercises and can read easily; that much is certain and it's restoring my confidence, but the distortion and exaggerated colors that I see are quite terrifying. As for going for a walk in these spectacles, it's out of the question for the moment anyway, and if I was condemned to see nature as I see it now, I'd prefer to be blind and keep my memories of the beauties I've always seen.["24] Clemenceau had encouraged Monet to have both eyes operated on, but Monet steadfastly refused. He stated his reasons in a letter to Clemenceau dated September 22, 1923: "I have to say that in all sincerity and after much deliberation, I absolutely refuse (for the moment at least) to have the operation done to my left eye; you are far away and can have no idea of the state I'm in as regards my sight and the alteration of colors, and you cannot do anything to help me. I can see, read, and write and I fear that this is very probably the only result that can be obtained. So unless I find a painter, of whatever kind, who's had the operation and can tell me that he can see the same colors he did before, I won't allow it. I'm expecting Coutela tomorrow. I hope he'll change my lenses and we'll see if there's an improvement. I've been patient, and now you must be too.["25]

Clemenceau consoled Monet, and Monet took up his brushes again in order to complete the water-lily series (see fig. 30.7). He wore glasses with one thick lens that corrected for the power of the cataract that was removed from the right eye, and with one cloudy lens that blocked vision from the left eye to avoid any confusion of images (see fig. 30.8). He continued to have difficulties, both psychological and visual, as is apparent in this letter to Coutela dated April 9, 1924: "For months I have worked with obstinacy, without achieving anything good. I am destroying everything that is mediocre. Is it my age? Is it defective vision? Both certainly, but vision particularly. You have given me back the sight of black on white, to read and write, and I cannot be too grateful for that, but I am certain that the vision of [this] painter . . . is lost, and all is for nothing. I am telling you this confidentially. I hide it as much as possible, but I am terribly sad and discouraged. Life is a torture for me.["26]

In the summer of 1924, still one more ophthalmologist was called in to care for the aging artist. This was Jacques Mawas, MD, an esteemed researcher based at the Rothschild Eye Foundation.[27] Though he fit Monet with new lenses, the artist remained discouraged and depressed: "At night I am constantly haunted by what I'm trying to achieve. I get up exhausted every

morning. The dawning day gives me back my courage. But my anxiety comes back too soon as I set foot in my studio . . . Painting is so difficult. And a torture. Last fall I burned six canvases along with the dead leaves from my garden. It's hopeless. Still I wouldn't want to die before saying all that I have to say, or at least having tried to say it. And my days are numbered."[28]

Mawas was patient with Monet. Monet described some of his difficulties to Mawas in March 1925: "I am quite late in giving you news concerning the outcome of my new glasses, but they arrived at such a bad period. I was very discouraged and I no longer hoped for better, so that I discontinued using these glasses which I probably might have accustomed myself to had they not completely disturbed me—eyesight trouble, the slightest color tones broken and exaggerated. As soon as I am in a better frame of mind I will try to get used to them, though I am even more certain that a painter's eyesight can never be returned. When singer loses his voice he retires; the painter who has undergone a cataract operation, must give up painting; and this is what I have been incapable of doing."[29]

Monet's depressive mood improved by July 1925. He wrote Mawas: "Since your last visit my vision is totally ameliorated. I am working harder than ever, am pleased with what I do, and if the new glasses are better still I would like to live to be one hundred."[30] His improved attitude was still present ten days later in this letter to Dr. Coutela: "I am very happy to inform you that finally I have recovered my true vision and that nearly at a single stroke. In brief, I am happily seeing everything again and I am working with ardor."[31]

It is noteworthy that the canvases ascribed reliably to Monet's postoperative period (see figs. 30.9 and 38.10), including the water lilies in the Orangerie Museum, resemble his style of painting from 1917 or before and return to color schemes consistent with the earlier pond and garden views. The artist did not, to our knowledge, produce any further canvases with rough paint and strong colors. This fact suggests that the relatively abstract style of works such as figures 30.3–30.5 was not developed by choice alone, but, rather, reflects Monet's difficulties with color vision and blur from cataract.

Monet painted almost to the day of his death in December 1926. The eighty-six-year-old artist (see fig. 30.10) had been a chronic smoker, and he died of chronic obstructive pulmonary disease and cancer of the lung. A group of his water-lily paintings was installed in the Orangerie Museum in 1927, where they may still be seen today. These paintings are the last triumphs of this great artist.

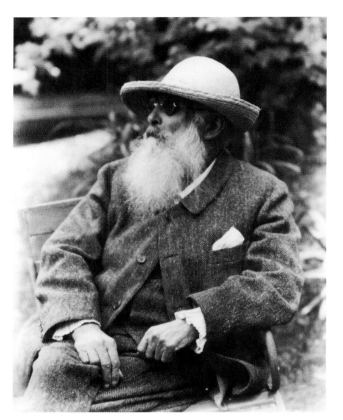

30.10

NOTES

1. Vollard, *Paul Cézanne: His Life and Art* (1926), p. 74.
2. Clemenceau, *Claude Monet: The Water Lilies* (1930), pp. 18–19.
3. Geffroy, "Monet: Sa vie, son oeuvre." Quoted in Stuckey, *Monet: A Retrospective* (1985), p. 156.
4. Fuller, "Claude Monet and His Paintings." Quoted in Stuckey, *Monet: A Retrospective* (1985), p. 203.
5. "The Conscientious Artist" (1908). Quoted in Stuckey, *Monet: A Retrospective*, (1985), p. 251.
6. Wildenstein, *Claude Monet biographie et catalogue raisonne* (1985), p. 108.
7. Ibid., p. 77.
8. Goldman, *Living My Life* (1934), p. 949.
9. Ravin and Kenyon, "From von Graefe's Clinic to the École des Beaux-Arts: The Meteoric Career of Richard Liebreich" (1992).
10. Wildenstein, *Claude Monet biographie et catalogue raisonne* (1985), p. 108.
11. Thiebault-Sisson, "Les nympheas de Claude Monet à l'Orangerie des Tuileries" (1927).
12. Monet, letter to Clemenceau, November 12, 1918. In Hoog, *Georges Clemenceau à son ami Claude Monet* (1993).
13. Stuckey, "Blossoms and Blunders: Monet and the State II" (1979).
14. Offret, "Necrologie, Charles Coutela, 1876–1969" (1969).
15. Monet, letter to Coutela, September 13, 1922.
16. Monet, letter to Coutela, October 20, 1922.
17. Monet, letter to Clemenceau, November 9, 1922.
18. Dittiere, "Comment Monet recouvra la vue après l'opération de la cataracte" (1973).
19. Monet, letter to Coutela, June 22, 1923.
20. Dittiere, "Comment Monet recouvra la vue après l'opération de la cataracte" (1973).
21. Ravin, "Monet's Cataracts" (1985).
22. Coutela, letter to Clemenceau, August 21, 1923.
23. Monet, letter to Coutela, August 27, 1923.
24. Monet, letter to Clemenceau, August 30, 1923. In Wildenstein, *Claude Monet biographie et catalogue raisonne* (1985), p. 416.
25. Monet, letter to Clemenceau, September 23, 1923. In Wildenstein, *Claude Monet biographie et catalogue raisonne* (1985), p. 416.
26. Monet, letter to Coutela, April 9, 1924.
27. Dubois-Poulsen, "Jacques Mawas 1885–1976" (1976).
28. Gordon and Forge, *Monet* (1983), p. 247.
29. Monet, letter to Coutela, March 25, 1925.
30. Hoschede, *Claude Monet ce mal connu* (1960), pp. 150–151.
31. Monet, letter to Coutela, July 27, 1925.

Fig. 30.10 Photograph by Nickolas Muray of Monet in a straw hat and glasses, gelatin-silver print, c. 1926. Monet is seated in the garden wearing his postoperative glasses, which are possibly tinted for the sun.

Fig. 31.1 Jules Chéret, poster advertising Vin Mariani, a popular French tonic wine, 1894. Color lithograph on paper, 46 ¹/₂ x 32 ¹/₄ in. (118.1 x 81.9 cm). The effervescent woman is typical of Chéret's imagery and style.

GLAUCOMA
AND THE ARTIST

Glaucoma is a potentially blinding and relatively common disease that damages the optic nerve between the eye and brain (see chapter 23). There are several forms, the most common being the open-angle type, characterized by slow progression over many years. Side (peripheral) vision is affected first, and an affected individual may not recognize there is a problem until central vision is lost, by which time the disease has destroyed much of the optic nerve. Narrow-angle glaucoma, also known as angle-closure glaucoma, is much less common than open-angle glaucoma in Caucasian and black populations, but occurs relatively frequently in Asian populations. Sharp spikes in pressure, severe pain, and sudden loss of vision are typical of this form of the disease. Neovascular (hemorrhagic) glaucoma, a rare form

of the disease, usually follows poor circulation (ischemia) within the eye, most often in diabetics.

Any form of glaucoma may have serious consequences for an artist. The loss of peripheral vision does not usually affect an artist's work, but the eventual loss of central vision in both eyes will force an artist to stop working. The lives and careers of four French artists who suffered from various aspects of glaucoma give insight into problems the disease can produce: Jules Chéret lost his vision late in life from acute angle-closure glaucoma, which ended his career. François-Auguste Ravier lost an eye from neovascular glaucoma. His other eye functioned well until late in life when it developed a cataract. The cataract altered his perception of colors and details, and eventually he stopped painting. Louis Valtat and Roger Bissière both developed open-angle glaucoma. The disease blinded Valtat and finished his career. Fortunately for Bissière, surgery was successful and he was able to continue to work.

JULES CHÉRET (1836–1932)

Chéret is considered the father of the color lithographic poster, a type of commercial art that converted the streets of Paris into a veritable poster gallery. A successful illustrator and graphic designer, Cheret made beautiful women the focus of his images, often positioning them at unusual angles, which draws attention to the composition (see fig. 31.1). In describing his approach, Chéret said he wanted to make his works as bright and joyful as a bouquet of flowers. He created more than a thousand posters during his long career. The French government gave him the unusual tribute of an exhibition of his work in the Louvre while he was still alive. Although best known for his posters, Chéret also painted portraits, sculpted, and decorated the walls of the City Hall in Paris. The critic Joris-Karl Huysmans liked to say that Chéret showed a thousand times more talent in his smallest poster than most painters exhibited in their paintings at the Salon. Never dull, Huysmans enjoyed being provocative. He also joked that Cézanne's originality was due to retinal disease, presumably from his diabetes (most likely without medical justification—see chapter 24).

Sadly, Chéret's career came to an end from angle-closure glaucoma in 1923. Treatment was ineffective, and the artist

VIN MARIANI

POPULAR
FRENCH TONIC WINE
Fortifies and Refreshes Body & Brain
Restores Health and Vitality

31.1

31.2

essentially lost all his vision. Claude Monet, one of his friends, was saddened to learn of Chéret's ocular difficulties. Monet was well aware of the possible effects of eye disease on an artist's creative ability, since he had undergone cataract surgery earlier the same year that Chéret became blind (see chapter 30). The following year, Monet discussed Chéret's problem with Maurice Denis, another artist with ocular problems, but neither could do more than offer solace to Chéret.

The Museum of Fine Arts in Nice, Chéret's adopted home, has been renamed the Jules Chéret Museum, but even it has little information about his blindness. A newspaper story from 1926 reports that Chéret suffered pain and loss of vision from glaucoma, but that he remained able to see the azaleas in his garden and the setting sun, at least for a while.[1] Five years before his death, he could not even perceive light, and he was forced to place his hands on the shoulders of the person ahead of him for guidance while walking. Had Chéret lived at the end of the twentieth century, he would have been far less likely to have become blind from angle-closure glaucoma. Surgery would probably have saved his sight.

FRANÇOIS AUGUSTE RAVIER (1814–1895)

The late-nineteenth-century French artist François Auguste Ravier created many charming romantic landscape paintings. During the 1880s he exhibited with the Paris gallery Boussod and Valadon, where Vincent van Gogh's brother Theo was in charge of his paintings. Ravier's loose technique, which included rubbing and scraping the painted surface, may have influenced Vincent as he developed his own unique style of painting. At age twenty-five, Ravier met the well-known landscape painter Camille Corot (1796–1875), the most important member of the

Barbizon group, who became his mentor. Corot taught Ravier to study the effects of light while painting out-of-doors and encouraged him to make a pilgrimage to Italy to improve his artistic skill. Ravier made several long trips to Italy, painting and drawing in the countryside near Rome and producing works such as *View of a Roman Villa* (see fig. 31.2). Then he returned to the area where he had grown up, the French countryside near Lyon. Here he evolved a style that was more in tune with the evolving movement of Impressionism, exemplified by *Landscape on the Outskirts of Crémieu* (see fig. 31.3), although he is not considered to be an Impressionist. He particularly enjoyed exploring the effect of light at daybreak and near sunset. He would draw in the morning and paint in the late afternoon. His choice of materials was unusual for the time. When working directly from nature, he preferred to use oil paint on paper or canvas to make preparatory studies for more finished watercolor works done later in his studio.

Ravier enjoyed good health until age sixty-five, when, while painting outdoors on a beautiful autumn day, he suddenly lost consciousness from a stroke (which may have been related to smoking). His treatment included reducing physical exercise, avoiding extremes of temperature, and taking arsenic. Although this heavy metal was known to be potentially poisonous, it had been used therapeutically for thousands of years.

Four years later he developed pain and loss of vision in his left eye. In a letter written three weeks after this problem began, he described it as an "ophthalmia," a nonspecific term that can encompass nearly any serious eye disease. His choice of words indicates that he retained a sense of humor despite the fear he must have been experiencing: "Since the beginning of the month I have been caught by an ophthalmia which has forced me to interrupt all work, all reading, and lead the life of a frog at the bottom of a well . . . At this moment I am doing better, but I

Fig. 31.2 François Ravier, *View of a Roman Villa*, c. 1841. Oil on canvas, 10 x 16 ¹/₈ in. (25.5 x 41 cm). Musée d'Orsay, Paris. This early painting was made with deliberation and precision.

Figure 31.3 François Ravier, *Landscape on the Outskirts of Crémieu*, late 19th century. Oil on panel, 10 x 13 in. (25 x 33.5 cm). A later work, this image was painted far more loosely than *View of a Roman Villa* (see fig. 31.2).

31.3

am not yet out of pain. I do not know what will happen."[2] Soon after, he wrote that he suffered from "hemorrhagic glaucoma (that is what the ophthalmologists called it). It made me lose an eye, which, the doctors advised me to have removed in order to prevent infection in the other one. After having spent more than three months unable to do anything, the 24th of last month [April, 1884] Dor performed the operation, which succeeded perfectly."[3]

Within a few weeks of his surgery, Ravier was able to resume painting. At times he would refer to himself humorously as a one-eyed Cyclops. He presented himself as vigorous and still capable of painting out-of-doors. One might ask whether loss of an eye (and loss of true depth perception) would affect a landscape painter, as a handicap or perhaps as an asset in transferring depth to a two-dimensional canvas (see chapter 27). However, while Ravier's works made after losing an eye have less sensation of space than do his earlier works, the reasons for this shift are stylistic, not physical. He could still use monocular clues to depict space, such as overlapping forms, reducing the relative size of objects as they recede into space, linear perspective, fogging distant objects (atmospheric perspective), and color differences (warm colors for near objects and cooler ones for distant ones). Furthermore, many avant-garde artists at that time were moving away from a traditional depiction of space, and Ravier incorporated this new trend into his work. He also experimented with different techniques. When working with watercolors, he would scrape the paper to create highlights and sponge it with water to tone down color. His brushstrokes became more splotchy, looser, and broader. He allowed the paint to puddle, so that chance effects, rather than control, determined more of the composition.

Five years after losing his left eye, Ravier began to have new difficulties due to a cataract in the right eye. It is hard to judge from his paintings whether there was any distinct effect, and he never described any changes in his color vision as he aged.[4] We don't even know which works date to the time of his cataract, since most of the paintings from his last decades were unsigned,

undated, and similar in subject matter. And the colors seen in *Landscape on the Outskirts of Crémieu* (see fig. 31.3) are not particularly characteristic of his style, as he produced paintings in warm colors as well as paintings that are cool and blue. His oeuvre points out the difficulty in making diagnostic judgments about the effects of cataracts from an artist's paintings alone. The situation was different with respect to Monet, whose visual complaints and problems are well documented (see chapter 30).

Less than a year before his death, Ravier summed up his career appropriately. He wrote that he had "brought to light an original way of seeing."[5]

LOUIS VALTAT (1869–1952)

The French painter Louis Valtat deserves to be more recognized than he is. Though there have been many exhibitions of his work and he has been the subject of several monographs, he remains little known. This is due in part to the fact that his dealer, Ambroise Vollard, represented many important artists, including Paul Cézanne, Edgar Degas, Paul Gauguin, van Gogh, Henri Matisse, Pablo Picasso, and Pierre-Auguste Renoir, and provided some of them more exposure than others. Vollard gave less attention to Valtat than he could have. Luckily for Valtat, his family was successful in the ship-building industry and he was independently wealthy.

Valtat studied under some renowned teachers in Paris and collaborated with Henri de Toulouse-Lautrec. Early in his career, he was influenced by the Impressionists, but later came under the influence of the two great aesthetic trends at the turn of the twentieth century: Pointillism and the Nabis movement (from the Hebrew *navi*, meaning "prophet"). He worked in a Pointillist style, using multiple small spots of color. Then the inspiration of friends' work in the Nabis transformed Valtat's painting, and he altered his method of painting, adopting elliptical forms and undulating lines. His personal style influenced the Fauve movement, best exemplified by the work of Matisse. Under the powerful sunlight of the Mediterranean coast, with

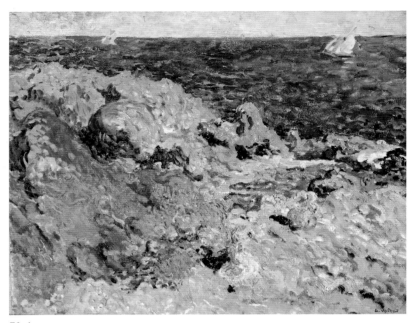

31.4

Figure 31.4 Louis Valtat, *Red Rocks at Anthéor*, 1901. Oil on canvas, 25 ³/₄ x 32 in. (65.5 x 81.2 cm). The brilliant colors of this painting are typical of Valtat's proto-Fauvist style.

Figure 31.5 Roger Bissière, *Painting with Green Tones*, 1955. Oil on canvas, 51 x 63 ³/₄ in. (130 x 162 cm). This painting is typical of Bissiere's abstract style.

its bright red rocks and glistening blue sea, Valtat painted landscapes with strong, sometimes clashing, tones (see fig. 31.4). He met Renoir unexpectedly one day while both were painting on a beach, and Renoir was amazed by the audacity and vigor of Valtat's painting.[6] Valtat was a guest many times at Renoir's home in the south of France, sometimes for extended stays, and they even painted each other.

At age seventy-eight, in 1948, Valtat was found to have glaucoma, which ended his career. The paintings he made during the last few decades of his life, however, are stylistically consistent, indicating that his eye problems did not affect his work appreciably until glaucoma finally destroyed his central vision.

ROGER BISSIÈRE (1888–1964)

Roger Bissière, a native of southwestern France, was educated at the Bordeaux School of Fine Arts. As a young man he moved to Paris for further study and came under the influence of Georges Braque, who, along with Picasso, founded Cubism. Bissière became an influential professor of painting but, paradoxically, liked to say that nothing can be taught.

31.5

By 1939 Bissière realized that his eyesight was deteriorating. When looking straight ahead he could not see the top of his canvas. Glaucoma was diagnosed but Bissière put off surgery for more than a decade. He was deeply troubled by the collapse of the world around him during World War II; his visual difficulties and emotional problems caused him to lose interest in painting. In his own words: "I had nothing to say. Events had drained me."[7] Over the next decade Bissière's vision worsened. Later he wrote: "My vision is decreasing slowly, but decreasing just the same. Beside this nightmare everything else appears to be of little importance."[8] After losing two-thirds of his visual field, he agreed to surgery, which controlled his glaucoma and ended his fear of his imminent blindness. The loss of his peripheral vision is not evident in the paintings he made between the time of his diagnosis and his surgery.

Bissière altered his manner of painting after surgery, but this change was not due to his eyesight. Between the wars, he, like many other artists, had come under the spell of Cubism, and by the middle of the twentieth century, he had turned toward nonrepresentational art (see fig. 31.5). Bissière's abstract works feature bright colors and short, curved lines. Already well known, he became even more famous in 1952 when the French government made him the first painter to be awarded the Grand-Prix National des Arts. Surgery for glaucoma had prolonged his career, unlike his predecessors Chéret and Valtat.

Glaucoma differs from cataract or macular degenerations in its implications for art, because the early visual effects (loss of peripheral vision) do not interfere with an artist's work or cause any recognizable stylistic changes. However, the eventual result can be devastating visual loss or even total blindness. For example, the American Modernist Abraham Walkowitz (1878–1965) still painted images of Isadora Duncan in his typical style (see fig. 23.7) and barns in Kansas just a few years before he was forced to stop all painting because of encroaching blindness. Although glaucoma remains "the thief of sight" because of its insidious progression, it can be detected early by periodic examinations, and with modern medications and surgical techniques, there is now much less of a risk of severe visual loss.

NOTES

1. *Le Figaro*, January 8, 1926.
2. Jamot, *Auguste Ravier: Étude critique suivie de la correspondence de l'artiste* (1921), pp. 172–174.
3. Ibid., p. 152.
4. Ferillo, "Two Landscapes by François-Auguste Ravier," in *Cleveland Studies in the History of Art* (1998), vol. 3, pp. 86–118.
5. Ibid.
6. Valtat, *Louis Valtat: Catalogue de l'oeuvre peint 1869–1952* (1977), vol. 1, p. xiii.
7. Fouchet, *Bissière* (1955), p. 17.
8. Lemoine, Lewino, and Jaeger, *Bissière* (2000), p. 122.

JAMES THURBER
AND THE SEQUELAE
OF CHILDHOOD INJURY

The *New Yorker* writer and cartoonist James Thurber (1894–1961) brought humor and insight to a generation or more of Americans. His drawings are deceptively simple, but they have a powerful poignancy. The dividing line between fine art and cartoons is arbitrary, as evidenced by the work of Honoré Daumier, George Du Maurier, and even Francisco José de Goya y Lucientes. But the visual difficulties that Thurber suffered are relevant to any artist.

Although Thurber is known as a humorist, joy and laughter were not always part of his life. A childhood injury to his left eye resulted in the removal of that eye. While he was still a child, his right eye developed an inflammation within the eye, and he was diagnosed as having sympathetic ophthalmia, an uncommon disorder in which a severe penetrating injury to one eye can stimulate (sometimes many months later) a "sympathizing" inflammatory response in the other eye. For several decades, peering over and through hyperopic glasses, Thurber's remaining eye functioned relatively well. Then, when he was in his early forties, the sight in this eye began to fail. He underwent a series of operations for cataract and secondary glaucoma, only to become legally blind.

Thurber's best-known written work is "The Secret Life of Walter Mitty," the story of a drab and timid man who escapes from his humdrum, henpecked world to a fantasy life of great adventure. Mitty is an average man who dreams of accomplishing great things. Thurber was not Mitty. He was an extraordinary man with a strong personality who worked long and hard on his writing. E. B. White, a colleague at the *New Yorker*, wrote of him: "Most writers would be glad to settle for any one of ten of Thurber's accomplishments. He has written the funniest memoirs, fables, reports, satires, fantasies, complaints, fairy tales and sketches of the last twenty years, has gone into the drama and the cinema, and on top of that has littered the world with thousands of drawings."[1]

Thurber suffered the accident that was to change his life when he was just six years old. He was playing with his eight-year-old brother, William, who had a toy bow and arrow. William told his younger brother to turn around to face a fence in their yard, so he could shoot him safely in the back. William, not quick to do anything, took a long time to set the arrow in the bow, and just as Thurber turned around to see what was taking so long, the arrow struck him in the left eye. After a few days,

pain in the badly injured eye became more intense, and Thurber's parents took him to see a specialist who removed the injured eye; but we do not know how soon after the original injury this was done. Prompt removal of a traumatized eye will generally prevent the development of inflammation in the other eye.

Having only one good eye and a prosthesis for the other did not help the tall, awkward boy develop self-confidence. He was fitted with glasses to improve his vision and protect the remaining eye, which did not enhance his appearance either. He was told to avoid baseball, running, and other normal childhood sports. Always self-conscious about having just one eye, for posed photographs he would turn his head to the left, away from the camera.

World War I coincided with most of Thurber's undergraduate years. He entered Ohio State University, Columbus, in 1913 and left in 1918, without having received a degree. He had spent much of his time there writing for the college newspaper. By 1918 many students and faculty had left the university voluntarily for military service, but the one-eyed Thurber was constantly rejected by the draft board. Just after the end of the war, Thurber was sent to Paris as a code clerk for the U.S. State Department.

Thurber returned to Columbus and worked for three years as a reporter for the *Columbus Dispatch*. Next, he returned to Paris as a writer for the French editions of the *Chicago Tribune* and the *Paris Herald*. In 1926 he moved to New York to write for the *New York Evening Post*. He wrote fiction as well, and sent a number of stories to a magazine that had just begun publication, the *New Yorker*. After twenty rejections, the magazine bought "An American Romance." Thurber soon met E. B. White, a writer for the *New Yorker*, who helped to get him a job at the magazine.

Thurber liked to draw cartoons, and when his sketches were introduced in the *New Yorker* in 1931, they were immediately popular. The simple line drawings, without shading or shadows, entranced the public (see fig. 32.1). The Thurber dog and the battle between the sexes were his favorite subjects. He dashed off the cartoons quickly, unlike the extensive time he took to write a story. According to his wife, Helen, Thurber never cared to be labeled a cartoonist or an artist.[2] He had so much fun drawing that he never took his pictures seriously. The witty Dorothy Parker compared the rounded forms of Thurber's characters to

"Certainly I can make it out! It's three sea horses and an 'h.'"

32.1

32.2

unbaked cookies. A psychiatrist wrote him frequently, offering to cure him of the neuroses apparent in the drawings.[3] Many parents said that their young children drew better. When the magazine was criticized for publishing the work of this "fifth-rate" artist, editor Harold Ross defended Thurber, saying that he was merely "third-rate" and just fine at that level.[4] Although some critics deprecated Thurber's cartoons, other were favorable and even saw similarities to the line drawings of Henri Matisse. This comparison displeased a few artists, but it provoked a good laugh from Thurber.[5]

A new crisis in Thurber's vision began in the 1930s when his right eye began to fail from chronic sympathetic ophthalmia and its associated cataract. Glare from oncoming car headlights and decreasing vision made him give up driving. In 1937 he wrote a physician friend, asking for help in finding an ophthalmologist: "I wonder if you would have a moment . . . to suggest a really good eye man to me? He can be an expensive one, because I haven't got any disease that needs treatment. I haven't any million dollars to spend, but have become a bit wary of $10 or $15-an-examination men. Have you got anything around $50 or a hundred? . . . I can promise any eye man one of the remarkable clinical eyes of the country. All oculists agree on that. They start out by deciding I shouldn't be able to see anything but moving shapes, end up with me reading two lines below normal on the chart, and finally discover a tiny hole left on a lens which otherwise is covered with 'organized exudation.'"[6]

Gordon Bruce, MD, an ophthalmologist at Columbia-Presbyterian Medical Center in New York, was recommended by others largely because of his military service during World War II, when he reached the lofty rank of rear admiral in the U.S. Navy. Bruce did not operate immediately on Thurber's cataract because of the risks to an eye with sympathetic ophthalmia, as well as Thurber's anxieties about the operation. Thurber wrote to Bruce during a visit to California in 1939: "The old eye is the same as ever for distance but I'll be goddam [sic] if I can read—except—and this is funny—under a big umbrella outdoors in a bright sun; under those conditions I see to read even newspaper type exactly as well without my glasses as with my distance ones (not reading ones)—or anyway, almost the same . . . I am get-

ting crosser and snappier and sadder every minute straining and struggling to type and read and draw (the latter is the easiest) . . . Life is no good to me at all unless I can read, type and draw."[7]

Bruce told Thurber that, for his vision to improve, the cataract would have to be removed. However, Thurber was not prepared for surgery psychologically, even though all he could read was forty-five-point type and large neon signs at a distance. In a letter written during the spring of 1940, he tried to put some humor into the problem: "I think that my eyesight is improving and that it rises and falls with my state of health and my weight. At first I bumped into horses by day and houses by night but now I only hit the smaller objects, such as hassocks and sewer lids that are slightly ajar."[8]

Bruce recommended operating in two stages: a preliminary removal of part of the iris (an iridectomy) followed by extraction of the cataract—the same procedures used on Claude Monet in France in the 1920s (although the first stage is rarely done today). After the first stage, Bruce noted that Thurber's vision was no better, but not much worse, and that the humorist was able to type a story for the *Saturday Evening Post*. In the story Thurber described getting into difficulty because of his poor vision: "Do you raise them? I said to a lady on the bus. Raise what? she says. Those chickens like the one you have in your lap, I said. She pulled the emergency cord and brought the bus to a halt at the corner of Mobray and Pineberry Street in Jersey City. What she had on her lap was a white handbag. I may be put away any day now."[9]

The cataract was removed in October 1940, and was followed by secondary glaucoma and iritis. Ultimately three additional operative procedures were needed. Thurber became quite depressed, which is not a good condition for a humorist. Helen Thurber described the situation sadly: "He cannot go out alone, has to be led around, except indoors, where he is very agile. And the worst is that he cannot read or draw. He writes in longhand on yellow paper, but cannot see what he writes."[10] Thurber gradually improved to a modest degree. In a letter to Bruce dated "spring 1941," he wrote, "I'm adjusted to the new glasses now. Things seem out of the edge of the lens, curled up like burning paper, but I have got used to that too. I can make out the pencil

point now and Helen says I write a straighter line, though often writing meaningless words."[11] Unfortunately, the inflammation persisted and his vision declined slowly, and by the late 1950s he was barely able to perceive light.

The loss of vision affected both Thurber's writing and drawing. He was reduced to writing only a few words on each page, and eventually to dictating. But ever philosophical, he noted in 1953 that "blindness is only a challenge, not a handicap. In many ways it's actually an advantage for a writer. There are less distractions by useless reading, or a bird at the window, or a pretty girl passing by . . . I now am able to write complete stories in my head. I can remember a 3500-word story without missing a punctuation mark."[12]

The effect of visual loss on Thurber's drawing technique was not apparent until his visual acuity was rather minimal, since his style is deceptively simple. After his multiple eye surgeries in 1940–41, he drew cartoons on a large board with the aid of a magnifying loupe (see fig. 32.2). Even this method became a challenge as his vision gradually worsened; and his last major set of new drawings, created in 1948 for "A New Natural History,"[13] shows a definite loss of precision and clarity. His cartoons were never pictorially detailed, but they reflect confidence, a sense of purpose, and a marvelous control over details of expression and demeanor (whether dog, seal, or human) that defined their creator's wistful and ironic humor. The 1948 animal drawings show simpler designs, shakier lines, and less of the expressive detail (compare figs. 32.3 and 32.4). Comparing late Thurber drawings to early ones can be confusing because even after he could no longer draw, he contributed recycled cartoons to the New Yorker as well as published them in his books. As Thurber describes, "I got so I couldn't draw at all, so Ross went through all kinds of worry and suffering about that and said: You see, we can arrange all of it. He decided we could reverse cuts and use new captions . . ."[14]

By 1950 Thurber had largely given up drawing. He tried again briefly with new equipment—a lighted drawing board by General Electric Co., and a white marker that produced a glowing line on black paper. But even these tools were not up to the task. Thurber occasionally joked about the visual difficulties he had had since early childhood. He challenged a friend to come

up with a cornier title for an autobiography than *Long Time No See*.[15] Although he never used this title, his wife did in writing about him after his death.[16]

Thurber minimized the impact of his blindness, saying "My drawing? I've never taken it very seriously."[17] He may or may not have believed that in his heart, given the effort he expended on various visual aids. For the generations who have enjoyed his drawings, they created a world beyond words. At the end of his life Thurber could only see light and dark, but his humorous and wistful portrayals of the follies of human nature, and the follies of war, continue to illuminate those who seek them out.

NOTES

1. Obituary of James Thurber, *The New York Times* (November 3, 1961).
2. Thurber, "Self-Portraits and Self-Appraisals by James Thurber," *Harper's Magazine* (August 1966).
3. "Priceless Gift of Laughter," *Time* (July 9, 1951).
4. Obituary of James Thurber, *The New York Times* (November 3, 1961).
5. "Priceless Gift of Laughter," *Time* (July 9, 1951).
6. Kinney, *James Thurber: His Life and Times* (1997), p. 706.
7. Thurber and Weeks, eds., *Selected Letters of James Thurber* (1981), p. 71.
8. Kinney, *James Thurber: His Life and Times* (1997), pp. 753–754.
9. Ibid., p. 761.
10. Ibid., p. 769.
11. Thurber and Weeks, eds., *Selected Letters of James Thurber* (1981), p. 74.
12. Unger, American Writers, suppl. 1, pt. 2 (1979), p. 604.
13. Thurber, "A New Natural History" in *The Beast in Me and Other Animals: A New Collection of Pieces and Drawings about Human Beings and Other Less Alarming Creatures* (1948). Reprinted in Thurber, *Thurber: Writings and Drawings* (1996).
14. Brandon, "A Conversation with James Thurber: 'Everybody is Getting Very Serious," *The New Republic* (May 26, 1958). Reprinted in Fensch, *Conversations with James Thurber* (1989).
15. "Priceless Gift of Laughter," *Time* (July 9, 1951).
16. Thurber [Helen], "Long Time No See." *Ladies Home Journal* (July 1964).
17. Gilmore, "'Call Me Jim": James Thurber Speaking," *The Columbus Sunday Dispatch* (August 3, 1958). Reprinted in Fensch, *Conversations with James Thurber* (1989).

Fig. 32.1 James Thurber, *Certainly I can make it out. It's three sea horses and an h.* This cartoon was originally published in *The New Yorker* on March 6, 1937.

Figure 32.2 Photograph of James Thurber, c. 1950. The artist drawing with the aid of a magnifying loupe.

Figure 32.3 James Thurber, *The Lion Who Wanted to Zoom*, 1940. This drawing is characteristic of Thurber's spare but evocative animal drawings.

Figure 32.4 James Thurber, *Two Widely Distributed Rodents: The Barefaced Lie (left) and the White Lie*, 1948. These drawings are among the last Thurber made. Although there is no loss of wit, the rendering is much less precise than in *The Lion Who Wanted to Zoom* (see fig. 32.3).

32.3

Two widely distributed rodents: the Barefaced Lie (left) and the White Lie.

32.4

Fig. 33.1 Henri-Joseph Harpignies, *The Mediterranean Coast*, 1900. Oil on canvas, 32 1/4 x 25 9/16 in. (82 x 65 cm). Harpignies was near eighty when he made this painting. He complained of "dim vision" in his late years.

Fig. 33.2 Philip Connard, *Wilson Steer Sketching—90° in the Shade*, 1932. Watercolor on paper, 13 x 9.5 in. (33 x 24 cm). Although Steer had lost vision in his left eye to age-related macular degeneration by the time this picture was made, his right eye remained good and he could work comfortably with a sketchpad resting on his lap.

RETINAL DISEASE AND ART

Diseases of the retina attack the fundamental tissue that transforms light and image into neural signals for the brain to recognize. To ignore retinal disease in an artist is like ignoring damage or defects in a photographer's film: The camera can still take a picture, but gaps or distortion will need to be recognized or compensated for, and the nature of the problem with the film must be recognized, to interpret the effects. However, there are many types of retinal disease, and the implications for vision—and for art—depend on both the disease process and the locus of damage within the retina. For example, relatively nonspecific damage from infection, inflammation, or trauma may affect the retina along with the lens, iris, or other ocular tissues, and there is no "standard" pattern of damage. The visual effects will depend upon severity and whether the macula, the central visual area of the retina, is involved (see fig. 1.1). Diabetes affects the retinal vessels and can damage the macula, but it can also cause bleeding into the eye, glaucoma, and cataract. Retinal detachment, when the retina comes loose from the wall of the eye, is a disorder unique to the retina, and it will often destroy sight unless surgically repaired (an option only available with good expectations in the last half century). Hereditary diseases affect the genes that control retinal chemistry and function, and the effects can be relatively mild (as in color deficiency) or severe (as in retinitis pigmentosa, a progressive retinal degeneration). Retinal damage to the periphery may not have much effect on day-to-day life, but even a small lesion in the macula can be devastating to reading, driving, recognizing faces—and, of course, painting. The most prevalent macular disease—and retinal disease in general—is age-related macular degeneration or AMD (see also chapter 23).

This book highlights painters with a variety of retinal disorders to demonstrate effects on their artistic lives and their art. Francisco José de Goya (see chapter 34) and James Thurber (see chapter 32) had deep inflammatory diseases that affected not only the retina but other parts of the eye as well. Edvard Munch (see chapter 36) had hemorrhaging within his eye, most likely from blood vessels within the retina. The fascination in his story is that he painted images to show how the world looked to him both through the blood and as the problem resolved. Edgar Degas (see chapter 35) most likely had a macular disease. Although we don't know if it was hereditary or inflammatory, it worsened slowly over many decades. Age-related macular degeneration forced Georgia O'Keeffe (see chapter 37) to stop painting. There are other notable examples among artists who are not so well known.

AGE-RELATED MACULAR DEGENERATION (AMD)

The most common form of AMD, called "dry AMD," is a chronic and insidious process of gradual atrophy of the macula. It causes slowly progressive visual loss, affects many older individuals, and it is not treatable even today. More serious, but less frequent, is "wet" AMD, when new blood vessels grow into the aging macula, where they may bleed or cause reactive inflammation and scarring. This type of active AMD is treatable to some degree (if caught early), but prior to the new millennium doctors had little to offer.

An artist who may have suffered from dry AMD was the Frenchman Henri-Joseph Harpignies (1819–1916). Harpignies lived for nearly a century and worked until the end of his life, but he complained of dim vision in his last two decades. He was a prolific artist who created landscapes depicting the French countryside. His work underwent little variation over the course of his career, despite the contemporary trends of Impressionism, Post-Impressionism, Fauvism, and Cubism.

Harpignies led an adventurous, even racy life. He loved fine cuisine, drank two absinthes daily until the end of his life, and had a penchant for beautiful women. When the artist John Lewis Brown came to visit him at this studio, the not-so-young Harpignies led him to the bedroom, where a "supreme creature" was lying on her stomach, stretched out on the bed. "'Look at this,' he said, uncovering a sumptuous pair of buttocks, 'don't you think it is tempting for an artist? . . . And I have to be a landscapist.'"[1] As a nonagenarian, his eyesight was almost his only limitation.

The Mediterranean Coast (see fig. 33.1) was painted when Harpignies was almost eighty years old. Even at this advanced age, he would paint for two or three hours every day, although his vision was slowly failing. He was not able to depict details as carefully as before, and his work had become more decorative, with less faithful representation of the scene. The trees and ground form a denser clump than in his earlier, more subtle

33.1

33.2

paintings, and the lighting of the sky is stronger. Harpignies' slow visual loss at an advanced age has led to the speculation that dry AMD may have been the cause.[2] Cataract surgery would have been available to him if cataracts were the problem. Not long after completing *The Mediterranean Coast*, Harpignies abandoned the large format of oil painting and turned to etching and watercolors, which he continued to produce nearly to the time of his death.

The English landscape painter Philip Wilson Steer (1860–1942) had documented wet AMD, most likely due to age, and there are good descriptions of how his vision affected his painting. In the 1890s he was perhaps the best-known English proponent of Impressionism, though his style was personal and showed the influence of James McNeill Whistler and John Constable, among others. Steer painted in both oil and water-color, and when he began to lose his vision, the latter became his primary medium.

Steer grew aware of visual loss in his left eye in 1928, when he was sixty-eight, and consulted an oculist Dr. Mary Nelson, who provided considerable information on the affliction to Steer's friend and biographer Dugald Sutherland MacColl.[3] Steer was diagnosed with "macular choroiditis," which means inflammatory change in the central macula and was, in those days, a common term for wet AMD. Steer's right eye remained good, and he continued to work actively. Friend and colleague Philip Connard painted Steer sketching a scene on a hot day in 1932 (see fig. 33.2). Steer was a tall and somewhat corpu-

lent man, and Connard portrayed him holding the drawing pad flat on his lap, which suggests that his vision must have been good enough at the time to draw with precision. Connard noted that Steer's main priorities were: "(1) Shelter from the wind, (2) Proximity to a lavatory, (3) Shade from the sun, (4) Protection from children . . . and finally (5) Subject.[4]

In 1935 Steer's right eye began to show the same symptoms as the left. He consulted another specialist, who was not comforting: He put a hand on Steer's shoulder at the end of the visit and said, "God help you!" In relating this story, Steer grumbled, "If God could not help me He would not charge me three guineas."[5] Dr. Nelson confirmed that Steer retained side vision up to the time of his death. He was able to walk alone to the end, and read large headlines in the paper. As late as 1938 he was still trying to paint a few watercolor seascapes, looking around the blind spots to put objects in their proper places. She wrote: "It was tragic to see him making these last efforts, but characteristically he made light of his affliction and often said to me that it was just as well that he could not paint any more; that he had painted enough and that many people painted far too many pictures!"[6]

Jane Munro, an art historian, wrote that Steer's style "became looser yet compositionally more refined with his deteriorating vision"[7] after 1927. This shift may in part represent the stylistic freedom of age and maturity since it is not clear that Steer's second eye was significantly affected until 1935.

EARLY ONSET MACULOPATHY

There are a number of disorders that can affect the macula at younger ages than is typical of AMD. For example, Degas first

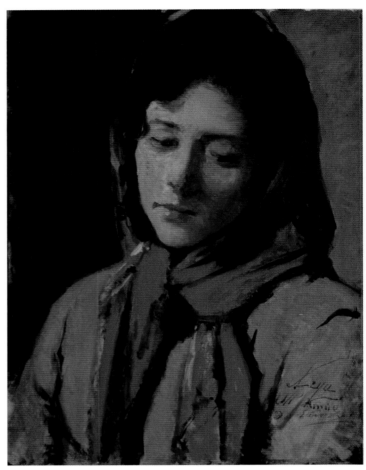

noted visual loss in one eye at age thirty-six (see chapter 35), and thus, his long-evolving problem could not have been AMD. Silvestro Lega (1826–1895), a contemporary of Degas, was reported to have had "a serious eye disease" when about forty-six years old.

Lega was a member of the "Macchiaioli," an artistic and political group of artists working in Florence in the 1850s and 1860s. Caught up in the political turmoil of nineteenth-century Italy, they sought to restore Florence to preeminence as a cultural center. "Macchiaioli" comes from the word "macchia," which has multiple meanings,[8] including a spot of paint, a patch, a nucleus, and (in the nineteenth century) an artistic sketch. Typical of the artists of the Macchiaioli, Lega sought to glorify the countryside and local people, but without the refined elegance of formulaic Salon painting, and using a technique that was often rough or sketchy (see fig. 33.3).

Later in his career, Lega continued to paint landscapes as well as portraits of friends and idealized impressions of village women. However, his eye disease in 1872–73 reportedly reduced him "to seeing in nature only the broad masses, the solid planes, the general tonalities, with the almost complete elimination of those subtle hues, those fine details, those analyses of form that had so distinguished [earlier] works."[9] This dramatic description is perhaps hard to accept, given that his paintings from that time show no obvious change in style or clarity, and we have no other documentation about the nature of the event.

It would seem he experienced some type of chronic or progressive eye disorder, and as a result, he feared for his eyesight for the remainder of his life. A friend wrote in 1885: "Now Silvestro Lega works relentlessly despite an eye disease which has tormented him for several years.[10] Another friend offered another impression, recalling a visit in 1885 or 1886, when the artist "was already seeing little and his health was anything but good. His great preoccupation was with his eyesight, which he realized, with dismay, he was steadily losing . . . Gradually, he came to see details less and less; when he was working, he was able to make very few distinctions among colors. And sometimes, with the model before him, he would ask me what I saw in a shadowed area which he could see only as a mass, without distinguishing any detail; or he would ask me if a color that he had on his palette was a white or a yellow, a blue or a green, etc. It surprised me that, seeing so little, he could still do such good things and work with so much passion . . . "[11]

It seems doubtful that Lega had significant cataracts (which would likely have been operated upon) or glaucoma (which if severe enough to be symptomatic would likely have progressed to near total blindness). While both of these conditions were well known in that era, retinal disease was still not easily diagnosed or characterized. Lega's story is a bit like Degas', who continued to work over a forty-year span as his vision progressively diminished. The symptoms of poor detail and also poor color distinction can certainly be caused by retinal disease, although the color difficulties from maculopathy are harder to classify than those from a yellowish cataract. Lega was too young for AMD but, like Degas, may have suffered from some other inflammatory, vascular, or hereditary disorder of the retina.

33.5

Fig. 33.3 Silvestro Lega, *Primo dolore (First Grief)*, 1863. Oil on canvas, 27 x 19.5 in. (39 x 50 cm). This painting, which is rustic yet sensitive, depicts Lega's skills in midcareer.

Fig. 33.4 Silvestro Lega, *Ritratto di contadina (La scellerata?)*, 1889–90. Oil on canvas, 15 x 11 in. (38 x 28 cm). Lega maintained his rustic approach in this late painting, but with a rather flat and impersonal countenance. The artist had reduced vision in the latter part of his life.

Fig. 33.5 Maurice Denis, *The Sunny Beach, or "September Evening,"* 1911. Oil on canvas, 51 3/16 x 70 7/8 in. (130 x 180 cm). This modernistic painting is typical of Denis' style.

Fig. 33.6 Maurice Denis, *The Yacht Run Aground at Trégastel*, 1938. Oil on wood, 13 x 20 1/2 in. (33 x 52 cm). This late painting by Denis shows less detail and delicacy. This shift could be stylistic, but the artist had suffered for years with distorted and moderately blurred vision.

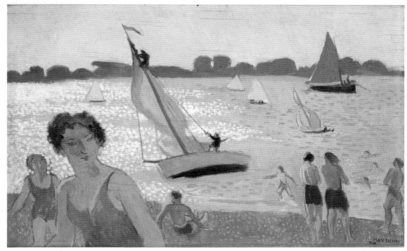

33.6

Because the Macchiaioli style is not a precise one, it is hard to see evidence of these visual problems in Lega's work. The coloring of his late paintings is relatively simple, but he had always used subdued colors, and even early landscapes were dominated by amber hues; and works from his last decade, such as *Ritratto di contadina (La scellerata?)* (see fig. 33.4), show decreasing facial and landscape details. His portraiture became less expressive of each subject's individuality, and his late paintings of young women have been described as "generalized and sentimentalized."[12] Nevertheless, Lega was still producing respectable works up to the year of his death in 1895.

Retinal difficulties also plagued the French painter and art theorist Maurice Denis (1870–1943). Denis is known for his role in founding Les Nabis in 1890, a group of innovative painters who opposed the traditional naturalism of academic art at that time and advocated pictorial symbolism. Denis wrote: "It is well to remember that a picture, before being a battle horse, a nude woman, or some anecdote, is essentially a flat surface covered with colors assembled in a certain order."[13] Les Nabis broke up within a decade, and Denis turned increasingly to religious subjects. He painted in a modernistic style on canvas (see fig. 33.5) as well as working in other mediums, such as stained glass, for churches.

Denis kept a journal throughout much of his life, which describes his ocular difficulties. The sequence of events has been detailed by Philippe Lanthony, MD.[14] In 1916 at the age of forty-six, Denis recognized the first signs of trouble. He noticed a small blind spot in his left eye in September, but in October wrote: "My eye gets better." In 1918: "The blind spot has become enormous. I can no longer read and it is torture to work." In 1919: "I have lost one eye and prepare myself for the idea of losing the other and entering into darkness." But he did not go blind, and the right eye was not affected until 1923, at which point Denis was discouraged, stopped painting, and resigned himself to be "blind and poor." Within a few weeks

he returned to work on frescoes and glass windows, although he explained: "I work there with such difficulty, my right center being completely obstructed." In 1929 he wrote: "I see well only up close . . . I can no longer distinguish well objects that are in poor lighting or are back-lit." His color vision had weakened as well: "I lose myself in gray . . . I don't recognize the colors of the Giotto, yellow, and the sky which was blue became warm gray." These symptoms continued to plague him for many years.

Lanthony has proposed that Denis may have had a disorder called central serous chorioretinopathy, which causes small blisters of fluid (localized retinal detachments) to form in the macula. The fluid may come and go, so that vision may spontaneously improve, but repeated attacks eventually result in permanent blind spots that are often small and central. The cause is unknown, though it may involve vascular effects of adrenalin and cortisone, and some patients suffer attacks during times of

33.7

Fig. 33.7 George Du Maurier, *Helas! Mon jeune ami* [Frédéric Hairion, MD, on left, with Du Maurier], 1898. This print from a posthumous book re-creates a visit between Du Maurier and the doctor many years before.

Fig. 33.8 Sir Joshua Reynolds, *Unfinished Self-Portrait*, c. 1792. Oil on wood, 29 ½ x 24 ¼ in. (75 x 63 cm). This self-portrait is believed to have been found on Reynold's easel at the time of his death. The artist portrays himself wearing glasses, presumably for myopia.

stress. Denis' first attacks came during World War I, and at a time when his wife was in the throes of a painful illness.

A classic symptom of this disorder is "metamorphopsia" or distortion of objects, because the local elevation of the retina disrupts the precise focusing of images on the retina. Denis did not specifically write of this symptom, and one does not see distortions in his work. However, some of the later paintings, such as *The Yacht Run Aground at Trégastel* (see fig. 33.6) lack the delicacy of earlier ones, whether for visual or stylistic reasons. Most of his work after his vision failed was large scale (e.g., church decorations), and he had assistants who would presumably correct abnormalities. Denis recognized his visual limitations and adapted his work accordingly. He wrote that it was necessary "to approach painting with freedom, without great detail, according to my visual means." He commented on the example of Degas, whose visual difficulties were well known: "Degas no longer made heads or hands, nor any of the details that he had rendered with such perfection and taste, but movement surrounded by spots, as a bouquet."

MYOPIA AND RETINAL DETACHMENT

A high degree of myopia predisposes an individual to both maculopathy, which can mimic AMD, and to retinal detachment. The late Victorian artist and author George Du Maurier (1834–1896) may well have had a myopic retinal detachment in one eye, although the effects on his art were more a result of the medical advice he was given than of the disease itself.

Du Maurier was an illustrator for *Punch* magazine, for which he drew cartoons as social commentary. After working more than thirty years for *Punch*, he wrote a novel, *Trilby* (1894), probably the best-selling work of fiction in both the United States and Britain at the end of nineteenth century.[15] One character, Svengali, is remembered for his ability to exert tremendous mind control over others. Du Maurier's granddaughter Daphne wrote the romance novel *Rebecca*, which Alfred Hitchcock made into a classic suspense film in 1940.

Du Maurier was studying painting in Belgium in 1854 when,

without any warning signs or symptoms, at the age of twenty-three, he suddenly lost the vision in his left eye: "I was drawing from a model, when suddenly the girl's head seemed to me to dwindle to the size of a walnut. I clapped my hand over my left eye. Had I been mistaken? I could see as well as ever. But when in its turn I covered my right eye, I learned what had happened. My left eye had failed me; it might be altogether lost. It was so sudden a blow that I was as thunderstruck."[16]

He consulted an eminent ophthalmologist Frederic Hairion, MD (1809–1888), and *Helas! Mon jeune ami* (an engraving, based on a drawing by Du Maurier) depicts the bearded artist in the ophthalmologist's study (see fig. 33.7). Hairion dilated his pupils with atropine and examined him with an ophthalmoscope. This instrument had only been invented by Helmholtz four years earlier in 1850, and early models were difficult to use. The source of light was a candle or oil lamp that was reflected into the eye, using a mirror with a central opening through which the physician could see the ocular interior. Hairion told Du Maurier that "it was merely a congestion of the retina—for which no cause could be assigned." He later added that there was also "detachment of the retina." He told Du Maurier that he would be cured in less than a month."[17] However, Du Maurier's sight with his left eye never improved.

Du Maurier returned to England and found that newspapers, magazines such as *Punch*, and book publishers were looking for skillful, imaginative illustrators. His vision with the good right eye remained stable for a long time, but in late 1871 he noticed something unusual was happening to the sight of that eye. Deathly afraid of losing his remaining eye ever since the acute episode of the left eye seventeen years earlier, he became extremely agitated. He had a wife and four small children to support and no savings to fall back upon. Early in 1872 he consulted the most prominent ophthalmologist in London, Sir William Bowman (1816–92). While Bowman's diagnosis is unknown today, he advised Du Maurier that he could resume drawing, but only if he worked on a larger scale, which the physician believed would reduce eyestrain.

After consulting Bowman, Du Maurier drew twice as large as he had previously. His engraver would then reduce the drawing photographically before cutting the images into blocks for printing. Du Maurier had difficulty adhering to Bowman's advice, since he was a moderate myope and working on a small scale came more naturally to him. Even his late works feature numerous details, but at least one historian feels that the quality of Du Maurier's late work suffered: "He simply could not adjust to the greater scale, and disappointed with himself, he reverted to old themes and formulas for his drawings."[18]

What was the proper diagnosis for Du Maurier's ocular problems? The event at age twenty-three may have been a retinal detachment, as myopes have a higher risk of detachments than non-myopes. In his semi-autobiographical novel *The Martian*, Du Maurier described in the third person what were probably observations about himself: "He had to confess to himself that his eye was getting slowly worse instead of better; darkening day by day . . . He could still see with the left of it and at the bottom, but a veil had come over the middle and all the rest."[19] This description is consistent with an inferior detachment, which would blur mainly vision above. The event in Du Maurier's good right eye is unlikely to have been another retinal detachment, however, because it did not progress. It was presumably an independent minor event, but we have no real clues.

Du Maurier's vision in the right eye stabilized and he was able to continue creating illustrations for *Punch* for nearly two more decades and for books for even longer. Was Bowman's advice wise? The risk of myopic detachment might be enhanced by intense focusing on near work, but this would not be much of an issue at age thirty-eight (when the eye's focusing power is diminished by age anyway). Furthermore, Du Maurier could have eased any strain on his eyes by using reading glasses or magnifiers. Paradoxically, much of the effect of Du Maurier's

ocular illness on his art may have come from misguided medical recommendations rather than a loss of vision.

Sir Joshua Reynolds (1723–1792), the first president of the Royal Academy in England and the most respected portrait painter of his time, may have suffered a similar fate. In 1789 the sight of his left eye became suddenly obscured, and within ten weeks was entirely gone.[20] The cause is unknown, but it may have been a myopic retinal detachment as he was moderately nearsighted. One famous, much-copied self-portrait shows him wearing glasses (see fig. 33.8). A pair of his glasses has been measured at -4.00 diopters.[21] Reynolds became depressed over fear that his good eye would be similarly affected, and was afraid to paint, read, or write. He immediately gave up his career, even though his vision was not impaired in the good eye.

Reynolds eventually softened his resolve to avoid all visual tasks, and he painted occasionally although never again on a regular basis. He wrote letters in a precise hand, which provides evidence that his vision remained good.[22] In September 1791, his bad eye developed an inflammatory tumor. He was again fearful for the good eye, although his physician assured him that it would not be affected. Reynolds died soon after, in February 1792, of an enlarged liver, leading some to speculate that the left eye had had a malignant melanoma that metastasized. We shall never know for sure, but we do know that between two and three years of painting was largely abandoned for fear of visual loss rather than visual loss itself.

NOTES

1. Crespelle, *Les Maitres de la belle époque* (1966), p. 84.
2. Lanthony, *Les Yeux des peintres* (1999), p. 147.
3. MacColl, *The Life and Setting of Philip Wilson Steer* (1945), p. 153.
4. Ibid., p. 119.
5. Ibid., p.153.
6. Ibid.
7. Munro, "Philip Wilson Steer," in *The Grove Dictionary of Art*, Turner J, editor (1996), p 596.
8. Boime, *The Art of the Macchia and the Risorgimento: Representing Culture and Nationalism in Nineteenth-Century Italy* (1993), p. 4.
9. Broude, *The Macchiaioli* (1987), p. 171.
10. Ibid., p. 174.
11. Ibid., p. 175.
12. Ibid., p. 180.
13. Denis, in Nochlin, *Impressionism and Post-Impressionism 1874–1904; Sources and Documents* (1966), p. 187.
14. Lanthony, *Les Yeux des peintres* (1999), pp. 91–94.
15. Pick, *Svengali's Web: The Alien Encounter in Modern Culture* (2000), p. 2.
16. Sherard, "The author of "Trilby." *McClure's Magazine* (1895), pp. 397–398.
17. Du Maurier, *The Martian, A Novel with Illustrations by the Author* (1898), p. 195.
18. Kelly, *The Art of George Du Maurier* (1996), p. 9.
19. Du Maurier, *The Martian, A Novel with Illustrations by the Author* (1898), 214.
20. Leslie and Taylor, *Life and Times of Sir Joshua Reynolds: With Notices of Some of His Contemporaries* (1865), p. 546.
21. Levene, "Benjamin Franklin, FRS, Sir Joshua Reynolds, FRS, PRA, Benjamin West, PRA, and the Invention of Bifocals" (1972).
22. Ingamells and Edgcumbe, *The Letters of Sir Joshua Reynolds* (2000), p. 213.

33.8

34

GOYA'S STRANGE MALADY

The great Spanish artist Francisco José de Goya y Lucientes (1746–1828) was hit by a severe illness in midcareer. Its principal features were loss of vision and hearing, ringing in the ears, vertigo, weakness on one side of the body, confusion, abdominal pain, and malaise. Goya recovered most of his faculties over the next few months, including his eyesight, but remained permanently deaf. As an artist dependent on sight, he was greatly distressed by even the temporary loss of vision, and he was unable to work at all for months afterward. He tried to continue employment as an instructor, but inability to communicate with his students forced him to stop teaching. Later he turned inward. He departed from his early style of light, lyrical compositions and bright colors, typified by works such as *Children with a Cart* (see fig. 34.1). Toward the end of his life he went through a morbid phase and created a number of works that were dark in color and in theme, brooding and horrific, including *Saturn Devouring One of His Sons* (see fig. 34.2).

The cause of Goya's near-death experience has long been the subject of speculation. The early supposition of syphilis has not held up well. Theories of stroke, seizure disorder, and schizophrenia lack substantiation. Two more recent proposals—lead toxicity and immune-mediated illness—have strengths as well as weaknesses. A more likely cause was an infectious disease, such as malaria, meningitis, or encephalitis, perhaps complicated by quinine toxicity (cinchonism). The relevance for our discussion here is that ocular disease may, for an artist, have ramifications that extend beyond vision.

EARLY LIFE

Goya was the most important Spanish artist of the late eighteenth and early nineteenth centuries. He was active as an artist for more than fifty years and created approximately seven hundred paintings, three hundred prints, and nine hundred drawings. His early work belongs to the Rococo period, while his late work extends into the Romantic era. Many of the Impressionists and Post-Impressionists admired his work. They appreciated his use of color, his bold compositions, and his elimination of excessive detail. He is often considered the first modern artist and a link to the progressive styles of the late nineteenth century.

Goya was born near Zaragoza in northeastern Spain, where

34.1

he occasionally assisted his father, who was a master craftsman. Goya's first important artistic opportunity came in 1774, when he was appointed as a designer to the Royal Tapestry Factory of Santa Bárbara in Madrid. In 1780 he was elected to the Royal Academy of Fine Arts. He was sought after as a portraitist, enjoyed success at the court, and was appointed painter to the king. Spain went through considerable political upheaval during Goya's lifetime, but the artist was able to maintain his position as a prominent painter. When the French occupied Spain in 1806, he kept active by painting the French generals. The British under Arthur Wellesley, the 1st Duke of Wellington, defeated the French, and Goya painted a portrait of the duke. During the Peninsular War, Goya depicted the atrocities he had witnessed. Following the war, the court of the Spanish king, Ferdinand VII, challenged Goya's loyalty to Spain during the French occupation. He deflected questions skillfully and asked for official permission to depict Spain's battles against Napoleon. In 1815 he was forced to appear before the tribunal of the Spanish Inquisition to explain why he painted nudes in an irreligious manner. Fortunately, with the aid of well-placed friends, he was able to avoid any penalty.

Goya's unusual illness occurred during the winter of 1792–93 and had a marked impact on him, both physically and psycholog-

Fig. 34.1 Francisco de Goya, *Children with a Cart*, 1778. Oil on canvas, 57 1/4 x 37 in. (145.4 x 94 cm). This early work depicts a light-hearted theme.

Fig. 34.2 Francisco de Goya, *Saturn Devouring One of His Sons*, 1821–23. Oil on canvas, 57 1/2 x 32 11/16 in. (146 x 83 cm). This late painting differs not only in precision and color tonality, but in its morbid theme.

34.2

southern Spain.[2] He got only as far as Cadiz, when sickness forced him to stop at the home of a friend, Sebastian Martinez. In January 1793 Goya reported being "bedridden for two months with colicky pains."[3] A friend, Martin Zapater, commented on the illness: "Since the nature of his malady is of the most fearful, I am forced to think with melancholy about his recuperation."[4] The illness lasted several months. In March 1793 Martinez explained that Goya was unable to write because it troubled his head, "which is where all his illness lies."[5] But the artist soon recovered his writing ability and in a sad letter to Zapater stated: "I am standing, but so badly that I do not know if my head is on my shoulders." He had no appetite and had no idea what was happening to him.[6] The length of his illness, deafness, and vertigo were depressing. Martinez wrote Zapater that Goya was improving and that better weather and a visit to a spa would help.[7] The ringing in his ears and deafness were still present, but his eyesight and sense of balance had improved markedly.

A friend indicated that Goya suffered from apoplexy, which left him unable to write.[8] However, at that time the word *apoplexy* did not necessarily imply a stroke as it does today, and in fact could refer to almost anything which affected the head. A year later, Goya was not quite back to normal psychologically, as is evident in a letter he wrote at the time: "I am the same, referring to my health, one moment raving with a humor that I myself cannot stand, the next more moderate, like now when I've picked up the pen to write you, and already I am tired."[9]

POSSIBLE DIAGNOSES: INFECTIOUS DISEASES

Several early investigators believed that Goya's clinical constellation of loss of vision, hearing, and motor ability, combined with behavioral changes, was highly suggestive of late-acquired syphilis. Syphilis was well known in that era and was commonly presumed to be the cause of complex symptomatology. Goya's wife was often pregnant but delivered infrequently, and there was suspicion that she had acquired a venereal disease that caused the miscarriages and infant deaths. Of course, childhood mortality was high at that time, and infectious diseases killed many children. Contrary to the diagnosis of syphilis is the fact that Goya's first major illness began in 1792, at age forty-six, yet he lived until 1828 and remained creative for most of the rest of his life.

Epidemics raged through Europe during the eighteenth and early nineteenth centuries, especially during periods of war. The

ically. This illness lasted several months, gravely affected his eyesight, and left him permanently deaf. The cause has long been debated, and the facts are few. The only documents that remain are a few notes and letters by Goya and some of his friends. There is no information from any physician, no precise description of his loss of vision and hearing, and no laboratory data. This situation is not unusual for an eighteenth-century case, but it makes evaluation of his medical problems difficult.

Goya had been in relatively good health until 1792. His self-portraits done before that year reveal vitality and confidence (see fig. 34.3). At age forty-one, Goya was still working hard, but when he looked in a mirror, he recognized the inevitable signs of aging: "I have become old, with so many wrinkles that you wouldn't recognize me except for the dullness and sunken eyes."[1]

Late in 1792 Goya became severely ill. For reasons that are poorly understood, he left Madrid for a trip to Andalusia in

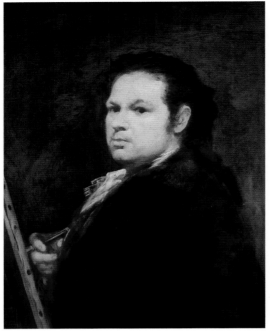

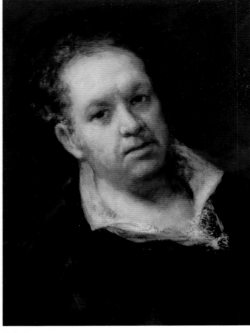

Fig. 34.3 Francisco de Goya, *Self-Portrait,* 1783. Oil on canvas, 34 x 23 ¹/₂ in. (86 x 60 cm). Goya in mid-life.

Fig. 34.4 Francisco de Goya, *Self-Portrait,* 1815. Oil on canvas, 20 x 18 in. (51 x 46 cm). Goya near seventy years of age.

Fig. 34.5 Francisco de Goya, *Self-Portrait with Dr. Arrieta,* 1820. Oil on canvas, 45 ¹/₈ x 30 ¹/₈ in. (114.6 x 76.5 cm). This painting was a thank-you note from Goya to his physician, after the artist recovered from a severe illness in 1819.

34.3 34.4

most devastating diseases, because of their high mortality rates, were plague, malaria, typhoid, and yellow fever. Smallpox, influenza, typhus, meningitis, and dysentery were also major problems. Even measles left many people permanently blind or deaf and carried a high fatality rate. Malaria was endemic in Europe during the eighteenth and nineteenth centuries.

IMMUNE SYSTEM DISEASES

An English ophthalmologist has suggested that Goya's illness was due to a rare systemic inflammatory disease known as Vogt-Koyanagi-Harada syndrome, or uveoencephalitis.[10] Typical features of the disease are recurrent inflammation within the eye, auditory disturbances, and loss of pigment in the skin and hair, and Goya is not known to have had any change of skin or hair color. Cogan's syndrome, an even rarer disorder, also of unknown cause, is characterized by inflammation in the cornea, vertigo, ringing in the ears, and deafness, often with some general symptoms of malaise and weight loss, as Goya had. The loss of hearing may be severe and permanent, but the vision loss is usually transitory and a long life is possible. Inflammatory diseases of blood vessels could also have caused Goya's illness.

LEAD TOXICITY

In 1972 a psychiatrist published the provocative hypothesis that Goya suffered from lead toxicity.[11] He had observed several patients whose mental and physical problems were similar to Goya's, and they had been exposed to lead, often in an industrial setting. Some of the paint used during Goya's lifetime was lead based, particularly lead white, which he used as a primer.[12] At that time paint pigments came in solid form and had to be ground into a powder before being mixed with oil and other materials. Goya did mix his own paints when away from the court; however, when at the royal court, he had an assistant who ground up his pigments for him.[13] Given that his illness struck when he was working at the court, a severe toxic episode at that time is puzzling.

QUININE TOXICITY

Quinine toxicity, or cinchonism, may follow ingestion of the bark of the cinchona tree or its many alkaloids, and it can affect many systems of the body. Vision may be blurred temporarily, defects in color vision may occur, hearing may be lost (although rarely permanently), and there may be ringing in the ears and vertigo. If the central nervous system is injured, headaches, confusion, delirium, seizures, and even coma may take place. Digestive symptoms, which Goya had, include abdominal pain, nausea, vomiting, and diarrhea. Cinchona bark has been used for centuries, and written reference to its use in treating fever and malaria dates from the early seventeenth century. Goya was familiar with the bark and recommended it to his friend Zapater in a letter from 1787: "God permits the tertiaries [tertiary fever; malaria] to be shortened by a pound of cinchona bark that I have bought you, from the best that can be found, well selected, and as good as that from the King's pharmacy."[14] If Goya's illness of 1792–93 was malaria, he is likely to have ingested a considerable amount of the bark over an extended period of time.

The exact diagnosis of Goya's illness remains unclear, and he may have suffered from a combination of afflictions. Regardless, this review shows the complexity of his symptoms and his suffering, as well as the limitations of eighteenth-century medicine, both relevant as he struggled to return to painting.

THE SECOND HALF OF GOYA'S LIFE

Goya was never the same after enduring his severe illness. His later self-portraits reveal an older man with less formality (see fig. 34.4). He returned to Madrid, happy that his vision had recovered, but deaf and feeble. Deafness had an obvious impact on his interpersonal relationships. He was able to temporarily continue as director of painting at the Royal Academy, but deafness made teaching difficult and so he resigned. His artistic style changed as well. It had been evolving even before his illness, away from

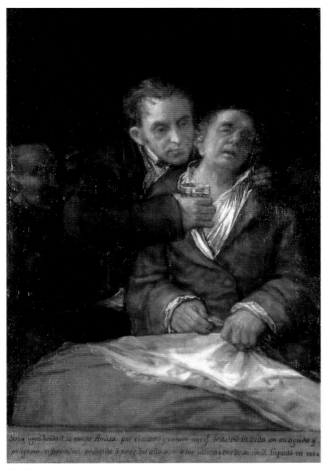

The years from 1820 to 1824 were a turbulent time for Spain. In 1823 the French king, Louis XVIII, sent troops to Spain, overturned the liberal government, and named King Fernando VII absolute ruler. On assuming power Fernando pledged amnesty to the liberals but instigated a rule of terror instead. Fearing a return of the Inquisition with restoration of the monarchy, Goya emigrated from Spain to Bordeaux in southern France. He was relieved to escape the terror he had known in Spain, and his style of this time reflects a new sense of freedom. The colors of his paintings became bright again, which suggests that much, if not all, of the darkening of his canvases may have been intentional and psychological rather than a result of altered color perception.

Soon his health deteriorated, and in 1825 he developed urologic difficulty. A trio of physicians identified "paralysis" and "hardening" of his bladder, and a tumor was found in the perineum.[15] In the early nineteenth century this problem was untreatable, and he died at age eighty-two.

We may never know for certain what crippled Goya in 1792. What we do know is that he survived, regained vision, and returned to painting with both darkened psyche and palette. Both brightened when the political climate brightened. How much of his stylistic change was due to changes in his vision is unclear; yet his temporary visual loss, coupled with prolonged malaise and deafness, altered the man and his approach to art. Much as stylistic changes of aging artists may represent a combination of factors, so may the extraordinary swings of technique that characterize the work of Goya.

34.5

the earlier brightly colored, lyrical images such as *Children with a Cart* (see fig. 34.1). The titles of paintings made before and after the illness give an idea of his shift. *Wedding* and *Blanket Tossing* were made just prior to the illness, while *The Madhouse at Saragossa* and *Fire at Night* followed. He said he no longer could create large tapestry designs and turned to painting on a smaller scale. Many of his most important portraits were painted at about this time, including the well-known nude and clothed *majas*. In 1799 he published the *Caprichos*, a series of aquatints that contains disturbing images. Insanity and witchcraft are themes in these prints. Following the disastrous Peninsular War, Goya painted some of the morbid scenes he had witnessed and created another fine group of prints, *Disasters of War*.

Goya had another bout with illness in 1819, during a period when "the pest" (probably yellow fever) ravaged Spain. The following year Goya painted *Self-Portrait with Dr. Arrieta* (see fig. 34.5). The annotation reads: "Goya, thankful to his friend Arrieta for the skill and care with which he saved his life during this short and dangerous illness endured at the end of 1819, at seventy-three years of age. He painted it in 1820." Beyond this caption, little is known about Goya's second major illness. After recovering from it, he became more withdrawn. During the early 1820s Goya painted the walls of two rooms of his country house with a series of dark, morbid scenes. The titles of some of these works indicate the eerie nature of the subject matter: *Witches' Sabbath*, *Holy Office* [of the Inquisition], and *Old Woman and Skeletal Figure Eating*. This is also the period in which he painted *Saturn Devouring One of His Sons* (see fig. 34.2).

NOTES

1. Goya, *Cartas a Martin Zapater* (1982), pp. 178–179.
2. Tomlinson, *Francisco Goya: The Tapestry Cartoons and Early Career at the Court of Madrid* (1989), p. 213.
3. Sambrico, *Tapies de Goya* (1946), documento 158, p. 108.
4. Ibid., documento 159, p. 108.
5. Ibid., documento 160, p. 109.
6. Goya, *Cartas a Martin Zapater* (1982), pp. 214–215.
7. Sambrico, *Tapies de Goya*, documento 161, p. 109.
8. Torres, Goya, *Saturno y el saturnismo* (1993), p. 43.
9. Goya, *Cartas a Martin Zapater* (1982), p. 218.
10. Cawthorne, "Goya's Illness," *Proceedings of the Royal Society of Medicine* (1962).
11. Niederland, "Goya's Illness: A Case of Lead Encephalopathy?" *New York State Journal of Medicine* (1972).
12. Muller, *Goya's "Black" Paintings: Truth and Reason in Light and Liberty* (1984), p. 37.
13. Moffitt, "Painters 'Born Under Saturn': The Physiological Explanation" (1988).
14. Goya, *Cartas a Martin Zapater* (1982), p. 176.
15. Sambrico, *Tapies de Goya*, documento 264, p. 164.

Fig. 35.1 Edgar Degas, *Self-Portrait*, c.1862. Oil on canvas, 36 ¼ x 27 ³/₁₆ in. (92 x 69 cm). Degas painted this self-portrait when was twenty-eight years old.

THE BLINDNESS OF DEGAS

The French Impressionist Edgar Degas (1834–1917) (see fig. 35.1) suffered from a chronic and progressive eye disease. The records of the ophthalmologists who are believed to have treated him no longer exist; and except for his correspondence and the memoirs of his friends, the only primary sources of information are the works of art he made. His story, considered in light of ophthalmological knowledge in the late nineteenth century, yields insights into both his disability and its effects on his work.

EVOLUTION OF THE OCULAR PROBLEM

Degas' visual problem became severe in 1870. He was thirty-six that year and had enlisted in the National Guard during the Franco-Prussian War. Many years later, Degas wrote that during this time he could not see a rifle target with his right eye.[1] He blamed his loss of vision on exposure to the elements while a sentinel during the siege of Paris.[2]

Degas discussed his eyesight in 1871 with his friend and colleague, the English painter Walter Richard Sickert. Degas described the effect of bright sunlight on his eyes while painting outdoors: "I have just had and still have a spot of weakness and trouble in my eyes. It caught me at Chatou, by the edge of the water in full sunlight, while I was doing a watercolor, and it made me lose nearly three weeks being unable to read or go out much, trembling all the while lest I should remain like that."[3] Degas believed that his problems were due to overexposure to cold weather and to sunlight. The fact that he did not continue to paint outdoors, unlike many of his fellow Impressionists, may have been because of experiences such as this one.

In 1873 Degas traveled to New Orleans, farther south than he had ever been, to visit relatives on his mother's side. In a letter sent back to France he complained of the intensity of the sunlight in Louisiana: "The light is so strong that I have not yet been able to do anything on the river. My eyes are so greatly in need of care that I scarcely take any risk with them at all. A few family portraits will be the sum total of my efforts."[4] Few works from this voyage exist, and those that do are interior scenes. They contain occasional references to the outdoors, indicated by streaks of white paint, perhaps signifying the artist's sensi-

tivity to light. The only fully finished painting from the trip is *Portraits in an Office (New Orleans)*, also known as *The Cotton Exchange, New Orleans* (see fig. 7.2), which Degas created in his studio from sketches made on-site. This became the artist's usual method of working.

During his sojourn in Louisiana, Degas developed a close friendship with his brother René's wife, Estelle Musson de Gas (see fig. 35.2), who also happened to be a first cousin. The importance of their relationship goes beyond their blood and marital relationships. Estelle suffered from a progressive eye disease, at that time called ophthalmia, a nonspecific and now obsolete term. At age twenty-five she lost all useful vision in her left eye. Her sight deteriorated, and by age thirty-two she was blind in both eyes. The parallel of Degas' situation to the more extreme case of his cousin could not have escaped the artist's attention. In fact, his medical history bears a striking similarity to hers: Both suffered severe loss of vision in each eye, with one eye preceding the other by a few years. Degas' portraits of Estelle, as well as his letters home, reveal a great deal of sympathy for her, but his paintings of her show no sign of her blindness. If any evidence of eye disease was apparent, he chose not to depict it.

When Degas wrote his friend and artistic colleague James Tissot in 1873,[5] he described the problems of his eyes in bleak terms: "This infirmity of sight has hit me hard. My right eye is permanently damaged." This letter, written shortly after his return from New Orleans, reveals how alarming that trip must have been for Degas. In another letter he said he expected to "remain in the ranks of the infirm until I pass into the ranks of the blind."

Degas' condition continued to worsen throughout the 1880s and 1890s. Sickert described a conversation with his friend, in which the problem of a blind spot in the center of Degas' vision figured prominently: "It was natural that during the years when I knew him (from '83 onwards), that he should sometimes have spoken of the torment that it was to draw, when he could only see around the spot at which he was looking, and never the spot itself."[6] Painting became an "exercise of circumvention,"[7] of avoiding this blind spot. Sickert confirmed Degas' severe loss of central vision in both eyes down to a level of visual acuity that is now defined as legal blindness.

TREATMENT

Degas' notebooks and letters mention several ophthalmologists who may have treated him from 1870 until his death in 1917. One was Charles Abadie, MD (1842–1932), an eminent eye physician and surgeon, teacher, and collector of art. Only a few words in Degas' handwriting link him to Abadie. In the notebook the artist used in 1872 and 1873, he recorded the doctor's name and address: "Abadie . . . oculist de la part de Manet, rue St. André des Arts."[8] This notation simply indicates that the painter Edouard Manet had consulted and probably recommended Abadie, who may have prescribed the treatment described by Degas in 1874: "My eyes are very bad. The oculist wanted me to have a fortnight's complete rest. He has allowed me to work just a little until I send in my pictures. I do so with much difficulty and the greatest sadness."[9]

Maurice Perrin, MD, another distinguished ophthalmologist of the time, is mentioned in the notebook Degas used between 1875 and 1878.[10] Unfortunately, there is no other information given.

In 1891 Degas was treated by ophthalmologist Edmond Landolt, MD (1846–1926). A founder of the journal *Archives d'Ophtalmologie* and of the French Ophthalmological Society, Landolt was particularly concerned with ocular surgery, strabismus (crossed eyes), and the measurement of vision, and like Abadie, he was interested in art. Landolt treated other artists, including Degas' friend the American Impressionist Mary Cassatt (see fig. 29.1). Although Landolt's medical records no longer exist, the books and journal articles he wrote provide a great deal of information about his approach to clinical medicine. Degas referred to Landolt's treatment in his correspondence, and in 1892, he wrote to a fellow artist, Evariste de Valernes: "You will see me with a comparatively ominous looking contraption [stenopeic spectacles, or spectacles with only a slit opening] over my eyes. They are trying to improve my sight by screening the right eye and allowing the left one to see through a small slit."[11]

At this time, Degas was also aware of the work of the ophthalmologist Richard Liebreich, MD, and his 1872 publication "Turner and Mulready—On the Effect of Certain Faults of Vision on Painting, with Especial Reference to Their Works."[12] This article was published simultaneously in England and France, and had great impact on both sides of the channel for decades. In Liebreich's words: "If it is the dispersion of light which, as in Turner's case alters the perception of nature, it can be partly rectified by a kind of diaphragm with a small opening."[13] Inspired by Liebreich's report, Degas and Landolt may have wanted to try this approach, to see if it would be useful to another artist who suffered from ocular disease. Unfortunately, Degas found stenopeic spectacles to be both an embarrassment and not helpful.

The artist Maurice Denis, who knew Degas, wrote after Degas' death about his eye problems.[14] He reported that Degas told him: "I can see your nose but I cannot see your mouth." He added that Degas suffered from chorioretinitis and was treated by Empress Eugenie's oculist. This oculist may in fact have been Richard Liebreich, who treated the empress's mother. He cured her of acute glaucoma surgically in the period prior to the discovery of topical anesthesia.[15] The term *chorioretinitis* implies inflammation but was used in the nineteenth century to describe many conditions that scar the retina, including heredi-

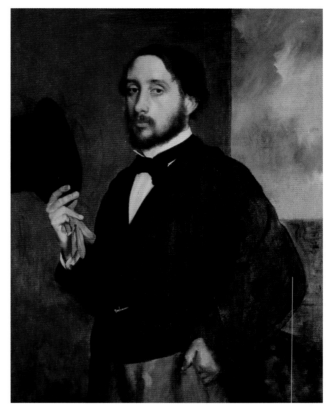

35.1

tary degenerations and even age-related macular degeneration. Denis said Degas went to the sisters of Saint Germain for care of Degas' eyes after consulting the oculist. This information is not surprising, considering the fact that in the nineteenth century, there was no effective form of therapy available to treat retinal degeneration.

Several pairs of Degas' glasses are in the collection of the Museé d'Orsay in Paris.[16] The lenses vary from no prescription to lenses that corrected mild myopic astigmatism. The first pair is a pince-nez with no prescription to the lenses. The lenses are tinted neutral gray, which blocks out about 85 percent of the incoming light. This pair of glasses appears in an 1876 portrait of Degas by Marcellin Gilbert Desboutin and was probably an early form of his treatment. The second pair is also a pince-nez, tinted slightly more blue than the first pair. These lenses have a mild myopic and astigmatic correction. The third pair is a deeply tinted pair of spectacles with temples. The power of each lens is -1.50 diopters. Photographs of Degas taken from 1890 to 1900 show him wearing glasses that may have been these. The mild myopic correction indicates that he should have been able, if his retinas were functioning normally, to read most print without glasses. The fourth pair is the stenopeic spectacle prescription described previously. The right-eye side of these spectacles has an occluder; Landolt may have been trying to keep stray light out of Degas' weaker eye to reduce glare and discomfort. The left-eye side of these spectacles has a metal covering with a long narrow slit that is 1.5 by 15 millimeters in length. Slits of this type have been used for centuries to reduce light exposure in arctic and desert regions, where intense direct and reflected light can cause extreme visual discomfort.

35.2

Fig. 35.2 Edgar Degas, *Madame René de Gas*, 1872–73. Oil on canvas, 28 ¾ x 36 ¼ in. (72.9 x 92 cm). Madame René de Gas (Estelle Musson) was Degas' first cousin and sister-in-law, and she became blind early in life.

DIAGNOSIS

As mentioned previously, Degas believed that the loss of useful sight in his right eye was related to the cold, damp weather he had experienced during the Franco-Prussian War and that the problem was exacerbated by the harsh sunlight of Louisiana. Since he suffered no known neurologic deficit or other major health problems until very late in his long and productive life, his deficit must have been ocular in origin. The treatment he received is consistent with this diagnosis.

Degas must have retained some sight in his right eye for many decades after his initial complaint in 1870, and his eyes remained straight. Photographs of the artist taken throughout his life show no evidence of deviation of his eyes. If he had total loss of vision in the right eye, some deviation of that eye would have been likely to have followed. The fact that Degas' eyes remained straight indicates that he retained peripheral fusion (i.e., the ability to combine the peripheral visual fields of the two eyes into a single coherent image).

Another reason to conclude that Degas retained some vision in his right eye is the fact that Landolt treated his right eye with an occlusive lens. If Degas had no vision in that eye, he would not have needed an occluder. Degas may have told Landolt that the remaining vision in his weaker right eye was making it difficult for his left eye to see.

Some commentators have suggested that Degas suffered from corneal disease or from uveitis (inflammation within the eye).[17] However, there is no evidence that Degas experienced any externally visible signs of eye disease. Certainly his friends,

physicians, or Degas himself would have noticed overt signs, such as redness or swelling, or a whitish pupil.

Diagnosis of a disease of the posterior segment of the eye was often difficult during the late nineteenth century. Mydriatic drops were not always used to dilate the pupil for examination and ophthalmoscopes were crude by today's standards. Furthermore, Landolt was not an expert in retinal disease, despite his wide fame. (The sections of his textbook on ophthalmology concerning retinal disease were written by his co-author Louis de Wecker, MD, not by Landolt.[18]) Degas' close friend and biographer, Daniel Halevy, questioned, "What was the true nature of Degas' problem? The oculists seem not to have understood it."[19] It is likely that the abnormality of Degas' eyes was a subtle one, not easily identified by the methods available a century ago.

Denis' brief remembrance that Degas suffered from an untreatable chorioretinitis is the most specific bit of information available.[20] We have not found reference to this important statement in any other description of Degas, but it clearly leads to the conclusion that Degas suffered from a retinal disease that may have been infectious, degenerative, or familial in nature. An infectious case, such as tuberculosis, is one possibility, with scarring involving the right macula more than the left. Hereditary macular degeneration is another. The fact that his first cousin Estelle Musson de Gas had similar findings makes a familial form of macular degeneration a distinct possibility. However, the hereditary pattern was not dominant, since no one else is known to have been affected, and it would have been very bad luck for both Edgar and Estelle to have had the same recessive condition.

Degas complained of sensitivity to light. An individual who suffers from retinal disease may have this symptom and require an extended period of time to recover from stimulation of the retina by bright light.[21] Retinal disease could thus have caused Degas difficulty in painting outdoors. While inflammation of the anterior segment of the eye can also produce light sensitivity, there is no indication that Degas was treated for this type of problem. Landolt's therapy for corneal disease included topical therapy, even surgery, and subconjunctival injections, but there is no evidence that Degas underwent any of these treatments. Landolt's therapeutic program for Degas matches his therapy for retinal disease: bed rest, avoidance of strong light, and use of tinted lenses for retinal problems.[22]

Degas' primary difficulties were with poor visual acuity, but he also encountered difficulty in distinguishing colors, especially late in his life. At one point he was having so much trouble that he asked one of his models to identify the colors of his pastels.[23] This is not inconsistent with the concept that he had macular disease, because mild color vision abnormalities are common in macular disease and these patients often require greater color saturation to make up for the washed-out appearance of color.[24] The intense colors of Degas' late works may have been due, at least in part, to his eye disease (although brighter pastels had recently come on the market). However, color difficulties in retinal disease are rarely as severe as those with cataract until very late (when the macular damage is extreme); and furthermore, Degas' use of color was never as delicate as Monet's, even in earlier years.

Degas' late works show a loss of form when compared to his earlier works. Philippe Lanthony, MD, a French ophthalmologist and expert in color vision, measured how Degas' cross-hatchings became broader and more widely separated as he aged.[25] The changes in cross-hatching correlate well with Degas' reduction in vision.

Sickert's description of Degas' blind spot strongly supports a diagnosis of central retinal disease, and central visual loss is characteristic of disease involving this area. Degas' complaint that "he could only see around the spot at which he was looking, and never the spot itself" indicates that he retained peripheral vision despite his disability. All commentators on Degas' vision have assumed this comment refers to Degas' left eye, since the right eye saw next to nothing. The stenopeic spectacles prescribed by Landolt would not have been effective under circumstances of central visual loss. The stenopeic slit would have reduced glare, but it would also have made images dark by reducing the amount of light reaching areas of Degas' retina that still worked. A magnifying glass, which Degas found helpful until his vision deteriorated too severely, was more useful because the magnified image extended to the portion of the retina that functioned normally.

Some individuals have suggested that Degas exaggerated his visual problems in order to gain sympathy from his friends or to forestall social situations he found uncomfortable. The art dealer Ambrose Vollard wrote: "Degas used to pretend to be more blind than he was in order to not recognize people he wanted to avoid." Vollard also described how Degas used his deteriorating eyesight as an excuse for not attending art exhibitions with his friends: "'My eyes! My poor eyes!' Immediately after such a refusal Degas took out his watch and said, without

the slightest hesitation, 'It's a quarter past two.'"[26] While there may be some psychological basis for Degas' behavior, this incident can also be explained on physical grounds: The fine details of a person's face or a painting would not have been clear to a person affected by central retinal disease, since the portion of the retina concerned with fine details would not function properly. However, a watch face with large, dark hands in marked contrast to a light-colored background would have been easily seen, particularly if held close to the eyes. Its image would be spread out broadly on the retina and would not require the fine acuity of the macular region. Undoubtedly, given his condition, Degas would have had a watch with large hands.

OTHER OPINIONS

In 1965 the art historian Quentin Bell wrote that "the symptoms of his [Degas'] malady suggest, to an expert, the development of senile macular degeneration."[27] Bell consulted a physician but he gave no further information. We agree that macular damage is a reasonable diagnosis but would delete the word "senile." Degas was not senile in 1870, when his symptoms became apparent. He was only thirty-six years old.

The ophthalmologist Patrick Dacre Trevor-Roper, MD, published his book on eye disease of artists in 1970. He wrote: "Degas was highly myopic, and wore heavy glasses during his adult life."[28] He attributed the loss of central vision in Degas' right eye to the retinal degeneration of high myopia. Trevor-Roper was undoubtedly unaware of the artist's glasses, which show that Degas was only mildly nearsighted. In the revised edition of his text (1988), Trevor-Roper changed his opinion. He wrote that Degas "certainly had damage to the macula (the central patch of the retina), which could well be a degenerative change, either from a dystrophy, a sequel to his myopia, or even to an iridochoroiditis."[29] On the basis of Landolt's stenopeic spectacles, Trevor-Roper assumed the artist also suffered from irregular astigmatism. However, Landolt's text indicates stenopeic slits were also used for diseases other than irregular astigmatism.

The art historian Richard Kendall published a study of Degas' vision in 1988.[30] He contacted Trevor-Roper and accepted his diagnosis of corneal disease. We have difficulty in accepting this diagnosis in the absence of substantiating medical records or photographs. We agree with Kendall's findings that the vision in Degas' right eye after 1870 was nearly, but not totally, lost, and that sensitivity to light and a central blind spot, or scotoma, existed in his left eye. Kendall offered two diagnoses that give us difficulty, however. He wrote that Degas had a lazy right eye that deviated outward, i.e., was amblyopic from exotropia. Abundant photographs of the artist exist, but none shows a convincing deviation. Since Degas' ocular problem originated about 1870, when he was thirty-six years old, it could not have been amblyopia, which begins early in childhood when the brain first learns to recognize images from each eye. Kendall accepted the diagnosis of retinal disease in the left eye, which is reasonable to us.

Lanthony published his views in 1990.[31] Ever cautious, he feels any diagnosis can only be provisional and that a corneal abnormality or iridochoroiditis (inflammation within the eye) are the most likely possibilities.

IMPACT ON HIS CREATIONS

Degas never specifically described the impact of his disability on his art. He referred only to his symptoms, such as his blind spot. His works themselves reveal Degas' adaptation to his visual disturbance in ways that written documents have not. Degas' adjustments to his limitation are found in the applications of his art and in his choice of subject matter. They mark his art as original—and deeply personal. Although affected by a progressive eye disease, Degas' new vision did not prevent him from continuing to express his experiences.

Degas began to adjust to his limited sight soon after the onset of his problem in the early 1870s. He explored alternatives to the complex process of oil painting and experimented with many other mediums—sculpture, photography, monotypes, and, as the disease progressed, pastel. In particular, he found sculpture (see fig. 35.3) and pastel to be conducive to the themes in which he was interested. With both, he could work quickly and broadly, without concern for mixing colors on a palette or having to wait periodically for oil to dry.

Since several factors may have contributed to the stylistic changes in Degas' late works, including a conscious simplification of his compositions as well as failing eyesight, the relative contribution of each is difficult to determine. However, there is no question that his sense of artistic form, which did not require excellent visual acuity, remained sound. It is interesting to compare three of his works based on the same theme: dancers in the ballet (see figs. 35.4–35.6). These compositions were created at approximately thirteen-year intervals, from c. 1885 to c. 1910. Over this twenty-five-year period, the lines of color became coarser and more widely separated, the shading became diminished, and the details of face and limb are progressively lost. One critic who visited Degas at this studio in 1907 described his work on a pastel: "The execution was a bit summary like everything currently being done by this man, whose eyes are becoming worse each day. But what vigorous and magnificent drawing!"[32] A similar series of nudes in the bath is shown in chapter 38, where simulations of Degas' own view of these works add another dimension to the analysis.

Degas' way of seeing is a modern point of view. If modern life includes adjusting to the chopped-up fragments of our visual experience, then Degas' personal and professional history makes him an excellent spokesman for modern experience. Degas' visual problems certainly contributed to the way he interpreted the world. He would not have been the same artist if he had had normal sight. In the case of this man, visual limitations have created, for the viewer, a liberating experience.

35.3

NOTES

1. Blance, *Propos de peinture: De David à Degas* (1919), p. 286.
2. Halevy, *My Friend Degas* (1964), p. 22.
3. Guerin, *Degas Letters* (1947), p. 12.
4. Ibid., p. 25.
5. Ibid., p. 34.
6. Sickert, "Degas" (1923).
7. Ibid.
8. Reff, *The Notebooks of Edgar Degas* (1976), p. 119.
9. Guerin, *Degas Letters* (1947), p. 39.
10. Reff, *The Notebooks of Edgar Degas* (1976), p. 127.

11. Guerin, *Degas Letters* (1947), pp. 184–185.
12. Liebreich, "Turner and Mulready—On the Effect of Certain Faults of Vision on Painting, with Especial Reference to Their Works" (1872).
13. Ibid.
14. Barazetti, "Souvenirs de Maurice Denis" (1937).
15. Ravin, *From Von Graefe s Clinic to the École des Beaux-Arts: The Meteoric Career of Richard Liebriech* (1992).
16. Lanthony, "La malvision of d'Edgar Degas" (1990).
17. Ibid.
18. de Wecker and Landolt, *Traitécomplex d ophtalmologie*, (1880–1889).
19. Halevy, *My Friend Degas* (1964), p. 22.
20. Barazetti, "Souvenirs de Maurice Denis" (1937).
21. Wu et al, "Macular Photostress Test in Diabetic Retinopathy and Age-related Macular Degeneration" (1990).
22. Landolt and Gygax, *Vade Mecum of Ophthalmological Therapeutics* (1898), pp. 21, 40–42, 59, and 113–117.
23. Michel, *Degas et son modèle* (1919).
24. Fine, "Earliest Symptoms Caused by Neovascular Membranes in the Macula" (1983); Alvarez, King-Smith, and Bhargava, "Spectral Thresholds in Macular Degeneration" (1983).
25. Lanthony, *Degas et al fréquence spatile* (1991).
26. Vollard, *Degas: An Intimate Portrait* (1937), p. 22.
27. Bell, *Degas: le viol* (1965).
28. Trevor-Roper, *The World Through Blunted Sight* (1970), pp. 33–34.
29. Trevor-Roper, *The World Through Blunted Sight* (1988), p. 39.
30. Kendall, "Degas and the Contingency of Vision" (1988).
31. Lanthony, "La malvision of d'Edgar Degas" (1990).
32. Moreau-Nelaton, "Deux heures avec Monsieur Degas." In Lemoisne, *Degas et son oeuvre* (1946), pp. 257–261, n. 218.

35.4

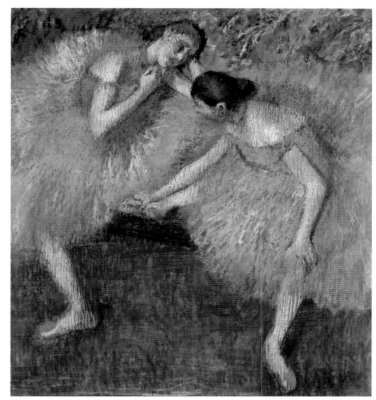

35.5

Fig. 35.3 Edgar Degas, *Dancer Looking at the Sole of Her Right Foot*, c. 1900. Bronze, 18 ¼ x 9 ⅝ x 6 ¾ in. (46.4 x 24.4 x 17.1 cm). Example of a late sculpture by Degas.

Fig. 35.4 Edgar Degas, *Dancers at Rest*, 1884 or 1885. Pastel on paper, 29 ½ x 28 ¾ in. (75 x 73 cm). This pastel is carefully drawn and delicately shaded, demonstrating that Degas' vision was still relatively good at the time it was made.

Fig. 35.5 Edgar Degas, *Two Dancers*, c.1898. Pastel on paper, 37 ½ x 34 ¼ in. (95.5 x 87 cm). Roughly thirteen years later, a similar subject is drawn much less precisely in terms of outline, facial features, and shading.

Fig. 35.6 Edgar Degas, *Two Dancers Resting*, 1910–12. Pastel on paper, 30 ¾ x 37 ¾ in. (78 x 96 cm). In Degas' very late pastels, made when his vision was poor, similar dancers are drawn with inconsistent lines, almost no facial features, and irregular, coarse coloring and shading.

35.6

MUNCH AND VISIONS
FROM WITHIN THE EYE

The Norwegian painter Edvard Munch (1863–1944) is famous for his haunting images that probe psychological themes such as love and death. His expressionistic canvases in striking colors, done at the turn of the nineteenth to twentieth century, influenced the development of German Expressionism and predate Fauvism (see fig. 36.1). His most famous picture is *The Scream*, in which stark perspective and a brilliant red sky heighten the sense of mystery and terror. Munch painted throughout his long life, but his work was interrupted in 1930 by hemorrhaging in his left eye. As his sight recovered, he made a remarkable series of images showing how the world appeared through his diseased eye.[1] In some of these drawings and paintings, he depicted the debris within the eye, while in others he revealed his aesthetic or emotional response to the disease.

Munch's father, a physician, was a strict and religious man who could never quite rationalize the death of Munch's mother of tuberculosis when their son was only five.[2] Death struck the household again ten years later, when Munch's beloved older sister, Sophie, also died of tuberculosis. The teenaged Edvard had watched his sister waste away from the disease, and the apparent failure of God to avert this disaster contributed to his ultimate rejection of religion as well as to his move toward a bohemian lifestyle. In his artistic work, he often incorporated images of death intermingled with visions of love, anxiety, and sex. Munch had shown a talent for art as a child, and he chose painting as a career, much to the consternation of his father. He soon developed an individual style, influenced in part by a visit to Paris in 1885, where he saw the revolutionary changes in contemporary French art brought about by Impressionism. In his most productive years, the decades before and after the turn of the century, Munch lived mainly in Berlin and Paris, and attained international stature as an important artist. However, he suffered a nervous breakdown in 1908, and in 1910 moved back to Norway, where he continued to paint in Ekely (near Oslo) until his death in 1944 at age eighty.

Munch was a somewhat sickly child, yet he outlived all but one of his three siblings. Little is known of his medical history, and he was not reported to have had any major disorders or disabilities. His left eye was apparently weak for many years, but the origin or nature of this problem is unknown. In 1904 he was punched in a fight, but there is no record of whether a blow to the head accounts for the poor vision in the left eye.[3] Disability in the left eye didn't seriously affect Munch until May 1930, when at the age of sixty-seven, he suffered a hemorrhage within his right eye. His vision was now poor in both eyes, and he was unable to draw or paint for several months until the hemorrhage began to clear. Throughout August and September of 1930, Munch documented what he saw through the diseased right eye in a series of drawings and paintings. These images show not only the resolution of an intraocular hemorrhage but also how Munch's changing visual perceptions became integrated into his view of life and art.

The nature of Munch's hemorrhage is unknown. He was cared for by Professor Johan Raeder,[4] one of the eminent eye specialists of the time in Oslo, but records of the examinations are lost. Raeder strictly advised his patient to rest so that the eye would heal, and he even gave the artist the following note to ward off would-be visitors: "Herr painter Edvard Munch suffers from an acute eye disease caused by a long-standing overexertion. He needs complete bodily and mental rest for a long period of time. Any disturbance, oral, written, by telephone or by telegraph, is to be entirely avoided."[5]

One of the more likely causes of a spontaneous hemorrhage into the interior of the eye is hypertension, but there is no direct evidence that Munch was hypertensive. Hemorrhages can also occur from vascular malformations, from a tear in the retina, or from age-related changes within the retina (although these usually cause permanent loss of vision). The evidence is too sketchy to draw any firm conclusions, but it appears that the hemorrhage developed within the retina (since Munch had a fixed blind spot) and then broke out into the vitreous gel that fills the interior of the eye. It is likely that some underlying ocular or physical condition predisposed the artist to ocular hemorrhages, since a similar hemorrhage would occur in his weaker left eye in 1938.[6]

It is perhaps ironic that Dr. Max Linde, one of Munch's friends and patrons in Germany, was a prominent ophthalmologist.[7] Linde was an avid art collector who bought his first painting by Munch in 1902, and remained in contact with the artist until Linde's death in 1940. However, there is no record that Munch corresponded with him about his ocular hemorrhages.

One image that Munch drew during this period of ocular

Fig. 36.1 Edvard Munch, *Melancholy (Laura)*, 1899. Oil on canvas, 43 ¹/₂ x 49 ¹/₂ in. (110 x 126 cm). Laura is Munch's sister, who was institutionalized for mental illness.

Fig. 36.2 Edvard Munch, 1930. Watercolor on paper, 19 ¹/₂ x 25 ¹/₂ in. (50 x 64.6 cm). These sketches illustrate the artist's perceptions through his vitreous hemorrhage. The colored circles may represent an effect from the sun on an electric light. The middle image in the bottom row shows a more shadowy pattern with a branched bird's-head figure near the top.

convalescence was a set of six concentric circles, some of which are colored vividly (see fig. 36.2). None of these circles is explicitly labeled, but they resemble auras about bright lights in a mist or fog. Under the circumstances, one may guess that they represent a view through Munch's resolving hemorrhage, possibly while he was looking toward an electric light or the sun. (Some of his drawings made during his convalescence were annotated "electric light" or "sunshine.")[8] It is interesting that the colors in this series of images show no consistent order and do not follow the rainbow; some of the drawings are blue on the inside and red on the outside (as those in figure 36.2), while others are the reverse. Munch must have been intrigued by these patterns of light and color that appeared in his eye, even if they were the signs of disease.

Munch also drew a number of sketches of the dense but shadowy blind spot in his vision as the blood began to absorb. In some of these sketches, the shadow from the blood is quite opaque and has the vague shape of a skull or of an inverted heart. In others, the obscuration is more tenuous and appears as a circular haze with a small, dense branched figure at its upper edge (see figs. 36.2 and 36.3). In one of these drawings, Munch drew an arrow to show that when he stared directly at one of these dark shadows, the center of his gaze would actually be at a point near the top of it; and when he superimposed the blind spot shadow over sketches of his room, it always appeared in the lower part of the scene. This is intriguing, in terms of speculation about possible causes for the hemorrhage. Images are always inverted within the eye (as they are in a camera) so that the location of a blind spot in the lower field of view indicates that the blood or debris would have been located in the *upper* part of the eye. Hemorrhage usually settles inferiorly by gravity, and causes a loss of vision for objects above. Thus, the source of bleeding in Munch's eye was probably within the upper part of the retina,

and clots or debris may have persisted either on the retina itself or within the upper portion of the vitreous gel.

Munch viewed his resolving eye problem with precise clinical interest. Some of his sketches of the shadows in his eye are accompanied with notes indicating the exact distance of the paper from his face, and the conditions of observation. For example, he drew some letters, partially obscured by his blind spot (see fig. 36.4), along with the notation: "In the shadow of full sunshine after the eye has been covered, reading distance, spectacle lens #5."[9] Another sketch is annotated: "Bedroom, electric light, no glasses, one-half meter."[10] He even superimposed a grid of lines

36.3

36.4

over some of the drawings to more accurately show the extent of the blind spot, and to help him follow its improvement (see fig. 36.5). This simple idea was, in fact, a most perceptive innovation, and was well ahead of the medical practice at the time. Munch was known to have had a scientific interest in optics and photography, but we do not know whether this quantitative grid method of charting the progress of a blind spot was Munch's idea or something suggested by Dr. Raeder.

Munch's technique of self-examination anticipated by seventeen years the publication, by Swiss ophthalmologist Dr. Marc Amsler, of printed grids that are now widely used by patients with macular degeneration as a means of self-plotting and recognizing changes in their disease.[11] It is inherently difficult to plot the central visual field when acuity is poor, because it is difficult to fixate on a small target. What Munch—and later Amsler—recognized is that even people with poor vision can orient their gaze quite well within the outline of a square grid, and thus can draw the area of their own blind spots. Munch's grids were not published, of course, and Amsler in Switzerland was undoubtedly unaware of Munch's private sketches in Norway.

36.5

Munch likened the small dark spot at the top of the shadow, which has a beaklike extension, to the head of a bird (see figs. 36.2 and 36.3).[12] Viewed in this manner, the larger shadows (see fig. 36.5) appeared to him like large and ominous wings. This "bird" was an image that the artist followed over time, writing at one point: "The distance between the bird's beak and the new beak beneath seems longer—I can make out two letters while earlier just one—the bird's neck seems longer—I am clearing up on the left side."[13]

As the major opacity in his eye cleared, he was left with smaller fragments of debris that floated within his eye: "There are dark spots which show up like small flocks of crows far up when I look at the sky—can they be blood clots which have been resting in the periphery of the damaged circular part—which by a sudden movement or by the effect of sharp light are moved from their origin—when they suddenly disappear it looks as if they fly down to their first place."[14]

The fibrillar bird's head probably represents small amounts of blood or tissue in the vitreous gel that fills the back of the eye. Alternatively, parts of the bird may represent a detachment of the vitreous gel, independent of the blood. The vitreous gel tends to shrink and collapse with age, and while this event is ordinarily benign, strands of the partially collapsed gel cast shadows on the retina. These shadows are called "floaters" and seem suspended in air when viewed against a bright sky or white wall. The birdlike shape could represent such a floater.

As his vision improved, Munch made pictures of his room, or outdoor scenes, to the extent that they would be visible over the residual debris in the eye. Some of these pictures are simply representational and clinical, but others illustrate his past or present emotions, or incorporate the shadows artistically rather than objectively. By the time these drawings and paintings were made, Munch was rapidly improving and must have been hopeful of a return to full artistic activity. Yet he had not forgotten that when the hemorrhage first occurred, and before the prospects of recovery were evident, he was fearful of both blindness and death. For example, in one self-portrait (see fig. 36.6), the dense blind spot has become Death's head hovering over the foot of his bed, threatening the artist as he covers his weak left eye to evaluate the view through the right one. On the same day Munch also drew an outdoor scene in which a tenuous circular

Fig. 36.3 Edvard Munch, 1930. Sketch on paper, 8 x 8 in. (20 x 20 cm). Munch illustrated the branched intraocular debris, which reminded him of a bird (see figs. 36.5, 36.7, and 36.8).

Fig. 36.4 Edvard Munch, 1930. Sketch on paper, 15 ¼ x 15 ¼ in. (6 x 6 cm). Letters are broken up by the artist's blind spot.

Fig. 36.5 Edvard Munch, 1930. Sketch on paper, 8 x 8 in. (20 x 20 cm). The intraocular shadow is drawn over a grid, perhaps as a means of following the size and shape of the blind spot over time.

36.6

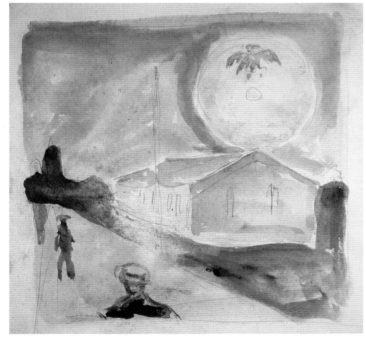

36.7

Fig. 36.6 Edvard Munch, 1930. Watercolor and pastel on paper, 12 ½ x 19 ½ in. (32 x 50 cm). Munch portrays himself in bed, checking his vision in the right eye. The ominous dark spot from the hemorrhage looms as Death's head over the foot of his bed.

Fig. 36.7 Edvard Munch, 1930. Watercolor and pencil on paper, 23 x 25 ½ in. (9 x 10 cm). In this outdoor scene, the circular shadow and bird become a part of the sky.

Fig. 36.8 Edvard Munch. 1930. Oil on canvas, 31 ½ x 38 in. (80.5 x 64.5 cm). In the artist's room, a figure (presumably the artist) is standing in a pose of fear or anguish, while a sinister bird blots out much of the scene.

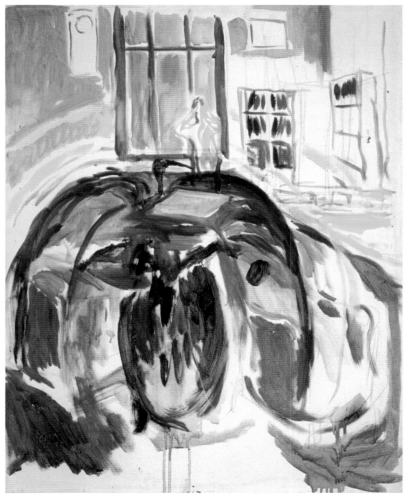

36.8

shadow appears high in the sky, perhaps representing an aura about the sun over which is hovering the omnipresent and mysterious floating bird (see fig. 36.7—compare fig. 36.3). The blind spot here is painted high in the field of view where it must be symbolic rather than representational. In another picture (see fig. 36.8—compare fig. 36.5), Munch shows himself standing in his room, looking at the large and ominous bird with his hands pressed to his face in a pose similar to that of his famous painting *The Scream*. It is also noteworthy that he worked intensively with photography during his convalescence, possibly as a hedge against visual problems that might interfere with painting.

An interesting sideline to these pictures is the fact that Munch appears in several of them, covering his left eye to evaluate the recovery of his right. Munch painted many self-portraits throughout his long career, and in making them, he was known to use a mirror which, by necessity, reverses right and left. In his convalescent works, however, the left eye is always covered correctly; these are not mirror-generated self-portraits but rather sketches made from memory to illustrate what he saw and what he felt.

Munch's vision apparently cleared further as the year progressed, and birds and blind spots disappeared permanently from his work after 1931. Munch returned to full-scale painting and continued to work practically up to the time of his death, producing evocative images such as *Self-Portrait Between Clock and Bed* (see fig. 36.9). Munch's eye disease was only a brief interlude in his long career, and it occurred long after he had produced his most famous works. Although his regular painting was interrupted for nearly a year, his career was not cut short or permanently compromised. Thus, his work from this period affords an interesting glimpse into his method and his mind, and under circumstances that we know did not alter his ultimate approach to art. His sketches and drawings from the period of his illness are in one sense clinical in that they describe what he actually saw. And yet, they describe it in the unmistakable style of the artist. Like a subject doing a Rorschach test, Munch shares the visions evoked by his intraocular debris and incorporates these visions into paintings that are both artistic and poignant. One might argue that in some respects these pictures are no different than any other paintings of places, people, or events, in which an artist has invested the scene with his or her own interpretation. The difference here is that an integral part of the scene lies within the eye, and the painter is revealing a landscape that no one else could have seen.

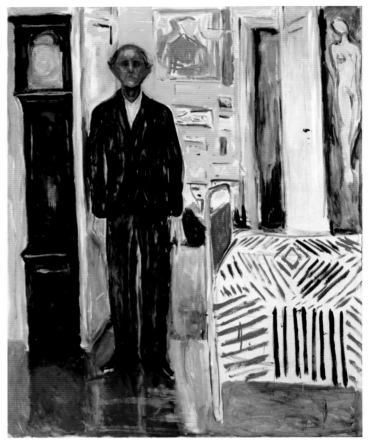

36.9

NOTES

1. Eggum, *Munch and Photography* (1989).
2. Heller, *Munch: His Life and Work* (1984).
3. Arne Eggum, conversation with Michael F. Marmor, June 22, 1995.
4. Marmor, "A Brief History of Macular Grids: From Thomas Reid to Edvard Munch and Marc Amsler" (2000).
5. Raeder, letter to Edvard Munch, May 10, 1930. The same letter was re-issued almost word for word on Sept. 27, 1930.
6. Raeder, letter to Edvard Munch, March 29, 1938.
7. Marmor, "A Brief History of Macular Grids: From Thomas Reid to Edvard Munch and Marc Amsler" (2000).
8. Notes on sketches T2143, T2148, T2165, Munch Museum, Oslo.
9. Notes on sketch T2149, Munch Museum, Oslo.
10. Notes on sketch T2148, Munch Museum, Oslo.
11. Amsler, "L'examen qualitatif de la fonction maculaire" (1947).
12. Eggum, *Munch and Photography* (1989); Lanthony. "L'oiseau d'Edvard Munch" (1994).
13. Notes on sketch T2136, Munch Museum, Oslo.
14. Notes on sketch T2167, Munch Museum, Oslo.

Fig. 36.9 Edvard Munch, *Self-Portrait Between Clock and Bed*, 1940–42. Oil on canvas, 58 ⁷/₈ x 47 ⁷/₁₆ in. (149.5 x 120.5 cm). Munch was nearly eighty when he painted this image.

Fig. 37.1 Georgia O'Keeffe, *Black Mesa Landscape, New Mexico/Out Back of Marie's II*, 1930. Oil on canvas mounted to board, 24 ¹/₄ x 36 ¹/₄ in. (61.6 x 92 cm). This luminous painting depicts O'Keeffe's beloved New Mexico hills.

THE BLURRED WORLD OF GEORGIA O'KEEFFE

The paintings of Georgia O'Keeffe (1887–1986) are easily recognized. Her unique, oversize images depict subjects in an unexpected manner and size that is often disproportionate to our usual way of seeing them. The colors are bright, sometimes very luminous, as was the sun at her home in New Mexico. Her painted edges are often hard, as is more characteristic of high-contrast black-and-white photography. These edges differ from the modulated contours of most old master paintings and are at odds with the art school aphorism "there are no lines in nature." However, this sharpness is balanced by dramatic shading and contrast effects (see chapter 6), which give her work its feeling of three-dimensionality.

O'Keeffe's sensual flower paintings depict magnified blossoms characterized by broad sweeps of color (see fig. 6.8). Verging on abstraction, these up-close views compel the observer to look more carefully at aspects of a flower that might ordinarily be overlooked and thus find new forms and associations in the blends of shapes and colors. The graded colors and overlapping hills in O'Keeffe's distinctive landscapes (see fig. 37.1) evoke Asian brush paintings.

Late in her life, O'Keeffe wrote: "Objective painting is not good painting unless it is good in the abstract sense."[1] In this spirit, she often found beauty and joy in simple shapes, such as those in *Red and Pink Rocks and Teeth* (see fig. 37.2). The shading in this work is subtle and tantalizing, and the natural objects abstracted. O'Keeffe leads the viewer to focus on light, shading, and dark, although some of the perceptions may be illusory from Mach band effects (see chapter 6).

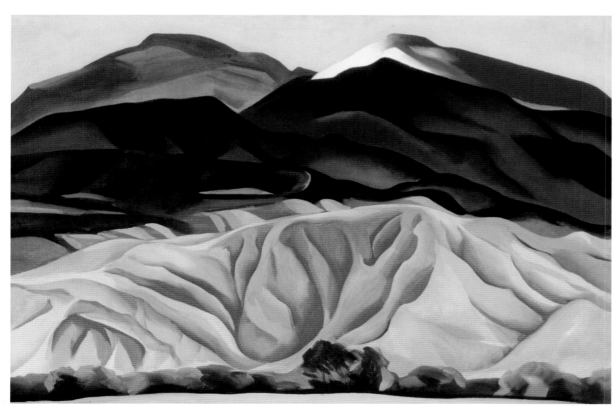

37.1

37.2

Fig. 37.2 Georgia O'Keeffe, *Red and Pink Rocks and Teeth*, 1938. Oil on canvas, 21 x 13 in. (53.3 x 33 cm). O'Keeffe painted natural objects with precision and with characteristically subtle shading and contrast.

Fig. 37.3 Georgia O'Keeffe, *Black Rock with Blue Sky and White Clouds*, 1972. Oil on canvas, 36 x 30 ¹/₂ in. (91.5 x 77.5 cm). In this late painting of a similar subject to *Red and Pink Rocks and Teeth* (see fig. 37.2), there is little shading, the shadow is hard-edged and black, and the clouds and pedestal are roughly rendered.

37.3

AGE-RELATED MACULAR DEGENERATION

O'Keeffe was fortunate to live into her ninety-ninth year. With advancing age, however, came severe loss of vision due to macular degeneration and a central retinal vein occlusion. These ocular problems were a great hardship and caused the need for major changes in both the artist's lifestyle and her approach to art. Someone who enjoyed being in control of her destiny, she became forced to rely on others for the most basic activities of everyday life. She had been proud of her excellent vision and had come to take it for granted; and except for a brief episode of ocular inflammation associated with an attack of measles in adulthood, her eyesight had always been remarkably good.

For a period of time in her sixth decade, O'Keeffe was an enthusiastic follower of the Bates method of eye exercises.[2] In a book entitled *Perfect Sight Without Glasses*, the eccentric William Horatio Bates, MD, describes his technique for getting rid of the need for spectacles.[3] He claims that poor eyesight is caused by poor visual habits. One of his exercises includes the dangerous recommendation to flutter the eyelids while looking directly at the sun. It is not known if O'Keeffe performed this specific exercise, but if she did, it may have been a factor in the development of her loss of vision. She may also have been influenced by the British author Aldous Huxley, whom she knew. He had

first tried the Bates method in 1937,[4] and eventually became such a strong advocate of Bates's theories that he wrote a book entitled *The Art of Seeing*, which relates his experiences with the method.[5] Huxley claims that his vision improved so greatly from Bates's exercises that he no longer needed glasses (although it is not clear that his vision actually changed).

O'Keeffe was obstinate about her vision and refused to wear sunglasses, even in the powerful New Mexico sunlight.[6] She objected to the distortions of colors that tinted lenses induce. However, excess exposure to sunlight can predispose to certain types of cataract, and may be a risk factor (albeit not a major one) in the development of macular degeneration.[7] Although the strong sunlight of the Southwest may have had something to do with O'Keeffe's macular degeneration, it is probably of greater relevance that she had a family history of the disease, which is influenced by genetic predisposition. Her maternal grandfather, George Totto, suffered from it. (She was named Georgia Totto O'Keeffe in his honor.[8])

Macular degeneration is the major cause of visual disability among the elderly in our society today. It accounts for more visual loss in individuals over fifty-five than any other disorder, including cataracts (since they are curable by surgery). In most people, the process is a slow and indolent degeneration of the central part of the retina, called the macula, which can make central images hazy, fragmented, and distorted (see fig. 23.8).

As the disease progresses, central vision becomes worse, and in advanced cases only the peripheral vision remains. In some individuals blood vessels and scar tissue grow into the diseased area, and these fragile, new vessels may hemorrhage or leak fluid. Such exudative or "wet" macular degeneration damages vision more quickly and severely. This is the form of the disease that eventually afflicted O'Keeffe.

It is perhaps a commentary on medical progress that whereas presbyopia and cataracts were the most prevalent visual disasters to befall elderly painters before the twentieth century, it was their cure by glasses and modern surgery that exposed the scourge of macular degeneration. The latter was hardly appreciated in ancient times because while a cataract could be seen if present, instruments to look at the retina had not been invented, and few people lived long enough to be afflicted. In fact, macular degeneration did not receive much space in the ophthalmologic literature until the latter half of the twentieth century, when increasing life expectancy made late visual loss a more prevalent problem, and the development of ophthalmic cameras and therapeutic lasers made better diagnostic distinctions and therapy possible. Prevention and cure of this disease is now a major ophthalmologic priority, to preserve not only the productivity of superannuated artists but the visual futures of us all.

According to a recent biography of the artist, O'Keeffe first noticed the symptoms of macular degeneration in 1964, when she was seventy-seven years old. She "was driving from Ghost Ranch on a brilliantly sunny day when she experienced the shock of her life. As her Buick convertible rounded a curve in the road and the valley narrowed to a patch of greenery along the river, her vision was obscured. It felt, she said later, as if a cloud had entered her eyeballs—and, in a way, it had. She called a friend on the phone. 'My world is blurred!' the artist cried into the receiver. For years, only those very close to the artist knew about her problem."[9] She was examined by her personal physician, Constance Friess, MD, in autumn 1964 and was diagnosed with macular degeneration. She came under the care of Frank Constantine, MD, chairman of the department of ophthalmology at the Manhattan Eye and Ear and Throat Hospital.

Back home in New Mexico, she was the patient of Walter J. Levy, MD, an ophthalmologist who practiced in Santa Fe. He wrote: "This fascinating lady was a patient of mine from 1972 through 1979. She proved to be quite a character. She would arrive unannounced in my waiting room in her nun-like outfit, looking like Queen Victoria, and regally inform my staff that she would be seen momentarily. My other patients seemed to tolerate this intrusion with good humor . . . When I first saw her she had a severe exudative maculopathy in the right eye with extensive pigmentary changes and laser retinal scarring surrounding. The left eye had the typical hemorrhagic vascular changes of a vein occlusion [that had occurred in December 1971]."[10] It was unfortunate that O'Keeffe had this additional problem in the left eye. Retinal vein occlusions occur when a vein becomes blocked from compression or clotting, reducing blood flow and rupturing small capillaries within the retina. The end result is usually very poor visual acuity. This condition is not uncommon among the elderly and is often associated with hypertension.

Dr. Levy found O'Keeffe's vision to be less than 20/200 in each eye, and not improvable with glasses. However, she could read small print with a telescopic spectacle. "She tried this," he wrote, "but was too impatient to use it well. I suggested to her that she continue painting with a very broad sweeping technique to allow for her central scotomatous handicap [her blindspots]. Through the years on regular visits her condition remained fairly static."[11]

In the mid-1970s, O'Keeffe consulted Glenn O. Dayton Jr., MD, a specialist in retinal disease who practiced in Los Angeles. She had been advised to see him by a friend in Santa Fe, whom he had treated with laser photocoagulation for macular degeneration. Dr. Constantine wrote Dr. Dayton and gave him details of O'Keeffe's case. Dr. Dayton writes that he remembers her well: "She was quite elderly with gray hair pulled back in a severe manner, quite alert and not interested in any nonsense . . . Both maculae were thoroughly destroyed by a degenerative atrophic process with no thought of treatment by any type of modality. Her New York physician had informed her of this and she rather stoically accepted my concurring opinion. I might add she showed little evidence of blindness in her moving about the consultation room or reception area."[12] This is not surprising since mobility is to a large degree a function of off-center vision; Degas exhibited the same ability to walk easily despite poor visual acuity (see chapter 35).

O'Keeffe consulted yet another ophthalmologist in Santa Fe, Tim Knowles, MD. When he examined her a few years before her death in 1986, he diagnosed her with extensive macular disease.[13] She was also examined at several other major medical centers in the United States and England.

Jeffrey Hogrefe, a recent biographer of O'Keeffe states: "As her eyesight failed progressively, she became increasingly suspicious and paranoid. One of her friends noted that she was always losing things in this period and accusing other people of stealing them."[14] This unfortunate type of behavior is reminiscent of that of Mary Cassatt and Edgar Degas (see chapters 29 and 35). As these two artists aged and lost vision, both became alienated from friends with whom they had been close for years.

Hogrefe also writes, "Like many disabled people, O'Keeffe discovered that her other senses were heightened as she lost her sight."[15] This discovery was also true for Degas, who turned to the more tactile medium of sculpture when he found it too difficult to paint in oils, due to his poor eyesight. Degas, in all likelihood, also suffered from macular dysfunction. While O'Keeffe and Degas may have become more aware of their other senses, such as touch and hearing, these senses could not have actually "improved." Like Degas, O'Keeffe did not give up painting entirely when her vision became severely impaired. Both continued to paint, but less often, and they created paintings that have far fewer details than the works they created when their eyesight was good.

IMPACT ON ART

O'Keeffe was guarded about describing her visual loss and its impact on her art, but there is evidence of it in her late paintings. The *Black Rock* series occupied O'Keeffe between 1970 and 1971, when her vision was failing to critical levels. *Black Rock with Blue Sky and White Clouds* (see fig. 37.3), may be compared with similar, earlier works such as *Red and Pink Rocks and Teeth* (see fig. 37.2). *Black Rock with Blue Sky and White Clouds* has much less subtlety of shading, and the harsh black shadow is devoid of gradation. The focus of the picture on a single natural shape is as powerful as ever, but the delicacy of shading and contrast that

37.4

37.5

37.6

Fig. 37.4 Georgia O'Keeffe, *From a Day with Juan II*, 1977. Oil on canvas, 48 x 36 in. (121.9 x 91.4 cm). This large, late canvas shows a section of the Washington Monument. There is little detail and shading is uneven.

Fig. 37.5 Georgia O'Keeffe, *Red Line with Circle*, 1977. Watercolor on paper, 29 1/2 x 21 3/4 in. (74.9 x 55.2 cm). Some of O'Keeffe's last paintings are simplified watercolor abstractions without detail or shading. The style of these later works was not a new one for O'Keeffe, however, as she had done similar works early in her career (see fig. 37.6).

Fig. 37.6 Georgia O'Keeffe, *Blue #4*, 1916. Watercolor on cream, thin, very smooth textured, gampi-fibered wove paper, 15 15/16 x 10 15/16 in. (40.5 x 27.8 cm). Example of an early abstract watercolor.

Fig. 37.7 Photograph by Dan Budnik of Georgia O'Keeffe at the Ghost Ranch with pots by Juan Hamilton, March, 1975.

were so characteristic of O'Keeffe's earlier works is missing from the later ones. *From a Day with Juan II* (see fig. 37.4) was painted in 1977, and is one of the artist's last oil paintings. The canvas is large and the subject, a section of the Washington Monument, is highly simplified and recognizable, even with poor visual acuity. Shading is present, but it is irregular and coarse despite the large scale. One can sense O'Keeffe's struggle.

Macular degeneration not only affects visual acuity but also diminishes the critical ability to judge contrast (see chapter 1). Even without a serious loss of acuity, many elderly individuals have difficulty recognizing objects at dusk or in dim light. Macular degeneration can also diminish color sense and make adaption to changing light conditions more difficult. This type of visual difficulty must have been especially disturbing to an artist such as O'Keeffe, whose style and content were directly dependent on the subtle components of vision. Indeed, she recognized visual trouble because of dimness as opposed to blur: "I'd been to town and was going home. And I thought to myself, well, the sun is shining, but it looks so gray. I thought that's a little funny, but I didn't pay any attention to it."[16] It is a tribute to O'Keeffe's willpower that she persevered with her art as long as she did, given her condition.

Toward 1976 O'Keeffe compensated for her visual loss by having assistants help her paint her canvases. Though her central vision was poor, there were gaps through which she could see better, and she would use these glimpses of clarity to direct the choice and application of colors. One of her assistants, John Poling, described her visual struggles as she demonstrated

her painting technique: "Bare patches of canvas were overlooked . . . Sometimes she painted the same area twice . . . then she might continue several inches away, thinking she was where she had left off . . . I had an odd feeling: Her brush movements should have produced something significantly different from what appeared on the canvas. I realized she must have made those movements by habit, from memory. Though her motions were sure and those of a master, she could not maneuver or adjust them based on what came through her eyes." On the other hand, Poling recalled a time when O'Keeffe picked up a small sliver of charcoal on a black table, where it was hard to see. She "moved toward the black table, scanning its surface. Suddenly and unerringly she picked up the piece of charcoal. I was surprised. 'It's like there are little holes in my vision,' she said. 'I can't see straight on very well. But around the edges are little holes where I can see quite clearly.'"[17]

One of the paintings created with Poling's assistance was published in *Art News* in the next year, and Poling complained that he was given no credit for it. O'Keeffe was furious—perhaps more from distress that the world would invade her privacy and know of her blindness than from anger about his claims. She told a reporter that her assistant "was the equivalent of a palette knife . . . nothing but a tool . . . Since the beginning of time, artists have had assistants."[18] And in his later reminiscence Poling describes clearly the tight artistic control that O'Keeffe maintained over her work: "The color I mixed wasn't right. She eyed the palette intently. I made some adjustments . . . When she thought it seemed right I began applying it." He even acknowl-

edged that "what we had painted so far was like the anticipation of some wonderful secret; it was as if O'Keeffe knew the secret and took pleasure in withholding it from me."[19] This distinction between an artist, who conceives an image, and a craftsman who merely realizes it, was accepted in earlier eras when artist's workshops were common. However, some modern critics have looked down upon artists who use assistants. There is no question that a technical assistant may influence the style or appearance of a painting, but whether this matters is a judgment that probably should not be made a priori: We would surely not criticize the bedridden Matisse for using assistants to color and cut his paper shapes when he could no longer paint (see chapter 12). The issue of consequence is whether the artist is exercising a full degree of aesthetic or technical control—and, of course, this could be affected by poor vision.

Whether criticism of O'Keeffe on this point is justified or not, she was stung by the negative publicity, ceased using assistants, and stopped painting in oil. She did produce some late watercolors that are interesting in terms of her artistic development as well as her sight. They have been described as "increasingly simplified,"[20] for their saturated colors in discrete, single images, such as *Red Line with Circle* (see fig. 37.5). One might look at these reduced shapes, still powerful in conception but lacking in detail, and argue that they illustrate the limits of the artist's vision. This may be true insofar as O'Keeffe could no longer produce the complex visual effects that characterize her mature painting, but the forms and execution of these watercolors are in fact a reprise of ideas and techniques that she used while experimenting with abstract shapes during her formative years (see fig. 37.6).

As Degas turned increasingly to sculpture when his vision diminished, O'Keeffe turned to pottery when her vision became poor. She was instructed by Juan Hamilton, a potter, who also served as an assistant about her home. For both O'Keeffe and Degas, the preference for a tactile, sculptural medium was neither total nor new. Both had worked in sculpture before their eyesight became significantly problematic. There is perhaps a resemblance between O'Keeffe judging pots by feel (see fig. 37.7) and the Greek vase painter Euphronios, who turned to potting at presbyopic age (see fig. 4.5).

Nonmedical observers of O'Keeffe have given interesting evaluations of her eyesight. One notes: "She wasn't completely blind; she could see shadows. And there were times when she could see more than at other times, perhaps because of the quality of the light. Sometimes she'd ask me what the moon looked like or ask me about the clouds. Once when we were outside walking she looked up and said, 'Well, I see there are clouds in the sky.' She could see the movement of things and large patterns."[21] Another individual, who interviewed the artist in 1977 when she was ninety, appears to have been in awe of her subject and clearly overestimated O'Keeffe's visual acuity: "I had heard that her eyes were failing, but during the interview I had noticed nothing wrong with them. She is surefooted along narrow paths and precarious bridges, pointing with her cane to all sorts of details in her garden. She looks carefully at her new paintings and watercolors, telling me about them. She also chides me when I am not looking at her. She points out every mountain on the horizon. Her distance vision appears to be perfect. It is the small, close-up things that she cannot see. And yet, she says, sometimes she can see the tiniest piece of lint on the floor." The most impor-

37.7

tant aspects of this interview are not the writer's judgments about O'Keeffe's visual acuity but the documentation of the artist's continued dedication and perseverance in the face of acquired visual deficit. "O'Keeffe says simply, 'I can see what I want to paint. The thing that makes you want to create is still there.'"[22] She remained dedicated to her work until the end of her life.

NOTES

1. O'Keeffe, *Georgia O'Keeffe* (1976), text accompanying figure 88.
2. Lisle, *Portrait of an Artist: A Biography of Georgia O'Keeffe* (1980), p. 237.
3. Bates, *Perfect Sight Without Glasses* (1920).
4. Bedford, *Aldous Huxley* (1985), p. 366.
5. Huxley, *The Art of Seeing* (1942). Reprinted in 1982.
6. Hogrefe, *O'Keeffe: The Life of an American Legend* (1992), p. 257; Lisle, *Portrait of an Artist: A Biography of Georgia O'Keeffe* (1980), p. 237.
7. Taylor et al, "Visible Light and Risks of Age-related Macular Degeneration" (1990).
8. Robinson, *Georgia O'Keeffe: A Life* (1989), p. 514.
9. Hogrefe, *O'Keeffe: The Life of an American Legend* (1992), p. 229.
10. Levy, letter to James G. Ravin, December 18, 1990.
11. Ibid.
12. Dayton, letter to James G. Ravin, March 4, 1991.
13. Puro, letter to James G. Ravin, January 23, 1991.
14. Hogrefe, *O'Keeffe: The Life of an American Legend* (1992), p. 298.
15. Ibid.
16. Warhol, "Georgia O'Keeffe and Juan Hamilton" (1983).
17. Poling, "Painting with Georgia O'Keeffe." In Merrill and Bradbury, from the *Faraway Nearby: Georgia O'Keeffe as Icon* (1992), pp. 193–209.
18. Aldrich, "Art Assist: Where Is Credit Due?" In Castro, *The Art and Life of Georgia O'Keeffe* (1995), p. 176. Also in Robinson, *Georgia O'Keeffe: A Life* (1989), pp. 514 and 538. Originally published in the *Santa Fe Reporter*, July 31, 1980, p 5.
19. Poling, "Painting with Georgia O'Keeffe." In Merrill and Bradbury, from the *Faraway Nearby: Georgia O'Keeffe as Icon* (1992), pp. 193–209.
20. Haskell, "Georgia O'Keefe: Works on paper, a critical essay." In *Georgia O'Keefe: Works on Paper* (1985), pp. 1–13.
21. Patten and Cardona-Hine, "Days with Georgia" (April 1992).
22. Klotz, "George O'Keeffe at 90" (December 1977).

38

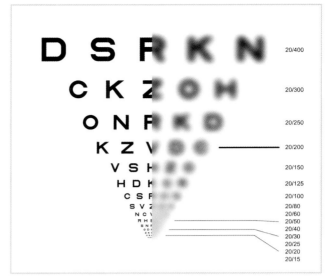

38.1

SIMULATING THE VISION OF DEGAS AND MONET

In earlier chapters, we describe the failing vision of Edgar Degas (see chapter 35) and Claude Monet (see chapter 30), and note that contemporaries commented on how the late works of both were strangely out of character with the work that each had produced previously.[1] To better understand what Degas and Monet were facing in their late years, it is helpful to know how they actually saw their worlds—and their canvases.

With medical knowledge and computer technology, it is possible to simulate their perceptions, and to show how their diseases impacted their styles of painting. For example, figure 38.1 is an image of a near-acuity test card that has been modified with Photoshop to show the blur of 20/200 visual acuity, as might occur with macular disease. Figure 38.2 shows a color spectrum upon which the progressive effects of a brunescent (brown) cataract are superimposed. These simulations were made by removing more and more blue (effectively adding a yellow filter) and darkening the image. We have applied these same techniques to photographs of Monet's garden and to works of art, simulating different stages of Degas' and Monet's eye disease.[2]

DEGAS

Degas (1834–1917) probably had a progressive retinal disease that caused central, or macular, damage,[3] and the primary effect of such disease would be visual blur, or poor acuity. Based on several different lines of evidence, figure 38.3 shows his steady loss of visual acuity between 1860 and 1910.[4] Degas first talked about "infirmity of sight" in the mid-1880s. Given that he was still able to read the newspaper at this point, one may surmise that his acuity was in the 20/40 or 20/50 range. By the 1890s, Degas was making frequent reference in his letters to poor eyesight as well as to difficulty with reading and writing; and his handwriting had become enlarged and less regular. By this time, his visual acuity had probably fallen to the range of 20/100 to 20/200. By the turn of the twentieth century, he was quite disabled, with visual acuity of 20/200 to 20/400. Remarkably, he continued to work in pastels until 1912, when he had to move out of his familiar studio because the building was to be demolished. The move disrupted his familiar patterns of activity and he never painted seriously again; his health gradually failed and he passed away in 1926.

Changes in Degas' style correlate closely with his progressive loss of vision (see figs. 35.5 and 38.4a–c). As his acuity began to diminish in the 1880s and 1890s, he drew the same subjects, but the delicacy of shading and the details of face, hair, and clothing grew less and less refined. One study shows that over nearly three decades, the spacing of the lines, or hatching, that Degas used to make up shaded areas increased in proportion to his failing acuity (see fig. 38.3).[5] After 1900 the roughness of drawing and shading became quite extreme, and many pictures from this time seem mere shadows of his customary style (see figs. 35.6 and 38.4c). In his works of this time, bodies are outlined irregularly, images are marred by strange blotches of color, and there is virtually no detailing in faces or clothing. Nothing in Degas' correspondence indicates that he was consciously trying to work more expressionistically or abstractly, and in fact he drew on larger and larger expanses of paper as he struggled to see. One critic wrote: "These sketches are the tragic witnesses of this battle of the artist against his infirmity."[6] One may question whether Degas intended these images to appear the way they do, and why he continued to work when the results seem so out

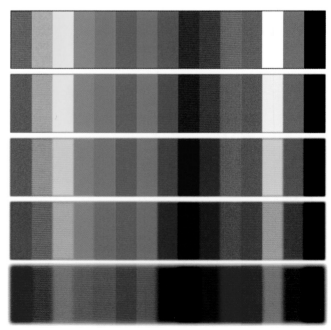

38.2

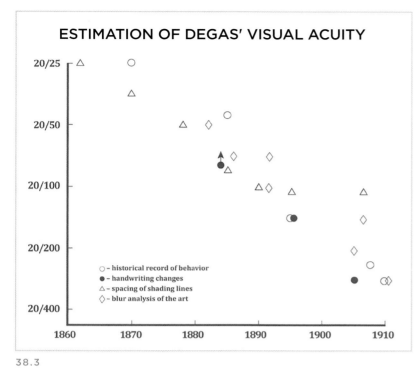

ESTIMATION OF DEGAS' VISUAL ACUITY

○ – historical record of behavior
● – handwriting changes
△ – spacing of shading lines
◇ – blur analysis of the art

38.3

Fig. 38.1 Visual acuity test chart. This chart is split to show the effects of a disabling (20/200) level of blur.

Fig. 38.2 Color spectra (with gray scale) to show the effect of an age-related cataract as it becomes progressively more brown and dense. These estimations are based on Monet's description of his vision and color perception. A normal color spectrum is on top, followed by the appearance through different levels of cataract: mild (20/50 visual acuity), moderate (20/70), severe (20/100) and disabling (20/200). The denser levels of cataract not only blur vision but cause a severe loss of color discrimination.

Fig. 38.3 Degas' vision between 1860 and 1910. This chart shows estimations of the artist's visual acuity from the historical record, his use of shading lines, his handwriting, and his art.

Fig. 38.4 Edgar Degas. Paintings of nude bathers, showing the change in style (and loss of refinement) from approximately 1885 to 1910. **Above:** Original paintings. **(a)** *Woman Combing Her Hair*, c. 1886. Pastel, 20 7/8 x 20 1/2 in. (53 x 52 cm). **(b)** *After the Bath, Woman Drying Herself*, c. 1889–1900. Pastel on paper, 26 5/8 x 27 3/4 in. (67.7 x 57.8 cm). **(c)** *Woman Drying Her Hair*, c. 1905. Pastel on paper, 28 1/8 x 24 3/4 in. (71.4 x 62.9 cm). **Below:** The same paintings blurred to the level of Degas' eyesight at the time of painting. **(d)** 20/50. **(e)** 20/100. **(f)** 20/300. Note that the shading appears more graded and natural in these blurred images than in the original works.

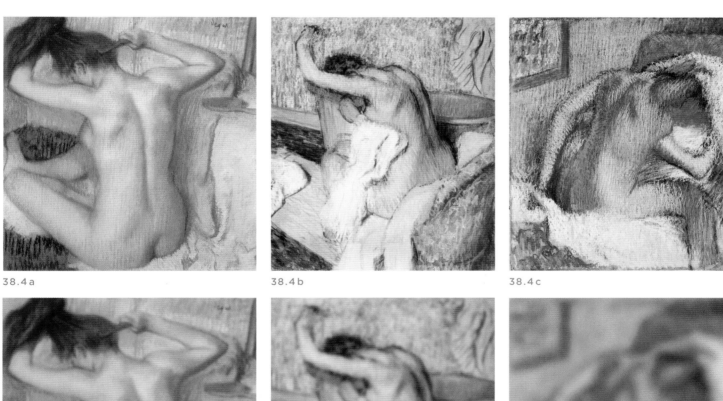
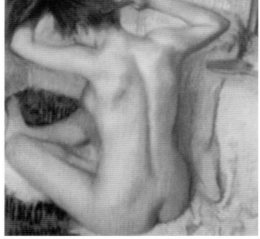
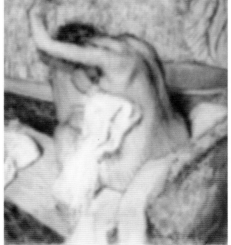

38.4 a

38.4 b

38.4 c

38.4 d

38.4 e

38.4 f

of line with his traditional style. Some answers may lie in the recognition of how these works appeared to him.

Figures 38.4d–f show works blurred to the level of Degas' visual acuity at the time that he made them. These computer simulations do not alter colors, since color discrimination loss with maculopathy is usually mild and is not consistent in its effects. The striking finding is that Degas' blurred vision smoothes out much of the graphic coarseness of his shading and outlines. One might even say that his works appear "better" through his abnormal vision than through our normal vision.

How can this be the case? The situation reflects, in large measure, the particular style of Degas' work. He was not creating precise landscapes or portraits as did Rembrandt or Cassatt (who stopped painting when cataracts blurred her vision). Degas' main concern was the shape and posture of his subjects, as well as their setting in space—characteristics easily discernable even with poor vision. Although he must have known through his hand movements (and perhaps by close-up examination) that he was using cruder lines, when he stood back to look at what he had drawn, he would have seen well-shaded nudes and dancers. We suggest that this seemingly beneficial effect of visual loss, relative to Degas' style, helps to explain why he continued to work. To him, these late works must have looked similar to his earlier ones, and he could not have effectively judged or understood how they would be perceived by viewers with normal vision.

MONET

Monet's (1840–1926) case was different. We know from medical records and correspondence that he had cataracts that worsened steadily from 1912 to 1922, and the progression of his visual problems is shown in figure 38.5.[7] Age-related cataracts, or nuclear sclerosis, slowly manifest as a yellowing and darkening of the lens, symptoms that are directly visible to an examining ophthalmologist, and that have a major effect on color percep-

tion as well as visual acuity. As a cataract grows, there is not only progressive blurring, but also lessening of the ability to distinguish between yellows and white, blues and greens, and reds and violets (see fig. 38.2). Monet was resistant to surgery, in part because he was worried that his color perception—so critical to his Impressionistic style—would be altered. Since Monet only described "slightly reduced" vision, and was having no major difficulties with his art or his personal life in 1912, his acuity at the time was probably no worse than 20/50.

By 1914 to 1915, Monet's visual difficulties had become more serious. He reported that "colors no longer had the same intensity" and that "reds had begun to look muddy." He said that his paintings were "more and more darkened."[8] He felt that he could no longer distinguish colors well, that he had to rely on the labels on his paint tubes when choosing colors, and that he was coloring by "force of habit."[9] He could still read and write with effort, but we estimate that his acuity by 1918 was near 20/100. However, the yellowing of his lens caused him greater difficulty than the blur. Compare Monet's *Waterlily Pond* from 1899 (see fig. 38.6), when his vision was unimpaired, with a photograph of the same scene (see fig. 38.7a). Figure 38.7b shows the garden as it would have appeared to Monet around 1915. Most colors are still distinguishable, but there is an overriding yellowish cast and a loss of subtle color discrimination. Figure 38.8 shows a water lily painting from 1915 as the painting appears to us (see fig. 38.8a) and as it would have looked to Monet at that time (see fig. 38.8b). In his view, the distinctions between the intense blue water and green lily pads would have been diminished; we can only speculate if this might have spurred him to use such a strong blue to overcome the melding of colors.

An artist can respond in several different ways to the presence of a yellow filter, or a cataract, and it is not possible to predict necessarily how it will influence his or her art. Because cataracts are chronic, a patient may not be aware that the world looks yellowish (as there are no "normal" colors with which to compare).

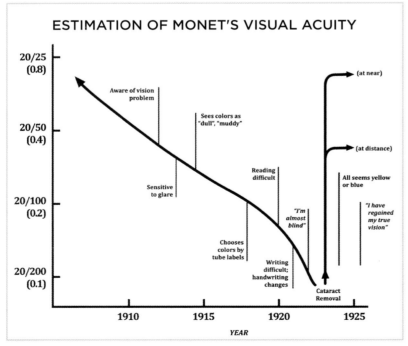

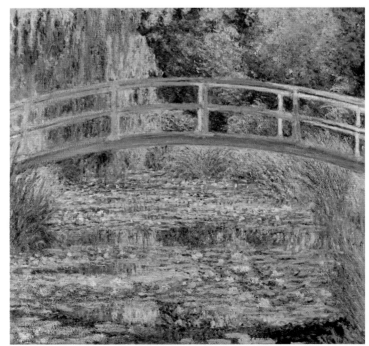

Fig. 38.5 Monet's vision between 1910 and 1925. This chart shows the artist's visual acuity and his complaints about color, based on his correspondence, and information from contemporaries and his ophthalmologists.

Fig. 38.6 Claude Monet, *Waterlily Pond*, 1899. Oil on canvas, 34 ¾ x 36 ⅝ in. (88.3 x 93.1 cm). This painting was done before the onset of any visual symptoms from cataract.

Fig. 38.7 Photograph by Elizabeth Murray of the lily pond and Japanese bridge at Giverny. (a) The bridge as it appears today. (b) Image blurred as it might appear through a moderate nuclear sclerotic cataract. (c) Image as seen through a disabling (20/200) cataract.

But whether or not an artist recognizes the yellow bias, there is the choice between painting a yellowish world, or adding extra blue as compensation (e.g., to make the sky appear "properly" blue). Furthermore, the artist may mix these techniques with experience and choose colors from habit rather than from observation. The idea that the artist will self-correct (i.e., select colors that match the scene) does not hold, because certain colors, such as yellow and white, will look the same through the cataract.

From 1919 to 1922, Monet was fearful that he might have to stop painting. By this time, he only painted when the lighting was optimal, and he was well aware that colors were lost in the yellow blur of his vision, making his garden appear to him to be severely monochromatic (see fig. 38.7c). His visual acuity was recorded in 1922 to be 20/200 in the better eye.

As with Degas, we find striking changes in the style of Monet's paintings during the period of progressive visual failure. Compare pictures of the water lily pond done in 1899 (see fig. 38.6), in 1915 (see fig. 38.8a), and around 1922 (see figs. 38.9a and c). These late works are almost abstract and show a predominant red-orange and green-blue tone, respectively, that is quite different from the subtle color shading that characterizes Monet's earlier work. And as with Degas, there is nothing in Monet's correspondence to suggest that he had any intention of exploring abstraction and distortion as other painters of his time were doing. However, visual failure affected Monet differently than it affected Degas. Monet's mature style was not dependent on the outlining of figures or the subtle shading of figures and clothing, and his applications of paint were heavier than those of Degas. When looking through Monet's eyes at these more abstract and strongly colored images (see figs. 38.9b and d), we see that while he would have recognized the *coarseness* of his brushstrokes, he could *not* have recognized the true *colors*. From 1914 to 1917 his color perceptions were merely dulled (see figs. 38.7a and b), but toward 1922 they became severely compromised (see fig. 38.7c). Images that are strikingly orange (see fig. 38.9a) or strikingly blue (see fig. 38.9c) were to him almost indistinguishable as a murky yellow-green (see figs. 38.9b and d). Even if he painted these works according to "habit," he could not judge their effect upon the viewer, nor could he refine the works without risking errors in judgment.

Figures 30.4 and 30.5 show paintings of his house and garden, in this same style and presumably from the same years. It is impossible, a century later, to know whether these works appear to us as Monet wanted them to appear. Monet finally acquiesced to cataract surgery, which was performed in January 1923; afterward he destroyed many of his later canvases. His paintings that remain from the time among 1919 and 1922 exist

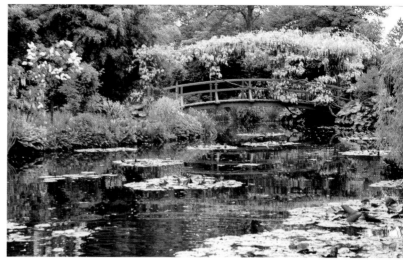

38.7a

38.7b

38.7c

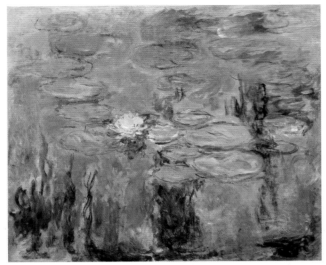

38.8a

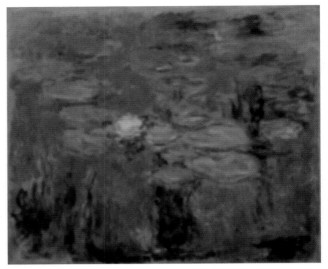

38.8b

Fig. 38.8 Claude Monet. *Waterlilies*, 1915. Oil on canvas, 51 ⁵/₁₆ x 60 ¼ in. (130 x 153 cm). **(a)** This painting of the lily pond was done when the artist had a moderate cataract. **(b)** The same image blurred as it would have appeared to the artist through the cataract.

Fig. 38.9 Claude Monet, Paintings of the pond and Japanese bridge done at the time of his severe visual disability. **(a)** *The Japanese Bridge*, c. 1918-24. Oil on canvas, 35 x 39 ³/₈ in. (89 x 100 cm). This version has a predominance of orange. **(b)** The image as it would have appeared to the artist through a disabling (20/200) brown cataract. **(c)** *The Japanese Bridge at Giverny*, c. 1918- 24. Oil on canvas, 35 x 39 ³/₈ in. (89 x 100 cm). This version has a predominance of blue. **(d)** The image as seen through a disabling (20/200) brown cataract. Note that while the two paintings differ markedly in color (left panels), they appeared surprisingly similar and dull to Monet (right panels).

only because they were salvaged by family and friends. Monet's works in this abstract style are undated, with the exception of a couple of Japanese bridge canvases dated 1919 and one painting of the house and garden dated 1922. This leads us to believe that all of these works, being very similar stylistically to the ones that are clearly dated, were done during his period of severely impaired vision. We may surmise that he was struggling to find some balance or feedback between his internal vision, his knowledge of chosen paints, and his own view of the works. Of course, we don't know the degree to which Monet "accepted" or liked these salvaged works, and we also don't know whether or not he reworked any of these canvases after his cataract surgery.

This latter issue is potentially a complicating factor in the interpretation of his strong color schemes. One visitor, Louis Gillet, described the artist, late in life, painting "wild landscapes . . . impossible color schemes, all red or all blue."[10] But it is unclear if this description refers to work before or after the cataract surgery. Another friend, André Barbier, visited in 1924 and was shown Japanese bridge canvases that Monet said were painted before and after surgery. Barbier wrote that the "colors [were] transposed,"[11] but we do not know which canvases he saw. We are a bit skeptical that paintings such as figures 38.9a and c (or figures 30.4 and 30.5) present this type of comparison. Monet did many works in this "abstract" style with a range of strong colors, and they are noticeably alike in size, layout, and execution. The use of strong colors at different ends of the spectrum is easy to understand, as Monet tried to gain sensory feedback through his brownish cataract. One might also expect him to have painted differently after the operation. Nevertheless, it is

possible that he revised and recolored some canvases that he had initiated before his operation.

What we do know is that he eventually regained confidence in his view of the world in 1924 and returned to work on the great water lily canvases now hanging in the Orangerie Museum. It should be noted that the style of these "Grand Decorations" (and also other paintings that can be clearly dated to 1923 or later) harkens back to that of his earlier paintings (compare figure 38.10 with figures 38.6 and 38.8a). Thus it seems unlikely that he had adopted or espoused his broader 1919–1922 style entirely by free choice, or that he was entirely pleased with it.

THE IMPACT OF FAILING VISION

Many have argued about the extent to which vision was or was not a factor in the late styles of Degas and Monet.[12] An important conclusion to make from these visual demonstrations is that one cannot generalize about the effects of eye disease on an artist's work. The specific effects will depend not only on the visual impact of the artist's particular disorder, but also on the artist's style of work, which may be more or less sensitive to different types of distortion.

With respect to seeing scenes or subjects, Degas had fewer problems than Monet, even though Degas' visual acuity fell to lower levels. Degas' main subject was the female form, a relatively large form even with poor levels of acuity, and so his visual loss was not an impediment to composing his pictures. The situation was more complicated for Monet. While the blurring of vision from his cataract did not impede his composition either, the loss of color perception created a major problem. His goal in painting was to highlight variations among times of day, seasons, lighting, and shadows. These judgments became nearly impossible for him to make during the several years prior to his cataract surgery. Though he could rely on memory to choose colors and to create an Impressionistic aura, we know that he took canvases outdoors when the lighting was favorable, so that he must have felt that even distorted observations were still relevant.

With respect to the application of pastel or paint, both Degas and Monet struggled when their visual acuity fell to levels at which it was difficult to see details. Degas' shading grew coarser, and the outlines of his subjects grew less refined. Monet began

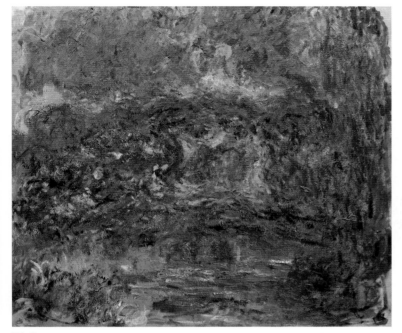
38.9 a

38.9 b

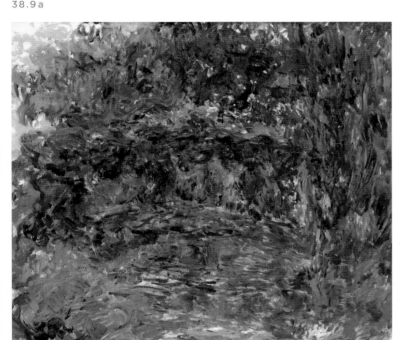
38.9 c

38.9 d

to work in a freer style, even before he was strictly forced to do so. Degas had for many years worked in a limited palette, and often used bright colors, so that even if his color perception were not entirely normal with his maculopathy, it was not a major hindrance to his technique. Monet, in contrast, must have struggled mightily as he looked out into a murky yellow-brown garden and tried to decide what subtle impression to render on the canvas. He recognized that he could not see colors well and chose tubes by their labels. (The use of colors directly from the tube may account for some of the intense colors in his late works.) However, he could no longer mix colors based on observation or make the refinements that had been a major part of his technique.

With respect to the impact of visual loss on the artists' judgment, we again find differences between Degas and Monet. The effect of Degas' maculopathy was to blur his own view of his late works, causing them to appear smoother and more "normal" to him than they do to us. This blurring of the works, given Degas' particular style, may have encouraged him to continue to paint with failing vision and may account in part for his acceptance of (or at least willingness to complete) works that seem crude to our normal eyes. Monet did not have such luck with respect to his cataracts. The blurring of vision did not seriously alter his basic style, but his cataracts severely changed (and challenged) the marvelous qualities of color in his works. From his correspondence we know that he was aware of his altered color

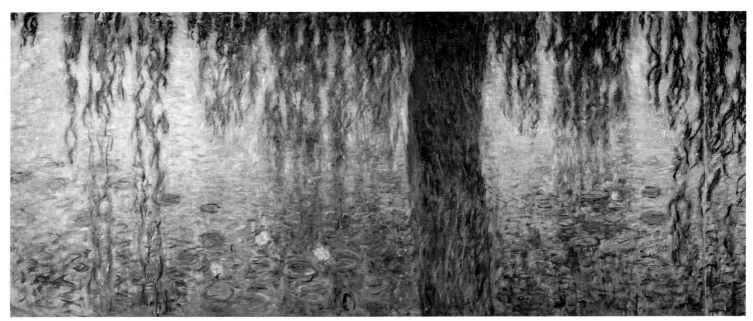

Fig. 38.10 Claude Monet, *Waterlilies: Morning with Weeping Willows* (detail of the left section), 1915-26. Oil on canvas, 78 ³/₄ x 167 ¹/₂ in. (200 x 425 cm). This painting was done after Monet's cataract was removed. The style and color is reminiscent of his work prior to his severe visual loss (see figs. 38.6 and 38.8a).

perception, and that he thought he was compensating. But it is hard to know how successful he was, since he could not judge for himself the canvases he created. If, in fact, he was pleased with what *he* saw, then we (with normal vision) are not seeing what he intended.

It is important to emphasize that we have described the effects of retinal damage and cataract on Degas and Monet because we have good historical documentation of the visual loss that afflicted these two great artists. If we did not have such records, it would be hazardous and inappropriate to presume a diagnosis from the art itself. Art is created for many reasons, and influenced by many factors, including aesthetics, cultural pressures, and economic opportunity; artists may choose to work with different colors, different degrees of representation, and different styles. It would be presumptuous, for example, to assume that nonrepresentational painting implies poor visual acuity, or that painting with strong colors (or a lack of color) implies the presence of cataract or color vision abnormalities. The observations presented in this chapter show how *known* visual disability would have altered the perceptions of Degas and Monet. By recognizing how the world appeared to them, we can better appreciate their struggles and their accomplishments, and better understand how their visual abilities are relevant to the interpretation of their late works.

NOTES

1. Halévy, "Edgar Degas" (1919); Thiebault-Sisson, "Les nymphéas de Claude Monet (1927). Translated in Stuckey, *Monet: A Retrospective* (1985), pp. 279–293.
2. This chapter is based upon Marmor, "Ophthalmology and Art: Simulation of Monet's Cataracts and Degas' Retinal Disease" (2006).
3. Ravin and Kenyon, "Degas' Loss of Vision: Evidence for a Diagnosis of Retinal Disease" (1994); McMullen, *Degas: His Life, Times and Work* (1984); Boggs, *Degas* (1988).
4. Marmor, *Degas Through His Own Eyes: Visual Disability and the Late Style of Degas* (2002).
5. Lanthony, "Degas et la fréquence spatiale" (1991).
6. Lemoisne, "Degas et son oeuvre 1 (1946). Translated in Boggs, *Degas* (1988), p. 163.
7. Ravin, "Monet's Cataracts" in *Journal of the American Medical Association* (1985); Lanthony, "Cataract and the Painting of Claude Monet" (1993); Tucker, *Monet in the 20th Century* (1998); Wildenstein, *Claude Monet biographie et catalogue raisonne*, vol. 4 (1985), p. 108, note 994.
8. Thiebault-Sisson, "Les nymphéas de Claude Monet" (1927). Translated in Stuckey, *Monet: A Retrospective* (1985), pp. 279–293.
9. Ibid.
10. Hamilton, "The Dying of the Light: The Late Works of Degas, Monet and Cezanne" in Rewald and Weitzenhoffer, *Aspects of Monet: A Symposium on the Artist's Life and Times* (1984), pp. 218–241; Gillet, *Trois variations sur Claude Monet* (1927), p. 104. Translated in Weitz, *Claude Monet: Seasons and Moments* (1960), p. 50.
11. Wildenstein, *Claude Monet biographie et catalogue raisonne*, vol. 4 (1985), p.125.
12. Ravin and Kenyon, "Degas' Loss of Vision: Evidence for a Diagnosis of Retinal Disease" (1994); Ravin, "Monet's Cataracts" Journal of the American Medical Association (1985); Lanthony, "Cataract and the Painting of Claude Monet" (1993); Tucker, *Monet in the 20th Century* (1998); Hamilton, "The Dying of the Light: The Late Works of Degas, Monet and Cezanne" in Rewald and Weitzenhoffer, *Aspects of Monet: A Symposium on the Artist's Life and Times* (1984), pp. 218–241; Gillet, *Trois variations sur Claude Monet* (1927), p. 104. Translated in Weitz, *Claude Monet: Seasons and Moments* (1960), p. 50; Wildenstein, *Claude Monet biographie et catalogue raisonne*, vol. 4 (1985), p.125; Kendall, "Degas and the Contingency of Vision" (1988); Werner, "Aging Through the Eyes of Monet." In Backhaus et al, *Color Vision: Perspectives from Different Disciplines* (1998), pp. 3–41.

Aldrich, H. "Art Assist: Where Is Credit Due?" In *The Art and Life of Georgia O'Keeffe*, by Jan Garden Castro, 176. New York: Crown, 1995. Also in *Georgia O'Keeffe: A Life*, by Roxana Robinson, 514 and 538. New York: Harper and Row, 1989. Originally published in the *Santa Fe Reporter*, July 31, 1980.

Alpern, M., S. Thompson, and M. S. Lee. "Spectral Transmittance of Visible Light by Living Human Eye." *The Journal of the Optical Society of America* 55 (1965): 723–727.

Alvarez, S. L., P. E. King-Smith, and S. K. Bhargava. "Spectral Thresholds in Macular Degeneration." *British Journal of Ophthalmology* 67 (1983): 508–511.

Amsler, M. "L'examen qualitatif de la fonction maculaire." *Ophthalmologica* 114 (1947): 248–261.

Anstis, S. "Was El Greco Astigmatic?" *Leonardo* 35 (2002): 208.

Arnheim, Rudolf. *Art and Visual Perception: A Psychology of the Creative Eye.* Berkeley: University of California Press, 1974.

Arnold, Wilfred Niels, and Loretta S. Loftus. "Xanthopsia and van Gogh's Yellow Palette." *Eye* 5 (1991): 503–510.

Art Newspaper, "Renoir Archive Now Belongs to Novelty Items Business," no. 180 (May 2007): 63.

Bailey, Anthony. *Responses to Rembrandt.* New York: Timken Publishers, 1994.

Barazetti, Suzanne. "Souvenirs de Maurice Denis." *Beaux-arts* 219: March 12, 1937.

Bates, William H. *Perfect Sight Without Glasses.* New York: Henry Holt & Co., 1920.

Beazley, John D. *Attic Red-Figure Vase-Painters*, Vol 2. London: Oxford University Press, 1963.

———. "Potter and Painter in Ancient Athens." An address delivered to the British Academy on May 17, 1944. Republished in *Greek Vases: Lectures by J. D. Beazley*. D.C. Kurtz, ed. Oxford: Clarendon Press, 1989.

Bedford, Sybille. *Aldous Huxley.* New York: Carroll and Graf, 1985.

Beethoven, Ludwig van. *Konversationshefte.* Band I, Heft 9 (Mar. 11–19, 1820). Edited by Karl-Heinz Köhler and G. Herr. Leipzig: VEB Deutscher Verdag fur Musik, 1972.

Bell, Quentin. *Degas: le viol.* Newcastle upon Tyne, England: University Press, 1965.

Benjamin, Roger. *Matisse's "Notes of a Painter": Criticism, Theory, and Context, 1891–1908.* Ann Arbor, MI: UMI Research Press, 1987.

Blakemore, C. "The Baffled Brain." In *Illusion in Nature and Art,* edited by R. L. Gregory and E. H. Gombrich, 9–47. New York: Charles Scribner's Sons, 1973.

———. "Development of the Brain Depends on the Visual Environment." Nature 228 (1970): 477–488.

Blanche, J. E. *Propos de peinture: de David à Degas.* Paris: E. Paul, 1919.

Blashfield, Evangeline W. "Rosalba Carriera." In *Portraits and Backgrounds,* by Evangeline W. Blashfield, 486–488. New York: Charles Scribner's Sons, 1917.

Boardman, John. *Greek Gems and Finger Rings.* New York: Harry N. Abrams, Inc., 1972.

Boggs, Jean Sutherland. *Degas.* New York: Metropolitan Museum of Art, 1988.

Boime, Albert. *The Art of the Macchia and the Risorgimento: Representing Culture and Nationalism in Nineteenth-Century Italy.* Chicago: University of Chicago Press, 1993.

Brandon, Henry. "A Conversation with James Thurber: 'Everybody is Getting Very Serious.'" *The New Republic,* May 26, 1958. Reprinted in *Conversations with James Thurber*, edited by Thomas Fensch. Jackson, MS: University Press of Mississippi, 1989.

Broude, Norma. *The Macchiaioli: Italian Painters of the Nineteenth Century.* New Haven, CT: Yale University Press, 1987.

Bullard, E. John. *Mary Cassatt: Oils and Pastels.* New York: Watson-Guptill Publications, 1972.

Burr, D. C. "Implications of the Craik-O'Brien Illusion for Brightness Perception." *Vision Research* 27 (1987): 1903–1913.

Cantor, G. "Anti-Newton." In *Let Newton Be!*, edited by J. Fauvel, R. Flood, M. Shortland, and R. Wilson, 203–221. Oxford: Oxford University Press, 1988.

Casanova, Giacomo. *History of My Life.* Translated by Willard R. Trask. 12 vols. New York: Harcourt Brace Jovanovich, Inc., 1969. (Original Casanova *Mémoires* published in 1826–1838).

Cassatt correspondence. Metropolitan Museum of Art, New York, NY, and the National Gallery of Art, Washington, DC.

Cave, Kathryn, ed. *The Diary of Joseph Farington* 3. New Haven, CT: Yale University Press, 1979.

———. *The Diary of Joseph Farington* 7. New Haven, CT: Yale University Press, 1982.

Cawthorne, T. "Goya's Illness." *Proceedings of the Royal Society of Medicine* 55 (1962): 213–17.

Charles, E. "Des tendances de la peinture moderne: Entretien avec M. Henri-Matisse." *Les Nouvelles* (12 April 1909): 4. Quoted in *Matisse on Art*, by Jack Flam, 52. Berkeley, CA: University of California Press, 1995.

Charman, W. N. and N. C. Evans. "Possible Effects of Changes in Lens Pigmentation on Colour Balance on an Artist's Work." *British Journal of Physiological Optics* 31 (1976): 23–31.

Charteris, Evan. *John Sargent.* London: W. Heinemann, 1927.

Chaspoux, N. Letter dated March 30, 1823, British Museum. In *Charles Meryon,* written by J. Ducros, number 287. Paris: Musée de la Marine, 1968.

———. Letter dated July 1829, British Museum. In *Charles Meryon,* written by J. Ducros, number 297. Paris: Musée de la Marine, 1968.

Clemenceau, Georges. *Claude Monet: The Water Lilies.* Garden City, NY: Doubleday, Doran, and Company, 1930.

Close, Chuck, Dave Hickey, Joanne Kesten, and William Bartman. *The Portraits Speak: Chuck Close in Conversation with 27 of His Subjects.* New York: A.R.T. Press, 1998.

Coleridge, Samuel Taylor. Samuel Taylor Coleridge to Thomas Poole, 23 March 1801. In vol 2, *The Collected Letters of Samuel Taylor Coleridge*, edited by Earl Leslie Griggs, 709. Oxford: Clarendon Press, 1956.

Collins, R. "The Landscape and Historical Paintings of Charles Meryon." *Turnbull Library Record* 8 (1975): 4–16.

"The Conscientious Artist." *The Standard* (May 20, 1908). Quoted in *Monet: A Retrospective,* edited by Charles F. Stuckey, 251. New York: H. L. Levin, New York, 1985.

Cook, R. M. "Epoiesen on Greek Vases." *Journal of Hellenic Studies* 91 (1971): 137–38.

Crespelle, J. P. *Les Maitres de la belle époque.* Paris: Hachette, 1966.

Cygielman, M., et al., eds. *Euphronios: atti del seminario internazionale distudi.* Florence: Il Ponte, 1992.

Daviel, J. Letter. *Mercure de France* (September 1748), 198–221 and *Sur une nouvelle method de guerir la cataracte par l'extraction du crystalline.* Paris: Memoires de l'Academie Royale de Chirurgerie, 1753. In vol. 3, *The History of Ophthalmology,* edited by Julius Hirschberg and translated by Frederick C. Blodi, 158–211. 11 vols. Bonn: J. P. Wayenborgh Verlag, 1984.

Davies, David. *El Greco.* New York: Metropolitan Museum of Art, 2003. Exhibition catalog.

da Vinci, Leonardo. *Leonardo on Art and the Artist.* Mineola, NY: Dover Publications, 2002.

Dawson, George. Introduction to *Paul Henry 1876-1951.* Belfast: Ulster Museum, 1973. Exhibition catalog.

Dayton, Jr., Glenn O. Letter to James G. Ravin. March 4, 1991.

Denis, Maurice. *Journal 1884–1943.* 3 vols. Paris: La Colombe 1957–1959.

Denoyelle, M., ed. *Euphronios peintre.* Paris: Documentation Français, 1992.

de Piles, Roger. In *The Artist Grows Old: The Aging of Art and Artists in Italy 1500–1800,* written by Philip Sohm, 8. New Haven, CT: Yale University Press, 2007.

Deregowski, J. B. "Real Space and Represented Space: Cross-Cultural Perspectives." *Behavior and Brain Sciences* 12 (1989): 51–119.

de Wecker, Louis, and Edmund Landolt, eds. *Traité complet d'ophtalmologie*. 4 vols. Paris: Delahaye et Lecrosnier, 1880–1889.

Dittiere, M. "Comment Monet recouvra la vue après l'opération de la cataracte." *Sandorama* 32 (1973): 30.

Doiteau, Victor. "La curieuse figure du Dr. Gachet." *Aesculape* 13 (1923): 254.

Doran, Michael. *Conversations with Cézanne*. Berkeley, CA: University of California Press, 2001.

Dormandy, Thomas. *Old Masters: Great Artists in Old Age*. London: Hambledon and London, 2000.

Dubois-Poulsen, A. "Jacques Mawas 1885–1976." *Annales d'Oculistique* 209 (1976): 325–331.

Duke-Elder, Stewart. *System of Ophthalmology*. In vol. 13, *The Ocular Adnexa*. St. Louis, MO: Mosby, 1974.

Du Maurier, George. *The Martian: A Novel with Illustrations by the Author*. New York: Harper & Brothers, 1898.

Eggum, Arne. *Munch and Photography*. New Haven, CT: Yale University Press, 1989.

Eisman, M. "A Further Note on Epoiesen Signatures." *Journal of Hellenic Studies* 94 (1974): 172.

Elkins, J. "Style." In vol. 29, *The Dictionary of Art*. Edited by Jane Turner, 876–879. New York: Grove Dictionaries, 1996.

Ernst, Bruno. *The Magic Mirror of M. C. Escher*. New York: Ballantine Books, 1976.

Escher, G. A. Letter to the editor. *Scientific American* 232 (1975): 8–9.

Escher, M. C. *Escher on Escher: Exploring the Infinite*. New York: Harry N. Abrams, Inc., 1989.

———. "How Did You as a Graphic Artist Come to Make Designs for Wall Decorations?" *De Delver* 14 (1941). Translated and reprinted in *Escher on Escher: Exploring the Infinite*, by M. C. Escher, 83–89. New York: Harry N. Abrams, Inc., 1989.

———. *The Graphic Work of M.C. Escher, Introduced and Explained by the Artist*. New York: Ballantine Books, 1967. Original Dutch edition published in 1960.

———. *The Regular Division of the Plane*. Utrecht: De Roos Foundation, 1958. Reprinted in *M. C. Escher: His Life and Complete Graphic Work*, edited by J. L. Locher. New York: Harry N. Abrams, Inc., 1982. Also reprinted in *Escher on Escher: Exploring the Infinite*, by M. C. Escher. New York: Harry N. Abrams, Inc. 1989.

Euphronios der Maler. Milan: Fabbri, 1991. Exhibition catalog.

Fama, P. G. "Charles Meryon: A Biographical and Psychiatric Reassessment." *New Zealand Medical Journal* 78 (1973): 448–455.

Fénéon, Félix. "Les Impressionistes." *La Vogue*, September 20, 1886. In *Félix Fénéon: Aesthete and Anarchist in Fin-de-Siecle Paris*, by Joan Ungersma Halperin, 92. New Haven, CT: Yale University Press, 1988.

Ferillo, L. B. "Two Landscapes by François-Auguste Ravier." Vol. 3, *Cleveland Studies in the History of Art*. Cleveland, OH: Cleveland Museum of Art, 1998.

Fine, A. M. et al. "Earliest Symptoms Caused by Neovascular Membranes in the Macula." *Archives of Ophthalmology* 67 (1983): 508–511.

Flam, Jack. *Matisse on Art*. Berkeley, CA: University of California Press, 1995.

Ford, C. "Works Do Not Make an Oeuvre: Rembrandt's Self-Portraits as a Category." In *Rethinking Rembrandt*, edited by Alan Chong and Michael Zell, 121–128. Boston: Isabella Stewart Gardner Museum / Zwolle, Netherlands: Waanders Publishers, 2002.

Franklin W. S., and F. C. Cordes. "Radium for Cataract." *American Journal of Ophthalmology* 3 (1920): 643–647.

Friedman, Martin. *Close Reading: Chuck Close and the Artist Portrait*. New York: Harry N. Abrams, Inc., 2005.

Fouchet, Max-Pol. *Bissière*. Paris: Le Musée de Poche, 1955.

Fuller, W. H. "Claude Monet and His Paintings." Quoted in *Monet: A Retrospective*, edited by Charles F. Stuckey, 203. New York: H. L. Levin, New York, 1985.

Gachet, Paul L. *Les 70 jours de van Gogh à Auvers*. Paris: Editions du Valhermeil, 1994.

———. "L'ophtalmie des armées en Europe." Unpublished manuscript in the collection of Pierre Amalric, 1887.

Gage, John. *Color and Culture*. Boston: Bulfinch Press: 1993.

———. *Color in Turner: Poetry in Truth*. New York: F.A. Praeger, 1969.

———. "Turner's Annotated Books: 'Goethe's Theory of Colours.'" *Turner Studies* 4 (1984): 34–52.

Gallatin, A. E. *Of Art: Plato to Picasso; Aphorisms and Observations*. New York: Wittenborn and Co., 1944.

Gastaut, H. "La maladie de Vincent van Gogh envisagée a la lumière des conceptions nouvelles sur l'épilepsie psychomotrice." *Annales Medico-Psychologiques* 114 (1956): 196–238.

Geffroy, G. "Monet: Sa vie, son oeuvre." Quoted in *Monet: A Retrospective*, edited by Charles F. Stuckey, 156. New York: H. L. Levin, New York, 1985.

Gillet, L. *Trois variations sur Claude Monet*. Paris: Librarie Plon, 1927. Translated in *Claude Monet: Seasons and Moments*, by William C. Weitz, 50. New York: Museum of Modern Art, 1960.

Gilmore, E. "'Call Me Jim': James Thurber Speaking." *The Columbus Sunday Dispatch*, Aug 3, 1958. Reprinted in *Conversations with James Thurber*, edited by Thomas Fensch. Jackson, MS: University Press of Mississippi, 1989.

Goethe, Johan Wolfgang von, and Charles L. Eastlake, trans. *Theory of Colours*. Reprint of 1840 edition, with an introduction by D. B. Judd. Cambridge: M.I.T. Press, 1970.

Goldman, Emma. *Living My Life*. New York: Alfred A. Knopf, 1934.

Gombrich, E. H. *Art and Illusion: A Study in the Psychology of Pictorial Representation*. Princeton, NJ: Princeton University Press, 1969.

Goodwin, Frederick J., and Kay Redfield Jamison. *Manic-Depressive Illness: Bipolar Disorders and Recurrent Depression*. New York: Oxford University Press, 1990.

Gordon, Robert, and Andrew Forge. *Monet*. New York: Harry N. Abrams, Inc., 1983.

Gould, C. "Titian." In vol. 31, *The Dictionary of Art*, edited by Jane Turner, 31 and 38. New York: Grove Dictionaries, 1996.

Goya, Francisco. *Cartas a Martin Zapater*, edited by Mercedes Águeda and Xavier Salas. Madrid: Ediciones Turner, 1982.

Guerin, Marcel, ed. *Degas Letters*. Translated by Marguerite Kay. Oxford: Cassirer, 1947.

Guiliani, L. et al. *Euphronios: pittore ad Atene nel VI secolo a. C.* Milan: Fabbri, 1991.

Hahnemann, S. *Traité de maitière médicale ou de l'action pure des medicaments homéopathiques*. Paris: Bailliere, 1835.

Hale, Nancy. *Mary Cassatt: A Biography of the Great American Painter*. New York: Doubleday, 1975.

Halévy, Daniel. "Edgar Degas." *Le Divan* 61 (Sept.–Oct. 1919): 209.

———. *My Friend Degas*. Middletown, CT: Wesleyan University Press, 1964.

Hamilton, G. H. "Cezanne and His Critics." In *Cezanne: The Late Work*, edited by William Rubin. The Museum of Modern Art, in association with the New York Graphic Society, 1977.

———. "The Dying of the Light: The Late Work of Degas, Monet, and Cézanne." In *Aspects of Monet*, edited by John Rewald and Frances Weitzenhoffer, 218–241. New York: Harry N. Abrams, Inc., 1984.

Harmon, Leon D. "The Recognition of Faces." *Scientific American* 229 (1973): 70–82.

Harmon, Leon D., and Bela Julesz. "Masking in Visual Recognition: Effects of Two-Dimensional Filtered Noise." *Science* 180 (1973): 1194–1197.

Haskell, Barbara. "Georgia O'Keeffe: Works on paper, a critical essay." In *Georgia O'Keefe: Works on Paper*, 1–13. Santa Fe: Museum of New Mexico Press, 1985.

Heller, Reinhold. *Munch: His Life and Work*. Chicago: University of Chicago Press, 1984.

Henry, Paul. *An Irish Portrait: An Autobiography of Paul Henry*. London: B.T. Batsford, Ltd., 1951.

Herbert, Robert L. *Seurat and the Making of "La Grande Jatte."* Art Institute of Chicago, in association with the University of California Press, 2004.

Herbert, Robert L., F. Cachin, A. Distel, S. A. Stein, and G. Tinterow. *Georges Seurat 1859–1891*. Grand Palais, Paris, and the Metropolitan Museum of Art, NY, in association with Harry N. Abrams, 1991.

Hirschberg, Julius. *The History of Ophthalmology*. Vol. 1. Translated by Frederick C. Blodi, MD. Bonn: J. P. Wayenborgh, 1982.

Hockney, David. *Hockney on Photography: Conversations with Paul Joyce*. London: Jonathan Cape, 1988.

Hogrefe, Jeffrey. *O'Keeffe: The Life of an American Legend*. New York: Bantam Books, 1992.

Homer, William Innes. *Seurat and the Science of Painting*. Cambridge, MA: MIT Press, 1964.

Hoppe, Ragnar. "På visit hos Matisse." An interview with Matisse in 1919 in *Städer och Konstnärer, resebrev och essäer om Konst*, 193–191. 1931. Translated by Desirée Koslin. Quoted in *Matisse on Art*, by Jack Flam, 75–76. Berkeley, CA: University of California Press, 1995.

Hoschedé, D. J. *Claude Monet ce mal connu*. Geneva: Cailler, 1960.

Hubel, David H. *Eye, Brain, and Vision*. Scientific American Library 22. New York: Scientific American Library, 1988.

Hudson, W. "Pictorial Depth Perception in Sub-Cultural Groups in Africa." *The Journal of Social Psychology* 52 (1960): 183–208.

Hug, M. "Le Docteur Gachet et l'homéopathie." *Journal de l'Homeopathie* 28 (1990).

Humfrey, Peter. *Titian*. London: Phaidon Press, 2007.

Huxley, Aldous. *The Art of Seeing*. New York: Harper and Brothers, 1942. Reprinted by Creative Arts Book Company, Berkeley, CA, 1982.

Huysmans, Joris-Karl. "Trois peintres." *La Cravache*, August 4, 1888. In "A Century of Cezanne Criticism" in *Cezanne*, edited by Francoise Cachin. Philadelphia Museum of Art, in association with Harry N. Abrams, Inc, 1996.

———. *Certains*. Paris: Tresse et Stock, 1889.

Ilardi, Vincent. *Renaissance Vision from Spectacles to Telescopes*. Philadelphia: American Philosophical Society, 2007.

Ingamells, John, and John Edgcumbe, eds. *The Letters of Sir Joshua Reynolds*. New Haven, CT: Yale University Press, 2000.

Jamison, Kay Redfield, and Richard Jed Wyatt. "Ménière's Disease? Epilepsy? Psychosis?" *Journal of the American Medical Association* 265 (1991): 723–724.

———. "Vincent van Gogh's Illness." *British Medical Journal* 304 (1992): 577.

Jamot, Paul. *Auguste Ravier: Étude critique suivie de la correspondance de l'artiste*. Lyon, France: H. Lardanchet, 1921.

Julesz, Bela. "Binocular Depth Perception of Computer-Generated Patterns." *Bell Laboratories Technical Journal* 39 (1960): 1125–1162.

Kelly, Richard Michael. *The Art of George du Maurier*. Aldershot, England: Scolar Press, 1996.

Kendall, R. "Degas and the Contingency of Vision." *Burlington Magazine* 130 (1988): 180–216.

Kennedy, S. B. *Paul Henry: Paintings, Drawings, and Illustrations*. New Haven, CT: Yale University Press, 2007.

Kinney, Harrison. *James Thurber: His Life and Times*. New York: Henry Holt & Co, 1997.

Klotz, M. L. "Georgia O'Keeffe at 90." *Art News* (December 1977): 40.

Koenderink, J. J., A. J. van Doom, and A. M. L. Kappers. "Pointing Out of the Picture." *Perception* 33 (2004): 513–530.

Landolt, Edmund, and P. Gygax. *Vade Mecum of Ophthalmological Therapeutics*. Philadelphia, PA: J. B. Lippincott Co., 1898.

Lanthony, Philippe. *An Eye for Painting*. Paris: Réunion des Musées Nationaux, 2006.

———. "Cataract and the Painting of Claude Monet." *Points de Vue* 29 (1993): 12–25.

———. "Daltonisme et peinture." *Journal français d'ophtalmologie* 5 (1982): 6–7 and 373–385.

———. "Degas et al fréquence spatiale." *Bulletin des sociétés d'ophtalmologie de France* 91 (1991): 605–611.

———. "Dyschromatopsies et art pictural." *Journal français d'ophtalmologie* 14 (1991): 510–519.

———. "J.J. peintre daltonien." *Journal français d'ophtalmologie* 17, no.10 (1994): 596–602.

———. "La malvision of d'Edgar Degas." *Médecine et hygiene* 48 (1990): 2382–2401.

———. *Les Yeux des Peintres*. Lausanne: L'Age d'Homme, 1999.

———. "L'oiseau d'Edvard Munch." *Bulletin des sociétés d'ophtalmologie de France*. 94 (1994): 555–559.

Lanzi, Luigi. *The History of Painting in Italy*. Vol. 3. Translated by T. Roscoe. 6 vols. London: Simpkin and Marshall, 1828.

Larson, S. A., and R. V. Keech and R. E. Verdick. "The Threshold for the Detection of Strabismus." *Journal of the American Association of Pediatric Ophthalmology and Strabismus* 8 (2003): 418–422.

Lashley, K. S. "Patterns of Cerebral Integration Indicated by the Scotomas of Migraine." *Archives of Neurology and Psychiatry* 46 (1941): 331–339.

Le Figaro. January 8, 1926.

Léger, Fernand. *Functions of Painting*. New York: The Viking Press, 1973.

Lejard, A. "Propos de Henri Matisse." *Amis des Arts* n.s. 2 (October 1951). Quoted in introduction by Jack Flam to *Henri Matisse: Paper Cut-Outs*, edited by Jack. Cowart, 17. New York: Harry N. Abrams, Inc., 1977.

Lemoine, Serge, Walter Lewino, and Jean-Francois Jaeger. *Bissière*. Neuchatel, Switzerland: Ides et Callendes, 2000.

Lemoisne, Paul André. *Degas et son oeuvre*. Vol. 1. Paris: Paul Brame et CM de Hauke, 1946. Translated in *Degas*, by Jean Sutherland Boggs. New York: Metropolitan Museum of Art, 1988.

Leslie, Charles Robert, and Tom Taylor. *Life and Times of Sir Joshua Reynolds: With Notices of Some of His Contemporaries*. London, England: John Murray, 1865.

Levene, John R. "Benjamin Franklin, FRS, Sir Joshua Reynolds, FRS, PRA, Benjamin West, PRA, and the Invention of Bifocals." *Notes and Records of the Royal Society of London* 27 (1972): 141–163.

Levin, I. "The Technic of Radium Application in Cataracts." *American Journal of Roentgenology* 7 (1920): 107–108.

Levy, Walter J. Letter to James G. Ravin. December 18, 1990.

Liebreich, Richard. "Turner and Mulready—On the Effect of Certain Faults of Vision on Painting, with Especial Reference to Their Works." *Notices of the Proceedings at the Meetings of the Members of the Royal Institution, with Abstracts of the Discourses Delivered at the Evening Meetings* 6 (1872): 450–463.

Lindauer, M. S. "Old Age Style." In vol. 2, *Encyclopedia of Creativity*, edited by Mark A. Runco and Steven R. Pritzker, 314–315. San Diego, CA: Academic Press, 1999.

Lindberg, David C. *Theories of Vision from Al-Kindi to Kepler*. Chicago: University of Chicago Press, 1976.

Linksz, Arthur. *An Ophthalmologist Looks at Art*. San Francisco: Smith-Kettlewell Eye Research Foundation, 1980.

Lisle, Laurie. *Portrait of an Artist: A Biography of Georgia O'Keeffe*. New York: Seaview Books, 1980.

Livingstone, Margaret. "Art, Illusion and the Visual System." *Scientific American* 258 (1988): 78–85.

———. *Vision and Art: The Biology of Seeing*. New York: Harry N. Abrams, Inc. 2002.

Livingstone, Margaret, and B. R. Conway. "Was Rembrandt Stereoblind?" *The New England Journal of Medicine* 351 (2004): 1264–1265.

Livingstone, Margaret, and David H. Hubel. "Segregation of Form, Color, Movement, and Depth: Anatomy, Physiology, and Perception." *Science* 240 (1988): 740–749.

Locher, J. L., ed. *M. C. Escher: His Life and Complete Graphic Work*. New York: Harry N. Abrams, Inc., 1982.

Loftus, Loretta S., and Wilfred Niels Arnold. "Vincent van Gogh's Illness: Acute Intermittent Porphyria?" *British Medical Journal* 303 (1991): 1589–1591.

Lopera, Jose Alvarez, ed. *El Greco: Identity and Transformation*. New York: Skira, 1999.

Lostalot, Alfred de. "Exhibition of the Works of M. Claude Monet." *Gazette des Beaux-Arts*, April 1883. In *Monet: A Retrospective*, edited by Charles F. Stuckey, 104. New York: Hugh Lauter Levin Associates, Inc., 1985.

Luz, M. "Témoignages: Henri Matisse." *XXe Siècle*, n.s. 2 (January 1952): 55–57. Quoted in *Matisse on Art*, by Jack Flam, 209. Berkeley, CA: University of California Press, 1995.

MacColl, Dugald Sutherland. *The Life, Work, and Setting of Philip Wilson Steer*. London: Faber and Faber, Ltd., 1955.

Mach, Ernst. "On the Dependence of Retinal Points on One Another." Translated and reprinted in *Mach Bands: Quantitative Studies on Neural Networks in the Retina*, by Floyd Ratliff, 307–320. San Francisco: Holden-Day, Inc., 1965.

Magnus, Rudolf, and Heinz Norden, trans. *Goethe as a Scientist*. New York: Collier Books, 1949.

Maillet, Arnaud. *The Claude Glass: Use and Meaning of the Black Mirror in Western Art*. New York: Zone Books, 2004.

Mandel, P. C. F. "Homer Dodge Martin: American Landscape Painter 1836–1897." PhD diss., New York University, 1973.

Manship, John. *Paul Manship*. New York: Abbeville Press, 1989.

March, B. "Linear Perspective in Chinese Painting." *Eastern Art: An Annual* 3 (1931): 112–139.

Marie, F. W. "Van Gogh's suicide." *Journal of the American Medical Association* 217: (1971): 938–939.

Marmor, Michael F. "A Brief History of Macular Grids: From Thomas Reid to Edvard Munch and Marc Amsler." *Survey of Ophthalmology* 44 (2000): 343–53.

———. *Degas Through His Own Eyes: Visual Disability and the Late Style of Degas*. Paris: Somogy éditions d'art, 2002.

———. "Ophthalmology and Art: Simulation of Monet's Cataracts and Degas' Retinal Disease." *Archives of Ophthalmology* 124 (2006): 1764–1769.

Marmor, Michael F., and James G. Ravin. *The Eye of the Artist*. St. Louis, MO: Mosby-Year Book, Inc., 1997.

Marmor, Michael F., and Phillipe Lanthony. "The Dilemma of Color Deficiency and Art." *Survey of Ophthalmology* 45 (2001): 407–415.

Marmor, Michael F., and S. Shaikh. Response to "Was Rembrandt Stereoblind?" *The New England Journal of Medicine* 352 (2005): 631–632.

Marmor, Michael F., and W. A. Wagenaar. "Escher and the Ophthalmologist." *Survey of Ophthalmology* 48 (2003): 356–61.

Martin, Elizabeth Gilbert. *Homer Martin: A Reminiscence*. New York, NY: William Macbeth, 1904.

Mathews, Nancy Mowll. *Mary Cassatt: A Life*. New York: Villard Books, 1994.

Matisse, Henri. "La Chapelle du Rosaire." In *Chapelle du Rosaire des Dominicaines de Vence*, 1951. Quoted in *Matisse on Art*, by Jack Flam, 196. Berkeley, CA: University of California Press, 1995.

———. "Letter from Matisse to Henry Clifford." In *Henri Matisse*, 15–16. Philadelphia: Philadelphia Museum of Art, 1948. Quoted in *Matisse on Art*, by Jack Flam, 181–183. Berkeley, CA: University of California Press, 1995.

———. "Matisse Speaks." Statements to E. Tériade in 1950, in *Art News Annual* 21 (1952): 40–71. Quoted in *Matisse on Art*, by Jack Flam, 202. Berkeley, CA: University of California Press, 1995.

———. "Notes d'un peintre." *La Grande Revue* LII, no. 24 (25 December 1908): 731–745. Quoted in Flam, *Matisse on Art*, 40–41. Berkeley, CA: University of California Press, 1995.

———. "Rôle et modalitiés de la couleur." In *Problémes de la peinture*, written by G. Diehl, 237–240. Lyons, France: Confluences, 1945. Quoted in *Matisse on Art*, by Jack Flam, 155. Berkeley, CA: University of California Press, 1995.

Maxmin, Jody. "Euphronios Epoiesen: Portrait of the Artist as a Presbyopic Potter," *Greece & Rome* 21 (1974): 178–80.

Maxmin, Jody, and Michael F. Marmor. "Euphronios: A Presbyope in Ancient Athens?" In *The Eye of the Artist*, by Michael F. Marmor and James G. Ravin, 48–57. St. Louis, MO: Mosby-Year Book, Inc., 1997.

McMullen, Roy. *Degas: His Life, Times and Work*. Boston: Houghton Mifflin Company, 1984.

Meryon, Charles. Letters in the collection of the British Museum. In *Charles Meryon*, by J. Ducros, numbers 366, 367, 449, 781. Paris: Musée de la Marine, 1968.

Michel, A. "Degas et son modèle." *Mercure de France* 131 (1919): 632.

Michelangelo di Lodovico Buonarroti Simoni (Michelangelo). Letter to Luca Martini, 1547. In *The Artist Grows Old: The Aging of Art and Artists in Italy 1500–1800*, by Philip Sohm, 3. New Haven, CT: Yale University Press, 2007.

Moffat, Charles. *The New Painting: Impressionism 1874–1886*. National Gallery, Washington, DC, and the Fine Arts Museums of San Francisco, in association with Richard Burton, SA, 1986.

Moffitt, J. F. "Painters 'Born Under Saturn': The Physiological Explanation." *Art History* 11 (1988): 195–216.

Monet, Claude. Letter to Clemenceau, November 12, 1918. In *Georges Clemenceau à son Ami Claude Monet*, edited by M. Hoog, 63. Paris: Réunion des Musées Nationaux, 1993.

———. Letters to Clemenceau, 1922–25. French Ophthalmologic Society, Paris.

———. Letter to Clemenceau, August 30, 1923 and September 23, 1923. In vol. 5, *Claude Monet biographie et catalogue raisonne*, by D. Wildenstein, 416. Paris: Bibliothèque des Arts, 1985.

Montebello, Philippe de. Director's note to "El Greco." *Metropolitan Museum of Art Bulletin* 39 (1981): 1.

Moreau-Nelaton, E. "Deux heures avec Monsieur Degas." In *Degas et son oeuvre*, edited by Paul André Lemoisne, 257–261, n. 218. Paris: P. Braume et C. M. de Hauke, 1946.

Muller, Priscilla E. *Goya's "Black" Paintings: Truth and Reason in Light and Liberty*. New York: Hispanic Society of America, 1984.

Munch Museum collection, Oslo. Notes on sketches T2136, T2143, T2149, T2148, T2165, and T2167.

Münchow, W. "Colour Vision Deficiencies in Painting." Presented at the *Regional Symposium of the International Research Group on Colour Vision Deficiencies*. Dresden, September 5–6, 1978.

Munro, Jane. "Philip Wilson Steer." In vol. 29, *The Grove Dictionary of Art*, edited by J. Turner, 596. New York: Oxford University Press, 1996.

Neitz, Maureen. "Society and Colorblindness." Presented at the *14th Biennial Eye Research Symposium, Research to Prevent Blindness*, 1997, 64–66.

Neitz, Maureen, and Jay Neitz . "Molecular Genetics of Color Vision and Color Vision Defects." *Archives of Ophthalmology* 118 (2000): 691–700.

The New York Times, obituary of James Thurber. November 3, 1961.

Niederland, W. G. "Goya's Illness: A Case of Lead Encephalopathy?" *New York State Journal of Medicine* 72 (1972): 413–18.

Noble, Joseph Veach. *Techniques of Painted Attic Pottery*. Rev. ed. London: Thames and Hudson, 1988.

Nochlin, Linda, ed. *Impressionism and Post-Impressionism 1874–1904: Sources and Documents*. Englewood Cliffs, NJ: Prentice-Hall, 1966.

Offret, G. "Necrologie, Charles Coutela, 1876–1969." *Archives d'Ophtalmologie* 29 (1969): 589–592.

O'Keeffe, Georgia. *Georgia O'Keeffe*. New York: Viking Press, 1976.

Parenteau, Daniel. *Leçons de clinique ophtalmologique*. Paris: Doin, 1881.

Pastoureau, Michel. *Blue: The History of a Color*. Princeton, NJ: Princeton University Press, 2001.

Patten, C. T. and A. Cardona-Hine. "Days with Georgia." *Art News* (April 1992): 109.

Payne, H. G. G., and G. M. Young. *Archaic Marble Sculpture from the Athenian Acropolis*. New York: William Morrow and Company, 1950.

Penrose, L. S., and R. Penrose. "Impossible Objects: A Special Type of Visual Illusion." *British Journal of Psychology* 49 (1958): 31–33.

Penrose, Roger. Remarks in *The Fantastic World of M. C. Escher*. Directed by Michele Emmer. Film 7 International and M. C. Escher Foundation, 1980.

Pick, Daniel. *Svengali's Web: The Alien Enchanter in Modern Culture*. New Haven, CT: Yale University Press, 2000.

Pickford, R. W. "The Influence of Colour Vision Defects on Painting." *The British Journal of Aesthetics* 5 (1965): 211–226.

———. "Two Artists with Protan Colour Vision Defects." *British Journal of Psychology* 56 (1965): 421–430.

Pissarro, Camille. *Correspondance de Camille Pissarro*. Edited by Janine Bailly-Herzberg. 5 vols. Paris: Editions du Valhermeil, 1986–1991.

Plato. *The Republic, Book 10*. Translated by F. M. Cornford. New York: Oxford University Press, 1945.

Pliny. *Natural History*. Translated by H. Rackham, Harvard University Press, Cambridge MA, 1952. Vol IX, Book XXXV (120).

Polack, A. "A propos d'une erreur d'interprétation des oeuvres du peintre Carrière." *La chronique médicale* (January 1, 1908): 29–30.

Poling, John D. "Painting with Georgia O'Keeffe." In *From the Faraway Nearby: Georgia O'Keeffe as Icon*, edited by Christopher Merrill and Ellen Bradbury, 193–209. Reading, MA: Addison-Wesley, 1992.

Ptolemy, *Theory of Visual Perception*. Translated by Smith, A. Mark as *Ptolemy's Theory of Visual Perception: An English Translation of the "Optics" with Introduction and Commentary*. Transactions of the American Philosophical Society, vol. 86, part 2. Philadelphia: American Philosophical Society, 1996, iii–300.

Puro, Gary V. Letter to James G. Ravin. January 23, 1991.

Raeder, Johan. Letter to Edvard Munch. May 10, 1930. Munch Museum, Oslo. The same letter was re-issued almost word for word on Sept. 27, 1930.

———. Letter to Edvard Munch. March 29, 1938. Munch Museum, Oslo.

Ratliff, Floyd. "Contour and Contrast." *Scientific American*, June 1972.

———. *Mach Bands: Quantitative Studies on Neural Networks in the Retina*. San Francisco: Holden-Day, Inc., 1965.

———. *Paul Signac and Color in Neo-Impressionism*. New York: Rockefeller University Press, 1992.

Ravin, James G. "Geriatrics and Painting." *Art Journal* 27 (1968): 397.

———. "Monet's Cataracts." *Journal of the American Medical Association* 254 (1985): 394–399.

Ravin, James G., and C. Kenyon. "Degas' Loss of Vision: Evidence for a Diagnosis of Retinal Disease." *Survey of Ophthalmology* 39 (1994): 57–64.

———. "From von Graefe's Clinic to the École des Beaux-Arts: The Meteoric Career of Richard Liebreich." *Survey of Ophthalmology* 37 (1992): 221–228.

Ravin, James G., and G. P. Hodge. "El Greco: Astigmatism or Calculated Distortion." *Journal of Pediatric Ophthalmology & Strabismus* 4 (1967): 55–59.

Ravin, James G., and Peter M. Odell. "Pixels and Painting: Chuck Close and the Fragmented Image." *Archives of Ophthalmology* 126 (2008): 1148–51.

Reff, Theodore. *The Notebooks of Edgar Degas*. Oxford: Oxford University Press, 1976.

Renoir, Jean. *Renoir: My Father*. Boston: Little, Brown & Co, 1962.

Rewald, John, ed. *Paul Cézanne: Letters*. New York: Hacker Art Books, 1976.

Rhigellini, G. M. *Osservazioni sopra alcuni casi rari medici, e chirurgici*. Venice: Pietro Bassaglia, 1764.

Richter, Gisela M.A. *Korai: Archaic Greek Maidens—A Study of the Development of the Kore Type in Greek Sculpture*. London: Phaidon Press, Ltd., 1968.

———. *Kouroi*. London: Phaidon Press, Ltd., 1970.

Riley, Bridget. *The Eye's Mind: Collected Writings 1965–1999*, edited by Robert Kudielka. London: Thames and Hudson, Ltd., 1999.

———. "In Conversation with Robert Kudielka." In *Bridget Riley: Paintings and Drawings, 1961–1973*, by Bridget Riley. Arts Council of Great Britain, 1973. Quoted in *The Eye's Mind*, (1999), by Bridget Riley, 80. London: Thames and Hudson, Ltd., 1999.

———. "Perception Is the Medium." *Art News* 64, no. 6 (October 1965): 32–3, 66. Quoted in *The Eye's Mind*, by Bridget Riley, 66–68. London: Thames and Hudson, Ltd., 1999

———. "Talking to Mel Gooding." In *The Experience of Painting: Eight Modern Artists*, edited by Mel Gooding. London: South Bank Centre, 1989. Quoted in *The Eye's Mind* (1999), by Bridget Riley, 125. London: Thames and Hudson, Ltd., 1999.

Riley, Bridget and Maurice de Sausmarez. "Bridget Riley and Maurice de Sausmarez, a Conversation." *Arts International* 11, no. 4 (April 1967): 37–41. Quoted in *The Eye's Mind*, by Bridget Riley, 52. London: Thames and Hudson, Ltd., 1999.

Robertson, M. "Epoiesen on Greek Vases: Other Considerations." *Journal of Hellenic Studies* 92 (1972): 180–83.

Robinson, Roxana. *Georgia O'Keeffe: A Life*. New York: Harper and Row, 1989.

Rock, Irvin. *Perception*. New York: Scientific American Library, 1984.

Rogers, J. M. *Mughal Miniatures*. New York: Thames and Hudson, 1993.

Rood, Ogden N. *Modern Chromatics: Students' Text-book of Color, with Applications to Art and Industry Including a Facsimile of the First American Edition of 1879*. Preface, Co, 1973.

Sambrico, Valentin de. *Tapies de Goya*. Madrid: Patrimonio Nacional, 1946.

Schapiro, Meyer. *Impressionism: Reflections and Perceptions*. New York: George Brazziller, 1997.

Schattschneider, Doris. *Visions of Symmetry: Notebooks, Periodic Drawings, and Related Work of M.C. Escher*. New York: W. H. Freeman and Company, 1990.

Schwartz, Gary. *Rembrandt: His Life, His Paintings*. New York: Viking Press, 1985.

Screech, T. "The Meaning of Western Perspective in Edo Popular Culture." *Archives of Asian Art* 47 (1994): 58–69.

Seneca, and T. H. Corcoran, trans. *Naturales Quaestiones* I, 6.5. Cambridge, MA: Harvard University Press, 1971.

Sherard, R. H. "The Author of *Trilby*." *McClure's Magazine* 1895: 397–398.

Sickert, W. "Degas." *Burlington Magazine* 43 (1923): 308.

Smith, Paul. *Seurat and the Avant-Garde*. New Haven, CT: Yale University Press, 1997.

Sohm, Philip. *The Artist Grows Old: The Aging of Art and Artists in Italy 1500–1800*. New Haven, CT: Yale University Press, 2007.

Spassky, Natalie. *American Paintings in the Metropolitan Museum of Art*. Vol. 2. New York: Metropolitan Museum of Art, 1985.

Spurling, Hilary. *Matisse the Master: A Life of Henri Matisse; The Conquest of Colour, 1909–1954*. New York: Alfred A. Knopf, 2005.

Strauss, D. P. "Why Did Goethe Hate Glasses?" *Journal of English and Germanic Philology* 80 (1981): 176–187.

Strebel, J., "Quatre manières d'un peintre daltonien." *Formes et Couleurs* 6 (1944): 83–86.

Stuckey, C. F. "Blossoms and Blunders: Monet and the State II." *Art in America* 68 (1979): 116.

Sweet, Frederick A. *Miss Mary Cassatt: Impressionist from Pennsylvania*. Norman, OK: University of Oklahoma Press, 1966.

Taylor, H. R. et al. "Visible Light and Risks of Age-related Macular Degeneration." *Transactions of the American Ophthalmological Society* 88 (1990): 163–178.

Tériade, E. "Constance du fauvisme." *Minotaure* II, no. 9 (15 October 1936), 3. Quoted in *Matisse on Art*, by Jack Flam, 122. Berkeley, CA:

———. "Visite a Henri Matisse" *L'Intransigeant* (14 and 22 January 1929). Partially reprinted as "Propos de Henri Matisse a Tériade." *Verve* IV, no. 13 (December 1945): 56. Quoted in Flam, *Matisse on Art*, 84. Berkeley, CA: University of California Press, 1995.

Teuber, M. L. "Sources of Ambiguity in the Prints of Maurits C. Escher." *Scientific American* 231 (1974): 90–104.

Thiebault-Sisson, F. "Les nymphéas de Claude Monet." *La revue de l'art ancien et moderne* 52 (1927): 41–52. Translated in *Monet: A Retrospective*, edited by Charles F. Stuckey, 279–293. New York: Hugh Lauter Levin Associates, 1985.

Thurber, Helen. "Long Time No See." *Ladies Home Journal*, July 1964.

———. "Self-portraits and Self-appraisals by James Thurber." *Harper's Magazine*, August 1966, 44.

Thurber, Helen, and Edward Weeks, eds. *Selected Letters of James Thurber*. Boston: Little, Brown & Co., 1981.

Thurber, James. *Fables for Our Time*. New York: Harper & Row, 1940. Reprinted in *Thurber: Writings and Drawings*, by James Thurber. New York: Library of America, 1996.

———. "A New Natural History" in *The Beast in Me and Other Animals: A New Collection of Pieces and Drawings about Human Beings and Other Less Alarming Creatures*. New York: Harcourt, Brace, 1948. Reprinted in *Thurber: Writings and Drawings*, by James Thurber. New York: Library of America, 1996.

Time. "Priceless Gift of Laughter." July 9, 1951.

Tomlinson, Janice Angela. *Francisco Goya: The Tapestry Cartoons and Early Career at the Court of Madrid*. New York: Cambridge University Press, 1989.

Torres, María Teresa Rodríguez. *Goya, Saturno y el saturnismo*. Madrid: University of Madrid, 1993.

Toti, A. "Nuovo metodo conservatore de cura radical delle suppurazioni croniche del saco lacrimale (dacriocistorinostomia)." *La Clinica Moderna* 10 (1904): 385–387.

Trevor-Roper, Patrick. "Influence of Eye Disease on Pictorial Art." *Proceedings of the Royal Society of Medicine* 52 (1959): 721–744.

———. "The Withdrawal of Colours." In *The World through Blunted Sight*, by Patrick Trevor-Roper, 75–93. London: Thames and Hudson, 1970. In rev. ed., 84–100. London: Allen Lane, 1988.

———. *The World Through Blunted Sight*. London: Thames and Hudson, 1970.

———. *The World Through Blunted Sight*. Rev. ed. London: Allen Lane, 1988.

Tucker, Paul Hayes et al. *Monet in the 20th Century*. New Haven: Yale University Press, 1998.

Unger, Leonard, ed. *American Writers*, suppl. 1, pt. 2. New York: Charles Scribner's Sons, 1979.

Valeton, J. M., and D. van Norren. "Light Adaptation of Primate Cones: An Analysis Based on Extracellular Data." *Vision Research* 23 (1983): 1539–1547.

Valtat, Jean. *Louis Valtat: Catalogue de l'oeuvre peint 1869–1952*, vol. 1. Neuchatel, Switzerland: Editions Ides et Calendes, 1977.

van de Wetering, Ernst, ed. *A Corpus of Rembrandt Paintings*. Vol. 4, *The Self-Portraits*. Dordrecht, Netherlands: Springer, 2005.

van Gogh, Vincent. Letter 136. *The Complete Letters of Vincent van Gogh*. Greenwich, CT: New York Graphic Society, 1959.

Vasari, Giorgio. *Lives of the Most Eminent Painters, Sculptors and Architects*. Vol 4. New York: Charles Scribner's Sons, 1917. Originally published in 1550.

———. *Lives of the Most Eminent Painters, Sculptors, and Architects*. Vol. 7. Translated by G. DeVere. London: The Medici Society, 1912–1914.

Viènot, F., H. Brettel, L. Ott, A. M'Barek, and J. D. Molton. "What Do Colour-Blind People See?" *Nature* 376 (1995): 127–128.

Vollard, Ambroise. *Degas: An Intimate Portrait*. New York: Crown Publishers, 1937.

———. *Paul Cézanne: His Life and Art*. New York: Frank-Maurice, 1926.

———. *Renoir: An Intimate Record*. New York: Alfred A. Knopf, 1934.

von Bothmer, Dietrich. Chart in Guiliani, L. et al. *Euphronios: pittore ad Atene nel VI secolo a. C*, 268. Milan: Fabbri, l991.

———. *The Amasis Painter and his World: Vase-Painting in Sixth-Century B.C. Athens*. London: Thames & Hudson, 1985.

Wagenaar, Johan W. "The Importance of the Relationship 'Figure and Ground' in Fast Traffic." *Ophthalmologica* 124 (1952): 309–315.

Warhol, Andy. "Georgia O'Keeffe and Juan Hamilton." *Interview* 13 (1983): 54–55.

Weale, Robert Alexander. "A Matter of Illumination." In *The Eye of the Artist*, by Michael F. Marmor and James G. Ravin, 70–89. St. Louis, MO: Mosby-Year Book, Inc., 1997.

———. "Discoverers of Mach-Bands." *Investigative Ophthalmology & Visual Science* 18 (1979): 652–654.

———. "Painters and Their Eyes: Age and Other Handicaps." *Zeitschrift fur Kunstgeschichte* 69 (2006): 402–410.

Webster, J. Carson. "The Technique of Impressionism: A Reappraisal." *College Art Journal* 4 (1945): 3–22.

Wehgartner, I., ed. *Euphronios und seine Zeit*. Berlin: Staatliche Museen zu Berlin; Preussischer Kulturbesitz, 1992.

Werner, J. S. "Aging Through the Eyes of Monet." In *Color Vision: Perspectives from Different Disciplines*, edited by W. G. K. Backhaus, R. Kliegl, and J. S. Werner, 3–41. New York: Walter de Gruyter, 1998.

West, Shearer. "Gender and Internationalism: The Case of Rosalba Carriera." In *Italian Culture in Northern Europe in the Eighteenth Century*, edited by Shearer West, 46–66. New York: Cambridge University Press, 1999.

White, Barbara Ehrlich. *Renoir: His Life, Art, and Letters*. New York: Harry N. Abrams, 1984.

Whitley, William T. *Art in England 1800–1820*. New York: Macmillan Co., 1928.

———. *Art in England 1821–1834*. Cambridge: Cambridge University Press, 1930.

Wildenstein, D. *Claude Monet biographie et catalogue raisonne*. Vol. 4. Lausanne et Paris: Bibliothèque des Arts, 1985.

Witts, L. J.,"Porphyria and George III." *British Medical Journal* 4 (1972): 479–480.

Wollaston, W. H. "Apparent Direction of Eyes in a Portrait." *Philosophical Transactions of the Royal Society of London* (1824): 1–10.

Wu, G. et al: "Macular Photostress Test in Diabetic Retinopathy and Age-Related Macular Degeneration." *Archives of Ophthalmology* 108 (1990): 1556–1558.

Zeki, Semir. *Inner Vision: An Exploration of Art and the Brain*. Oxford: University Press, 1999.

———. *A Vision of the Brain*. Oxford: Wiley-Blackwell, 1993.

Zell, M. "Why Rethink Rembrandt?" In *Rethinking Rembrandt*, edited by Alan Chong and Michael Zell, 10–16. Boston: Isabella Stewart Gardner Museum / Zwolle, Netherlands: Waanders Publishers, 2002.

IMAGE CREDITS

TITLE PAGE seed pot, B. and J. Cerno, Acoma, New Mexico, 1989.

CHAPTER 1 **Fig. 1.4** San Nicolo, Treviso, Italy / The Bridgeman Art Library; **Fig. 1.5** Uffizi, Florence, Italy. Photo: Erich Lessing / Art Resource, NY; **Fig. 1.6** The Louvre Museum, Paris. Photo: Erich Lessing / Art Resource, NY; **Fig. 1.7** Palazzo Barberini, Rome, Italy / The Bridgeman Art Library; **Fig. 1.8** Kunsthistorisches Museum, Vienna, Austria / The Bridgeman Art Library; **Fig. 1.9** Philadelphia Museum of Art, Philadelphia, Pennsylvania, U.S.A. The Louis E. Stern Collection, 1963. Photo: The Philadelphia Museum / Art Resource, NY.

CHAPTER 2 **Fig. 2.1** Private collection / The Bridgeman Art Library; **Fig. 2.2** Private collection / The Bridgeman Art Library; **Fig. 2.3** Haags Gemeentemuseum, The Hague, The Netherlands / The Bridgeman Art Library; **Fig. 2.4** Gemaldegalerie, Berlin, Germany / The Bridgeman Art Library; **Fig. 2.5** Musée d'Orsay, Paris, France / Giraudon / The Bridgeman Art Library; **Fig. 2.6** Musée d'Orsay, Paris, France / Giraudon / The Bridgeman Art Library; **Fig. 2.7** Private collection / The Bridgeman Art Library.

CHAPTER 3 **Fig. 3.1** National Gallery of Art, Washington, DC, U.S.A. Widener Collection. Image courtesy of the Board of Trustees, National Gallery of Art, Washington; **Fig. 3.2** The Metropolitan Museum of Art, New York, New York, U.S.A. Robert Lehman Collection, 1975 (1975.1.146). Image copyright © The Metropolitan Museum of Art / Art Resource, NY; **Fig 3.3** Gemaeldegalerie Alte Meister, Dresden, Germany. © Staatliche Kunstsammlungen Dresden / The Bridgeman Art Library; **Fig. 3.4** Santo Tomé, Toledo, Spain / Giraudon / The Bridgeman Art Library; **Fig. 3.5** Museo de Santa Cruz, Toledo, Spain / The Bridgeman Art Library; **Fig. 3.6** Copyright © Michael F. Marmor.

CHAPTER 4 **Fig. 4.1** Antikensammlung, Staatliche Museen zu Berlin, Berlin, Germany. Photo: Bildarchiv Preussischer Kulturbesitz / Art Resource, NY; **Fig. 4.2** Cantor Arts Center at Stanford University, 1961.69; **Fig. 4.3** Intesa Sanpaolo Collection, Vicenza, Italy; **Fig. 4.4** Courtesy of the Soprintendenza per i Beni Archeologici dell'Etruria Meridionale. All rights reserved; **Fig. 4.5** Staatliche Antikensammlungen und Glyptothek, Munich, Germany.

CHAPTER 5 **Fig. 5.3** Copyright © Michael F. Marmor; **Fig. 5.8** Yale University Art Gallery, New Haven, Connecticut, U.S.A. 1986.86.1g. Photo: Yale University Art Gallery / Art Resource, NY; **Fig. 5.9** Collection of the artist. Copyright © Matt Kahn; **Fig. 5.10** Copyright © Michael F. Marmor; **Fig. 5.11** National Gallery of Victoria, Melbourne, Australia/ The Bridgeman Art Library. © National Gallery of Victoria, Melbourne; **Fig. 5.12** Cantor Arts Center at Stanford University. Gift of Mrs. William Babcock; **Fig. 5.13** Van Gogh Museum, Amsterdam, The Netherlands. Photo: Art Resource, NY.

CHAPTER 6 **Fig. 6.2** Copyright © Michael F. Marmor; **Fig. 6.3** Museo Archeologico Nazionale, Naples, Italy. Photo: Scala / Art Resource, NY; **Fig. 6.4** The Metropolitan Museum of Art, New York, New York, U.S.A. Gift of John M. Crawford Jr., in honor of Alfreda Murck, 1986 (1986.493.2). Photo: Malcom Varon. Image copyright © The Metropolitan Museum of Art / Art Resource, NY; **Fig. 6.5** The Metropolitan Museum of Art, New York, New York, U.S.A. The Cloisters Collection, 1956 (56.7). Image copyright © The Metropolitan Museum of Art / Art Resource, NY; **Fig. 6.6** The Louvre Museum, Paris / Giraudon/ The Bridgeman Art Library; **Fig. 6.7** Yale University Art Gallery, New Haven, Connecticut, U.S.A. Everett V. Meeks, B.A. 1901, Fund. 1960.9.1. Photo: Yale University Art Gallery / Art Resource, NY; **Fig. 6.8** The Metropolitan Museum of Art, New York, New York, U.S.A. Alfred Stieglitz Collection, 1969 (69.278.1). © 2009 Georgia O'Keeffe Museum / Artists Rights Society (ARS), New York. Photo: Malcom Varon. Image copyright © The Metropolitan Museum of Art / Art Resource, NY; **Fig. 6.9** Smithsonian American Art Museum, Washington, DC, U.S.A. Bequest of Suzanne M. Smith. © The Estate of Arthur G. Dove. Photo: Smithsonian American Art Museum, Washington, DC / Art Resource, NY; **Fig. 6.10** Museo Thyssen-Bornemisza, Madrid, Spain. © 2009 Artists Rights Society (ARS), New York / VG Bild-Kunst, Bonn. Photo: Scala / Art Resource, NY; **Fig. 6.11** Private collection. © 2009 Artists Rights Society (ARS), New York / ADAGP, Paris; **Fig. 6.12** The Metropolitan Museum of Art, New York, New York, U.S.A. Gift of Kathryn B. Miller, 1964 (64.15). Image copyright © The Metropolitan Museum of Art / Art Resource, NY.

CHAPTER 7 **Fig. 7.1** Musée d'Orsay, Paris, France. Photo: Hervé Landowski / Réunion des Musées Nationaux / Art Resource, NY; **Fig. 7.2** Musée des Beaux-Arts, Pau, France / Giraudon / The Bridgeman Art Library; **Fig. 7.3** Yale University Art Gallery, New Haven, Connecticut, U.S.A. Purchase Leonard C. Hanna Jr., B.A. 1913, Fund. 1961.22. Photo: Yale University Art Gallery / Art Resource, NY; **Fig. 7.4** Galerie Neue Meister, Dresden, Germany. © Staatliche Kunstsammlungen Dresden / The Bridgeman Art Library; **Fig. 7.5** National Gallery of Ireland, Dublin, Ireland / Bridgeman-Giraudon / Art Resource, NY; **Fig. 7.6** Wellington Museum, London, Great Britain. Photo: V&A Images, London / Art Resource, NY; **Fig. 7.7** The Louvre Museum, Paris, France / The Bridgeman Art Library; **Fig. 7.8** Abbey of St. Florian, Sankt Florian, Austria. Photo: Erich Lessing / Art Resource, NY; **Fig. 7.9** Musée d'Orsay, Paris, France / Giraudon / The Bridgeman Art Library.

CHAPTER 8 **Fig. 8.3** Blanton Museum of Art, The University of Texas at Austin. Gift of Mari and James A. Michener, 1991. Photo: Rick Hall. Art © Richard Anuszkiewicz/Licensed by VAGA, New York, NY; **Fig. 8.5** *Interaction of Color*, by Josef Albers, plate VI 3, top. New Haven, CT: Yale University Press, 1963. © 2009 The Joseph and Anni Albers Foundation / Artists Rights Society (ARS), New York; **Fig. 8.6** Musée d'Orsay, Paris, France / Lauros / Giraudon / The Bridgeman Art Library; **Fig. 8.7** Toledo Museum of Art. Purchased with funds from the Libbey Endowment. Gift of Drummond Libbey, acc. No. 1952.78; **Fig. 8.10** Musée d'Art Moderne de la Ville de Paris, Paris, France. © 2009 Artists Rights Society (ARS), New York / ADAGP, Paris; **Fig. 8.11** The Museum of Modern Art, New York, New York, U.S.A. Gift of Mr. David Whitney. (70.1968.10). © 2009 The Andy Warhol Foundation for the Visual Arts / ARS, New York. Digital Image © The Museum of Modern Art / Licensed by SCALA / Art Resource, NY; **Fig. 8.12** Kupferstichkabinett, Staatliche Museen zu Berlin, Berlin, Germany. © 2009 The Andy Warhol Foundation for the Visual Arts / ARS, New York. Photo: Joerg P. Anders / Bildarchiv Preussischer Kulturbesitz / Art Resource, NY; **Fig. 8.13** The Museum of Modern Art, New York, New York, U.S.A. Gift of Mr. and Mrs. Charles Zadok. (195.1952). © 2009 Artists Rights Society (ARS), New York / ADAGP, Paris. Digital Image © The Museum of Modern Art / Licensed by SCALA / Art Resource, NY; **Fig. 8.14** The Museum of Modern Art, New York. The William S. Paley Collection. (SPC66.1990). © 2009 Artists Rights Society (ARS), New York / ADAGP, Paris. Digital Image © The Museum of Modern Art / Licensed by SCALA / Art Resource, NY; **Fig. 8.15** Galleria Borghese, Rome, Italy. Photo: Mauro Magliani for Alinari, 1997 / Alinari / Art Resource, NY; **Fig. 8.16** Pushkin Museum of Fine Arts, Moscow, Russia. Photo: Scala / Art Resource, NY; **Fig. 8.17** Musée Marmottan Monet, Paris, France / Giraudon / The Bridgeman Art Library.

CHAPTER 9 **Fig. 9.1** Tate Gallery, London, Great Britain. Photo: Tate, London / Art Resource, NY; **Fig 9.2** Tate Gallery, London, Great Britain. Photo: Tate, London / Art Resource, NY; **Fig. 9.3** National Gallery, London, UK / The Bridgeman Art

Library; **Fig. 9.4** National Gallery of Art, Washington, DC, U.S.A. Andrew W. Mellon Collection, Image courtesy of the Board of Trustees, National Gallery of Art, Washington; **Fig. 9.5** Tate Gallery, London, Great Britain. Photo: Tate, London / Art Resource, NY; **Fig. 9.6** Tate Gallery, London, Great Britain. Photo: Tate, London / Art Resource, NY.

CHAPTER 10 **Fig. 10.1** Yale University Art Gallery, New Haven, Connecticut, U.S.A. Bequest of Stephen Carlton Clark, B.A. 1903. Photo: Yale University Art Gallery / Art Resource, NY; **Fig. 10.2** Van Gogh Museum, Amsterdam, The Netherlands / The Bridgeman Art Library; **Fig. 10.3** Private collection / The Bridgeman Art Library; **Fig. 10.4** Museum Boijmans Van Beuningen, Rotterdam, The Netherlands; **Fig. 10.5** National Gallery, London, UK / The Bridgeman Art Library; **Fig. 10.6** Fogg Art Museum, Harvard Art Museum, Cambridge, Massachusetts, U.S.A. Bequest from the Collection of Maurice Wertheim, Class of 1906, 1951.65. © Harvard Art Museum / Art Resource, NY; **Fig. 10.7** Van Gogh Museum, Amsterdam, The Netherlands (Vincent van Gogh Foundation).

CHAPTER 11 **Fig. 11.1** Art Institute of Chicago, Chicago, U.S.A / The Bridgeman Art Library; **Fig. 11.2** Musée d'Orsay, Paris, France / Lauros / Giraudon / The Bridgeman Art Library; **Fig. 11.3** The Courtauld Gallery, London, UK. © Samuel Courtauld Trust, Courtauld Institute of Art Gallery / The Bridgeman Art Library; **Fig. 11.4** Museum of Fine Arts, Houston, Texas, U.S.A. / Gift of Audrey Jones Beck / The Bridgeman Art Library; **Fig. 11.5** Musée d'Orsay, Paris, France / Giraudon / The Bridgeman Art Library; **Fig. 11.6** Private collection / Giraudon / The Bridgeman Art Library.

CHAPTER 12 **Fig. 12.1** Musée National d'Art Moderne, Centre Georges Pompidou, Paris, France. © Succession H. Matisse Artists Rights Society (ARS), NY. Photo: Jacqueline Hyde / CNAC / MNAM / Dist. Réunion des Musées Nationaux / Art Resource, NY; **Fig. 12.2** Musée d'Orsay, Paris, France. © Succession H. Matisse Artists Rights Society (ARS), NY. Photo by RMN: Herve Lewandowski / Réunion des Musées Nationaux / Art Resource, NY; **Fig. 12.3** Musée de l'Annonciade, Saint-Tropez, France. © Succession H. Matisse Artists Rights Society (ARS), NY. Photo: Erich Lessing / Art Resource, NY; **Fig. 12.4** Pushkin Museum of Fine Arts, Moscow, Russia. © Succession H. Matisse Artists Rights Society (ARS), NY. Photo: Scala / Art Resource, NY; **Fig. 12.5** Pinacoteca Gianni e Marella Agnelli, Turin, Italy. © Succession H. Matisse Artists Rights Society (ARS), NY. Photo © Gilles Mermet / Art Resource, NY; **Fig. 12.6** Pinacoteca Gianni e Marella Agnelli, Turin, Italy. © Succession H. Matisse Artists Rights Society (ARS), NY. Photo © Gilles Mermet / Art Resource, NY; **Fig. 12.7** Musée Matisse, Nice, France. © Succession H. Matisse Artists Rights Society (ARS), NY. Photo: Gérard Blot / Réunion des Musées Nationaux / Art Resource, NY.

CHAPTER 13 **Fig. 13.1** San Francisco Museum of Modern Art, San Francisco, California, U.S.A. Collection of the Art Supporting Foundation to the San Francisco Museum of Modern Art. © Chuck Close, courtesy PaceWildenstein, New York; **Fig. 13.2** Toledo Museum of Art, Toledo, Ohio, U.S.A. Gift of the Apollo Society, acc. no. 1987.218. © Chuck Close, courtesy PaceWildenstein, New York; **Fig. 13.3** Cantor Arts Center at Stanford University, Stanford, California, U.S.A. Gift of the Cardea Foundation (Drs. K. and J. Marmor) in Honor of the 100th Anniversary of Stanford University's Founding 1987.92. © Estate of Roy Lichtenstein; **Fig. 13.4** Private collection. Photo: Erich Lessing / Art Resource, NY; **Fig. 13.5** San Francisco Museum of Modern Art, San Francisco, California, U.S.A. Collection of the Art Supporting Foundation to the San Francisco Museum of Modern Art. © Chuck Close, courtesy PaceWildenstein, New York.

CHAPTER 14 **Fig. 14.3** Collection of the artist. Copyright © Jens Johannsen; **Fig. 14.4** Private collection. Copyright © Jens Johannsen; **Fig. 14.5** Collection of the artist. Copyright © Jens Johannsen; **Fig. 14.6** Private collection. Copyright © Jens Johannsen; **Fig. 14.7** National Gallery, London, UK / The Bridgeman Art Library; **Fig. 14.8** Musée de Tesse, Le Mans, France / Lauros / Giraudon / The Bridgeman Art Library.

CHAPTER 15 **Fig. 15.1** The Toledo Museum of Art, Toledo, Ohio, U.S.A. Museum Purchase Fund, acc. no. 1936.79; **Fig. 15.2** The Toledo Museum of Art, Toledo, Ohio, U.S.A. Museum Purchase Fund, acc. no. 1922.105; **Fig. 15.3** The Toledo Museum of Art, Toledo, Ohio, U.S.A. Museum Purchase Fund, acc. no. 1923.3089; **Fig. 15.4** Musée Eugene Delacroix, Paris, France. Photo: Réunion des Musées Nationaux / Art Resource, NY.

CHAPTER 16 **Fig. 16.1** Private collection. Photo: Bryan F. Rutledge B.A.; **Fig. 16.2** Private collection. Courtesy of S. B. Kennedy; **Fig. 16.3** Private collection. Courtesy of Pyms Gallery, London; **Fig. 16.5** Private collection. Courtesy of S. B. Kennedy.

CHAPTER 17 **Fig. 17.1** Museo Archeologico Nazionale, Naples, Italy. Photo: Erich Lessing / Art Resource, NY; **Fig. 17.2** Duomo, Siena, Italy / The Bridgeman Art Library; **Fig. 17.3** Santa Maria Novella, Florence, Italy. Photo: The Bridgeman Art Library; **Fig. 17.4** Gemaeldegalerie, Staatliche Museen zu Berlin, Berlin, Germany. Photo: Bildarchiv Preussischer Kulturbesitz / Art Resource, NY; **Fig. 17.5**

Saint Ignazio, Rome, Italy. © DeA Picture Library / Art Resource, NY; **Fig. 17.6** National Portrait Gallery, London, UK. © National Portrait Gallery, London; **Fig. 17.7** © 1960. Reprinted with permission of Heldref Publications, the Helen Dwight Reid Educational Foundation; **Fig. 17.11** The Metropolitan Museum of Art, New York, New York, U.S.A. Bequest of John M. Crawford Jr., 1988 (1989.363.129). Image copyright © The Metropolitan Museum of Art.

CHAPTER 18 **Fig. 18.1** Valley of the Kings, Thebes, Egypt / Giraudon / The Bridgeman Art Library; **Fig. 18.2** Monastery Church, Ohrid, Macedonia. Photo: Erich Lessing / Art Resource, NY; **Fig. 18.3** Private collection. Photo: Werner Forman / Art Resource, NY; **Fig. 18.4** Institute of Oriental Studies, St. Petersburg, Russia. Photo: Erich Lessing / Art Resource, NY; **Fig. 18.5** Private collection / The Bridgeman Art Library; **Fig. 18.6** Private collection. © 2009 Estate of Pablo Picasso / Artists Rights Society (ARS), New York. Photo: The Bridgeman Art Library; **Fig. 18.7** © David Hockney.

CHAPTER 19 **Fig. 19.2** Tate Gallery, London, UK. © 2009 Artists Rights Society (ARS), New York / ADAGP, Paris. Photo: V&A Images, London / Art Resource, NY; **Fig. 19.4** Collection of Sarah Riley. © Bridget Riley; **Fig. 19.5** Private collection; **Fig. 19.6** Private collection. Photo of Quichua bowl by Ian Reeves. **Fig. 19.8** Musée d'Orsay, Paris, France. Photo: J. G. Berizzi / Réunion des Musées Nationaux / Art Resource, NY; **Fig. 19.10** *Interaction of Color*, by Josef Albers, Plate XXII-1 (left). New Haven, CT: Yale University Press, 1963. © 2009 The Josef and Anni Albers Foundation / Artists Rights Society (ARS), New York; **Fig. 19.12** Private collection. © 2009 Artists Rights Society (ARS), New York / ADAGP, Paris; **Fig. 19.13** Palazzo Spada, Rome, Italy. Photo: Scala / Art Resource, NY; **Fig. 19.15** Department of Art and Archeology, Princeton University. Photo: Antioch Expedition Archives; **Fig. 19.17** M. C. Escher's, *Waterfall* © 2009 The M. C. Escher Company-Holland. All rights reserved. www.mcescher.com; **Fig. 19.21** Private collection / The Bridgeman Art Library; **Fig. 19.22** Private collection. Copyright © Peter Silten. Photo by Ian Reeves; **Fig. 19.23** Museo Thyssen-Bornemisza, Madrid, Spain. © 2009 C. Herscovici, London / Artists Rights Society (ARS), NY. Photo: Banque d'Images, ADAGP / Art Resource, NY.

CHAPTER 20 **Fig. 20.1** The Munch Museum, Oslo, Norway. © The Much Museum / The Munch-Ellingsen Group / Artists Rights Society (ARS), NY; **Fig. 20.4** Copyright © Michael F. Marmor. Photos: Stephen Gladfelter, Visual Art Services, Stanford University; **Fig. 20.5** The Louvre Museum, Paris, France. Photo: Hervé Lewandowski / Réunion des Musées Nationaux / Art Resource, NY.

CHAPTER 21 **Fig. 21.1** M. C. Escher's, *Self-Portrait* © 2009 The M. C. Escher Company-Holland. All rights reserved. www.mcescher.com; **Fig. 21.2** M. C. Escher's, *Another World* © 2009 The M. C. Escher Company-Holland. All rights reserved. www.mcescher.com; **Fig. 21.3** M. C. Escher's, *Sky and Water I* © 2009 The M. C. Escher Company-Holland. All rights reserved. www.mcescher.com. **Fig. 21.4** M. C. Escher's, *Day and Night* © 2009 The M. C. Escher Company-Holland. All rights reserved. www.mcescher.com; **Fig. 21.5** M. C. Escher's, *Moebius Strip II* © 2009 The M. C. Escher Company-Holland. All rights reserved. www.mcescher.com.

CHAPTER 22 **Fig. 22.1** Collection of the artist. © Bridget Riley; **Fig. 22.2** Tate Gallery, London, UK. © Bridget Riley. Photo: Tate, London / Art Resource, NY; **Fig. 22.3** Tate Gallery, London, UK. © Bridget Riley. Photo: Tate, London / Art Resource, NY; **Fig. 22.4** Tate Gallery, London, UK. © Bridget Riley. Photo: Tate, London / Art Resource, NY.

CHAPTER 23 **Fig. 23.1** Gemäldegalerie Alte Meister, Kassel, Germany. © Museumslandschaft Hessen Kassel / Ute Brunzel / The Bridgeman Art Library; **Fig. 23.2** Gemäldegalerie Alte Meister, Kassel, Germany. © Museumslandschaft Hessen Kassel / Ute Brunzel / The Bridgeman Art Library; **Fig. 23.3** The Barnes Foundation, Merion, Pennsylvania, U.S.A. © The Barnes Foundation, Merion, Pennsylvania, USA / The Bridgeman Art Library; **Fig. 23.4** Musée des Beaux-Arts, Caen, France / Giraudon / The Bridgeman Art Library; **Fig. 23.5** New York Historical Society, New York, New York, U.S.A. © Collection of the New-York Historical Society, USA / The Bridgeman Art Library; **Fig. 23.6** Courtesy of Peep Algvere, MD; **Fig. 23.7** Private collection.

CHAPTER 24 **Fig. 24.1** Prado, Madrid, Spain / The Bridgeman Art Library; **Fig. 24.2** Galleria Borghese, Rome, Italy. Photo: Scala / Ministero per i Beni e le Attività culturali / Art Resource, NY; **Fig. 24.3** Archbishop's Palace, Kromeriz, Czech Republic. Photo: Erich Lessing / Art Resource, NY; **Fig. 24.4** Museum of Fine Arts, Boston. Charles H. Bayley Picture and Painting Fund and Partial Gift of Elizabeth Paine Metcalf / The Bridgeman Art Library; **Fig. 24.5** The Courtauld Gallery, London, UK. © Samual Courtauld Trust, The Courtauld Gallery, London, UK / The Bridgeman Art Library; **Fig. 24.6** Philadelphia Museum of Art, Philadelphia, Pennsylvania, U.S.A. The George W. Elkins Collection, 1936. Photo: The Philadelphia Museum of Art / Art Resource, NY; **Fig. 24.7** The Louvre Museum Museum / Lauros / Giraudon / The Bridgeman Art Library; **Fig. 24.8** The Museum of Modern Art, New York, New York, U.S.A. Lillie P. Bliss Collection. (18.1934). Digital Image © The Museum of Modern Art / Licensed by SCALA / Art Resource, NY.

CHAPTER 25 **Fig. 25.1** National Gallery of Art, Washington, DC, U.S.A. Andrew W. Mellon Collection. Image courtesy of the Board of Trustees, National Gallery of Art, Washington; **Fig. 25.2** The Louvre Museum, Paris / Peter Willi / The Bridgeman Art Library; **Fig. 25.3** © Collection of the Earl of Pembroke, Wilton House, Wilts. / The Bridgeman Art Library; **Fig. 25.4** National Gallery of Art, Washington, DC, U.S.A. Andrew W. Mellon Collection. Image courtesy of the Board of Trustees, National Gallery of Art, Washington.

CHAPTER 26 **Fig. 26.1** Dallas Museum of Art, Dallas, Texas, U.S.A. The Wendy and Emery Reves Collection; **Fig. 26.2** Toledo Museum of Art, Toledo, Ohio, U.S.A. Purchased with funds from the Libbey Endowment. Gift of Edward Drummond Libbey, acc. No. 1951.361; **Fig. 26.3** Musée d'Orsay, Paris, France. Photo: Réunion des Musées Nationaux / Art Resource, NY.

CHAPTER 27 **Fig. 27.1** Los Angeles County Museum of Art, Los Angeles, California, U.S.A. Gift of Bruce Davis AC1994.138.2; **Fig. 27.2** Graphische Sammlung, Universitätsbibliothek Erlangen-Nürnberg, Germany; **Fig. 27.3** The Louvre Museum, Paris, France. Photo: Hervé Lewandowski / Réunion des Musées Nationaux / Art Resource, NY; **Fig. 27.4** National Gallery of Art, Washington, DC. Andrew W. Mellon Collection. Image courtesy of the Board of Trustees, National Gallery of Art, Washington; **Fig. 27.5** National Gallery of Art, Washington, DC, U.S.A. Rosenwald Collection. Image courtesy of the Board of Trustees, National Gallery of Art, Washington; **Fig. 27.6** Graphische Sammlung, Albertina, Vienna, Austria; **Fig. 27.7** Accademia, Florence, Italy. Photo: Scala / Ministero per i Beni e le Attività culturali / Art Resource, NY; **Fig. 27.8** Copyright © Michael F. Marmor. Photos: Stephen C. Gladfelter, Visual Art Services, Stanford University.

CHAPTER 28 **Fig. 28.1** Uffizi, Florence, Italy. Photo: Scala / Art Resoure, NY; **Fig. 28.2** Musée des Beaux-Arts, Dijon, France. Photo: Erich Lessing / Art Resource, NY; **Fig. 28.3** Musée National d'Art Moderne, Centre Georges Pompidou, Paris, France. © 2009 Artists Rights Society (ARS), New York, ADAGP, Paris. Photo: CNAC / MNAM / Dist. Réunion des Musées Nationaux / Art Resource, NY; **Fig. 28.4** The Philadelphia Museum of Art, Philadelphia, Pennsylvania, U.S.A. The Samuel S. White III and Vera White Collection, 1967. © 2009 Artists Rights Society (ARS), New York, ADAGP, Paris. Photo: The Philadelphia Museum of Art / Art Resource, NY; **Fig. 28.5** Smithsonian American Art Museum, Washington, DC, U.S.A. Photo: Smithsonian American Art Museum, Washington, DC / Art Resource, NY; **Fig. 28.6** Smithsonian American Art Museum, Washington, DC, U.S.A. Photo: Smithsonian American Art Museum, Washington, DC / Art Resource, NY; **Fig. 28.7** The Metropolitan Museum of Art, New York, New York, U.S.A. Gift of Several Gentleman, 1897 (97.32). Image copyright © The Metropolitan Museum of Art / Art Resource, NY.

CHAPTER 29 **Fig. 29.1** National Portrait Gallery, Smithsonian Institution, Washington, DC, U.S.A. Photo: National Portrait Gallery, Smithsonian Institution / Art Resource, NY; **Fig. 29.2** Philadelphia Museum of Art, Philadelphia, Pennsylvania. Bequest of Charlotte Dorrance Wright, 1978. Photo: The Philadelphia Museum of Art / Art Resource, NY; **Fig. 29.3** The Metropolitan Museum of Art, New York, New York, U.S.A. From the Collection of James Stillman, Gift of Dr. Ernest G. Stillman, 1922 (22.16.22). Image copyright © The Metropolitan Museum of Art / Art Resource, NY; **Fig. 29.4** Musée d'Orsay, France / Lauros / Giraudon / The Bridgeman Art Library; **Fig. 29.5** The Metropolitan Museum of Art, New York, New York, U.S.A. H. O. Havemeyer Collection. Bequest of Mrs. H. O. Havemeyer, 1929 (29.100.50). Image copyright © The Metropolitan Museum of Art / Art Resource, NY.

CHAPTER 30 **Fig. 30.1** Musée Marmottan Monet, Paris, France / Giraudon / The Bridgeman Art Library; **Fig. 30.2** Kunsthistorisches Museum, Vienna, Austria / The Bridgeman Art Library; **Fig. 30.3** Musée Marmottan Monet, Paris, France / The Bridgeman Art Library; **Fig. 30.4** Musée Marmottan Monet, Paris, France / The Bridgeman Art Library; **Fig. 30.5** Musée Marmottan Monet, Paris, France / The Bridgeman Art Library; **Fig. 30.6** Musée Marmottan Monet, Paris, France / Giraudon / The Bridgeman Art Library; **Fig. 30.7** Private collection / Roger-Viollet, Paris / The Bridgeman Art Library; **Fig. 30.8** Musée Marmottan Monet, Paris, France / The Bridgeman Art Library; **Fig. 30.9** Galerie Daniel Malingue, Paris, France / The Bridgeman Art Library; **Fig. 30.10** The Museum of Modern Art, New York, New York, U.S.A. Gift of Mrs. Nickolas Muray. © Nickolas Muray Photo Archives.

CHAPTER 31 **Fig. 31.1** Private collection / Archives Charmet / The Bridgeman Art Library; **Fig. 31.2** Musée d'Orsay, Paris, France / Lauros / Giraudon/ The Bridgeman Art Library; **Fig. 31.3** Musée d'Orsay, Paris, France. Photo: Réunion des Musées Nationaux / Art Resource, NY; **Fig. 31.4** Musée des Beaux-Arts et d'Archeologie, Besançon, France. © 2009 Artists Rights Society (ARS), New York / ADAGP, Paris. Photo: Musée des Beaux-Arts et d'Archeologie, Besançon, France / Lauros / Giraudon / The Bridgeman Art Library; **Fig. 31.5** Musée National d'Art Moderne, Centre Georges Pompidou, Paris, France. ©2009 Artists Rights Society (ARS), New York / ADAGP, Paris. Photo: Musée National d'Art Moderne, Centre Georges Pompidou, Paris, France / Giraudon / The Bridgeman Art Library.

CHAPTER 32 **Fig. 32.1** Copyright © 1937 by Rosemary A. Thurber. Reprinted by arrangement with The Barbara Hogenson Agency. All rights reserved; **Fig. 32.2** Photo by Bob Landry, Time & Life Pictures, Getty Images; **Fig. 32.3** Copyright © 1940 by Rosemary A. Thurber. Reprinted by arrangement with The Barbara Hogenson Agency. All rights reserved; **Fig. 32.4** Copyright © 1945 by Rosemary A. Thurber. Reprinted by arrangement with The Barbara Hogenson Agency. All rights reserved.

CHAPTER 33 **Fig. 33.1** Toledo Museum of Art, Toledo, Ohio, U.S.A. Gift of Arthur J. Secor, acc. No. 1922.44; **Fig. 33.2** Ipswich Museums and Galleries, Ipswich, England; **Fig. 33.3** Palazzo della Provincia, Genova, Italy; **Fig. 33.4** Museo Civico Giovanni Fattori, Livorno, Italy; **Fig. 33.5** Musée des Beaux-Arts, Nantes, France. © 2009 Artists Rights Society (ARS), New York / ADAGP, Paris. Photo: Gerard Bonnet / Réunion des Musées Nationaux / Artists Resource, NY; **Fig. 33.6** Musée des Beaux-Arts, Rennes, France. © 2009 Artists Rights Society (ARS), New York / ADAGP, Paris. Photo: Louis Deschamps / Réunion des Musées Nationaux / Artists Resource, NY; **Fig. 33.7** From *The Martian; A Novel With Illustrations by the Author.* London: Harper, 1898; **Fig. 33.8** By Kind Permission of The Trustees of the Chequers Estate / Mark Fiennes / The Bridgeman Art Library.

CHAPTER 34 **Fig. 34.1** Toledo Museum of Art. Purchased with funds from the Libbey Endowment. Gift of Drummond Libbey, acc. no. 1959.14; **Fig. 34.2** The Prado Museum, Madrid / The Bridgeman Art Library; **Fig. 34.3** Musee des Beaux-Arts, Agen, France / Lauros / Giraudon / The Bridgeman Art Library; **Fig. 34.4** Real Academia de Bellas Artes de San Fernando, Madrid, Spain / The Bridgeman Art Library; **Fig. 34.5** Minneapolis Institute of Arts, The Ethel Morrison Van Derlip Fund, Minneapolis, Minnesota, U.S.A.

CHAPTER 35 **Fig. 35.1** Museu Calouste Gulbenkian, Lisbon, Portugal / Giraudon/ The Bridgeman Art Library; **Fig. 35.2** National Gallery of Art, Washington, DC. Chester Dale Collection. Image courtesy of the Board of Trustees, National Gallery of Art, Washington; **Fig. 35.3** Private collection / Photo © Lefevre Fine Art Ltd., London / The Bridgeman Art Library; **Fig. 35.4** Musée d'Orsay, Paris, France. Photo: Erich Lessing / Art Resource, NY; **Fig. 35.5** Neue Meister, Staatliche Kunstsammlungen, Dresden, Germany. Photo: Bildarchiv Preussischer Kulturbesitz / Art Resource, NY; **Fig. 35.6** The Louvre Museum, Paris, France. Photo: Réunion des Musées Nationaux / Art Resource, NY.

CHAPTER 36 **Fig. 36.1** Munch Museum, Oslo. © 2009 The Munch Museum / The Munch-Ellingsen Group / Artists Rights Society (ARS), NY; **Fig. 36.2** Munch Museum, Oslo. © 2009 The Munch Museum / The Munch-Ellingsen Group / Artists Rights Society (ARS), NY; **Fig. 36.3** Munch Museum, Oslo. © 2009 The Munch Museum / The Munch-Ellingsen Group / Artists Rights Society (ARS), NY; **Fig. 36.4** Munch Museum, Oslo. © 2009 The Munch Museum / The Munch-Ellingsen Group / Artists Rights Society (ARS), NY; **Fig. 36.5** Munch Museum, Oslo. © 2009 The Munch Museum / The Munch-Ellingsen Group / Artists Rights Society (ARS), NY; **Fig. 36.6** Munch Museum, Oslo. © 2009 The Munch Museum / The Munch-Ellingsen Group / Artists Rights Society (ARS), NY; **Fig. 36.7** Munch Museum, Oslo. © 2009 The Munch Museum / The Munch-Ellingsen Group / Artists Rights Society (ARS), NY; **Fig. 36.8** Munch Museum, Oslo. © 2009 The Munch Museum / The Munch-Ellingsen Group / Artists Rights Society (ARS), NY; **Fig. 36.9** Munch Museum, Oslo. © 2009 The Munch Museum / The Munch-Ellingsen Group / Artists Rights Society (ARS), NY.

CHAPTER 37 **Fig. 37.1** Georgia O'Keeffe Museum, Santa Fe. Gift of the Burnett Foundation. © 2009 Georgia O'Keeffe Museum / Artists Rights Society (ARS), New York; **Fig. 37.2** Georgia The Art Institute of Chicago. Alfred Stieglitz Collection, gift of Georgia O'Keeffe, 1955.1223. © 2009 Georgia O'Keeffe Museum / Artists Rights Society (ARS), New York. Photography © The Art Institute of Chicago; **Fig. 37.3** The Art Institute of Chicago. Alfred Stieglitz Collection, bequest of Georgia O'Keeffe, 1987.250.3. © 2009 Georgia O'Keeffe Museum / Artists Rights Society (ARS), New York. Photography © The Art Institute of Chicago; **Fig. 37.4** The Museum of Modern Art, New York. Georgia O'Keeffe Bequest (447.993). © 2009 Georgia O'Keeffe Museum / Artists Rights Society (ARS), New York. Digital Image © The Museum of Modern Art / Licensed by SCALA / Art Resource, NY; **Fig. 37.5** Photo: Malcolm Varon. © 2009 Georgia O'Keeffe Museum / Artists Rights Society (ARS), New York; **Fig. 37.6** Brooklyn Museum, Brooklyn, New York. Dick S. Ramsay Fund 58.76. © 2009 Georgia O'Keeffe Museum / Artists Rights Society (ARS), New York; **Fig. 37.7** Copyright © 2000 Dan Budnik.

CHAPTER 38 **Fig. 38.2** Copyright © Michael F. Marmor; **Fig. 38.3** Copyright © Michael F. Marmor; **Fig. 38.4(a)** Hermitage, St. Petersburg, Russia / The Bridgeman Art Library, **(b)** © Samuel Courtauld Trust, Courtauld Institute of Art Gallery / The Bridgeman Art Library, **(c)** Norton Simon Museum, Pasadena, California, U.S.A. Norton Simon Art Foundation, **(d–f)** Copyright © Michael F. Marmor; **Fig. 38.5** Copyright © Michael F. Marmor; **Fig. 38.6** National Gallery, London, UK/ The Bridgeman Art Library; **Fig. 38.7 (a)** Copyright © Elizabeth Murray, www.elizabethmurray.com, **(b–c)** Copyright © Michael F. Marmor; **Fig. 38.8 (a)** Musée Marmottan Monet, Paris, France / The Bridgeman Art Library, **(b)** Copyright © Michael F. Marmor; **Fig. 38.9 (a and c)** Musée Marmottan Monet, Paris, France / Giraudon / The Bridgeman Art Library, **(b and d)** Copyright © Michael F. Marmor; **Fig. 38.10** Musée de l'Orangerie, Paris, France / Lauros / Giraudon / The Bridgeman Art Library.

INDEX

Page numbers in italics refer to illustrations.

Project Manager: Eric Himmel
Editor: Susan Homer
Designer: Kara Strubel
Art Director: Michelle Ishay-Cohen
Production Manager: Jules Thomson

Cataloging-in-Publication Data has been applied for an may be
obtained from the Library of Congress.

ISBN 978-0-8109-4849-5

Copyright © 2009 Michael F. Marmor and James G. Ravin

Please see page 216 for image credits.

Published in 2009 by Abrams, an imprint of ABRAMS. All
rights reserved. No portion of this book may be reproduced, stored
in a retrieval system, or transmitted in any form or by any means,
mechanical, electronic, photocopying, recording, or otherwise,
without written permission from the publisher.

Printed and bound in China
10 9 8 7 6 5 4 3 2 1

Abrams books are available at special discounts when purchased
in quantity for premiums and promotions as well as fundraising
or educational use. Special editions can also be created to
specification. For details, contact specialmarkets@abramsbooks.com,
or the address below.

ABRAMS
THE ART OF BOOKS SINCE 1949
115 West 18th Street
New York, NY 10011
www.abramsbooks.com

GLEN COVE PUBLIC LIBRARY

3 1571 00277 7640

701.08 Marmor, Michael F.,
M 1941-

 The artist's eyes.

DISCARDED BY THE
GLEN COVE PUBLIC LIBRARY

DATE

GLEN COVE PUBLIC LIBRARY
GLEN COVE, NEW YORK 11542
PHONE: 676—2130
DO NOT REMOVE CARD FROM POCKET

BAKER & TAYLOR